MW00648014

# Global Objects

## Toward a Connected Art History

Edward S. Cooke, Jr.

**Princeton University Press**

Princeton and Oxford

*Dedicated to the many students who have expanded my horizons and inspired this volume.*

Copyright © 2022 by Princeton University Press

Princeton University Press is committed to the protection of copyright and the intellectual property our authors entrust to us. Copyright promotes the progress and integrity of knowledge. Thank you for supporting free speech and the global exchange of ideas by purchasing an authorized edition of this book. If you wish to reproduce or distribute any part of it in any form, please obtain permission.

Requests for permission to reproduce material from this work should be sent to permissions@press.princeton.edu

Published by Princeton University Press, 41 William Street, Princeton, New Jersey 08540

In the United Kingdom: Princeton University Press, 6 Oxford Street, Woodstock, Oxfordshire OX20 1TR

press.princeton.edu

Illustrations in front matter:
p. i, detail of fig. 3.40; p. ii, detail of fig. 3.35; p. iv, detail of fig. 3.43; p. viii, detail of fig. 3.24

Illustrations in part openers:
pp. 20-21, detail of fig. 1.19; pp. 98-99, detail of fig. 2.12; pp. 176-77, detail of fig. 6.11

Illustrations in back matter:
p. 264, detail of fig. 3.55; p. 269, detail of fig. 1.13; p. 270, detail of fig. 3.6; p. 277, detail of fig. 2.43; p. 278, detail of fig. 3.26

Cover images: (*lower left to upper right*) Bowl, Iraq, tenth century; drape-molded and wheel-trimmed earthenware with tin glaze and luster decoration. Cleveland Museum of Art, Cleveland, OH, John L. Severance Fund, 1959.331. One of a set of six plates, Willem Kick, Amsterdam, Netherlands, 1620–25; turned plane wood with black varnish, gold leaf, and polychrome glazes with inset pieces of Chinese porcelain from 1600–1620. Gustavanium, Uppsala University Museum, inv. UUK 0392–0397. Photograph by Mikael Wallerstedt. Plate, Portugal, 1660–1700; drape-molded and wheel-trimmed, tin-glazed earthenware with cobalt blue decoration. Private collection. Photograph by Gavin Ashworth.

All Rights Reserved

ISBN (pbk.) 9780691184739

ISBN (ebook) 9780691237558

British Library Cataloging-in-Publication Data is available

Publication has been made possible by a grant from the Frederick W. Hilles Publication Fund of Yale University and the generous support of the Department of the History of Art Publications Fund, Yale University

Designed by Jeff Wincapaw

This book has been composed in Minion Pro and Doctrine

Printed on acid-free paper. ∞

Printed in Canada

10 9 8 7 6 5 4 3 2 1

# Contents

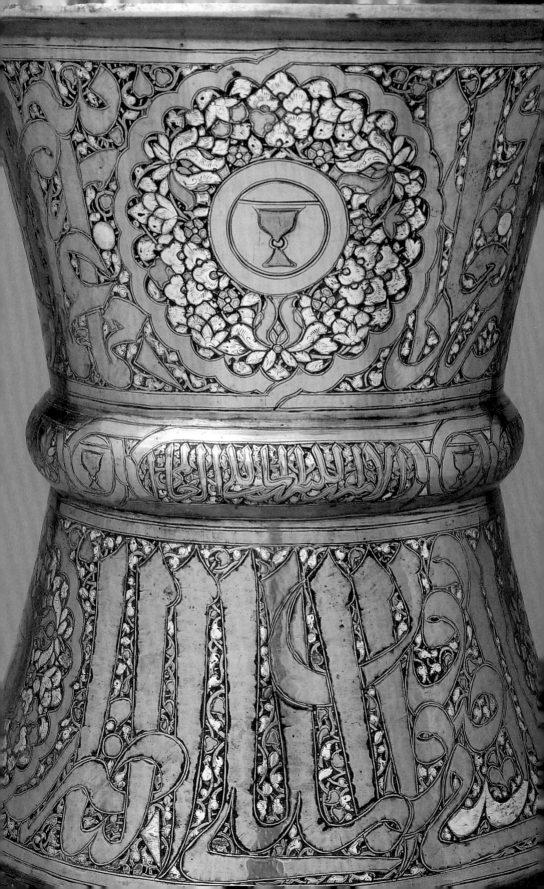

# Introduction

A seventeenth-century Japanese folding chair with lacquer decoration seems to be a straightforward object (fig. 0.1). It is a small, portable seat that prioritizes light weight and the ability to be folded flat, rejecting a thronelike form, extensive carving, or elaborate upholstery. It appears to be a temporary form of seating. It might be easily be mistaken for a Japanese imitation of a contemporaneous Dutch *preekstoeltje*, a small sermon chair that women carried to church (fig. 0.2). In fact, it is a complex object that reveals a great deal about the interconnected flow of forms, technologies, and values of the early modern world.

The very notion of a chair, a seating platform raised above the ground, was unusual in late-seventeenth-century Japan, where one was more likely to sit on tatami mats placed on the floor. As traders from China, Southeast Asia, South Asia, and even Europe arrived in Japan in the sixteenth century, chairs assumed particular significance in this floor culture, and folding chairs had a prestigious role in that context. On the Nanban screens made for local and European merchants, the most distinguished male trader often sat in a folding Chinese chair as silks, ceramics, and other desirable commodities were unpacked, suggesting that the merchant's folding chair was an important symbol of his prominence as purveyor of desirable products from afar, a throne also transported from another culture (fig. 0.3).

This particular lacquered chair lacks the curved crest rail (or rounded back), solid splat, and huanghuali wood common to most Chinese chairs, although the carved finials at the top of the backrest feature carved shishis, or

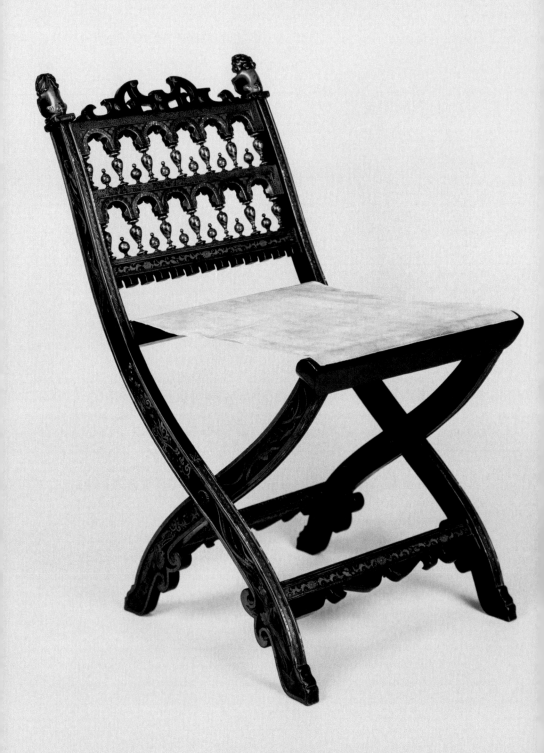

Fig. 0.1. Folding chair, Nagasaki area, Japan, 1614–1716; wood with *maki-e* and *raden* lacquer decoration, linen seat. Private collection.

Fig. 0.2. Folding church chair, Netherlands, 1620–50; joined and carved rosewood. Referred to as a *preekstoeltje*, or sermon chair, it was used primarily by women and features carved angels' faces, dolphins, acanthus, and lions. Rijksmuseum, Amsterdam, purchase 1948, BK-16073.

guardian lions, a common feature of Chinese ornament of the period. Instead the chair's arcaded back with turned spindles resembles the chairs commonly found in late-sixteenth-century Portugal and early-seventeenth-century Netherlands. Where the European artisans relied on carved decoration, the Japanese lacquerer used mother-of-pearl and gold and silver powders set into the lacquer (the *raden* and *maki-e* techniques) to decorate the various wooden parts of the chair. Unlike the Dutch example, a form carried by women to church and not used at home, the Japanese example followed Chinese usage and served as a seat of authority for male use in a distant land. The chair thus speaks to the complexities of material translation in the global world, where Japanese artisans relied on local materials to interpret forms and details from far away, resulting in a chair that conveys multiple meanings across a variety of cultures. In Japan its form and turnings suggested sophistication derived from the "Southern Barbarians," those traders and missionaries who arrived from Goa, Macau, and Malacca, and its authoritative meaning resonated with Chinese practice, while to those Europeans in India, Portugal, or the Netherlands, who focused on the lacquer, the chair stimulated a fascination with the exoticism of distant Asia.[1] The manner in which a single chair responded to

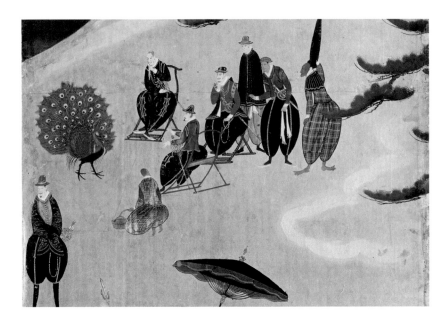

Fig. 0.3. Detail from Nanban trade screen, Japan, ca. 1600; wooden frame with ink, color, gold, and gold leaf on paper. Museu Nacional de Arte Antiga, Lisbon, 1641 Mov.

and fulfilled different expectations underscores the way in which the study of a work of art can unlock the richness and complexity of the past in real and tangible ways.

Awareness of distant practices and the opportunity to translate those ideas into a new form relying on familiar techniques and local materials can also be seen in a bowl made in the mid-seventeenth century at Awatovi Pueblo in present-day Arizona (fig. 0.4). Indigenous potters there, who were women, had typically made round-bottomed dough bowls and water ollas from local earthenware that they coiled, shaped, painted with yucca fiber brushes using minerals as pigments, and hardened in a low-temperature, open-air firing. Round bottoms were appropriate, since these vessels were usually set on earth. When Spanish Franciscan friars arrived and oversaw the construction of a church with appropriate equipage, they relied on Indigenous artisanal skills and labor. With no Spanish craftspeople and limited supplies of goods transported from the center of New Spain, the missionaries apparently had the local potters make a baptismal font, alms dishes, and sacramental vessels. Following European prototypes, local potters made bowls whose shape was closer to a European soup bowl, with a flaring rim and a footed bottom that leveled it for placement on a table.[2]

There is no written evidence that proves that Indigenous artisans were conscripted to produce this work, a practice of forced labor common in other

Fig. 0.4. Bowl, Awatovi Pueblo, northeastern Arizona, ca. 1650; coiled earthenware with painted slip decoration. Recovered by the Awatovi Archaeological Expedition of the Peabody Museum, 1935–39. The sherds were reassembled and some blank filler used along the rim and part of the bowl to provide some integrity for the original pieces. Peabody Museum Expedition, J. E. Brew, director, 1937. Harvard College, Peabody Museum of Archaeology and Ethnology, 37-111-10/9983.

parts of the Spanish empire in the Americas, or that the missionaries, who were considerably outnumbered by the Puebloans, may have depended only on a local supply. Yet the physical evidence suggests that the artisans were not entirely subservient to the Europeans but rather controlled the process and adapted the form to their own purposes. The variable thickness in sections of the plates and bowls indicates that these potters continued to coil local earthenware rather than using European techniques such as turning and trimming on a wheel or drape molding. And rather than glazing the surface, they simply burnished it with slip and then painted the edges in their own Sikyatki style. Furthermore, archaeological evidence suggests the potters and their fellow Puebloans adapted the liturgical form to a domestic use, as such dishes and

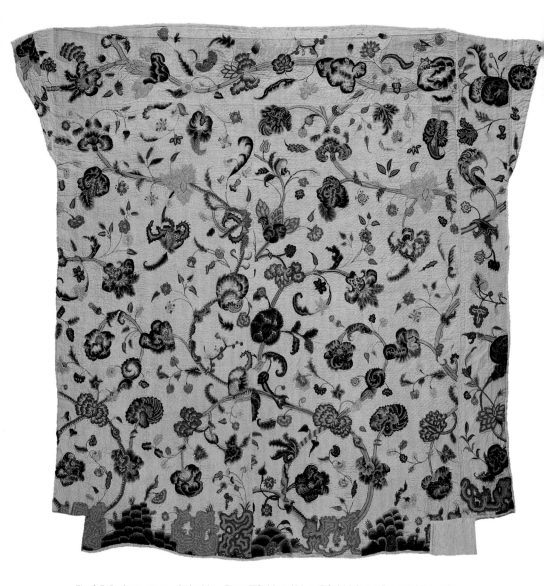

Fig. 0.5. Bedcover, wrought by Mary Drew Fifield and Mary Fifield Adams, Boston, Massachu-
setts, ca. 1714, and reworked by Mary Avery White, 1778–1860; English fustian ground (linen
and cotton), English embroidery wool in a variety of stitches including laid, stem, link, knot,
and bullion. This quilted bedcover was made sometime around the turn of the nineteenth
century from two early-eighteenth-century bed curtains and a valance wrought by women
in the Fifield family. The valance, which has a different sort of vine, can be seen along the
top of this cover. Museum of Fine Arts, Boston, gift of Mrs. E. Emerson Evans, 1972.910.

Fig. 0.6. Bed curtain, Coromandel Coast, India, 1680–1700; plain woven cotton with painted and mordant and resist dyed decoration. This was part of a full set of hangings from Ashburnham Place, Sussex. Museum of Fine Arts, Boston, Samuel Putnam Avery Fund and Gift of Mrs. Samuel Cabot, 53.2202.

plates were found not only in the church but also throughout the homes of the Native population.[3] Although we do not know the identity of the makers of the bowl or the lacquered folding chair, attention to the formal, material, and fabrication details embedded in each reveals artisans able to respond to new external ideas within their own system of production.

While these two examples of entangled objects from the early modern period highlight production far from Europe but influenced by European forms and styles, a set of bed hangings embroidered in Boston in 1714 by Mary Fifield and her daughter Mary and passed along to Mary's descendants reverses this sort of exchange (fig. 0.5). In the late seventeenth century, Indian painted cottons from the Coromandel Coast and wrought cottons from Gujarat became extremely popular for bed hangings, curtains, and wall coverings in Britain and its colonies (fig. 0.6). Such imported chintzes also served as inspirations for genteel woman, who worked imported needlework kits from England or followed patterns provided by local needlework teachers. According to family tradition, Captain Richard Fifield, a Boston merchant, sent to Britain for a full set of fustian hangings with the designs drawn on them and the necessary colored wool thread to embroider them.[4]

The Fifield hangings reveal full awareness of Indian chintz compositions, characterized by rocky, hilly scenery along the bottom, delicate flowers dispersed along various meandering vines, and internal patterning and color gradations on the leaves and petals, executed with British embroidery techniques. The scale and distribution of the flowers and the amount of open background space more closely resembles Indian designs than British embroidery of the same period, which often incorporates large-scale flowers, animals, and insects, but the Fifield women drew on a wider variety of stitching techniques to develop shading and texture. Whereas Gujarati and Bengali needleworkers relied on chain stitches exclusively, the Anglo-American embroiderers used a variety of stitches such as laid, stem, link, knot, and bullion. This distinction speaks to a different set of production values. The reliance on chain stitch in works from Gujarat and Bengal suggests the necessity of habitual rhythm and skill as the embroiders covered large expanses of cloth fairly quickly with neat consistent stitches for the external market. The greater variety of stitches in the Fifield hangings demonstrates how the affluent female embroiderer who worked her cloth in a number of different stitches possessed different motivations: to display her accomplished skills in decorative embroidery, to seek creative stimulation, and to take pleasure in the variety of stitches without worrying about efficiency. Since she did not intend to sell it, she was less concerned with the required time and disruptive rhythm as she changed stitches. The products of this refined labor celebrate the luxury of time and were often given to and preserved by family members, as a form of familial capital and female memory and thus enjoyed a rather limited circulation.[5]

The folding chair, footed bowl, and bed hangings are just three of many objects that document an interconnected world and highlight the need to take a more global view about the production, reception, and lives of works of art. Scholars have traditionally narrated longue durée art histories through national or ethno-cultural lenses, focusing on a specific geography with a chronological narrative that contains a beginning, an exemplary golden age, and a decline.[6] Following this paradigm, the three examples discussed above would all be considered simply as inferior versions of European art and their makers as aspirational copyists, even though the Japanese or Awatovi artisans maintained control over the nature of their work and innovatively adapted new ideas for a broader market, while the Fifield women were the copyists who simply followed British designs inspired by South Asian textiles. The chronological narrative often leads scholars to string together the examples of a series of artistic centers to construct an evolutionary arc of art history and chart the drift of artistic performance as one moved further away from those centers. Such studies also tend to focus on specific artistic practices characteristic of that nation or culture: bronze in ancient China, marble sculpture and painted

ceramics in ancient Greece, architecture in ancient Rome, architectural arts in medieval Europe, oil painting in early modern Europe, ink painting on paper in Ming and early Qing China, and so on. The result has been a fragmented, hierarchical field that privileges certain media or styles and essentializes certain media to stand in for specific cultures. Oftentimes studies of such objects take an imperial or even racist line of interpretation that considers the conquered or defeated as inferior. As a result, broad comparative strokes have proved difficult to sustain.[7]

Part of the difficulty in such a broader approach has been a modern frame of reference: to define art as the fine arts of painting, architecture, and sculpture; to assign the highest real and intellectual value to such works of art; and to view the world through filters generated by familiarity with these particular formats. Conditioned by the values of capitalism, Western notions of artistic value are tied to concept, originality, visuality, authorial identity, and economic value rather than function, deft skill, suitability, materiality, anonymous shop production, and cultural value. If we encounter work that exists outside this sort of framework, we often dismiss it as insignificant, merely functional, lacking in imagination, or even primitive. More often this work is relegated to a museum of natural history or an anthropology museum rather than an art museum.[8] Such an act of aesthetic imperialism only reinforces the superiority of the Western canon and its underlying value system. As Henry Glassie reminds us, "No matter how important easel painting is in the late West, it is uncommon in world history. It would be more just, truer to reality, to begin with textiles and ceramics."[9]

In this assertion Glassie pushes back against a language of distinction and hierarchy that emerged in western Europe only about five hundred years ago. The European misunderstanding of art began valuing the cerebral over the manual, the head over the body, the visual over the haptic and other senses, and the aesthetically autonomous over the socially functional. These binaries can be found clearly in the writings of Giorgio Vasari and other early art historians who celebrate the individual genius artist as distinct from the guild-bound nameless craftsperson, and in the embrace of Kantian aesthetics that separates aesthetics from function and ranks autonomous art above socially embedded craftwork. Such a narrow definition privileges the visual and denies a wider range of senses and types of engagement with works of art. This focus on so-called fine arts to the exclusion of other practices can be found in the various terms used to describe the "artistic other," step-relatives of "real art," such as "applied arts" in the mid-nineteenth century, "decorative arts" in the late nineteenth century, "industrial arts" or "handicrafts" in the early twentieth century, or "minor arts" through much of the twentieth century. But such a hierarchical taxonomy, one buttressed by academic fields,

curatorial departments, and entrenched art markets, lacks the historical specificity given to the relative value of things, ignores a deeper temporal and wider geographical perspective, and precludes a multisensoral approach to works of art in the broadest definition of the term.[10]

Inspired by Glassie's exhortation, this book challenges the hierarchy of genres and materials as well as the concept of singular artistic origins and centers. Objects are messy, so we need to develop a different interpretive strategy that builds a bottom-up understanding rather than projects a top-down interpretation. But we should not merely rehash the craft romanticism of John Ruskin and William Morris or the *Wissenschaft* formalism of Gottfried Semper. Rather, this endeavor is different because it questions both a linear chronological narrative, often a progressive or illusionary one, and the accepted notion of art as a category that favors certain modes of production such as oil painting on canvas, marble or bronze figurative sculpture, and academic public architecture, each associated with known creators and often associated with a specific location. Objects of use, wrought in clay, fiber, wood, or metal, usually made by craftspeople whose names have disappeared from the written historical record and often portable, rarely are included in such a standard account and resist neat categories. Even when metal appears in traditional scholarship, it tends to be certain precious metals like gold and silver, because of their current market value, or copper alloys used for figurative sculpture.

Skillfully made and daily-used ceramics, textiles, wooden objects, or base metal vessels rarely appear in standard art historical narratives even though they can be found throughout the world and have possessed significant exchange, relational, or situational value throughout time. It is their very circulation that contributes to their interpretive power, one that is distinct from the monumentality of fixed architecture, burial goods, and murals or wall-hung paintings. Instead, this volume consciously embraces these quotidian materials as the very embodiments of a more inclusive human history of art—one that allows for varied types of aesthetic value; multiple coexisting and often connected centers; a multidirectional flow of material ideas; a sense of dynamic hybridity, inspiration, or appropriation; and accrued meanings over generations.

Many examples of this cultural interchange occurred outside of western Europe. In the twelfth century, metalworkers in Herat, in Khorasan (present-day Afghanistan), developed a particular talent for producing wrought brass vessels inlaid with silver for merchants as well as for political and religious officials. With the Mongol invasion of the thirteenth century, many of these craftspeople fled westward to Mosul, the Jazira region of Syria, and Cairo and began to work for a diverse clientele that included local Muslims and Eastern Christians as well as Crusaders. Whereas the Herat artisans had borrowed

freely from Chinese imagery, such as mythical creatures (dragons, phoenixes, and qilins), and inserted them into hunting scenes, courtly cycles, or astrological motifs typical of Seljuk imagery, those who settled in Mosul, Syria, and Egypt often incorporated Christian themes, demonstrating an ability to respond to local demands with a fluid and selective interchanging of imagery. These metalworkers, well versed in using silver and gold inlay to provide ornamental programs that included calligraphic benedictions or dedications and that used rondels or arabesques with zodiac signs or scenes of hunting and feasting, provided local Islamic customers with pen boxes and inkwells for scribes, ewers and basins for the court, and candlesticks for the mosque and home. These designs often revealed close affinities with regional Islamic manuscript illustration but also incorporated biblical imagery acceptable to Islamic patrons.[11]

A covered cylindrical vessel embodies the artisans' abilities to blend different decorative traditions. In this Copto-Arabic environment, Eastern Christian and Ayyubid imagery could be fluid and together comprised the basis of a common, naturalized, visual vocabulary. The body of the cylinder features panels illustrating Jesus entering Jerusalem and a series of individual saints, set within an Islamic composition of arabesques surrounded by vegetal motifs (fig. 0.7). These images were acceptable to Muslims, unlike scenes of Christ's death or divinity. The top is decorated with a single Madonna and Child image, but not the typical European version of an enthroned Virgin Mary (fig. 0.8). Instead she is depicted as a Seljuk ruler, sitting cross-legged on the ground, dressed in pants and with a bound turban on her head. This cylinder is one of numerous objects from the period that combined Christian and Islamic imagery, underscoring the interchangeable visual vocabulary in this locality. Even its owner or use is ambiguous: its elaborate decoration suggests it was commissioned and used by a local Christian or Muslim to hold aromatics, jewelry, or precious items, but it might also have been purchased by a Crusader who sought a souvenir from the region.[12] This fluid use of locally available and acceptable imagery attests to the flow of ideas through the movement of makers, technology, and objects within a shifting series of networks.

The mobility of craftspeople and their skills, the trade in materials and objects, and the opportunities for easy artisanal adaptation during a period of "low technology" endowed the preindustrial material world with a certain fluid vitality born of engagement and exchange.[13] Objects are inherently complex assemblages of ideas, materials, and performances that traveled in various directions, often at varied speeds, from centers to peripheries, from the edge of empire back to the metropole, and between various locales in between. To capture this nonlinear sense of interchange, one that crosses arbitrary borders and possesses its own sense of temporality, I have consciously used the terms

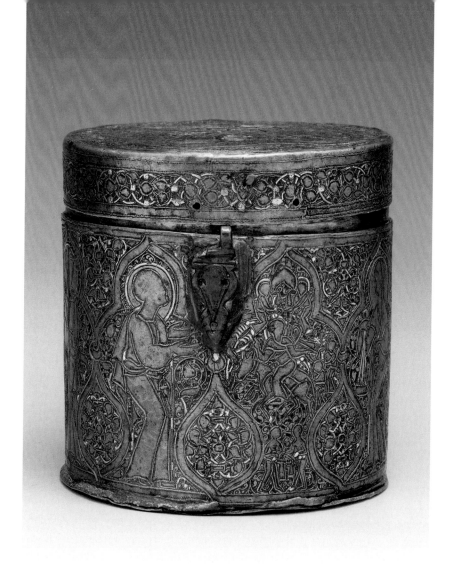

Fig. 0.7. Pyxis depicting standing saints or ecclesiastics and the entry into Jerusalem with Christ riding a donkey, Syria or Mosul, Iraq, mid-thirteenth century; fabricated copper alloy, chased and inlaid with silver and black niello-like material (significant losses of silver sheet). The panel to the right of the hasp shows Jesus entering Jerusalem. Metropolitan Museum of Art, New York, Rogers Fund, 1971, 1971.39a, b.

"global" and "objects" in the title of this volume. "Global," rather than "transnational" or "transcultural," defines a geohistory in which the interchange was both economic and cultural. The action of interchange, often facilitated by objects and images, was undertaken by a wide variety of agents: nation-states, religious organizations, traders either venturing to another land or entertaining visitors from distant territories, soldiers, other sorts of travelers, and indi-

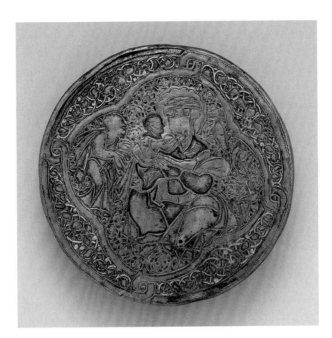

Fig. 0.8. Detail of the top of the cylindrical box in fig. 0.7. Metropolitan Museum of Art, New York, Rogers Fund, 1971, 1971.39a, b.

viduals. The resulting networks of parallels, connections, and dead ends favor the use of the word "global," in which location has a very particular resonance and multiple locations of various sizes are connected. Moreover, the term is readily understood today.[14]

Throughout this book, I also use the term "object," for its neutrality, or "work of art," for its explicit reference to the work of skilled fabrication and for its inclusivity. For me, "artifact" has certain typological associations in the archaeological world, "stuff" is too colloquial, and "thing" is closely connected to literary "thing theory," which focuses on the discourse around an object. Although thing theory has a certain academic cachet at the moment, the term "thing" tends to be a modernist construction that dematerializes the object and emphasizes the representation of the void of an object or the discourse that surrounds the object. While helpful for teasing out multiple meanings and reminding us about the instability of an object, this abstraction of material culture emphasizes the visual and obscures the maker and process. Economic historians interested in gross flows of material culture also tend to use terms like "things" or "goods," thereby contributing to a frustrating vagueness about the specificity of physical evidence. My preference for "object" concretizes the links between materials, process, and people (makers and users). These objects of circulation emphasize interconnections that are geographical, social, and temporal and underscore how objects, their materials, and their making are processual, situational, and relational.[15]

By focusing on objects, this book offers a non-normative guide to thinking about a global art history through widely available material types. It offers neither a series of regional or national case studies nor an evolutionary timeline that charts rises and falls of certain decorative arts, but rather takes a thematic approach to interconnected histories.[16] These products, and the materials from which they were made, have specific histories that are rooted in particular places but that can also cross geographies and cultures, resulting in multiple centers of production, many different loci of innovation, and a shifting variety of meanings and associations. This permeability necessitates that we shift our focus to the conception, production, and circulation of man-made objects that operate locally, regionally, and globally, often at the same time. I use the term "global" not as an all-encompassing, homogenizing macro lens but rather as a large-scale, comparative framework that is attentive to the various networks, the relationships between specific localities as well as between the local lived experience and global trends. The very nature of decentralization and exchange, and of multiple possible interpretive narratives, makes such an approach timely.[17] This book is thus a distinctive and unique, if not radical, approach to thinking about a global history of art.

This interest in broader global histories of art is related to but separate from the recent "material turn" in history. Extending their reach beyond mere social and consumption history, many scholars have begun to focus on a specific material to unwrap the harvesting, fabrication, trade, and value of specific commodities such as cod, cotton, or mahogany. Art historians have demonstrated new interest in charting an object in motion, as it accrues different values or is adapted or altered in different contexts. Related to this interest in object-centered inquiry is the recent spate of books promising a history of a region or topic through analysis of a number of objects.[18] The attention to a specific commodity provides rich insight into the global flow of raw materials, but it precludes a broader understanding of what other possible material options might have been available, what its relationship was to complementary or alternative materials or other products of the same region, or how the material might be used by different people for different purposes. What might be the spectrum of possibilities in a choice of material or the uses of a material? Just as artisans often exerted their own agency upon a material, so did material often dictate the limits and possibilities of the medium to the maker.[19] In art history, the materials approach typically begins from the perspective of the viewer/user and then works toward a formal and associational "reading" of an object. Such an approach risks a superficial theorization of the illustration or representation of an object, in which vision is privileged over tactility and other senses and the final product is emphasized over deliberate choices taken along the way of making. This perhaps reflects an ever-increasing illiteracy

Introduction

about our own relationship to materials and processes.[20] Materials and their properties were intertwined with artisanal knowledge and thus complicate a simple notion about the materiality of an object.

Recent exploration of the movement of objects through space and time has been productive but has not been fully explored. Most scholarly efforts have focused on a single object or tracked a single leg of the journey from one place to a second. Much of this work might be categorized as trade history, the mapping of the diffusion of certain aesthetic styles. The emphasis in this approach is often on the exterior, the appearance or iconography, rather than the interior, where the agency of the maker is expressed in the choice of materials and technologies. A related approach is the object biography, which emphasizes the provenance or social life of an object as an end onto itself, rather than exploring the social contexts of creation and circulation. Other possible ways that mobility might prove a valuable approach is to consider how paths of movement might have crossed, how an object might accrue or lose elements as it was transshipped through several points, or how nonlinear or asymmetric exchange might have affected objects and their value. In short, objects in motion were rarely stable.

Rather than chart one specific canonical narrative or offer an inclusive survey, this volume is designed to provide readers with the principles of material literacy, a guide of sorts to systematic and sustained analysis, so that they might recognize and interpret the raw materials, commercial exchanges, technological adaptations, directional flow, cultural flux, and reception of the material world. Such an approach thinks with and through materials and techniques to understand function, desire, and meaning. Objects are not simply reflections of values but are complex entities that defy easy categorization. They perform as active, symbolic agents that emerge in specific contexts yet might change in form, use, or value over time. Human activity creates material culture, which in turn makes action possible while also recursively shaping and controlling action.[21]

This volume focuses mainly on a period in world history characterized by an overlapping of long-distance trade, regional exchange, and local production, beginning primarily with the Central Asian and Indian Ocean routes that existed as early as the second century BCE, extending up through the Atlantic and Pacific trade from the sixteenth through the eighteenth centuries, and concluding basically in the nineteenth century, as improvements in production and transportation, the rise of industrial capitalism, and development of synthetics reordered the material world and alienated many people from the making of objects.[22] The temporal range is further determined by the rate of survival, the result of both the inherent properties of the materials and trends in production. Older objects have not survived in great numbers:

wood decays or burns; base metals are often melted down and repurposed, either as new objects or as military materiel; textiles rip, are altered or become scraps to be used in making something new, or are consumed by insects; and ceramics break and are discarded. Archaeological work and manuscripts help offset some of this bias. But this time period is exactly the moment when production of objects increases, first through intensification and improvement of processes and then through movement of materials, thereby contributing to the survival of a greater number of examples.[23]

I have also relied on scholars who have published in English even though their fieldwork is based on intense local study and command of languages. Looking at objects from so many geographies and cultures precluded sufficient command of so many native languages. Similarly, I had to make decisions about which objects to illustrate. Many are part of prominent, internationally recognized museum collections; this facilitated the acquisition of good photography. While the time period and origins of objects contained in this volume are not totally comprehensive, its methodology can and should be applied to objects from many places and periods.

Through a process of object-driven inquiry—one that begins with the object and works outward rather than object-centered confirmation that begins with set ideas and then narrows down to look at a single work—the goal of this book is a more global and complex view of culture from varied regions and over a long period of time in which inception, emulation, adaptation, innovation, and appropriation flow in various directions. It is an opportunity to step away from a strict diffusionist paradigm in which less talented makers at the periphery slavishly copy or bizarrely misinterpret the "correct" styles of the metropole and to take into account multiple motivations for and techniques used in artisanal interaction. This book is structured in three parts that follow the life of the object, from creation to purchase and use, and finally, to experienced meaning. The first section emphasizes the importance of materials and techniques, which in turn aids in understanding affordances—that is, a full accounting of the properties of different materials and processes relating to an object that make clear how it should be used. The second section analyzes the movement of objects through the examination of consumption, mobility, and initial use, while the third explores the ongoing social life of objects through a consideration of material meanings that accrue after that first transaction. What should go without saying is that, foundational to this approach, the world of the past three thousand years has always been interconnected in some fashion, and the global perspective on transcultural art is not a recent phenomenon but one with a long history of regional expertise, exchange, and consumer desire.

The first section consists of two chapters. Chapter 1 addresses the importance of materials to the study of an object. Materials such as earthenware clays, conifers, and wool are relatively ubiquitous, while others such as Chinese porcelain, Caribbean mahogany, and South Asian cottons have very specific geographies that lead to long-distance demand based on rarity, novelty, or desirability. Certain materials often possess specific ties to the local habitat and economy (woven raffia in Africa or zinc alloy bidriware in the Deccan region of India), resulting in cumulative tacit knowledge over generations that contributes to a local expertise. In some locations people also conceive of raw materials not simply as natural resources but as living entities, the use of which requires permission from ruling spirits or the materials themselves. A broad consideration of raw ingredients permits an understanding of specific properties that lend themselves to certain technologies or uses and results in a topographical sense of materiality. There are often geographic explanations for suitability, rarity, and desire.[24]

The next chapter focuses on realization: how makers transform these materials into objecthood. Understanding the range of possibilities is key to unlocking the structural logic and underlying grammar of a work of art on its own terms, as well as systems of production. The awareness of possibilities and appropriateness corrects a tendency to be judgmental in the assessment of objects, to project one's own view or prejudices on it and to place it in some sort of progressive chain. Instead, it is crucial for analysis to begin inside an object and move outward. An understanding of the range of materials and technologies available to the maker, and what the choice of material or level of workmanship means within specific contexts of labor or social use, will enable scholars to make more accurate cross-cultural observations and better understand the exchange of ideas and things.

Building on this fuller understanding of materials and processes, the second section consists of another two chapters. Chapter 3 explores how objects lived in the world once they left the shop, initially as commodities for sale, trade, and exchange. While they were the products of specific organizational structures, these items often served local functional needs as well as exchange value, but many also found wider markets owing to regional specialization and production efficiency, trade routes, or the production of specific high-end objects. Works of art circulated not only in fully finished form but also more conceptually or partially, through the movement of makers, the exchange of technology, and the sharing of imagery found on prints, textiles, or decorated surfaces.

Such objects could satisfy a variety of functional needs, from basic ergonomic function to social distinction or ritualistic practice. A fourth chapter

explores how they could establish or reinforce social distinction through materials, size, workmanship, or style. Many specialized forms also supported identity-affirming leisurely rituals such as card playing, smoking, or drinking fermented beverages.[25] In addition to use and social value, other objects possessed metaphorical value. This chapter thus also examines the practice of collecting and displaying certain trade objects that support racial difference and showcase prestige or power. Whether promoted by the state or by the initiative of individuals picking up souvenirs from travel, much of this collecting impulse is tied to the colonial imperialism that emerges from these networks of trade. Acknowledgment of trade and function not only reveals the flow of ideas and desires over time but also helps sharpen the interpretive eye deployed in the third section.[26]

Once objects have been set in motion, the third section addresses how these works of art then enter into different contexts, develop different meanings, or serve an active role in the construction of new attitudes apart from their original context. Chapter 5 engages with the themes of memory and gifting. Objects are often presented or transferred to another person, with a series of artifactual or social reciprocal obligations implied. These objects are then subject to continued social maintenance: they might get repurposed or reworked based on an outdated function or changing cultural value, accretions to an object might alter its function or meaning, and some objects might be recycled.[27] A sixth chapter looks at the role of appearance in the construction of meaning. Objects could seduce users and viewers in a number of ways: large or small size, elaborate ornamental program, wondrous or unnatural surfaces, or the ingenuity of skilled workmanship. For example, artisans sought to create shiny, lustrous finishes to make objects wondrous and unnatural: lacquer, glaze, and planishing all contributed to glossy objects in which the outer skin reflected light, made objects seem to float, and concealed the labor underneath. Makers also manipulated surfaces to suggest alternative narratives: deliberately rubbed-through lacquered wooden objects suggested a history for new work, while certain industrially produced metalwares during the arts and crafts movement featured deliberate hammer marks to evoke an earlier era of explicit handwork. Linking the history of visuality to material exploration and artisanal performance is central to this chapter.[28]

The chapter on appearance, and its focus on vision, leads logically to the next one, which emphasizes the importance of touch and the haptic engagement with objects. While visual engagement is important, the embodied experience is equally if not more important in terms of value or meaning. Many of these objects evolved to answer human needs, and bodily interaction was key to their successful function or perceived use. A multisensory approach makes

it possible to move on to more abstract ideas about constructing identity or navigating between different cultures.[29]

It has been common to rely on terms such as "encounter" or "exploitation" in charting such interconnected contact, but perhaps we need to rethink what exchange or hybridity really means for all sides. There is politics both in making and in the made object. It is essential to pay attention to all participants in the creative and social life of an object: producer, transporter, consumer, user, and collector. Can adaptation, initiative, innovation, or appropriation flow in various directions at once? Throughout this kind of analysis and interpretation it is essential to keep in mind the relationship between surface and substrate, exterior and interior, front and back, public and private, original intent and later use. Objects can tell us a great deal about the creative impulses and lived experiences of different times. The ultimate goal of this sort of object-driven inquiry is a material literacy informed by cultural curiosity rather than a desire to judge, classify, and rank and by an awareness and appreciation of varied approaches to problem solving rather than an assumption there is only a best way identified in hindsight.

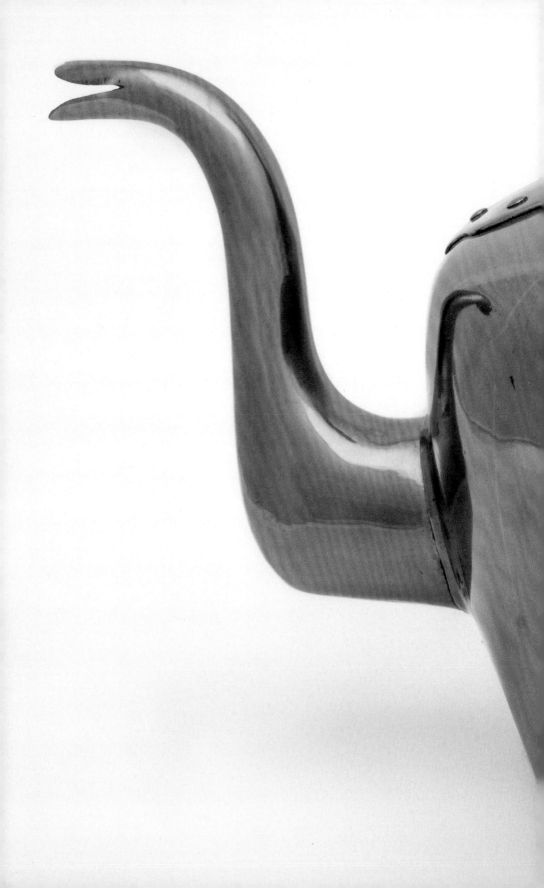

# I. MAKING

# Chapter 1  Materials

In today's era of globalized capitalism and Internet commerce, we have unparalleled access to a wide range of materials and goods. Whatever we might need or want is often just a click away. We rarely think that some material we might need has become obsolete or is no longer available. However, abundance and scarcity of materials characterizes much of human history. While some materials such as clay or iron ore can be found throughout the world and therefore have been readily accessible, other materials such as lacquer or silk have historically had a more restricted range. Wood can be found throughout the world, but different species grow in different climates. Furthermore, they have different properties and therefore are best used in specific ways. Knowledge of materials allows us to understand the specific properties that make them suitable for different fabrication processes or uses.

However, the raw stuff of an object is not only an inert, passive collection of ingredients waiting for the magic touch of a craftsperson to bring it to life; this corpus of elements possesses agency of its own. As Ann-Sophie Lehmann argues, material affordances, the inherent possibilities of the particular medium, restrict or encourage certain action in the fabrication of objects. The varying plasticity of different types of clay, the tensile strength of different fibers, the workability of different metal, or the continued movement of wood all impact the performance of makers. Encounters with materials can depend on conventions of habit or require technical adjustments, rely on standard tools or spur the development of new equipment, and draw on existing labor systems with stages efficiently distributed or call for new talent from far away.

Finished objects result from the interconnection of material, technique, and idea; resources, culture, and the maker's body and brain all play active roles.[1]

In interpreting objects, one needs to think beyond the facade or style of the finished product. It is often the evidence of the unconscious act of the maker—the substrate, interior, or back rather than the surface, exterior, or front—that provides a true sense of the conditions of its creation. Revealing a deep structural logic, materials are the crucial first step in delving into this hidden history of an object. A scholar's knowledge of materials and the extrapolation of the maker's local period knowledge from the artifactual evidence allows us to understand an object in its original context rather than projecting an ahistorical interpretation on it or settling for an assessment of face value alone. In short, attention to materials is the first step in giving voice to the makers and their objects.[2]

The materials used for the production of everyday utilitarian objects often have little intrinsic value and are rarely discussed in the written historical record. Thus, recent scholars have been unable to turn to documentary sources such as those that have guided new research on painting pigments or sculptural practice.[3] As a result we need to fully tease out the nature of materials and processes from wordless everyday objects. It is the objects themselves that offer the best evidence. In addressing the impact of materials, it is tempting to rank them primarily according to their economic value as revealed in period accounts and documents or their artistic value as revealed by more recent aesthetic hierarchies. By this logic, more common local materials would be perceived as less desirable or even cheap substances. In addition, many modern scholars have valorized makers who have exerted their creative will on costly or difficult-to-work materials. As a result, desirable properties such as plasticity or malleability become negatives, and the economic basis of making is overlooked.[4]

A comparison between two thirteenth-century ceramic handled jugs, neither of which is made of porcelain, highlights the impact of local materials and the importance of understanding the economic basis of making (figs. 1.1, 1.2). The jug made in Kashan stands out for its white body, blue decoration, and poetic inscription, while the London example is characterized by its reddish body; reliance on irregular, loosely applied glazing; and lack of explicit decorative program. It is easy to see the former as superior to the latter from an aesthetic point of view, and both as inferior to examples of porcelain, which is currently viewed as the more valued material. Yet each is an exemplar of its locale and intended market. The Iranian example highlights the white fritware body, a quartz-based clay developed initially by Egyptian and Syrian potters in the tenth and eleventh centuries and further refined with local materials in Kashan during the twelfth century, as well as the underglaze cobalt blue

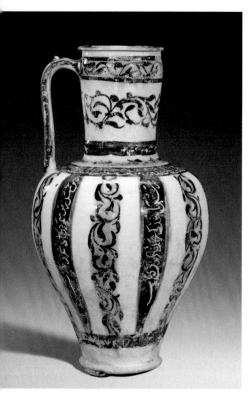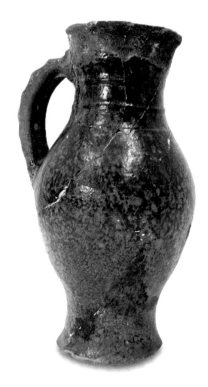

Fig. 1.1. Jug, Kashan, Iran, early thirteenth century; wheel-thrown body and molded handle of fritware with black-and-blue underglaze decoration. Sarikhani Collection.

Fig. 1.2. Jug, London, ca. 1250; wheel-thrown body and pulled handle of earthenware with copper and lead glaze. British Museum, London, 1896,021.20.

decoration developed in Kashan in the late twelfth century. From the perspective of ceramic technology, it represents the most sophisticated achievements of the period. Furthermore, its size and poetry mark this not as a vessel of everyday use but as one intended more for show.

The London example demonstrates something different: how refined artisanal skill can produce a well-made form that can satisfy the intended utilitarian use in households of varying status. It is a straightforward object produced with efficient dexterity and care but for a different purpose. Like their Kashan contemporaries, the London artisans favored familiar local materials, in this case earthenware clays and copper and lead ores for glazes. To make the vessel, they relied on the rhythm of turning a form on a potter's wheel. They pulled the jug up into shape on the potter's wheel, paying attention to the flaring foot and swelled belly, and articulated small moldings around the neck. With the body shaped, they then drew out a handle that they pressed with their thumbs

into the body. The finished jug bespeaks total command of the material, reliance on wheel-driven decoration, and ability to produce efficient, inexpensive work for a broader market. Subtle skill and appropriateness can help expand our notion of what constitutes the quality of an object.[5]

As these jugs prove, material value is relative and can also be tied to skill, tools, local production or exchange systems, cultural preferences, availability, or other factors beyond sticker price. The appropriateness or suitability of a material to the required structural or decorative task, the fit of a material, contributes significantly to value. Objects were produced and circulated in a variety of exchange systems.[6] Therefore, we need to begin with an understanding of materials by delving into their very essence—their particular geography, properties, and ways of harvesting and processing that grow from a specific locale.

A more expansive approach to materials encourages a broader understanding of the dynamic between the local and the distant, between intensive knowledge of local materials and the pressures or opportunities generated by materials from afar. Common materials might be used in different ways depending on local knowledge, season, climate, system of production, or need. While many of these ubiquitous materials satisfied quotidian needs within their community of production, some also became export items for distant markets. Uneven distribution of materials also led to the rise of desire for the different, the allure of novelty, or the symbol of an exotic other place. Chinese porcelain, the product of deposits of kaolin and petuntse and cumulative ceramic technical expertise, especially in the Jingdezhen area, held a spell from the seventeenth through the eighteenth centuries. The specific ingredients were tied to a distinct geographical place.[7]

It is fundamental for art historians and material culture scholars to build knowledge of a broad range of materials for the time periods they study. These materials are often in dialogue with each other, sometimes in a single work, and within historical contexts. Makers in one medium often interact or produce parts for those working in other media. For example, wood turners and potters provide patterns for metal casting; furnituremakers depend on blacksmiths for tools and workers in copper alloys for hardware; and weavers provide loose cloth to refine clay. Scholars need to resist the tendency to become medium specialists, which precludes an understanding of material flows and a fuller sense of artistic, social, and historical context. To promote a better understanding of the range of materials, their properties, distribution, and processing, the following sections introduce the various types of materials that constituted the broader categories of clay, fiber, base metal, and wood in the preindustrial period.[8] I recognize that there are many other types of materials, such as ferrous metals, glass, jade, and ivory, but I have decided to

focus on the most common materials used in domestic life throughout history. Detailed studies of each are available, but the intent of the following sections is to develop a language of materials and possibilities rather than connoisseurly expertise in each.

## Clay

Clay, a workable mineral-based material that holds its structural shape when it dries, differs compositionally from simple mud, a more liquid material that consists of soil, silt, water, and perhaps a little clay. Found throughout the world, clay's universal, elemental quality has meant that nearly all cultures have sought to harness its potential. Clay's structure endows it with a plasticity that allows it to be modeled and with hardness when subjected to heat. Clay is the central ingredient of ceramics, which have provided one of the most complete archives of historical study. Not subject to decay or rot, and resistant to corrosion, they have survived in great number, whether in whole form or more typically as sherds, in collections or in the ground. Certain characteristics make ceramics particularly valuable as works of art: their sculptural possibilities, use as a ground for decoration, ubiquity, evidence of wide circulation of forms and techniques, capacity for individual expression, and ability to satisfy a very wide market, from high-status luxury goods to everyday food preparation vessels. While clay constitutes the central ingredient of ceramics, the term "ceramics" is an overarching category rather than a single cohesive material. To reveal its complexities, we need to be attentive to the specific types of clay bodies, each of which has its own availability, properties, means of hardening, and geographic range. The four basic ceramic body types are earthenware, stoneware, porcelain, and fritware (also referred to as stonepaste).[9]

Fig. 1.3. Cooking pot, Iroquois people in St. Lawrence River region, sixteenth century; coiled earthenware with impressed and incised decoration. Canadian Museum of History, Quebec, VII-E:00013, CD2000-0159-005.

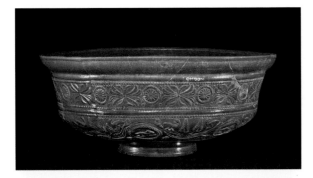

Fig. 1.4. Vessel, La Graufesenque, France, 55–88 CE; wheel-thrown body of earthenware with red slip and rouletted decoration. Typical of Roman terra sigillata. British Museum, London, 1915,1208.53.

Fig. 1.5. Plate, Portugal, 1660–1700; drape-molded and wheel-trimmed, tin-glazed earthenware with cobalt blue decoration. Private collection.

Earthenware, the most common ceramic body, can be found in most locations throughout the world and can be hardened easily. Its geological ubiquity and ease of working and hardening enables it to be fully integrated into local economies, and it is not necessarily transported over long distances. The mineral basis of earthenware clay contributes to a wide range of colors, from grayish clays in the English Midlands and northern Europe to reddish, iron-rich clays in southwest England and New England. More unusual is kaolin white clay, found in China, Limoges, parts of Africa, western North Carolina, and several other discrete regions. Earthenware's great plasticity allows it to be shaped in a variety of ways, including pinching, coiling, press or drape molding, or throwing on a wheel, and its versatility can be seen in its wide range of uses. When minimally processed, it provides rough material for utilitarian storage and cooking pots (fig. 1.3), but when cleaned of sticks, grit,

Fig. 1.6. Teapot, Wedgwood and Company, Ferrybridge, Yorkshire, 1785–96; wheel-thrown body, press-molded spout, and extruded handle of refined earthenware with lead glaze and transfer decoration. Victoria and Albert Museum, London, CIRC.48&A-1959.

and impurities, often by adding water and then straining it through a loosely woven cloth, refined earthenwares yield more delicate tablewares (figs. 1.4, 1.5, 1.6).

Potters can harden earthenware in a variety of ways depending on the object's intended use: by sun-drying, firing in the open air, or firing in a pur-pose-built kiln. The first is more typical for simple figural forms, the second used by more mobile cultures or where investment in a permanent brick struc-ture was not warranted, and the third found in more sedentary populations with consistent demand. Hardening with fire, which firms up the structural plates of the minerals, requires access to fuel such as brush or dung for open-air firing and cords of wood or tons of coal for kiln firing. Economic alloca-tions, fuel sources, and markets determine the scale of production. Typically, earthenware is fired at low temperatures, from 800° to 1,000°C. Low firing contributes to its fragility—it breaks rather easily—and results in a rather porous membrane that allows moisture to condense on the exterior through capillary action. In hot climates, this helps keep water or liquid contents cool, but this condensation is not desirable for secure, long-term storage of liquids or on wooden surfaces. Therefore, earthenware vessels and plates need a glass-like coating (a glaze) or a burnished surface to function as containers for fluids. Used for food storage and processing as well as for tablewares, earthenware is

the most quotidian ceramic body, but its tendency to chip and break and its widespread production results in constant replacement and a great number of sherds. Even as refined earthenwares and other bodies became more common, low-fired locally produced common earthenwares continued to be valuable and essential to economic systems.[10]

The clay of stoneware is more refractory, or heat resistant, and fires to a more vitreous or solidified body because of the molecular structure of the minerals. Its different composition also makes it less ubiquitous; certain areas such as the Cologne region of Germany (fig. 1.7) or northern China (fig. 1.8) are historic centers of stoneware production, owing to nearby deposits of stoneware clay. Dense and endowed with great plasticity, stoneware can be worked into large forms, ideal for transport and storage, or refined and used for tableware. Fired at a higher temperature than earthenware (1,180–1,230°C), stoneware requires dedicated substantial kilns and specific knowledge about firing temperatures, timing, and the effect each variable has on different locations in the kiln. The higher firing temperature and the presence of silica that vitrifies at this higher temperature means that this body type does not always need to be glazed, although potters can add salt during the firing to vaporize on the surface. In a wood-fired kiln, potters monitor the temperature and time by sight

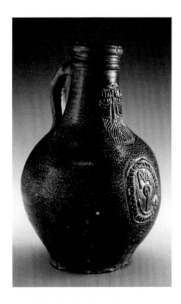

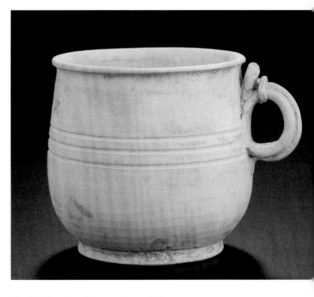

Fig. 1.7. Bottle, Frechen, Germany, 1655–65; wheel-thrown stoneware with sprig-molded decoration and salt glaze. Bears the medallion of Pieter van den Ancker, a Dutch exporter who ran a shop in London. Chipstone Foundation, Milwaukee, WI, 2000.71.

Fig. 1.8. Cup, Xing kilns, northern China, 825–50 CE; wheel-thrown stoneware. Asian Civilizations Museum, Singapore, Tang Shipwreck Collection, 2005.1.00465.

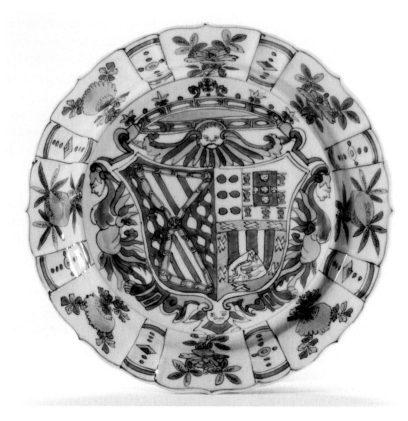

Fig. 1.9. Plate, Jingdezhen, China, 1590–95; porcelain, decorated with the underglazed cobalt blue coat of arms of Garcia Hurtado de Mendoza y Manrique, viceroy of Peru, and Teresa de Castro y de la Cueva. Thomas Lurie Collection, Columbus, OH.

and feel to produce a gaseous ash glaze that settles on the pottery. Since glazes are harder and absorb less liquid than clay, glazing enhances the non-leaking characteristics of stoneware.[11]

The specific sort of clay, necessity of dedicated and reliable kilns, and role of cumulative expertise in firing before the advent of temperature gauges and prepackaged ingredients result in a reliance on local expertise that took into account ecology, social networks, and economic opportunities. Empirical knowledge of local materials, broad-based familiarity with these materials that permits distribution of tasks throughout the community, and a village or regional approach to the work rather than an individual's shop characterize much preindustrial labor. As with many of the materials discussed in this volume, this dynamic local expertise with stoneware is generated through continuous interpretation and evaluation of the material through observation, assessment, adjustment, and improvement. As a result, specific regions

have emerged as centers of technological development and exportation to wider markets.[12]

Chinese advances in stoneware led directly to the development of kaolin-based porcelain in the Ding ware of Hebei Province in the tenth century and the more feldspar-rich porcelain in Jingdezhen in the late thirteenth century as stoneware shops began to change the material composition of their basic body forms, combining kaolin (white clay) with petuntse (china stone). Using a transparent glaze with a small amount of kaolin mixed with limestone burned using dry ferns, potters developed a strong, lightweight, white ceramic that was almost translucent. A single firing at the high temperature of 1,200–1,400°C fused body and glaze together. The specific materials of the body, the fabrication of permanent kilns capable of high-temperature firing, the local knowledge about formulas and temperatures, and the organized division of labor led to Jingdezhen's world dominance until Europeans developed their own porcelains in the mid-eighteenth century (fig. 1.9).[13]

The fourth body type, fritware, also has a specific geography that is tied more to culture than availability of materials. Developed in eleventh-century Egypt and then spread by mobile potters, fritware became the dominant ceramic in the Islamic world, from Egypt and the Levant to Greater Iran. Egyptian potters turned from a clay-based body to an artificial one derived from the glass faience bead tradition. Their formula consisted of 20 percent quartz, 30 percent glass, and 50 percent clay, while Iranian fritware of the late thirteenth century combined ground quartz (about 80 percent) with 10 percent white clay and 10 percent glass powder to produce a whiter body.[14] When fired, the molten clay and glass matrix adheres to the quartz and produces a light-colored body, ranging from white or light gray to yellow or pink, depending on the type of local quartz ground up. Fired in a kiln at temperatures similar to those of refined earthenware, in the 1,000–1,100°C range, fritware provides a brilliant white surface on which to paint under the glaze with minerals or over the glaze with enamels—thus rivaling porcelain. Depending on the proportions of materials, some fritware bodies lack the plasticity of the other three types of ceramics and thus are often molded. As a result, many examples of fritware consist of tiles, plates, and dishes (figs. 1.10, 1.11).[15]

The range of body types, each with a specific geography and technical requirements, helps to provide nuance to the importance of ceramics in the study of history. In analyzing a certain time and place, it is not sufficient to make broad generalizations about ceramics, but rather it is critical to distinguish between different body types whenever possible. Households may have included all four types, each for specific uses, or they might only have possessed earthenware. The ratio provides valuable insights into local values and opportunities.

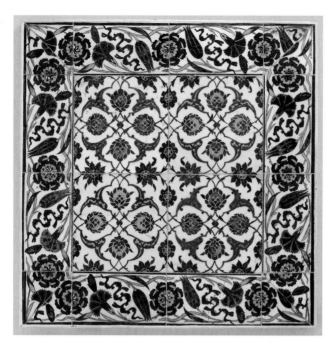

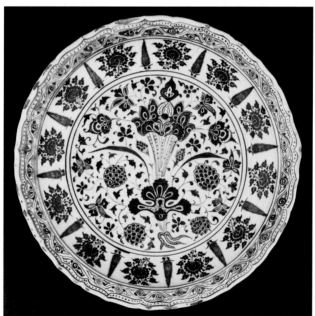

Fig. 1.10. Tile panel, Iznik, Turkey, 1560–90; molded fritware with underglaze painted decoration. Metropolitan Museum of Art, New York, gift of J. Pierpont Morgan, 1917, 17.190.2086.

Fig. 1.11. Dish, Bursa or Edirne, Turkey, mid-fifteenth century; drape-molded and wheel-trimmed fritware with cobalt painted decoration. Asian Civilizations Museum, Singapore, 2015.00063.

# Fiber

The fiber category refers to a variety of materials used to make rope, cord, or cloth. Just as clay consists of a number of bodies with different properties, so fiber has a number of different types. These can be broken down into two different groups: cellulose fibers extracted from plant materials and protein fibers obtained from animals. Each has different properties for dyeing, strength, elasticity, and warmth. Indigenous flora and fauna, as well as use and local labor systems, play a significant role in the type of fiber produced in a region. In this section, I focus on the use of fiber in the production of cloth for dress, wall hangings, curtains, or upholstery.[16]

In East Africa and the Indo-Pacific regions, rich in certain species of trees such as fig, mulberry, or breadfruit, a common type of cloth is tapa, what Europeans call "barkcloth" (fig. 1.12). Following customary cultural beliefs that prize stewardship of land and all living things and choosing not to devote labor to complex fiber and cloth production, communities in these regions harvest the bark of these species of trees without harming them. After peeling a layer of the bark, makers soften the fiber through heat and moisture, then hammer the bark with wooden mallets against logs to soften and stretch its fibers. The artisan can even blend strips together by hammering overlapping sheets. The

Fig. 1.12. Tapa, or barkcloth, collected by James Cook, Pacific Ocean, 1760–80; collated in *A Catalogue of the Different Species of Cloth Collected on the Three Voyages of Capt. Cook* (London: Alexander Shaw, 1787). Courtesy of Penn Museum, Philadelphia, PA, object no. 87-3-1.

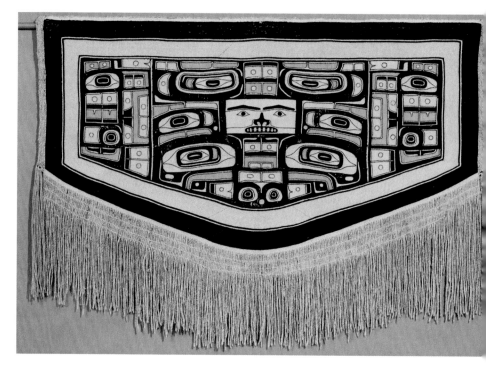

Fig. 1.13. Chilkat robe (*naaxein*), Chilkat Tlingit, Alaska, ca. 1850–80; mountain goat wool, cedar bark, and native dyes. Hood Museum of Art, Dartmouth College, gift of Robert L. Ripley, Class of 1939H, 40.15.12586.

resulting barkcloth, bleached white or decorated with natural pigments, provides rugged, utilitarian cloth for clothing, outerwear, ritual gear, or ceremonial gifts that stand up well in a hot climate. British explorers like James Cook wrote about the fine quality and beautiful painted pattern decoration of tapa in the Pacific region; they viewed it as a type of textile and thus often cut it up like a fabric, thereby removing it from its ritual contexts.[17]

In the Pacific Northwest, the wide availability of yellow cedar prompted some Indigenous people to use strips of the bark not only for basketmaking but rather as a core fiber, spun together with protein fibers like goat's wool or dog fur (fig. 1.13). Female weavers attach this rugged fiber to a horizontal wooden frame, let the warp dangle from this frame, and then twine a protein weft around the warp in a tapestry technique to produce blankets, wall hangings, shirts, leggings, bags, and robes. The use of the thin cedar strips imparts a certain stiffness and structure to the cloth, and the technique results in a loose fringe along the lower edge.[18]

Another tree product, the frond of raffia palms, is a popular fiber in West Africa, Madagascar, and the Philippines. Cutting, stripping, and twisting the

Fig. 1.14. Napkin with the coat of arms of Anne Boleyn and a portrait of her daughter, Queen Elizabeth, Flanders, 1570–1600; linen damask. Victoria and Albert Museum, London, given by Miss G.E.A. Fosbery, T.215-1963.

fronds produces a strong thread that can be woven into a cloth, which is then softened by pounding in a wooden mortar. While men traditionally cut the fronds and weave, women decorate the cloth with dyes or embroidery. The distribution of tasks among different sectors of the community makes raffia well suited to a mixed agricultural economy in which makers juggle the steps of production alongside demands of the larger agrarian system. In this allocation of effort, "part-time" does not mean partly skilled. Like barkcloth, raffia cloth is used both for everyday clothing and luxury cloth, as well as for diplomatic gifts and other ritual performances such as burials (see fig. 5.1).[19]

The surface of plain-woven raffia appears similar to cloth woven from bast fibers, particularly linen, a fabric made from weaving the fibers of the flax plant. Linen's long, strong flax fibers are cool to the touch and possess a slight sheen. Tending and processing the flax plant is labor intensive, so linen tends to be produced in densely populated agricultural zones in North America, northern Europe (Ireland, Belgium, Netherlands, Germany), and the Middle East (Mesopotamia and Egypt). In an extremely time-consuming process, one has to pull the whole plant from the ground; remove the seeds, which are turned into linseed oil; ret (soften in water) and break the stalk to separate the fiber from the stalk; use a hackle to remove shorter fibers and align the fibers in parallel; and then spin the fibers together to make thread. The coolness of

Fig. 1.15. Textile fragment, Gujarat, India, 950–1050; plain woven cotton with block-printed resist dyed decoration. Ashmolean Museum, Oxford, Newberry Collection, EA1990.247.

the woven cloth makes it preferable over wool for summer clothing, and the luster and stiffness make it ideal for tablecloths, napkins, and sheets (fig. 1.14).[20]

Another plant suitable for lightweight cloth is cotton, a soft, fluffy fiber that grows in a boll. Cotton grows best in hot, dry, tropical and subtropical climates (Gujarat, Rajasthan, India's Deccan region, Egypt, Nigeria, coastal Peru, and the American South). Different types of cotton have different colors, ranging from white to gray to brown, and different characteristics. The long staple pima cotton of Peru has seeds that do not cling to the boll, making it easier to remove them. For short staple cotton, the labor-intensive work consists of plucking the bolls from the dried-out pods, whose sharp skin often cuts the pickers' fingers, and then separating the fibers from the seeds. The harvesting of cotton is most viable where a dense population provides a sufficient labor force, often comprised of unfree labor, as in the American South before the Civil War. After combing the cotton fibers, spinning them into thread, and weaving, the finished cloth is soft and breathable, takes indigo blue and madder red well, and hangs fluidly. Cotton was the driving force in the Indian Ocean and Indonesian economy from the tenth through the eighteenth centuries, and in Europe it challenged and then replaced linen as the preferred fiber for summer clothing and sheets (figs. 1.15, 1.16). As Giorgio Riello notes, cotton cloth became the first global fabric, suitable for many uses in diverse climates.[21]

The most common of protein fibers is wool, particularly the fleece shorn from the undercoats or chests of sheep and goats, the fiber of cattle such as yaks or musk ox, and the fine threads shorn from camelids (camels, llamas, alpacas, and vicuñas). These animals tend to be found in cooler climates, so the geography of wool is the opposite of cotton. Like bast or linen production,

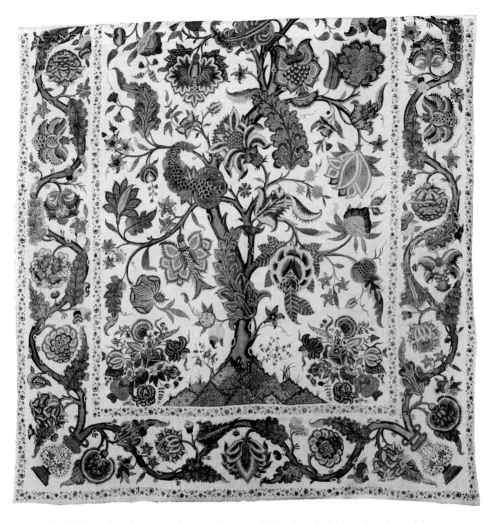

Fig. 1.16. Part of a palampore, or hanging, Coromandel Coast, early eighteenth century; plain woven cotton with mordant and resist dyed painted decoration. Victoria and Albert Museum, London, given by Miss H. Lowenthal, IS.182–1965.

wool requires a number of labor-intensive steps: care of the animals, removing the fiber from the living animal, scouring it to remove much of the dirt and greasy lanolin (if it is present), and then carding it and spinning it into thread and yarn. Its physical properties—crimped, barbed fiber that provides bulk and insulating air pockets and lanolin that helped the animal's coat repel water—make wool ideal for outerwear, cold weather clothing, and blankets. Even when wet, wool retains its insulating properties, unlike cotton, which when wet loses its insulating ability. The simplest way to make wool cloth is through felting, a nonwoven technique that, like barkcloth, makes use of

Fig. 1.17. All T'oqapu tunic, Inca, Late Horizon, 1450–1550; camelid and cotton fiber in a tapestry weave. © Dumbarton Oaks, Pre-Columbian Collection, Washington, DC.

friction and hot water to mat the wool fibers together into a durable warm cloth. More refined spun and woven wool fabric is used for upholstery and carpets, where its durability is prized. Wool drove the European economy from the thirteenth through sixteenth centuries, as raw wool from the West Country and north of England was shipped to the Low Countries and Italy, where it was woven into cloth and tapestries. In South America, Andean weavers achieved remarkable results with fine weft threads of camelid fiber woven across cotton warps, the former coming from the higher altitudes and the latter from the coastal region (fig. 1.17).[22]

Fig. 1.18. Textile fragment with pheasant in pearl roundels, Sogdiana, 680–900 CE; silk woven in a weft-faced compound twill (samite). Los Angeles County Museum of Art, M.2007.32.2.

Another fiber from a creature is silk, the long thread pulled from the cocoon of the silkworm (*Bombyx mori*). Unlike the shorter staple lengths of the previously mentioned fibers, silk is the continuous secretion of the worm as it constructs its cocoon. Its long length means that spinning, as used in the other fibers to twist together shorter staple lengths into longer threads, is not required, although often thin silk is spun together to make stronger threads. Cultivated silk requires considerable work, typically by women, in raising the worms, feeding them mulberry leaves, keeping them clean from their own excrement, and then placing them on a rack where they spin their cocoons. The tenders then kill the cocoons just prior to the emergence of the moth by heating them in an oven or in the hot sun before plunging them into boiling water to loosen the silk and allow easy reeling of the thread. Killing the worm ensures the full length of the single silk thread. If the moth eats its way out of the cocoon, it severs the filament, resulting in short staple length silk, referred to as wild silk, which is then spun. The final product is less smooth than the cultivated silk and often has lumps or slubs where it has been hard to spin consistently. The labor thus lies in the care and feeding of the worms. Extensive mulberry woods and abundance of labor favored China as the center of silk production, although Bengal also supported a strong silk industry. In the eighth and ninth centuries, trade routes through Central Asia brought silk cloth and thread to the skilled Sogdian weavers who supplied silk textiles for Chinese and European markets. The Asian threads tended to be long, ideal for warp threads, while the silk industry that developed in Italy, Turkey, and the Ottoman Levant in the seventeenth and eighteenth centuries tended to produce shorter length silk thread better suited for weft threads. The long, continuous, thin threads made silk a sturdy, smooth, shimmering material, ideal for luxury cloth (fig. 1.18).[23]

## Base Metals

While we currently maintain a hierarchy of metals with gold and silver at the top, primarily because of their use as currency and as the standard for economic systems in Europe and most highly developed economies, the cultural value of these precious metals has not always been high. In spite of plentiful gold in the Andes and Mesoamerica, Indigenous cultures there thought the plentiful gold to be more ornamental and less useful, with metaphysical value as elite burial goods or jewelry, and instead placed greater functional value on durable, practical minerals such as obsidian, slate, and copper.[24] In the western Sahara region of medieval Africa, abundant gold ranked below copper, primarily because of its limited use and more restricted range of working processes. Recognizing the utilitarian value of base metals throughout cultures necessitates a closer look at nonferrous metals and alloys made with them.[25]

The most common and extensively used nonferrous base metal is copper, a reddish ore found in veins on the surface of the earth or in easily excavated deposits and first processed in the eastern Mediterranean. Copper was initially smelted in clay bloomeries at a temperature of about 1,080°C; later, solidly constructed furnaces were more commonly used to separate larger quantities of ore from the impurities. Among the many strengths of copper are its malleability—it does not need to be reheated constantly while shaping it—and the various ways craftspeople could work with it, including raising with hammer work, bending into shape and brazing along a seam, or spinning on a lathe (fig. 1.19). Copper can also be melted and cast. Objects made from pure copper

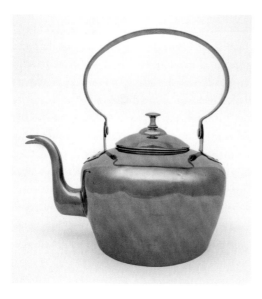

Fig. 1.19. Teakettle, John Morrison, Philadelphia, Pennsylvania, 1781–93; seamed copper body and spout, cast brass handle, tin wash. Courtesy of Winterthur Museum, Winterthur, DE, bequest of Henry Francis du Pont, 1960.0585 A, B.

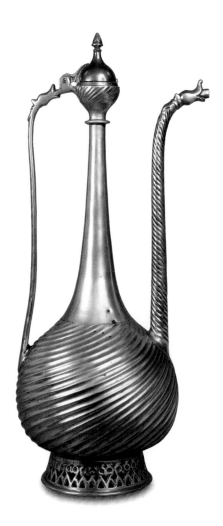

Fig. 1.20. Ewer, India, first half of sixteenth century; cast brass. Ashmolean Museum, Oxford, EA1976.43.

are stiff but can easily be dented.[26] While copper has some inherent strengths on its own, pure tin, another nonferrous metal, is even softer and requires other metals such as copper, antimony, or lead to stiffen it. Concentrations of tin can be found in Cornwall, England; Indonesia; and Bolivia. A third non-ferrous metal with a more circumscribed geography in the preindustrial era is zinc, found primarily in the Deccan area of South Asia and in China. Zinc, usually fabricated through casting, is a dense and heavy metal.[27]

In addition to its workability, copper possesses another feature that makes it valuable: it can be combined easily with a range of other metals to make a variety of alloys (metals blended in the molten state) that have differing strengths and practical advantages. While it can prove difficult to distinguish between alloys, there are five major types in which copper is the primary metal: brass, bronze, bell metal, paktong, and tumbaga. Before X-ray fluorescence and other analytical methods of determining the various trace elements of metals in alloys, metalsmiths depended on tacit or experiential knowledge of

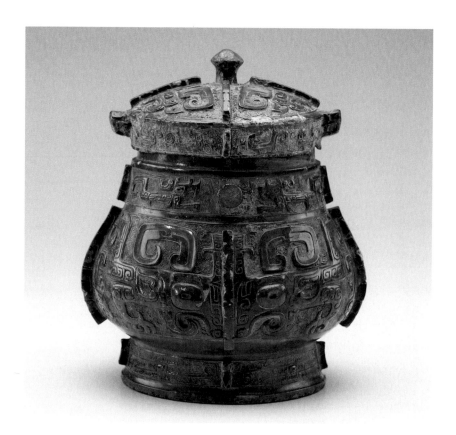

Fig. 1.21. Lidded ritual wine container (*you*) with dragons and taotie (another mythological creature), China, middle Anyang period, late Shang dynasty, ca. 1200–1100 BCE; cast bronze. Arthur M. Sackler Gallery, Washington, DC, gift of Arthur M. Sackler, S1987.968a-b.

the material, particularly color, weight, and response to heat, to identify these different types of alloys, so the proportions discussed here are approximate.[28]

Brass, the composition of which is approximately 65–70 percent copper and 35–30 percent zinc, is a yellowish alloy that is malleable and ductile, enabling it to be worked cold by hammering or spinning or to be cast into solid objects (fig. 1.20). Its hardness makes it easy to achieve a high polish and results in an ideal surface for engraving and chasing. As a result, brass domestic objects such as andirons, candlesticks, and furniture hardware have tended historically to be on view in social parts of the house. Bronze has a higher copper content (95–90 percent copper and 5–10 percent tin), but the combination of these two softer metals results in a hard, friable, and slightly brittle alloy. Used primarily for sculpture and cooking vessels, it can only be cast; it is worked hot but then finished with cold chisel and filing work (fig. 1.21). Its composition made it ideally suited for heavy cooking pots and mortars and

Fig. 1.22. Candlestick, Guang-zhou (Canton), China, 1750–84; cast paktong. The base features pseudo hallmarks to make it appear to be silver. Courtesy of Winterthur Museum, Winterthur, DE, museum purchase, 1961.240.1.

pestles, which were often kept in the kitchen and other working areas of a household. A higher tin content (20–30 percent tin and 70–80 percent copper) produces bell metal, which can be either cast or hammered, has a golden shine, and offers a very sharp sound when struck. While this alloy was favored for cast bells, metalsmiths in South Asia also made bell metal vessels and trays for ritual and special domestic use. A copper alloy closer in appearance to silver is paktong (80 percent copper, 15 percent nickel, and 5 percent zinc), also called "nickel silver," an alloy that resembles silver but that does not tarnish and is less expensive (fig. 1.22). Even though nickel was not recognized as an elemental metal until the mid-eighteenth century, Chinese metalsmiths in Hunan Province had developed the nickel alloy based on their own local metallurgical observations.[29]

While the alloys discussed above met certain structural, technological, or utilitarian demands, other alloys catered to values such as color or reflectivity. In the Andes, metalsmiths developed very sophisticated ways of making tumbaga, a copper-gold alloy for jewelry and vessels consisting of about 80 percent copper, 10–15 percent silver, and 5–10 percent gold, a technique that later spread

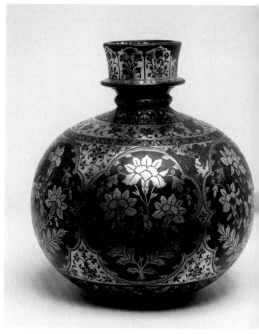

Fig. 1.23. Tankard, John Bassett, New York, ca. 1750; cast pewter. Wayne & Phyllis Hilt American and British Pewter, Haddam Neck, CT.

Fig. 1.24. Hookah base, Deccan region, India, second half of seventeenth century; cast zinc alloy with silver and bell metal leaf inlay. Victoria and Albert Museum, London, IS.27–1980.

through Indigenous communities across much of the Americas (see fig. 8.4). Makers used their preferred raising techniques to shape and decorate the form, covered the finished object with a corrosive vegetable juice, and then exposed it to low heat. This process dissolved the outer layer of copper and enriched gold, what is now called depletion gilding. The widespread availability of gold in the river beds and predilection for hammering over casting suggests that the reason for developing this alloy was the preference for the workability of a copper-dominant body and the high regard for a golden yellow color over red (closer in tone to the sun) and for shiny reflectivity. Symbolism outweighed utilitarian effectiveness.[30]

Important non-copper alloys include pewter and bidriware. The former, which features an 85–95 percent tin content with some copper or antimony to stiffen it, was cast into household objects and was popular throughout northern Europe and Anglo America (fig. 1.23). In the Deccan region of South Asia, the zinc alloy commonly called bidriware dominated. Cast in molds, it consists of zinc with a little copper and lead mixed in and was used for substantial household objects such as hookah bases and ewers (fig. 1.24).[31]

The empirical knowledge gained by mixing different ores underscores the knowledge and ingenuity of metalsmiths working in an era before scientific testing of trace elements, precise temperatures in furnaces, and mechanical processes like extrusion. Access to materials, familiarity with those specific substances, and a dependable system of knowledgeable participants—often all developed together over generations—led to the rise of certain centers of copper alloy production.

## Wood

Wood, the processed materials of trees, has been used for a wide variety of purposes, from fuel and light to a material for shelter and objects. Environmental conditions such as rainfall, temperature, and soil determine the extent and types of trees found throughout the globe: gymnosperms (conifers) such as fir and pine flourish in cooler and mountainous areas; angiosperms (deciduous trees) such as oak, maple, and birch grow in more temperate regions; tropical deciduous trees such as mahogany and rosewood inhabit warm, moist equatorial zones; and no trees are found in dry, desert climates.[32]

Transforming a tree into usable timber can be accomplished in a variety of ways. With some species like beech, willow, ash, and oak, woodworkers can cut offshoots from stumps or trunks without killing the tree, thereby permitting growth of future shoots. This technique, referred to as "coppicing" or "pollarding," is ideal for smaller-dimensioned stock used in wattle fences, chair parts, and handles. For larger stock, woodworkers fell trees with axes or saws and then prepare the stem or trunk of the tree into usable wood. Logs can be split into boards with wedges, squared into beams with the use of broadaxes and adzes, or sawn into boards either by means of pit sawing (where the log is placed over a pit or on a trestle frame and two sawyers saw it into planks) or with a water-powered frame saw in a sawmill. Wedges, saws, and edge tools are essential to harvesting and preparation of stock, and the choice of technique depends on tool availability, labor systems, and seasonal rhythms.

Wood anatomy determines much about the potential use of the material. Since most trees grow more in height than width, craftspeople need to figure out how to use long, fairly narrow boards effectively, by joining them together to achieve mass. Complicating this is wood's organic nature—the porousness of its end grain surface prevents the use of glue on that face, and it continues to expand and contract across the grain (tangentially) according to relative humidity as it sheds and takes on moisture. Once cut, wood loses its water at variable rates, resulting in checking or cracking if not cut into smaller pieces and allowed to dry slowly and evenly. The internal structure of the tree also often reverts to its original alignment. If the tree grew straight, this is not a

problem. But if it grew unevenly in a windy climate or the grain spiraled within the trunk, what is known as "reaction wood," a plank sawn from this tree might return to its twisted alignment as it dried. While slow-growth timbers, wood that has been split out, or wood that is quartersawn tends to be more stable, woodworkers need to account for this movement when constructing objects from multiple pieces. Blemishes on the trunk, either knots where branches extended out or burls where a fungus disrupted the cellular structure near the bark of the tree, also require adjustments. The former results in weakness in lumber from conifers but can provide aesthetically desirable figure in tropical woods, while the latter results in interlocked grain that is hard to work but provides a luminous appearance.[33]

Species of wood often have different tensile and compression strengths, specific gravities, and varying degrees of hardness, so their ideal properties can vary. Eastern white pine possesses great tensile strength and light weight, which makes it ideal for masts, while big leaf mahogany from the Caribbean resists rot, making it a preferred boatbuilding timber for Spanish colonists in the seventeenth century. In the eighteenth century, mahogany's fine even grain, availability in wide boards (because of the tree's large size), warm tone, and ability to take a polish made it a popular cabinetmaking wood. Experience with different species of wood, both local species and timber that different trade routes made available, allowed artisans to develop an empirical sense of the best use of local woods, matching supply and demand, and the advantages of distant species.[34] The weighing of local supply and intended use led to complex networks of harvesting and circulation that emerged as early as ancient Egyptian and classical times, when rulers sought out cedar and various other conifers from throughout the eastern Mediterranean world.[35]

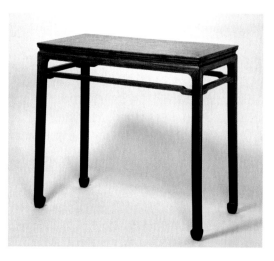

Fig. 1.25. Table, China, 1550–1650; huanghuali joined with mortise and tenon joints. Victoria and Albert Museum, London, FE.21–1980.

Rather than talk about specific species of trees, of which there are so many varieties, it is more helpful to focus on the source of wood and its particular use.[36] One critical way to consider different woods is to distinguish between local and imported timbers. Many local economies depend on local resource management to maintain wood supplies. In the inland towns of colonial New England, most inhabitants owned arable, pasturage, and woodlots, resulting in the extensive use of local woods by furnituremakers and builders. But crafts-people in port towns or urban centers did not have local trees with which to work, so they relied on trade and timber merchants to supply necessary raw materials. For example, artisans in the colonial American ports often imported a variety of woods from their hinterlands and more figured woods from the Caribbean, while Chinese cabinetmakers used locally available elm for much of their ordinary work and sought more highly figured and richly colored Hainan and Southeast Asian huanghuali and zitan for their finest furniture (fig. 1.25).[37]

Another important distinction is the difference between primary and secondary wood, that is, material for exterior finish and material hidden in construction. The former is often chosen for figure, color, or exotic associations; the latter is usually a readily available local wood. In mid-eighteenth-century Boston, cabinetmakers celebrated their access to Caribbean mahogany by hewing large boards of the imported timber to create swelled bombé sides and blockfront or serpentine facades, but they relied on local white pine and white cedar—abundant in the region, light in weight, and strong—to construct the back of the carcass and drawer linings (fig. 1.26). Plank-seated Windsor chairs, popular beginning in the mid-eighteenth century, also embody sophisticated technology in that they were made from a variety of woods, each chosen for its specific properties: soft, even-grained woods such as yellow poplar or white pine for the seats, where smooth shaping was desired; split, shaved, and bent ash or oak for the spindles and hoop, where continuous grain was essential for strength; and tight-grained woods like maple for turned legs, stretchers, and arm supports, where the crispness of the turned ornament was important. A coat of paint protected the wood and unified the appearance of the different species (fig. 1.27).[38]

## Choices

Wood provides the clearest example that makers and consumers often had choices in the selection and preparation of materials. Through deep local knowledge or irregularities in access to raw materials, artisans exercised choice in selecting specific types of wood for different parts of an object or developing their own proportional recipe for copper alloys or ceramic bodies.

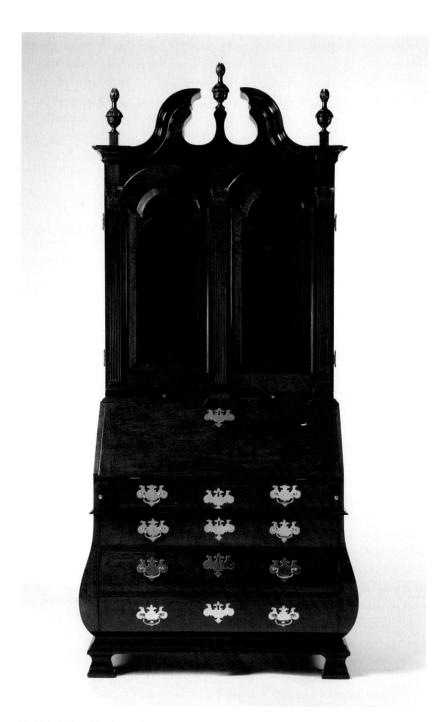

Fig. 1.26. Desk and bookcase, Benjamin Frothingham, Charlestown, Massachusetts, 1753; dovetailed, mortise and tenon panel construction, and nailed fastening of mahogany, eastern white pine, eastern red cedar, and Spanish cedar. Courtesy of Diplomatic Reception Rooms, US Department of State, Washington, DC.

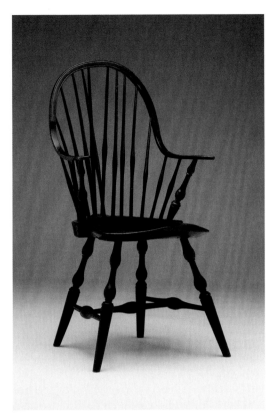

Fig. 1.27. Bowback Windsor armchair, Ebenezer Tracy, Lisbon, Connecticut, 1785–95; sawn and shaped chestnut seat, turned maple legs and stretchers; riven and shaved oak spindles, and riven and steamed oak bow back—originally painted green. Yale University Art Gallery, New Haven, CT, Mabel Brady Garvan Collection, 1930.2377.

For example, metalsmiths often accepted older broken or worn alloyed metal objects as a form of payment, but they needed to judge the type of metal and its quality in order to sort it into discrete piles of scrap that would be melted for future use. A potter might add wood ash, sand, or ball clay to earthenware to achieve different structural or aesthetic effects. Weavers in the colonial Andes and embroiderers in Mexico dismantled imported woven Chinese silks and then reused the colorful silk thread with camelid fiber in their own weaving.[39] Cumulative empirical material experience, often passed down through apprenticeship and usually with some roots in the specific conditions of place, forms an essential part of artisans' skill. They constantly have to adjust to availability and suitability to the task, weighing what is at hand, what can be acquired with some effort, and what the final result should be.

In examining the role of choice from a user's perspective, we need to avoid our own current economically based rationality, where the consumer initiates the purchase and offers the seller a specified amount of money. In a pre-specie economy, transactions were often based on exchange rather than purchase: one might receive an object as the result of settling a debt or as

third-party payment; makers could use one of their products in exchange for something they needed; or nimble ship captains and traders often picked up and exchanged a variety of goods, often unintended, in their travels. In short, one did not always purchase an object but rather simply came into possession of it. As a result, the value of materials might not just be a market price but rather based on the specifics of acquisition, the motive for transaction, and the cost of transportation. Local materials often can be assigned lower "costs."

Materials thus accrue meanings through comparison. The presence of complementary or comparable options and competitive materials can reveal or suggest the presence of local taste or diverse social or cultural values. It is the full understanding of available choices that allows us to ask pertinent questions of specific times and places. Scholars have proven that cotton became the most desirable fabric for clothing close to the body, but how did linen weavers of the European Low Countries respond to the competition of cotton cloth at the turn of the eighteenth century?[40] Did they simply incorporate the floral or pattern imagery of South Asian chintz into their woven patterns? Or did they adapt and consciously focus on a distinct section of the market, that of tablecloths, napkins, and sheets?

Alloys in nineteenth-century India offer another example. As more British goods were shipped to India and significantly encroached on regional production, what was the impact on local artisans and preferences? Scholars have charted the manner in which Manchester cottons flooded the South Asian market and threatened local handloom production of cotton cloth, but they have not examined other media. Pewter was an important British export at the turn of the nineteenth century, so why didn't British pewterers target the Indian market, which had demonstrated a fondness for cast metal alloys such as bidriware? Pewter's market remained restricted to Britain, North America, and northern Europe, while bidriware continued to be a South Asian good that did not expand beyond that region. Even Arthur Liberty, the purveyor of Indian and Indian-inspired goods, did not import bidriware or have local pewterers make bidri-like lines. Instead, he had Birmingham metalsmiths develop British Art Nouveau designs.[41]

And why did Dutch tin-glazed earthenware tiles become so popular in the seventeenth century? Was it because the Ottoman imperial production of tiles caught their fancy but the high cost of those tiles prohibited a broader market in the Netherlands? In this scenario, the Dutch pieces offered a less expensive substitute, made of local materials in local shops, just as the potters had responded to the high cost of Chinese porcelain. Or, did the Dutch ceramics shops have a clear sense of the local market, recognizing that the Iznik tiles tended to be large, often contained Arabic script, and covered large sections of walls in public places like mosques? Adapting to local domestic space, the

potteries reduced the size of tiles for use in the Dutch interior. The blue-and-white palette and use of Chinese-inspired calligraphic devices in the corners of an Ottoman-inspired object suggest that Dutch potteries consciously blended the external ideas and produced their own synthesis. Rather than using materials simply as a means of pinpointing where an object might have been made, beginning with the possibilities inherent in these materials as the first step in object-driven inquiry opens up questions.

While the materials from which an object are made are often listed on a museum label or in an illustration caption, one should not simply think of that material as inevitable, as a mere descriptor, or as less important than the name of a known maker. The choice of a material results from a long, complex series of decisions by suppliers, makers, and clients based on local resources, distant supply chains, and specific context. Availability and suitability of materials were based primarily on local supply, trade networks, and shared experiences. While materials possessed certain agency to suggest possibilities and to educate artisans, it is also important to recognize the agency of the maker in transforming those materials, which is the subject of the next chapter.[42]

# Chapter 2　Realization

Once materials are harvested or processed, artisans transform them into objects through a series of interrelated steps of fabrication, decoration, and finish, a sequence that I refer to as "realization." During an era before extensive investment in jigs, mechanization, and steam power would speed up work or increase production of a certain object, makers relied on a series of strategies to meet demand and maintain a livelihood. While early historians of artisans such as William Morris or Carl Bridenbaugh sought to develop an evolutionary history of making, with a sense of inexorable progress up until the age of industrial capitalism, it is more accurate to conceive of the artisanal landscape as a spectrum.[1] At any moment there were a variety of craftspeople who worked for different levels of demand, from batch production to one-off custom work. Many artisans or shops offered a range of goods within this spectrum. Deep familiarity with their materials, a reliance on acquired skill, and intensive use of a restricted number of specific tools permitted these preindustrial makers to choose the appropriate technique for the appropriate task or desired result. The successful application of this knowledge determined their livelihood.

Makers' choices remain grounded in their immediate environment. In some mixed agricultural economies in temperate climates, craftwork often takes place in public spaces, on the ground, and with many members of the community responsible for widely distributed preparatory tasks such as wood harvesting and sawing, clay refining and wedging, or thread spinning. Making is a socially unifying activity. Work is not continuous, but subject to

interruptions, and makers do not labor on one object at a time but rather work with one step or one tool at a time to make parts. Some makers consciously specialize in certain types of objects for a broader market or develop a network of decentralized specialists who collaborate with each other. While some craftspeople work in varied locations with portable equipment, others work in a fixed location dedicated to their art and have invested in certain equipment such as floor looms, kick wheels, benches, or forges. They devote more resources and time to their work. Yet this does not necessarily lead to better final products. The backstrap loom of the Andes, the integrated crucible molds of South Asian and African bronzeworkers, and the ground-based woodworkers of South Asia all produce work that continues to be admired for its sophisticated workmanship and beauty. In short, surviving objects document that low technology and part-time work do not necessarily mean less skill but are merely one option for productive activity.[2]

By recognizing that skilled work takes place over a considerable geographic and temporal range, we can thus divest ourselves of the notion that technology has continually improved and that the present offers the most advanced form of realization. Paying attention to the tacit knowledge and dexterous actions of past cultures questions this progressive model and allows us to see both quotidian and more refined objects in a different light. We can see why some East Asian objects such as lacquerwork or porcelain elicited a sense of wonder, why cottons from South Asia attracted the attention of the world, or why inlaid copper alloy objects made in the Levant received significant attention from Europeans. But we can also appreciate the simplicity of a turned wooden bowl used by many in medieval Britain, the luster of raffia textiles from West Africa, or the deep gold color of cast copper alloys from the Deccan.

The contrast between two sixteenth-century bowl forms illustrates the importance of recognizing the fit between realization and use. A wooden drinking bowl, one of about sixty bowls made from beech or alder recovered from the wreck of the English naval vessel *Mary Rose*, which sank in 1545, documents the deft application of low technology for a quotidian object (fig. 2.1). Made by a woodworker who split a section of a log in half, hewed it into general shape with an axe, and then turned the bowl on a leg-powered pole lathe, the bowl has evident tool marks that indicate the use of a turning gouge in a series of stepped passes to shape the bowl and the chamfered rim. Using green wood—recently cut and with high moisture content—the turning proceeded smoothly and efficiently. However, the turner was not concerned with a smooth finish; there is visible evidence of the turning gouge on all the bowls, and some still have the deep marks of the hewing, which were not removed with the turning. But the bowl did dry in a manner that left a slight peak where the pith of the log had been, since that part did not contract as the

Fig. 2.1. Drinking bowl, England, early sixteenth century; alder turned on a pole lathe. Recovered from the wreck of the *Mary Rose*. © Mary Rose Trust, 82A1712.

bowl dried. But this shrinkage did not affect its function as a drinking bowl or its owner's attachment to it; many of the bowls include carved initials and geometric designs on the exterior, and one cracked example was even repaired with stitching. The efficiency of production and resulting price matched the desire for a basic well-made cup.[3]

In contrast to this efficient example, a red lacquer bowl made in China during the second half of the sixteenth century exhibits more time-consuming and elaborate workmanship (fig. 2.2). The lacquerer took a plain turned wooden bowl provided by a turner and began to slowly build up layers of cinnabar-tinted lacquer, allowing each thin layer to dry before adding another. Applying hundreds of layers might take a year. Once the final form was realized, the maker carved down through the layers to produce relief scenes and designs to bestow a level of auspicious decoration to the bowl, likely also used for drinking, while keeping the interior perfectly smooth. The laborious, time-consuming steps of layering and the extensive overall freehand carving made this a very different sort of bowl, one in which skill was used to elaborate rather than simplify.[4]

This chapter lays out different approaches to fabrication, decoration, and finish to underscore the many choices available to artisans in the preindustrial workshop. In using the term "realization," I link together conceptualization or composition, fabrication, decoration, and performance. In this manner, realization combines mental and physical work, what the design historian David Pye refers to as "design" and "workmanship." The use of a single term permits

a more accurate way of thinking about making as a process that links brain, body, and hand without resorting to projected notions of individual creative genius, romanticization of handcraftsmanship, or assumption of inevitable progressive improvements over time. Unidentified makers working collaboratively in a shop or in a village economy could produce high-quality yet very simple objects that exactly met demand and expectations.[5]

Composition is often thought to be abstract, but it is in fact grounded in the social realm, whether it be the makers' training, wherein they learn and internalize habits and efficient ways of conceptualizing or fabricating an object; the inspirational influence of objects or ideas brought into the region from outside; or the development of new forms through the reorganization of older parts or through the adoption of new materials. In an era before school curricula, book learning, how-to guidebooks, or instructional videos contributed to a maker's foundational knowledge, the practice of craft was a cumulative, deeper experiential endeavor, what can be referred to as tacit knowledge. Conceptualizing an object is the transformational process by which a craftsperson draws from experience and observation a structural, technical, and decorative solution to the question of creation. It is a form of cerebral problem solving,

Fig. 2.2. Drinking bowl, China, second half of sixteenth century; turned wood with carved cinnabar-tinted lacquer finish. Victoria and Albert Museum, London, FE.38–1974.

what Roland Barthes describes when addressing weaving as "making visible a way of thinking about making." From a range of possibilities drawn from their particular physical and social environments and from their own expectations and needs, artisans pick the appropriate rules and solutions that will satisfy the needs, resources, and desires of the market. In this way, objects collect the circumstances of their making.[6]

In translating their concepts into physical form, makers could draw from a range of solutions based on a wide variety of practices derived from training, experience, or a kit of tools, and subject to external factors such as the labor system, market, and competitive materials. In an era before mechanized power and complex tools and jigs with very specific applications regulated the maker's efforts and minimized risk of error—what David Pye refers to as the "workmanship of certainty"—a premium was placed on dexterity, flexibility, and adaptability. These latter qualities define what Pye calls "free workmanship," an internalized approach that depended on skilled use of tools that did not necessarily predetermine the final result. The anthropologist Tim Ingold has defined this embodied knowledge as skilled practice, as distinguished from mere mechanical execution, a socially generated set of experiences rather than the innate talents of an individual. Even in highly organized industries like Roman terra sigillata or Chinese porcelain, the separation of tasks was developed both to ensure quality for high-end goods and to speed up work and increase gross production for trade goods. Makers might draw from a spectrum of appropriate materials, workmanship, and decorative finishes— from local materials to imported ones, from unregulated free work to highly regulated workmanship of certainty, and from plain tooled exteriors to intensively articulated surfaces—depending on available materials and equipment, market demands, and the functions of the finished product. Controlling the nature of work, they would sort through possible options to develop the specific response to the particular demand. They matched the creative solution to the social dynamics of production, distribution, and sales.[7]

In switching the focus on making from the modern emphasis on the application of technology to the more rooted practice of acquired skill as a form of cognitive and embodied knowledge, it is resourcefulness, efficiency of effort, and informed intensive use of tools that distinguishes tacit knowledge. As the experimental archaeologist Alexander Langlands reminds us, "The goal, in being cræfty, is not to use as much as possible of the technology and resources you have at your disposal but to use as little as possible in relation to the job that needs undertaking. This is the *resourcefulness* in cræft. Having physical adeptness, strength and fitness represents the *power* of cræft. And finally, understanding the materials, making critical decisions about how to approach the work, and factoring in wider financial and time constraints rep-

resents the *knowledge* in cræft."[8] Important to this exploration of shop floor history is attention to set up (the size, location, ownership, and arrangement of the production space), equipment (tools, structure of artisans within the shop, materials), and rhythms of production (daily and seasonal).

Whereas fabrication might be a transitional state from material to form, the emergence of a finished work into the immediate world outside the shop constitutes performance, the final step in the process of an object's realization. More than individual aesthetic judgment of the final product in relation to an idealized academic archetype, performance assesses the societal reception of the completed object and determines whether it embodies and manifests the shared values and experiences of maker and user. Like composition and fabrication, this fitness is rooted firmly in social and cultural contexts. Even a well-conceived skillfully made object can be a failure if it does not satisfy its intended market or purpose. A graceful ceramic teapot that does not pour well or an exquisitely made chair of precious wood that has a precariously high seat both fail functional requirements. While the maker might exert the greater control over what the sociologist Douglas Harper calls "the nature of work," the client or market often has a greater influence on "the context of work," that is its acceptance.[9]

With a fuller understanding of the stages in realization, and its contextual rootedness in specific places and time periods, we can turn our attention to the four different media. In no sense is there a hierarchy of processes; one is not inherently superior to another. Rather, there is considerable fluidity in the spectrum of choices. The same shop might cater to several different levels of the market or target different opportunities at different times. An object to be used for storage may have different requirements in regard to weight, level of workmanship, or decoration than one used for entertainment or show. Design economics dictate that the cost of materials and labor is usually commensurate with the display function of the object. Nevertheless, there are exceptions, such as Japanese tea bowls that are valued for imperfections that provide a sense of intimacy or stimulate the imagination about the making of the bowl.[10] Rather than focusing on a simplified notion of production or patronage, realization matches the physical and human resources of the shop to the appropriate fit for the market, whether bespoke work for an individual client or batch production for the masses.

## Ceramics

The realization of ceramics is largely a transformative one in which artisans move and shape the material with their hands, with the possibility of additive or subtractive adjustments to the form. For many, the popular image of

Fig. 2.3. Plate, Puebla or Tlaxcala, Mexico, 1250–1521; drape-molded earthenware body with burnished slip decoration. Yale University Art Gallery, New Haven, CT, gift of David Joralemon, B.A. 1969, M.Phil. 1974, 2017.14.24.

Fig. 2.4. Bowl, Iran, late eleventh / early twelfth centuries; press-molded fritware. Metropolitan Museum of Art, New York, Harry Dick Brisbane Fund, 1963, 63.159.3.

ceramic production that comes immediately to mind is the potter's wheel, a tool whose mesmerizing rhythm and speed with which a form emerges from a lump of clay can intoxicate the viewer. However, clay can be worked in a number of ways, from the free, unregulated work of pinching and coiling to more predictive work of molding and slip casting. Turning on a wheel offers a middle ground that regulates some aspects, such as the cross section of the form, but also relies on the potter's hand skills to feel and shape the clay. There was not a progressive or evolutionary linear flow from the former to the latter, but rather a cumulative variety of practices from which a potter might choose according to the material and the intended use or market.[11]

The core techniques for making clay objects are pinching, modeling, and coiling, commonly found in earthenware pottery made by the Indigenous potters of the Americas, and potters in Africa and parts of Asia (see figs. 0.4, 1.3). Not requiring an investment in special equipment or a dedicated work space, this type of ceramic art fit into the natural rhythms of a mixed agricultural economy that balanced grains and fruits, animal husbandry, and craft work. Often pottery is the domain of women who work outdoors on the ground in public spaces, fitting it in among other tasks such as child raising, food preparation, and cooking. This is episodic, low-technology work that can result in durable, thin-walled vessels, provide a steady supply of small batch production

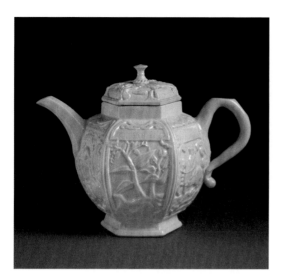

Fig. 2.5. Teapot, Staffordshire, ca. 1745; slip-cast, salt-glazed white stoneware. Victoria and Albert Museum, London, supported by the Friends of the V&A, C.21:1, 2–1999.

articles, and offer a means of livelihood passed down through the female line of a family.[12]

Slightly more regulated is drape molding, in which a potter can either paddle a lump of clay over a wooden or terra-cotta mold or drape a rolled-out sheet of clay over the mold and then trim off the excess (fig. 2.3). The use of a mold to shape the interior space of the final form ensures a consistent size and shape with smooth surfaces inside and outside. The potter justifies investment in these inexpensive molds because demand is consistent and predictable. As a result, this technique is used most often on utilitarian wares with simple open shapes, like dishes and platters used for food preparation or serving or large crocks for food storage.

Press molding uses more complex plaster molds to develop reproducible modeled forms with fairly thin walls. Creating the master pattern from which the molds are cast, typically carved wood or modeled clay, requires time and skill, but some potters make plaster molds from existing ceramic, wooden, or metal objects. Together with the time necessary to assemble and finish the forms, this cost makes press-molded products more valuable than coiled or drape-molded works. Offsetting this higher investment in equipment are certain advantages: the rapid production of objects in constant demand or the possibility of matched sets of the same form. Tiles are the simplest press-molded forms (see fig. 1.10), but pipes and refined tablewares of earthenware, stoneware, porcelain, and fritware are also fabricated with this technique (fig. 2.4). In the case of fritware in the Islamic world, the limited plasticity of the body composition, more than the market demand for matched sets, determines the selection of the technique.[13]

A more complex molding technique, developed in Europe, is slip casting, in which a very liquidy refined clay is poured into a two- or three-piece plaster mold and allowed to set for a specific amount of time. After the clay firms up near the plaster walls, the potter then pours out the liquid center, leaving the leathery shell behind. Like press molding, this technique provides the final decorated shape in a single step with minimal interior cleanup (fig. 2.5). French potteries began using this technique for small items in the early eighteenth century, and it was later adapted in Staffordshire in the 1730s. For smooth, symmetrical bodies the easiest technique is to turn it on a wheel. For asymmetrical shapes with some relief decoration press molding or slip casting is more efficient and results in a consistent product.[14]

Turning or throwing on a potter's wheel relies on centrifugal force to quickly produce forms that are symmetrical in section. Potters can make a body quickly and trim excess clay easily, relying primarily on touch and rhythmic habit, and then add handles, feet, finials, and other parts (see fig. 8.3). While they can craft a vessel entirely on the wheel, makers often use it in conjunction with other techniques such as pinching or press molding handles. Although they do not rely on the regulation of molds, potters working at a wheel often weigh amounts of clay for specific sizes, rely on a gauge post to measure height, and use a rib to smooth the sides of the vessel or to run a decorative molding along the side wall. For slightly more regulated work in which consistent volume is important, such as crocks or vessels, potters put a measured amount of clay into an open mold set on the wheel head and then use a jolly, a hinged arm with a cylinder head, to press the clay up against the interior walls of the mold. While the mold shapes and finishes the exterior of the vessel, the jolly shapes the inner surface. A jigger, on the other hand, consists of a hinged arm with a profile cutter that shapes the exterior. Usually employed with plates or dishes, a jigger shapes and trims the exterior and foot as the clay draped over a mold rotates face down on the wheel.[15]

While basic fired unglazed clay can provide a serviceable object like a flower pot, roof tile, or simple container for cool liquids, the exteriors of ceramic objects are often finished or decorated for a variety of reasons, including function, visual appeal, commemoration, emulation, or simulation. Decoration can also take on a semiotic role, providing a visual reference or link to ceramic trade or history. Three basic categories of ornament are surface decoration, modeling, and graphic design, each of which has a range of possibilities from simple to complex.

The essential form of decoration involves the application of a thin layer of liquidy clay, a slip, to a leather-dry body before firing. Covering the whole body, slip provides a consistent watertight skin; covering a section, it can provide a contrasting color. In the Andes and American Southwest, potters use

Fig. 2.6. Jar, Santa Clara Pueblo, New Mexico, ca. 1880; coiled and burnished earthenware. National Museum of the American Indian, Smithsonian Institution, Washington, DC (21/3357).

a smooth stone or old sherd to burnish the slip, which makes the exterior surface of a coiled pot glossier and more solidified (fig. 2.6). In Africa, potters sometimes apply an animal fat to a fired vessel and then hold it over a flame to carbonize it.[16]

Glazing is another type of surface covering that seals the body, but it also offers an opportunity to resemble the look of other types of ceramics. After mixing a fluid suspension composed of silica, alumina, a flux or melting agent, mineral colorants, and water, the potter covers a work with the liquid. Firing forces the water to evaporate and solidifies the ingredients into a matrix. Common applied glazes include lead-glazed earthenware in China, the Middle East, Europe, and colonial North America (see fig. 1.2); tin-opacified earthenwares first developed in ninth-century Abbasid potteries and then used in European potteries beginning in the mid-fifteenth century (see figs. 3.49, 1.5); burned limestone and kaolin clay covering for East Asian porcelain (see fig. 1.9); and kaolin, lead, and cobalt for Wedgewood's creamware and pearlware in the second half of the eighteenth century (see fig. 1.6). Another form of glaze is a vaporized residue that is deposited on stoneware in the heat of firing. Alkaline glaze, in which gaseous wood ash settles on the surface of the pots, or a wood ash glaze applied to the body before firing, produces soft tones (see fig. 8.3), whereas salt thrown into the kiln at a certain temperature turns into a vapor and results in a shiny, lemon-peel surface on European stoneware (see fig. 1.7). Glazes not only seal earthenware and stoneware but can use different minerals to introduce color: copper provides the basis for the deep green glaze of medieval European pottery; lead gives a wider range of yellows, tans, and

Fig. 2.7. Scarab vase (*The Apotheosis of the Toiler*), Adelaide Alsop Robineau, Syracuse, New York, 1910; wheel-thrown and carved porcelain. Collection of the Everson Museum, Syracuse, NY, museum purchase PC 30.4.78a-c.

Fig. 2.8. Teapot, Josiah Wedgwood and Sons, Stoke-on-Trent, Staffordshire, ca. 1765; slip-cast body, press-molded spout, and molded handle of refined earthenware with cream-colored glaze. Wadsworth Atheneum Museum of Art, Hartford, CT, bequest of Mrs. Gurdon Trumbull, 1934.89.

browns; iron results in brown; and tin contributes to opaque white glazes that simulate white porcelain.[17]

A second type of ornament emphasizes relief or modeled work, wherein the body is manipulated. Free workmanship for this type of craft includes the time- and skill-intensive techniques of stippling the surface, using carved wooden paddles or even rope to impress texture into the body, or carving into the clay with modeling tools (fig. 2.7). An alternative to this subtractive technology is an additive one, in which potters add elements to the ceramic body and then model these extra pieces (see fig. 8.3). To ensure a more consistent final product potters can develop molds for decoration. They push a convex mold into the wet body to produce impressed patterns, or they press clay into a concave mold and then take that clay piece and attach it to the clay body, a process called sprig molding that results in a raised decorative element (see fig. 1.7). Yet another application of the workmanship of certainty to achieve modeled forms combines fabrication and modeling through press molding or slip casting the whole object (fig. 2.8). Hiring a patternmaker or carver to create a prototype from which to make plaster molds ensures consistent production. However, one has to be sure that demand would warrant such

an investment in model making, storage space for prototypes and molds, and inflexibility.[18]

The third ornamental technique is graphic decoration, which runs the gamut from slip to underglaze decoration to overglaze painting. Pueblo potters in the American Southwest use yucca fiber to paint slip on burnished bodies (see fig. 0.4). When fired, these slips provide matte white, black, and red designs.[19] Ancient Greek ceramic decorators who made red-figured ware used slip with a multiple-step firing process. After the preliminary, or bisque, firing of the body, the painter would apply slip to define the areas around the desired images and then fire the pot in a kiln with green wood and no oxygen. This turned the entire pot black. A third firing with oxygen turned the body back to red-orange but did not affect the black of the slip (fig. 2.9).[20] Potters can also trail slip onto an earthenware body to create writing or then comb or jiggle it to create swirling patterns. Yet another slip technique is sgraffito, in which the maker covers a leather-dry body with an overall slip. After letting the slip dry, the artisan carves through the slip to reveal the body and then fires the object (fig. 2.10). Earthenware potters often add various minerals to the slip to produce different splotches of color. Copper produces green; cobalt, light blue; iron, reddish brown; and manganese, purple.[21]

Korean potters from the twelfth to the fifteenth centuries also used sgraffito with their stoneware bodies. Covering the bodies with a white slip, they carved in designs before glazing and firing. Combining slip and the principles of sgraffito, these makers also developed an inlay technique called *sanggam*.

Fig. 2.9. Stamnos, Attica, Greece, 460–450 BCE; wheel-thrown body and pulled handle of earthenware with slip decoration and reduction firing. Ashmolean Museum, Oxford.

Fig. 2.10. Plate, North Devon, England, 1670–80; drape-molded redware body with sgraffito decoration. This example was found in Jamestown, Virginia. US National Park Service, Colonial National Historical Park, COLO J 7367.

Into a stoneware body they carved or impressed voids in the shape of flowers, clouds, and waterfowl and then filled these channels with white and black slip. After covering the form with a glaze that contained a small amount of iron oxide, they fired the ware at a high temperature in a reduction kiln. The resulting celadon green with imagery was highly prized and used for ritual objects or for tablewares in affluent households (fig. 2.11).[22]

Abbasid potters working in the ninth century initiated the most sophisticated graphic work. They incorporated tin oxide into their glazing practice to produce a white-surfaced earthenware on which they painted calligraphic, floral, or geometric images in cobalt blue pigments. When fired, this blue bonded with the glaze, resulting in a refined, colorful, shiny surface (see fig. 3.49). The Abbasid potters also developed a painted glaze technique referred to as "lusterware," derived from glass decoration. To an already fired, opaque, white-glazed surface, the potter applied a pigment containing silver or gold oxides.

Fig. 2.11. Bottle, Gangjin, Korea, Goryeo period, fourteenth century; wheel-thrown stoneware with white and black slip inlay and celadon green glaze. Freer Gallery of Art, Smithsonian Institution, Washington, DC, gift of Charles Lang Freer, F1897.46a-b.

Fig. 2.12. Bowl, Iraq, tenth century; drape-molded and wheel-trimmed earthenware with tin glaze and luster decoration. Cleveland Museum of Art, Cleveland, OH, John L. Severance Fund, 1959.331.

When the object was fired a second time at a low temperature, the metallic particles melted into the glaze and provided an iridescent surface. In the ninth and tenth centuries Abbasid lusterwares found a wide market, from Spain to Southeast Asia (fig. 2.12). In the mid-twelfth century, potters in Greater Iran applied this luster technique to their white-bodied fritware.[23]

In Europe, decorated tin-glazed earthenware consisted of freehand painting on a dried tin glaze, which fused together in firing. The painter could either follow stenciled lines, which can be seen on some Italian work (fig. 2.13), or paint images freehand, which Dutch tile painters and British potters tended to favor (fig. 2.14).[24] During the mid-eighteenth century, an alternative for consistent batch decoration was developed in England for the refined earthenware called creamware and pearlware: transfer decoration (see fig. 1.6). Pottery firms contracted with engravers to cut copper plates for border decoration and central motifs. These engraved plates were inked and tissue was laid over the plate. The decorator placed this inked tissue on the glazed biscuit-fired object. Under a second low temperature firing, the tissue burned away and the ink melted into the lead glaze body. As did press molding, transfer decoration permitted matching sets and a consistent look, but it limited the possibilities. The turn

Fig. 2.13. Plate, Deruta, Italy, 1500–1510; drape-molded and wheel-trimmed earthenware with tin glaze and painted decoration. Metropolitan Museum of Art, New York, Robert Lehman Collection, 1975.1.1037.

Fig. 2.14. Plate, London, 1679; press-molded and wheel-trimmed earthenware with tin glaze and underglaze cobalt blue painted decoration. Bryan Collection, USA.

away from hiring skilled painters and the investment in replicable decoration resulted in more batch production, limiting decoration and even the forms onto which the designs could be easily transferred.[25]

Chinese porcelain drew on earlier stoneware and "proto-porcelain" painting traditions such as the use of cobalt blue in splashes on a lead glaze ground in eighth century *sancai* wares for local markets and the line drawing and iron black oxides painted underglaze to produce sharp imagery on tenth-century Cizhou ware. When the underglaze blue fritware from Greater Iran began to circulate, Chinese porcelain painters adapted their existing techniques to new possibilities and relied primarily on cobalt imported from Iran. Like the Iranian mina'i overglaze enamel-painted fritware of the twelfth and thirteenth centuries, Chinese porcelain, beginning in the fifteenth century, began to use enamel overglaze painting to provide green, red, pink, and gold colors. The process of overglaze decoration permitted customization of standard forms. In the eighteenth century, porcelain painters in Guangzhou could satisfy the various foreign demands for armorial porcelain by painting with enamels

Fig. 2.15. Covered tureen, serving platter, and plate, Society of Cincinnati service, Jingdezhen and Guangzhou (Canton), China, 1784; press-molded and drape-molded porcelain with underglaze blue and overglaze enamel decoration. Courtesy of Winterthur Museum, Winterthur, DE, gift of Henry Francis du Pont, 1963.0700.036, A, B, C.

on glazed blanks with underglaze blue decoration produced in Jingdezhen (fig. 2.15).[26]

Many types of objects combine different techniques or had different decorative options. Tiles are a particularly good example, since the basic forms are press molded. From there the tilemaker faces a variety of choices: solid-color glazing, pressing relief designs into the surface, painting designs with minerals, using transfer decoration techniques, or even cutting up solidly colored tiles and then reassembling them to create a geometric design, a technique called *alicatado* that was pioneered in Islamic Iberia (fig. 2.16).[27]

## Textiles

Whereas realization in clay is largely a transformative technology in which the maker manipulates the mass of the material, most fiber uses a constructive technology dependent on the conceptual work of internalizing pattern and structure. However, there are some direct clothmaking techniques that do not require spinning to produce thread or mathematically based weaving to produce a length, similar to how pinching clay is a direct process that does not

Fig. 2.16. Tiles in the National Palace, Sintra, Portugal, sixteenth century; lead-glazed earthenware. The main wall tiles display the *alicatado* technique. Tiles in the spandrel above the door are fashioned in the *cuerda seca* manner, a technique in which the design is laid out in lines made of linseed oil and manganese oxide to demarcate different color glaze regions, while the tiles around the door and along the top of the wall tiles are examples of the *arista*, or molded, techniques.

require the external technology of a mold or wheel. Rather, warm moisture and friction bind a raw material to create a soft, durable textile. Barkcloth is one example (see fig. 1.12), but another is felt, which takes advantage of wool's barbed fiber structure (fig. 2.17). Loose cleaned wool is spread out, sprayed with warm water, and then subjected to pressure, either a mechanical press or rolled up in a cover and dragged behind a horse, to compact the fibers together into a material that can be cut, sewn together, or appliquéd.[28]

Threads could be looped or knotted to create netting, loose baskets, and what is called macramé (fig. 2.18). No special equipment is necessary for this type of knotting, which is undertaken by both women and men. In addition, knotting does not take place in specific locations but can be done almost anywhere. Incorporating knitting needles and frames permits the production of clothing such as sweaters, hats, stockings, and socks. The most complicated forms of knotting, lacemaking (fig. 2.19) and Chilkat twining (see fig. 1.13), use loops and knots with a number of threads, and as a result require some very specific equipment. The former relies on bobbins, a cushion, and pins to create small pieces used as accents for clothing, and the latter has a horizontal wooden frame from which stiff warps hang.[29]

Most multi-thread work is worked in a mathematical grid on a loom, in which fixed warp threads run from the weaver toward a stationary anchor and weft threads run perpendicularly across these warps. A loom is simply an apparatus that provides consistent tension for the warp threads. It can be a

Fig. 2.17. Carpet, Pazyryk culture, Siberia, fifth–fourth centuries BCE; felt fabric with appliquéd felt decoration. Pazyryk Barrow No. 5 (excavations by S. I. Rudenko, 1949). State Hermitage Museum, St. Petersburg, Inv. No. 1687–94.

Fig. 2.18. Bag, southeast Australia, 1839–49; looped plant fiber. British Museum, London, Oc1981,Q.1740.

Fig. 2.19. Border, Italy, 1630–40; bobbin lace. Metropolitan Museum of Art, New York, Rogers Fund, 1906, 06.556.

Chapter 2

temporary setup, such as a backstrap loom in which a harness around a sitting weaver's back permits tension adjustments to the warp threads, or a more fixed apparatus, such as a floor loom with a bench, cloth beam to wind the woven cloth onto, and heddles that pick up the warp threads. An alternative to the floor loom, found in South Asia, is a pit loom, in which weavers sit on the edge of an excavated cavity in the earth and place their feet on the treadles in the bottom of the pit. Weavers who use backstrap looms push or pull a shed rod to raise and lower warps and might use their fingers to count threads as they pass weft threads through the warps. They rely on the muscle memory of their hands. Floor loom and pit loom weavers use their hands only to pass the shuttle back and forth, relying upon their feet to operate the treadles that raise and lower the heddles to produce different woven structures. The real conceptual work is recognizing the connection between pattern and structure and setting up the heddles to deliver the proper warp sequences. When making basic cloth, setting up the loom may be the most time-consuming part; after this, weavers can often work quickly, sliding the shuttle back and forth with their hands and possibly using their feet to operate the treadles to create woven patterns. Floor looms, while a more fixed and complex apparatus, were able to produce great widths of cloth and often eased and sped up the work of weaving.[30]

Tapestry weaving, used for durable textiles like rugs, carpets, and wall hangings, incorporates the warp structure of floor loom weaving but uses knotting rather than continuous wefts. Making use of a vertically oriented loom with fixed warp threads, weavers pass different colored discontinuous weft threads on the warp to create geometric or figural images, interlocking the different colors as the composition is built up. Whereas weaving on a floor or backstrap loom moves in a consistent perpendicular fashion up the warp, weft-faced tapestry weaving often progresses in color fields. Related to tapestry-woven flat-weave carpets are knotted-pile carpets, a plusher textile in which the discontinuous weft threads are knotted individually on the warp.[31]

The decoration of textiles can occur in a variety of ways, including woven structure, dyeing, surface design, and additive processes. Most subtle might be the weaving structure on a floor loom. In plain weaving, the wefts pass alternatively over and under the warps. This provides a uniform base ideal for decorative techniques like painting and printing. By alternating this rhythm, having the weft go over three warps and then under three warps, weavers produce the sturdier twill weave, found in denim, serge, and many upholstery fabrics and recognizable by its diagonal pattern. The smoothest sort of woven structure, used often with silk, is a satin weave, which features long lengths of the warp threads floating over the weft behind. Such a woven pattern allows for smooth hanging, ideal for robes and dresses.[32]

Fig. 2.20. Jamdani stole, Dhaka, Bangladesh, ca. 1850; muslin with cotton supplementary weft in jamdani technique. Victoria and Albert Museum, London, 832–1852.

Dyeing threads or whole cloth is the most direct form of decoration, like glazing ceramics. The use of local natural materials is crucial to this decoration. For example, in South Asia, the chay root (or madder) produces deep reds (see fig. 1.16), whereas in South America, use of madder was gradually supplanted by cochineal, the dried and pulverized bodies of insects (see fig. 1.17), and in Southeast Asia, similar lac bugs provided the red. Dyeing can also be used with the structure of weaving to provide graphic interest. Using warps or wefts of differently colored threads results in plaid or striped patterns.[33]

Another way in which the weaving structure impacts the look of textiles is through supplementary weaving, in which weavers add additional weft threads to create complex patterns. These additional wefts can be continuous, as in most brocades, or they can be discontinuous, as in the chok weaving of northern Thailand and Laos or jamdani cottons of Bengal (fig. 2.20). Weavers execute this supplementary work as they create the cloth on the loom; it is not added when the cloth is off the loom, as is the case with embroidery.[34]

The principles of dyeing can also be applied to plain woven cloth. Dyers can use wax or mud to demarcate areas where they do not want the dye, such as the blue of indigo, to take hold (resist dyeing), or they can use ingredients like alum to help dyes like the red of madder adhere to the cloth (mordant dyeing). Putting cloth through various dye baths, getting the colors to take in certain areas but not others, is critical not only to Indonesian batik (fig. 2.21) but also to the painted cottons of the Coromandel Coast (see fig. 1.16). In those regions, designs are drawn onto the fabric freehand, but in Gujarat, resist and mordant work is central to block printing as well (fig. 2.22). Using carved wooden blocks, printers gather dyes or mordants on the block and then imprint that design on the cloth. Blocks used in sequence build up elaborate designs and borders. Block printing with natural dyes can take up to thirty

Fig. 2.21. Textile, Java, 1750s–1810; plain woven cotton painted with resist in batik style. British Museum, London, As1939,04.120.

Fig. 2.22. Textile fragment, Gujarat, India, first–fifth centuries CE; plain woven cotton with block-printed and mordant and resist dyed decoration. Victoria and Albert Museum, London, IS.73–1972.

Fig. 2.23. Textile fragment, Gujarat, second half of the tenth century–fifteenth century AD; plain woven cotton with tie-dyed decoration. Ashmolean Museum, Oxford, EA1990.391.

Fig. 2.24. Patolu, Gujarat, India, late eighteenth century; silk double ikat. Metropolitan Museum of Art, New York, purchase, Friends of Asian Arts Gifts, 2012, 2012.164.

different steps of treating, printing, washing, and setting the cloth. The quality of the natural dye stuffs like madder, the availability of mineral-rich water and strong sunlight, and the deep craft knowledge in South Asia makes cloth from that region a valued commodity for trade and exchange. Because dyeing required a great deal of water for rinsing and setting and allowed no other use of the water (for drinking or irrigation), dyeing took place during the monsoon season when water was plentiful. The particular dyed qualities of South Asian cloth—strong, fast colors, and varied tones and shades—made it highly prized in the vibrant economy of the Indian Ocean from the tenth through the eighteenth centuries.[35]

Tying and dyeing provides another way to develop graphic imagery. Bunching plain woven fabric and knotting it to prevent the dye from adhering is a simple way to decorate cloth (fig. 2.23). A more complex and time-consuming form of tying and dyeing is the ikat technique, in which weavers tie off and then resist and mordant dye long lengths of warp or weft threads, preplanning the desired woven pattern and using multiple steps in dyeing to color the sections of thread appropriately. For the most complex double ikat in Gujarat, both warp and weft are dyed prior to weaving. Weavers then align

Fig. 2.25. Textile fragment, "Les travaux de la manufacture" pattern, designed by Jean-Baptiste Huet, made at the Oberkampf Manufactory, France, 1783; linen with copperplate-printed decoration. Metropolitan Museum of Art, New York, Rogers Fund, 1926 and 1927, 26.233.8 and 27.44.3.

the multicolored threads on the loom, adjusting the weft to line up with the warp pattern (fig. 2.24). Using silk and very dense patterns weavers can take several years to dye and weave a long luxury patolu, but they can also offer a less expensive shorter version in cotton, with larger and more spaced-out patterns and a looser weave.[36]

While South and Southeastern Asian textiles of the early modern period manifested the considerable skills of the dyer, block printer, and painter, European textiles in the period could not compete with the concentration of cotton cloth production and skilled decoration. Instead, they focused on the reproducible designs achieved through print technology. Just as British potters developed transfer decoration, British and French textile firms, who had used wooden blocks for printing on fabric, turned to engraved copper plates and then copper rollers to deposit ink in a consistent and reproducible fashion on

Fig. 2.26. Kantha, made by Srimati Manadasundari Dasi, Bengal, India, ca. 1850; silk embroidery on cotton ground. Gurusaday Museum, Kolkata, India.

plain woven cloth (fig. 2.25). As in ceramics, the manufacturers invested in engraving costs rather than hiring individual painters, reduced the number of steps required to decorate the finished product, and printed long yardages with the same decorative motifs. This permitted the upholsterer to use the same fabric for all furniture and wall surfaces in a room. The textile firms did not want to depend on variable skills, and they valued broad markets over flexible production.[37]

Another type of decoration that takes place off or after the loom can be considered additive. The most common type of additive textile decoration is needlework embroidery, which uses fine thread and a series of stitches and knots to add pictures or designs to a plain ground (fig. 2.26). This can be slow work and is often undertaken by women, both elite women with the benefit of leisure time who display their virtuosity in this way and single women who need employment and develop efficient skill in repetitive stitches or variations on the same motif. As demonstrated by the Fifield hangings discussed in the introduction, genteel needleworkers tended to display a pleasurable variety of stitches in their work, while Gujarati embroiderers catering to a European market simplified their repertoire of stitches to make sure the final product could be sold. In South Asia, male embroiderers specialize in metallic embroidery using gold and silver-wrapped thread. Other forms of additive decoration can be found in quilting, usually the domain of women who work in their homes and use either new fabric if they can afford it and have access to it or worn bits of clothing that are given a second life. A quilter can either stitch textile swatches onto a plain ground to create geometric or figurative designs, in a technique called appliqué (fig. 2.27), or sew together pieces of fabric into a composite covering cloth, a technique referred to as patchwork (fig. 2.28). The resulting product, a quilt, consists of several layers of cloth, the thickness and insulating qualities of which imparted warmth.[38]

## Base Metals

Realization of metals is largely a transformative one, much like ceramics. Central to working with metal is the moving and shaping of the material in liquid or hard form. Lacking the plasticity of clay before firing, metal is less forgiving. It therefore requires considerable cognitive abstraction to envision three-dimensional forms from the sheet of metal or to conceptualize how a cast object might emerge from the transformation of an idea from the positive to the negative mold and then back to the positive. In the era before scientific understanding of metallurgy, success of metalworking depended on makers' sensory engagement with their material, particularly its color, behavior, and quality, all judged by cumulative experience.[39]

Fig. 2.27. Quilt, possibly made by Elizabeth Connelly Middleton, Virginia, ca. 1850; appliquéd silk fabric pieces on a silk background and quilted. Museum of Fine Arts, Boston, gift of Mrs. Rufus F. Hale, 1985.389.

Fig. 2.28. Quilt, American, 1857; pieced and quilted English printed cottons. Museum of Fine Arts, Boston, gift of Dr. Herbert Harris, 1986.403.

The extraction of base metals from ores through a process of heat in a bloomery or blast furnace or the necessity of making alloys in molten form makes casting with liquid metals the most straightforward of fabrication techniques. Artisans can simply draw off molten metal and puddle cast a straightforward single-sided relief object in a sand cask right next to the furnace. For more three-dimensional work, metalworkers make molds. In Chinese bronze casting, metalworkers used single-use ceramic pieces consisting of a core and surrounding components with designs on the inside surfaces. A second casting technique is sand casting, in which the artisan uses a two-part mold, the halves referred to as the "cope" and "drag," into which a pattern is pressed and casting channels are articulated (see fig. 1.22). Ceramic molds and sand casting often link metalworkers to other artisans who helped supply molds and patterns. In ancient China, bronzeworkers teamed up with ceramic artisans who made the parts of intricate molds (see fig. 1.21). In Europe, braziers working in brass and bronze often collaborated with wood carvers and turners, who provided patterns to press into the casting sand of the furnace floor or the flasks.[40]

A third casting technique used in Europe and North America involves the use of durable bronze or iron molds, made up either of two parts to produce simple forms like plates and dishes, or complex multiple-part molds for vessels such as tankards, mugs, teapots, and pitchers. The latter requires a core that fits neatly within the exterior walls of the mold and allows a thin void into which the molten metal flows, as well as separate two-part molds to make spouts and handles. Using metal molds for casting requires significant investment in the purchase or making of molds; it is not a coincidence that many pewterers, who used metal molds, accepted brass, copper, bronze, and pewter as credit and were also described as braziers who worked in copper alloys (see fig. 1.23).[41]

In South Asia, some metalworkers use a pattern molding process in which moldmakers do not invest in expensive permanent metal molds. Instead they use local fine clay, mixed with some rice bran and cow dung to create molds of a metal, wood, or ceramic model and then make a clay core just slightly smaller than the interior of the model. They attach a crucible of clay, bran, and cow dung, filled with cut up scrap metal or cullet, to the open end of the mold, heat the mold-cum-crucible with the crucible end-down in a furnace, and, when the metal is molten, rotate the piece, allowing the molten alloy to flow easily into the empty space between the core and the exterior. Digging clay and mold- and crucible-making are often the tasks of women who do much of the shaping as outwork in their own homes. The rhythms of work also allow many metalworkers to still engage in agriculture: they can work at their own pace depending on the accumulation of raw materials and molding clay and crucibles, make efficient use of the furnace, and balance the human

resources and materials necessary for the separate tasks of mold making, casting, and finishing.[42]

A fourth casting technique, the lost wax technique, was widely used in South Asia, Africa, and South America, where metalworkers relied on the clay mold-cum-crucible technique (see fig. 1.20). Artisans wrap a ceramic core with wax, model the wax to the desired form, and then encase it in layers of clay, allowing for a drainage channel. After drying the clay, they heat up the mold and allow the liquid wax to flow out. They can then pour molten metal into the mold or add an integrated crucible. For the latter, they affix more clay to the mold opening, shape it into a bowl, add scrap metal to the bowl, and cover the bowl of metal with more clay, creating an integral crucible that restricts oxygen and conserves the spiritual essence of the material. With the crucible on the bottom of the mold, they heat up the unit and then turn it over, allowing the molten metal to flow into the space vacated by the melted wax. After cooling, they crack open the mold and burn out the core. The oxygen reduction of this technique results in yellower copper alloys, but it depends less on reusable permanent molds and more on the skill of the casters to make new molds from readily available materials.[43]

Among the metals most commonly worked through puddle casting, sand or metal mold casting, or lost wax casting are bronze, brass, bell metal, pewter, zinc alloys, and paktong. Casting allows relief work to be integral to fabrication, but finishing often requires some additional cold work such as filing, brushing, scraping, chasing, chiseling, or patinating with chemicals. Copper, brass, and bell metal can be cast but are often worked from sheets, especially copper. Craftsmen use hammers and anvils to flatten copper or copper alloy ingots into sheets, which can then be shaped and seamed or raised by hammering. Artisans can form their work by wrapping, folding, or hammering the sheet, cutting little dovetails along the edge, and brazing the seam with a lower-melting metal like tin and rely on the capillary action of the liquid metal to secure the edges of the copper. Spouts and bottoms made the same way are brazed to the body (see fig. 1.19). Another option is to hammer the sheet up into shape by raising it over a steel stake. Whether seamed or wrought, copper tends to be ideal for lighter-weight vessels and was the preferred substrate for silver plate in the eighteenth and early nineteenth centuries; raised brass and bell metal offer more heft and tend to be reserved for special use in the home. Toward the end of the eighteenth century, rolled sheet copper became more available in Europe and North America and is the product used by most metalworkers today, since it saves a laborious preliminary step in fabrication.[44]

The advent of sheet copper of a consistent gauge also led to a third technique in the early nineteenth century: spinning on a lathe. The metalsmith secures a shaped wooden chuck or mold on the headstock of the lathe, places

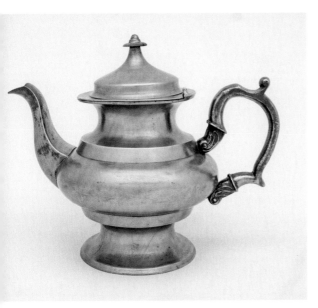

Fig. 2.29. Teapot, Hall, Boardman & Co., Philadelphia, Pennsylvania, 1846–48; pewter, wood, and Britannia metal. Courtesy of Winterthur Museum, Winterthur, DE, bequest of Henry Francis du Pont, 1964.1154.

a sheet of copper against it and secures it by tightening the tailstock against the sheet, and then uses a long steel tool levered against a fulcrum set into the tool rest to press the sheet against the mold. Spinning was also used in the production of high-tin-content pewter beginning in the early nineteenth century (fig. 2.29). As with bronze molds, the use of wooden chucks for copper and pewter vessels requires an initial investment in the pattern but then allows for consistent batch production that takes far less time than raising with hammer and stake.[45]

Copper and its alloys can be decorated in a variety of ways. Engraving, that is, cutting into the metal with a sharp-pointed tool called a burin, is possible for all of this group. Engravers use copper plates because its softness allows for the incising of a great variety of lines. Harder brass permits a stronger line for initials, heraldic crests, and inscriptions.[46] For objects formed through hammering and spinning, the simplest decorative option is to planish, or hammer, surfaces to provide a glimmering surface. Chased work, in which the maker fills the vessel with pitch or wax and then uses a light chasing hammer and small steel tools to emboss a design on the surface without affecting the integrity of the form (moving the metal rather than cutting into it), provides more complex patterns or figural decoration (see fig. 0.7). To accentuate the relief of a surface, artisans can use repoussé chasing, in which they first use a snarling iron and hammer to push the metal out from inside the vessel and then define this protrusion with chasing techniques.[47] For more regulated forms of deep chasing or repoussé chasing, metalsmiths can use steel swages, in which they

Realization

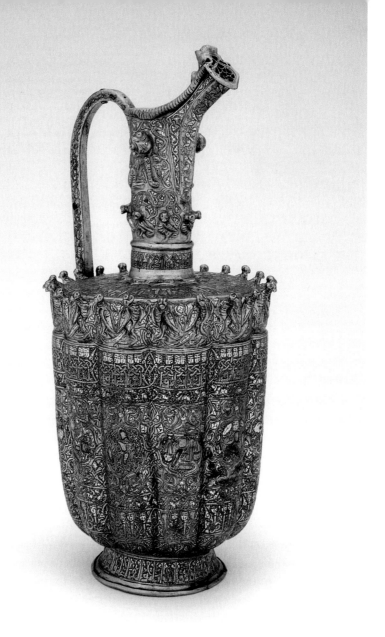

Fig. 2.30. Ewer, Herat, Afghanistan, 1180–1200; raised, chased, and repoussé-chased copper alloy with copper, silver, and gold inlay. British Museum, London, 1848,0805.2.

lay out a sheet of metal and then hammer it to take on the motif of the swage. The expense of cutting the swage makes this less common in base metals than in silver, but the development of drop stamping in the late eighteenth century permitted a wider application of this technique, seen most clearly on brass furniture escutcheons and pulls.[48]

Inlaying precious metals such as silver or gold into base metals is another region-specific form of decoration. Damascene work, in which gold or silver wire is set into undercut grooves, achieved through engraving or chasing, was common in ancient China and Egypt, and became popular in the Islamic world from Iberia and North Africa to India. Islamic inlay techniques not only use wire set into grooves, but also flat sheets set into recessed panels for larger expanses such as faces and bodies. In South Asia, bidri artisans use sand casting to form the body and then darken the surface with a water-soluble copper solution, which blackens the metal. The craftsperson lays out the pattern and cuts thin channels into which silver wire or silver sheet is hammered. Once the inlay is completed, the surface is covered with an ammonium chloride paste, which darkens the zinc permanently without affecting the silver (see fig. 1.24). Across Central Asia, from Herat in the twelfth century to Damascus and Cairo in the fifteenth century, metalsmiths raised or cast copper alloy vessels, then chased the surface and inlaid silver, gold, copper, or niello into the cavities (fig. 2.30). While these Islamic metals often featured inlaid dedications, names of makers or patrons, and zodiac and chivalrous scenes, such decorative convention on base metals was less common elsewhere.[49]

A final form of decoration on copper and copper alloys is enameling with colored glass. Since antiquity, the Near East had been a center of cloisonné, the shaping of metallic wires into a design that was soldered to a gold ground, filled with powdered enamel, and fired. Mainly used for jewelry and small devotional objects, cloisonné was usually applied to gold. Copper became a common ground for another enamel technique, champlevé, in which the design was chiseled or chased into the metal and then the embossed depressions filled with enamel powder. This technique was common in western Europe in the eleventh and twelfth centuries, but still tended to decorate smaller ritual objects. The Chinese embraced cloisonné in the fourteenth century, initially decorating the surfaces of heavy bronze and brass objects, but by the seventeenth century shifted to copper bodies, covering the surfaces of large bowls and vases. They also developed a technique of painting enamels mixed with a gum binder directly onto copper bodies. The Chinese imperial workshops produced this enamelware, but so did artisans in Guangzhou. Like the enamelers who painted colored glass paste on porcelain, they could customize work for a variety of markets (see fig. 6.3).[50]

## Wood

Realization in wood combines a subtractive practice as well as a constructive one. While metal may be rigid and unforgiving, wood is not a stable material, and thus the artisan has to work with it rather than on it. The stages of

realization with wood can be divided into three steps: preparation of stock (which is subtractive), construction, and decoration. Often these stages are connected to one another—a certain type of preparation leads naturally to certain types of construction—and they often overlap—decoration can be dictated by construction. Selection of the appropriate approaches depends on labor systems, market niche, and social intent.

The simplest form of transforming trees into boards is through riving, splitting a log lengthwise and then dimensioning it according to use. It is quick and easy, but squaring up the pie-shaped pieces results in a fair amount of material loss. Because unseasoned wood can be split and worked very easily, riven wood is central to the idea of what is now referred to as "green wood-working." Woodworkers smooth and shape moist wood on site or nearby with adzes, axes, wedges, knives, shaving benches, and pole lathes, all of which are portable. While the work can be excellent, the emphasis is squarely on efficiency over precision.[51] Locally sourced wood more easily retains a "workable moisture content," which makes shaping, bending, and joining the wood easier. It is particularly common for turning. Edge tools smoothly flow through the green wood, making work easier and not dulling the cutting edge as quickly.[52]

Another system of preparation depends on sawn boards, the product of pit sawing or water-powered frame saws. Easier to move than large trunks, these boards are then transported to local shops or to distant markets. Furnituremakers thus have access to rough dimensioned boards, which they can resaw to the exact thickness and length needed. Availability of sawn boards permits consistent quality, eliminates some of the physically demanding preparatory work, and allows the artisan to focus on precision and to work to tighter tolerances.[53]

Whether the stock is riven or sawn, woodworkers use edge tools to further refine the dimensioned timber. For straightforward green woodworking, artisans use the same tools that were carried to the outdoor worksite for cutting the trees. Craftspeople who acquire sawn boards tend to work in a dedicated shop and use a specific sequence of bench planes, from scrub planes to jointer planes, to surface the boards to proper dimensions and smoothness. The reliance on an integrated system of planes, chisels, and gouges means that their tool kit is more expansive and each tool has specific uses. Theirs is a more extensive system, whereas green woodworking tends to involve more intensive use of a smaller number of tools.[54]

Once dimensioned and surfaced stock is in hand, makers can fabricate items in a number of ways. The simplest technique is hewing a form from a solid of piece of wood. The material's live qualities—it continues to expand and contract slightly as it takes on or discharges moisture in its environment—means that solid forms often crack. Smaller objects or objects with significant

Fig. 2.31. Headrest, Zimbabwe, Shona culture, ca. 1900; carved solid wood. Yale University Art Gallery, New Haven, CT, gift of Mr. and Mrs. James M. Osborn for the Linton Collection of African Art, 1964.76.28.

carving and less mass, where internal tensions are minimized, have tended to survive best; hewn chests or chairs have not fared as well (fig. 2.31). Woodworkers can also butt riven or sawn boards and fasten them together with glue, wooden plugs, iron nails, or metal straps. This technique works best for chests and storage furniture, where there are long fastened seams that provide stability; chairs tend to be more problematic because there is considerable pressure on each of the many smaller joints.[55]

For chairs, chests, and more substantial furniture, woodworkers often turned to mortise and tenon joints and paneled construction, often referred to as joined work (fig. 2.32). Primarily a rectilinear system, the woodworker lays out and cuts a protruding tenon at the end of one framing element and a matching mortise cavity into which the tenon fits on another part. Secured with wooden pins, wedges, or glue, such a joint can also be used on its own or to construct a frame around a floating panel set into groves along the inside edges of that frame. This panel construction is used for green woodworking as well as for objects less reliant on moist wood.[56] Another means of fastening boards through layout and the cutting of interlocking elements with saw and chisel work is finger joints or dovetailing. For this technique, which often results in tighter tolerances, the grain of the two joined boards must be oriented in the same direction (fig. 2.33). Both finger joints and dovetails make strong joints, but the latter have angled pins and tails that make them ideal where the joint is under stress from pulling, such as where drawer sides connect to drawer fronts.[57]

While mortise and tenon and finger joints are best used on wooden objects with straight lines, woodworkers often want to make curved forms or incorporate curved elements. The internal structure of wood does not allow tight radius shaping, what is referred to as short grain wood, so artisans have

Realization

Fig. 2.32. Chest, attributed to Thomas Dennis, Ipswich, Massachusetts, 1670–1700; riven joined oak carcass with mill-sawn white pine lid; carved and painted surface. Museum of Fine Arts, Boston, gift of John Templeman Coolidge, 29.1015.

Fig. 2.33. Chest, Azores, sixteenth century; dovetailed cedarwood carcass with black mastic inlay and wrought iron hardware. Museu Nacional de Arte Antiga, Lisbon, Portugal, 1516 Mov.

Fig. 2.34. Bentwood chest, Haida culture, British Columbia, second half of nineteenth century; steamed kerf bent carcass with carved and painted decoration. Courtesy of UBC Museum of Anthropology, Vancouver, Canada, A7103 a-b.

developed other ways to work with the material. By packing thin wooden elements with some water within a watertight case and heating the contents, they can steam bend timbers with strong continuous fibers; the combination of heat and moisture permits bending or folding. The kerf bent box of the American Northwest offers a good example of this technology. Along a single cedar board, the maker scribes and cuts a groove, referred to as a kerf, for each inside corner, leaving a small amount of continuous fiber to ensure the structural integrity of the board. After steaming the board in moist heat, the artisan folds the board into a neat rectangle and sets it on a solid base (fig. 2.34). For elliptical shapes a woodworker can also make a series of saw cuts almost through the entire thickness of a board and then flex the board against the voids of the saw kerf. These techniques impart greater strength than simply cutting such shapes out of a solid and are not as wasteful of the wood.[58] The lathe—whether on the ground or on a frame and whether driven by a bow, wrapped cord, spring pole treadle, cranked wheel, or water power—provides a means to prepare, surface, and decorate stock, and even cut tenons. It is a true multiuse tool and is an important part of many woodworking shops.[59]

Wood shares similar broad decorative possibilities with ceramics: surface treatment, modeling, and graphic and pictorial embellishment. Like burnishing or simple protective glazes on earthenware, a variety of uniform protective

Fig. 2.35. Chest with two drawers, Shaftsbury, Vermont, ca. 1815; nailed and dovetailed eastern white pine with grained decoration to simulate figured wood. Shelburne Museum, Shelburne, VT, 1959–281.

coatings can be found on wood, ranging from wax to penetrating oils made with resinous spirits to shellac. The last, developed in South and Southeast Asia, is a sealing liquid made from pulverized secretions of the lac bug that have been dissolved in denatured alcohol.[60]

Stains and painted finishes, like tin-glazing, offer the opportunity to transform the wood into something else. Mixing lamp black, Spanish brown, and reddish pigments into oil varnishes or shellacs permits the mahoganizing or ebonizing of plain local woods like maple, fir, or cypress (fig. 2.35). Wood also offers an additional substrate for painters, not just in the form of panel painting. Italian Renaissance artists painted marriage cassones (large chests), drawing on themes of romance and heroism, but also borrowing motifs from imported textiles (fig. 2.36). Dutch painters explored the depths of the gray palette and illusion in a technique referred to as "grisaille." The carcass for these painted examples tended to consist of local woods assembled in a fairly straightforward, expedient manner (fig. 2.37).[61]

Fig. 2.36. Cassone with painted front panel depicting the conquest of Trebizond, attributed to the workshops of Apollonio di Giovanni di Tomaso and Marco del Buono Giamberti, Florence, Italy, ca. 1460s; pegged and nailed poplar carcass with polychromed and gilded gesso and panel painted with tempera and gold. Metropolitan Museum of Art, New York, John Stewart Kennedy Fund, 1914, 14.39.

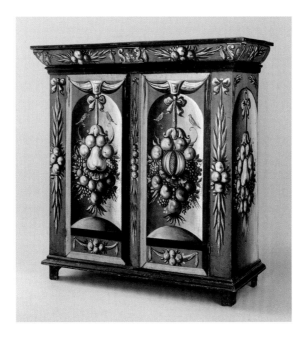

Fig. 2.37. Kast, New York, 1690–1720; joined and nailed yellow poplar, red oak, and white pine with painted decoration. Metropolitan Museum of Art, New York, Rogers Fund, 1909, 09.175.

Fig. 2.38. Writing cabinet, Nagasaki, Japan, late sixteenth century; hinoki cypress, black urushi lacquer, gold maki-e lacquer, raden (mother-of-pearl overlay), copper mounts. Metropolitan Museum of Art, New York, purchase, Harris Brisbane Dick Fund and Mary Griggs Burke gift, 1989, 1989.17a–l.

Fig. 2.39. High chest of drawers, japanned by Robert Davis, Boston, Massachusetts, 1735–39; dovetailed, joined, and nailed maple and white pine with japanned decoration. Private collection.

A more complex surface treatment with local variations is the creation of shiny surface with lacquer or varnish.[62] True lacquer comes from the sap of the urushi tree and is specific to what is now Japan, China, and Korea. Upon simply constructed forms, often turned or butted and pinned, lacquerers build up layers of polish, sometimes setting in thin pieces of mother-of-pearl. Chinese lacquerers combined lacquer and mother-of-pearl as early as the eleventh or tenth century BCE, and Chinese and Korean mother-of-pearl and black lacquer became particularly refined in the tenth and eleventh centuries. Japanese lacquerers in the twelfth century began to work with a gold rather than uniform black surface, sprinkling metal powders on the lacquer in a technique called maki-e (fig. 2.38). In China, lacquerers mixed in cinnabar and other colorants and then often carved through the layers of lacquer to create relief work (see fig. 2.2).[63]

In northern Europe and the British colonies in America, ornamental painters did not have access to true lacquer, but they developed a more opaque varnish version with oils and resins that they referred to as "japanning," a generic term used to describe all lacquerwork from East and South Asia (fig. 2.39).[64]

Fig. 2.40. Portable writing desk, Pasto, Colombia, 1684; *barniz de Pasto* lacquer on wood with silver leaf. Courtesy of Hispanic Society of America, New York, LS2000.

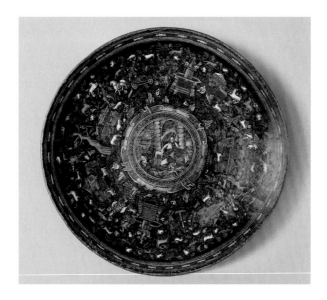

Fig. 2.41. Batea (tray), Peribán, Michoacán, Mexico, ca. 1650; Mexican lacquer on wood. Courtesy of Hispanic Society of America, New York, LS1808.

Fig. 2.42. Chest with drawers, Chester County, Pennsylvania, 1741; dovetailed, joined, and nailed black walnut carcass, chestnut and yellow poplar secondary woods, holly and sumac inlay. Courtesy of Winterthur Museum, Winterthur, DE, bequest of Henry Francis du Pont, 1957.1108.

In the Spanish American colonies, local Indigenous techniques were closer to Asian lacquers. In the Viceroyalty of Peru, the resin of the mopa mopa tree, often blended with mineral pigments to create an opaque colorant, provided a protective coat, referred to as *barniz de Pasto* (varnish of Pasto, a town in present-day Colombia), that is very similar to true lacquer (fig. 2.40), while in New Spain, the combination of insect secretions and oils from the chia seed led to another type of lacquer finish, often referred to as Mexican varnish (fig. 2.41).[65]

The main techniques for modeling wood are subtractive and involve removing mass: molding, turning, and carving. Molding involves the use of planes with shaped irons set within a stock that feature the same profile. The woodworker runs a molding plane, usually with the grain, to achieve a pre-determined molding profile, often along the edge. Typical profiles include quarter and half rounds, coves of various radii, cymas, and astragals. Combining a series of molding planes permits more complex moldings, but running moldings remains a form of regulated work.[66] Turning on a lathe also provides some visual impact to a piece of wood. A lathe, which some people refer to as a power carving tool, is unusual for its ability to combine several steps in the realization process: it helps to prepare split or sawn wood, cuts tenons, and fashions decorative features such as columns, balls, reels, urns, and balusters (see fig. 1.27). A turner often uses marking sticks to lay out the work but then relies on practiced habit and rhythm to make pieces consistently and efficiently. Whether low relief outline detailing or fully undercut naturalistic high relief, carving is the most time-consuming and skill-dependent modeling technique. Training and practice break down the steps of carving to a series of logical successive maneuvers. It is important to know how to remove wood without splitting it and what particular gouge will produce the desired lines and details.[67]

Fig. 2.43. Collector's cabinet, Netherlands, 1675–85; dovetailed, joined and nailed oak carcass with olivewood and rosewood veneer, turned walnut legs. Rijksmuseum, Amsterdam, BK-NM-5671.

While paint and lacquer can produce graphic imagery, two other techniques of graphically oriented surface decoration are inlay and veneer. The former involves cutting channels into the primary wood and laying a contrasting wood or other material into the groove, much as silver was inlaid into copper alloy objects (fig. 2.42), while the latter consists of thin pieces of wood or other natural materials laid over a substrate, much like lacquerwork. Inlaying provides a way to personalize objects, demarcate areas, or break up surfaces. Inlaying strings of copper, pewter, or brass wire is another way to provide graphic design on wood. In South Asia, woodworkers worked with larger bits of inlay, setting in pieces of engraved ivory to produce floral compositions (see fig. 5.5).[68]

Veneering in its most basic form consists of thinly sawn pieces of wood, often prized for their figure such as burls or tropical woods, glued onto a secondary wood (fig. 2.43). The availability of ivory in South Asia also led to the use of thinly sawn ivory, which was pinned onto a wooden structure with ivory pins (fig. 2.44). The most complicated sort of veneering is marquetry, in which a craftsperson uses a fine saw to cut out veneers of several different types of wood to compose a pictorial image which is then transferred and glued to the substrate (fig. 2.45). In Japanese Nanban lacquerwork, raden, what is often referred to as mother-of-pearl inlay, is actually closer in technique to

Fig. 2.44. Drop-front secretary, Vizagapatam, India, ca. 1780; dovetailed and nailed sandalwood veneered with ivory panels incised and filled with black lac; silver and brass pulls. Virginia Museum of Fine Arts, Richmond, Adolph D. and Wilkins C. Williams Fund, 2001.231a-b.

marquetry: the shell is not set into recesses in the wood substrate. Instead the lacquerer begins with a carcass of plain wood and then uses lacquer and thin pieces of shell-like veneers. The shell is set up on top of the carcass without cutting into it and the lacquer built up around it (see fig. 2.38).[69]

## Conclusion

Awareness of the sources of materials and their properties and command of the processes involved in transforming these materials enables us to understand objects on their own terms. Not projecting our own aesthetic or cultural values on an object or trying to plug an object into an existing hierarchical or Eurocentric model, we must begin with the artifactual evidence. Local and

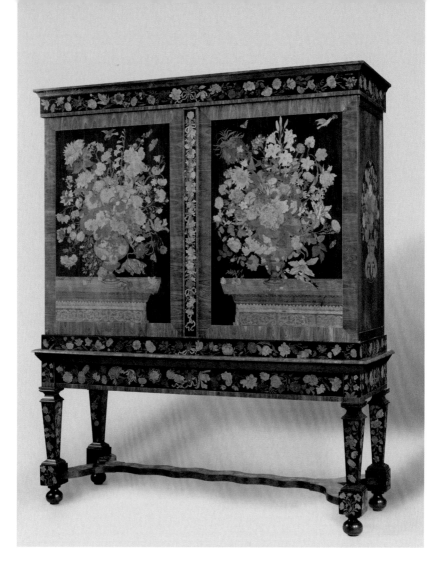

Fig. 2.45. Cabinet, attributed to Jan van Mekeren, Amsterdam, 1695–1710; dovetailed, joined and nailed oak veneered with kingwood, ebony, rosewood, olive wood, holly, boxwood, barberry, and sycamore. Rijksmuseum, Amsterdam, BK-1964-12.

tacit knowledge is experienced and felt rather than written about, so it is essential to understand the connection between ideas, materials, and processes. The preindustrial maker relied on deep embodied knowledge to be successful. Potters had to feel the way the platelike structures of clay aligned themselves and recognize the color or even sound of pots in the kiln to achieve the work they wanted; dyers drew on empirical knowledge about combinations of local mordants and dyes and the properties of various water sources; weavers had the geometry of patterned cloth in their heads and translated it to their hands or the heddles; metalsmiths had to differentiate between different ores and alloys

based on their experiences; and woodworkers had to recognize whether grain was running downhill or uphill when using an edge tool. Margaret Graves, an art historian who focuses on Islamic movable objects, has elaborated on the concept of the "intellect of the hand," emphasizing the inextricable connection between cognition, manual skill, and sensory faculties. Making is not the imposition of human will onto an inert material. Rather, Graves explains, an object was formed "through responsive processes of making and thinking that reacted to and were stimulated by the materials and techniques in hand, as well as preexisting and medium specific forms and motifs."[70] Making things depends on constant attention to the transmission of ideas from brain to hand and from tool to material, with feedback channeled back through the tool to the body and mind of the maker.

During the late seventeenth and eighteenth centuries, many European gentlemen engaged with an "arts et métiers" genre of literature, which compiled information about various trades. To understand the tools, steps, and flow of work—what apprentice agreements referred to as "the art, trade, and mystery" of a particular craft—these texts broke down a process into its constituent elements and then abstracted them, denying their very tangible interconnected nature. Even pictorial depictions of the inside of a shop presented stages of work in a frozen, isolated, and sanitized manner. In this way, a gentleman might convince himself that he could fully comprehend and analyze the mechanical arts. One example is the taxonomical project of laying out the tools of a specific craft in an organized, flat graphic composition. These diagrams were linked to other Enlightenment natural history illustrations: a means of gaining, displaying, and contributing to knowledge.[71] In the minds of these gentlemen, visualizing the individual tool was equated with understanding the trade. Of course, this left out the real, subtle linkages among tools, the rationale behind certain preferred techniques or tools, how work was divided within the shop, and the amount of time required. Much like watching how-to videos today, it would have been impossible to have learned a craft simply by reading Denis Diderot's *Encyclopédie* or Joseph Moxon's *Mechanick Exercises or The Doctrine of Handy-Works*, a late-seventeenth-century serial publication by one of England's prominent natural philosophers, a member of the Royal Society.[72]

A more integrated approach to realization, which links mind, body, tool, and material, is a critical first step before we can begin to explore the social lives of the finished object. Given the shortcomings of written evidence about making quotidian objects, we begin on the inside of a work of art before moving on to the exterior, privileging intent and resourcefulness before thinking about circulation and use. As we follow objects around the world, we need to be attentive to how ideas, technologies, and reception to materials and techniques might alter practices along those routes.

II. MOVEMENT

# Chapter 3 Circulation and Interchange

While realization is locally based and often leads to regional aesthetics, its social basis does not necessarily restrict the performance of the artisan and lead to discrete pockets of stagnancy or isolated islands of tradition. Rather, it offers open-ended possibilities. To understand the dynamism of realization, one needs to step outside the shop and consider objects as they moved out into the world of sale, trade, and use. The circulation of finished objects and their ability to transmit ideas, the mobility of craftspeople and their skills, and the opportunities for easy artisanal adaptation during a period of low technology endowed the material world with a certain fluid vitality born of interchange. Essential to understanding the movement of objects is to view them neither as gross aggregate or abstract commodities nor in a ranking of stylistic influence. Rather, objects are complex assemblages of ideas, materials, and performances that traveled in various directions often at varied speeds, from centers to peripheries, from the edge of empire back to the metropole, and between various locales in between. This was the world of material interchange, one that crossed cultural and political borders and possessed its own sense of temporality.

There are limits to the assumption implicit within the term "exchange" that objects moved from one point to another in a linear fashion or the simplistic notion of "export ware." What is the distinction between an object made for export and one simply exported? Who determines the originating point of

an object type? Carried over sea or over land, objects did not follow strict itin-eraries but rather moved in unexpected or unanticipated ways as they passed through the hands of users and traders. Scholars have talked about the Chinese export trade as if the merchants of Guangzhou were offering distinctive, purely Chinese objects to a global market. But Chinese blue-and-white porcelain, sil-ver, and reverse painting on glass all had roots elsewhere in the world and were inherently hybrid objects that the Chinese adapted, developed, and promoted.[1] Why don't we have a category of Staffordshire export ware or Flemish export tapestry? The term "export" possesses associations with imperial perspectives or racist attitudes. The Chinese used the term pejoratively, to describe a class of their own production items distinct from their more sophisticated work made for the Chinese market. Theirs was an inward-focused sense of superiority. For Europeans, "export" implied origin in another inferior culture, an outward-focused sense of superiority that linked export with the exotic. The preferred term of interchange allows agency to occur on several levels—object, maker, customer, and place—and in various strengths or concentrations. Interchange impacted technologies and fashion in new surroundings, often in subtle or unanticipated ways. In short, interchange provides a structure that explores the true social lives of objects in the fullest sense, giving them material agency that participated with human agency.[2]

Traditionally scholars have been more comfortable following examples of language slippage across cultures to argue for interchange. Textile specialists cite how the English used the word "chintz," a corruption of the Hindi word *chint*, which means "spotted" or "variegated," to refer to all painted and printed cottons from South Asia. The Anglo merchants must have heard Indigenous people using the adjective to describe the tonal variations on painted cottons and adapted it to a noun that included all categories of dyed cotton.[3] In the Viceroyalty of New Spain, access to East Asian goods through the Manila gal-leon trade across the Pacific Ocean introduced Japanese objects and terms that were then Hispanicized. Japanese *byobu*, folding screens made of paper stretched over a light wooden frame and decorated with ink, color, and gold leaf, were common exports from Manila and impacted local production in the Americas. Makers there blended Japanese and European elements to make screens of canvas stretched on a wooden frame decorated with oil pigments and gold leaf with imagery drawn from European visual culture. These Spanish screens in New Spain were referred to as *biombos*. Coffers and chests lacquered with gold and silver powders, a decorative technique referred to as *maki-e* in Japan, provided the language the Spanish used to describe a local West Mexican lacquer technique that used aje oils (insect secretions) and chia oils to seal and decorate a wooden form. This tradition became known as *maque*, rather than the term *barniz*, translated as "varnish," which was commonly

used to describe Indigenous lacquer traditions in the Viceroyalty of Peru (see figs. 2.40, 2.41).[4]

While the language of interchange is suggestive, we need to dig deeper and consider objects as key nonverbal evidence of movement. In framing the discussion of historical trade, scholars have tended to focus on raw data to chart the linear shipment of aggregate goods from one place to another or to follow the trail of raw materials within an imperialist mercantilist system. In the former framework, it is assumed that there was a rational symmetrical relationship, that a good was marketed and sold or exchanged with a specific return expected. There is little accounting for opportunistic, unpredicted transactions that ship captains or merchants might have undertaken during their lengthy voyages or caravan trips or that arose from third-party exchanges where a maker might have offered an object to settle a debt. For the latter framework, the colonizer extracted raw materials from the colony, shipped it back to the metropole, where objects were made from those resources, and then exported the finished goods back to the colonies. If scholars seek to flesh out the artifactual dimensions of trade, they tend to rely on the hyperbolic object, an item from a distant culture that is often elevated with the addition of gold or silver mounts or other precious materials as it becomes part of a royal or papal collection or a gentleman's cabinet of curiosities.

However, close analysis of a wider variety of finished quotidian objects can reveal more complex insights into cultural interchange during the preindustrial era, when objects possessed exchange value, use value, and social value, sometimes all at once. The history of material culture in a global perspective becomes one of increasing and overlapping spheres that extends back centuries, well before the age of European exploration and colonialism, and it is therefore crucial not to be beholden to a Eurocentric perspective. There are numerous examples in which interregional trade evolved into intraregional exchange, characterized by expanding transcultural webs and networks as well as initiative or control from either end of exchanges. During the early modern era, regional carrying trade became inextricably connected to long haul trade routes. To get a better grasp of these overlapping networks it is helpful to identify some of the major trading routes over time, paying attention to the movement of people and objects, before zeroing in on the impact of mobile artisans and their habits of workmanship or how a reliance on regulating tools like molds or templates affected the transmission of material intelligence. In addition, one has to recognize the roles of print and visual culture, as well as complementary or competitive objects, on the generation of ideas. This attention to various modes of transmission will then permit a fuller parsing of different patterns of interchange.[5]

# Trade Systems

Recognizing the long history of object flows provides an important understanding for the concept of interchange. While much of the classical Mediterranean commercial world revolved around the shipment of raw materials such as Lebanese cedar or wine and olive oil, the latter in ceramic amphora, well-wrought ceramics also circulated throughout the region, satisfying local needs while also serving as a medium of exchange. In the sixth and fifth centuries BCE, the Attic pottery trade expanded as potters who also painted their wares gave way to a more specialized industry with distinct potters and painters, a division of tasks that led to the production of a greater number of vessels for votive use in local sanctuaries, ritualistic libations, and export throughout the Mediterranean, especially to Etruria, where they were valued primarily as funerary objects (see fig. 2.9). The traders overseeing the Etruscan market favored forms used in Greek symposia, such as the kylix or krater, and specific types of images, such as stories of Herakles, toward which the Attic shops geared their production accordingly. As traders carried them further from their place of manufacture, they took on a different associational function.[6]

In the later *taberna* (shop) economy of the Roman Empire, ceramic workshops in various locales produced consistent terra sigillata that was distributed throughout the empire, relying on common understanding and preparation of materials, the workmanship of habit at the wheel, and the workmanship of certainty ensured by press molds to standardize their products, which were sold directly to local and regional markets, shipped by merchants throughout the Mediterranean, and even carried by traders to South Asia. Throughout the empire, urban middle-class citizens were linked to the elite by their common understanding of ceramic tableware; the differences between them often revolved around gross number and performative use (see fig. 1.4).[7] Such objects knit together a far-flung world in episodic ways. Personal contact was neither large in scale nor constant, but the empire of objects maintained a strong cohesive presence and had a lasting impact.[8]

While Roman trade for spices reached into the Arabian peninsula and South Asia, it was Chinese trade expansion into Central Asia in the second century BCE that ultimately led to the loosely connected network of trade routes. In the Han dynasty (206 BCE–220 CE), silk cultivation, dyeing and weaving, and consumption all dramatically increased. Plain, patterned, and brocaded fabrics could be found among many classes, and silk cloth became an accepted currency (fig. 3.1). Its light weight and ease in folding and packing also made it an ideal trade good. Beginning in the fifth century, Sogdian weavers trained in the traditions of the Sassanian Empire and Sogdian regions moved to the Tarim Basin, in the northwest regions of present-day China, and began

Fig. 3.1. Pair of fragments of silk, China, fifth–sixth centuries CE; warp-faced compound plain weave silk. Found in the Caves of the Thousand Buddhas, Dunhuang, China. British Museum, London, MAS 926 a and b.

to weave Chinese silk rather than wool. They adapted their sophisticated technical and compositional repertoire to a new material (fig. 3.2). Central Asian silks, which traded to South Asia, Africa, and the Middle East, revealed their increasing ties to distant markets initially through the incorporation of linked strapwork composition and arrangement and then of more specific motifs from the eastern Mediterranean such as winged griffins, acanthus leaves, and palmettes. From around the seventh century to the mid-fourteenth century, during the Tang, Song, Liao, Jin, and Yuan periods, woven silk became the major manufactured Chinese good in the overland trade between Constantinople and the Byzantine Empire in the Mediterranean and Xi'an, Beijing, Kaifeng, and Hangzhou in East Asia (see figs. 1.18, 3.2).[9] The success of that trade served as the foundation of Venice's rise to prominence as a commercial center from the thirteenth to the sixteenth centuries, when its merchants and ship captains carried the products of the Ottoman, Persian, and Asian worlds throughout Europe.[10]

As the exportation of silk cloth continued to increase after the seventh century, Chinese stoneware and metal production also rose dramatically, supplying goods for domestic use but also for export. These heavier and bulkier items were shipped by water to Southeast Asia and as far away as the Arabian Peninsula. By the end of the ninth century, Arab and Persian traders in dhows would sail under favorable monsoon winds, taking aromatics such as myrrh and frankincense to the ports of Guangzhou or Yangzhou, where they would assemble ceramics produced in various Chinese centers—the under-

glaze painted wares of Changsha (fig. 3.3), the white wares of Xing (see fig. 1.8), and the underglaze green-splashed wares of Gongxian (fig. 3.4)—and carry the cargo back to Arab lands. Many of the items made in China revealed an awareness of what was popular in the Abbasid market: large bowls and long-necked ewers, as well as ornament consisting of incised lozenges with flowers on the corners. This regional maritime trade became the foundation for the exchange of stoneware from Thailand and Vietnam, stoneware and porcelain from China, porcelain from Japan, textiles from South Asia, and spices from Indonesia that flourished from the fifteenth through the eighteenth centuries.[11]

While silk cloth dominated the overland trade from East Asia to the Mediterranean, metals dominated overland trade in northern Africa during the same period. With the establishment of the Islamic Empire in Andalusia (the Iberian Peninsula), along the northern shores of Africa, and in the Levant in the eighth century, commerce and communication flowed along the southern waters of the Mediterranean and into Africa. As in Central Asia, an overland caravan culture provided the necessary transportation link across the Sahara Dessert. From Mali, Ghana, and the Volta River region high-grade gold ore, slaves, and ivory were exported northward to Sijilmasa, Cairo, and the Islamic world; in return salt, wood, brass, and copper were sent south. While Europeans valued gold as the most desirable metal, West Africans placed higher value

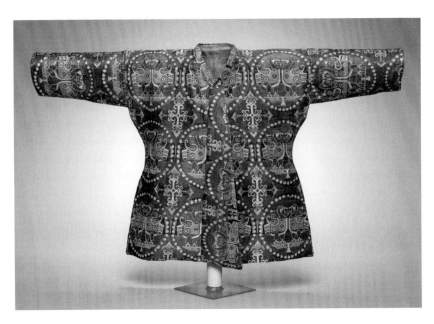

Fig. 3.2. Child's coat with "ducks in pearl" medallions, probably Sogdiana, eighth century; weft-faced compound twill weave silk. Cleveland Museum of Art, Cleveland, OH, purchase from the J. H. Wade Fund, 1996.2.1.

Fig. 3.3. Bowl, Changsha, Jiangxi Province, China, mid-ninth century; wheel-thrown stoneware with underglaze iron brown and copper green decoration. Asian Civilizations Museum, Singapore, 2005.1.00739.

Fig. 3.4. Ewer, Gongxian kilns, Henan Province, China, mid-ninth century; wheel-thrown and modeled stoneware with incised decoration, white slip body with green-splash decoration. Asian Civilizations Museum, Singapore, 2005.1.00900–1.

on copper and copper alloys, owing to its workability and use for a wide variety of items. Copper was mined and processed in Takedda in the south-central Sahara and Audaghost and the Middle Senegal River Valley at the western end, but West Africa supplemented that with copper alloy objects imported from the Mamluk Empire and Europe. Using the mold-cum-crucible casting techniques, they produced high-quality brass with a significant percentage of zinc (as much as 30 percent) through a cementation process, resulting in a bright yellow, goldlike material that could be worked hot or cold. African metalsmiths also developed sophisticated techniques of sequentially casting elements onto completed bodies without distorting the core. West African and Islamic copper alloy metallurgy produced the best work in base metals up until metallic zinc became available in mid-eighteenth-century Europe (fig. 3.5).[12]

Beginning around the tenth century, the Indian Ocean trade began to connect the regional networks of South Asia, Africa, the Arabian Peninsula, and Southeast Asia and Indonesia. The catalyst was cotton cloth, made of South Asian cotton that was spun and woven as plain cloth and then resist or mordant dyed, resist or mordant painted, or block-printed. The Gujarati ports of Cambay and then Surat focused on the Arabian market, sending cloths gath-

Fig. 3.5. Roped pot, Igbo Ukwu, Nigeria, ninth–tenth centuries; three-step lost wax bronze casting (body, ropelike casing, upper rim and base). National Commission for Museums and Monuments, Abuja, Nigeria.

ered from throughout Gujarat to the Swahili Coast, Muscat, Aden, Hormuz, and Cairo, from where traders carried them throughout North Africa and the Middle East (see fig. 1.15). The Gujarati cottons were valued for clothing and furnishing and were exchanged for gold and aromatics that had been carried by caravans of human porters that connected with overland caravans from the Saharan and sub-Saharan worlds.[13] The Coromandel Coast and Bengal were two other important textile centers that sent painted cottons and woven jamdani cottons (a very fine white cotton with discontinuous supplemental white wefts), as well as copper alloy objects made in southwestern India, to Southeast Asia in exchange for pepper, cloves, ginger, and cinnamon. These traders used cloth as currency and developed a sense of what sizes and decorative motifs were desired in each region; textiles thus constituted the economic engine for the spice trade of the region.[14]

While Chinese, South Asian, Islamic, and African traders developed overlapping networks from the eighth through the fifteenth centuries, Mongol merchants began to extend trade routes to Genoa and Venice in the mid-thirteenth century. Prized luxury silks with gold-wrapped silk cores became known in Italy as *panno tartarici*, or Tartar fabrics. With workshops composed

Fig. 3.6. Cloth of gold with winged lions and griffins, Central Asia, 1225–75; silk and gold-wrapped silk woven with supplementary wefts. Cleveland Museum of Art, Cleveland, OH, purchase from the J. H. Wade Fund, 1989.50.

Fig. 3.7. Writing desk, Gujarat, India, early seventeenth century; finger-jointed shisham wood carcass with mother-of-pearl set into black mastic (composite of pigmented animal glue, gypsum, and possibly charcoal) and interior painted decoration. For the Ottoman market. Virginia Museum of Fine Arts, Richmond, Adolph D. and Wilkins C. Williams Fund, 82.114.

of Chinese and Central Asian weavers, the cloths of gold combined eastern Iranian weaving structures of double wefts and round-framed pairs of animals with Chinese single warps and use of cloud imagery (fig. 3.6).[15] In the sixteenth century, Europeans began to encroach on these regional routes. The Portuguese, who initially explored the West African coast and established a base in the Azores, rounded the Cape of Good Hope in the late fifteenth century and pushed into the trading networks of the Indian Ocean and the South China Sea. Goa became the capital for the Portuguese State of India, a commercial empire in which the Portuguese carracks gathered chests and coffers covered with mother-of-pearl shells from Gujarat (fig. 3.7), ivory from Ceylon, and embroidered colchas (embroidered coverlets) from Bengal (fig. 3.8), and carried porcelains and silks picked up in Macau and spices in Malacca to the port of Nagasaki in Japan, where they exchanged those goods for lacquered goods and silver. They took full advantage of the regional carrying trade to gather and trade these materials along their routes. Lacquer and porcelain thus joined cotton and silk as the objects that drove the global economy.[16] The Portuguese followed a "monarchical capitalism" model, a conversion economy that linked

Fig. 3.8. Colcha, Bengal, early seventeenth century; cotton ground with yellow tussah silk embroidery. Metropolitan Museum of Art, New York, Helena Woolworth McCann Collection, purchase, gift of Winfield Foundation, by exchange, 1975, 1975.4.

religion and commerce, maintained a single administrative center with many small fortified ports along the sailing routes, and moved goods within the region rather than using the region as a market for Portuguese goods.[17]

Beginning in the early seventeenth century, the Dutch began to encroach on the Portuguese dominance in the region, making Batavia (present-day

Fig. 3.9. Coffer, Nagasaki, Japan, late sixteenth century; hinoki cypress, black urushi lacquer, gold maki-e lacquer, raden (mother-of-pearl overlay); silver mounts and semiprecious stones added in the Americas. Asunción parish church, Miranda de Arga, Navarra, Spain.

Jakarta) an administrative center of the Vereenigde Oostindische Compagnie (the VOC or the Dutch East India Company), taking over the port of Nagasaki after the Shogun drove out the Catholics; seizing Colombo, the capital of Ceylon; and establishing a center at Pulicat on the southeast coast of the South Asian peninsula. In contrast to the Portuguese system, the Dutch based their interest totally on trade. The Dutch government allowed the VOC to govern the region from Batavia, reduced the number of ports for the VOC to maintain, and concentrated on the gathering of spices, cloth, and porcelain for the European markets. The resulting economic system in that region combined the importation of Dutch-made goods like tin-glazed ceramics, textiles, and metals; regional South and Southeast Asian goods in the same media; and some local production of furniture and utilitarian ceramics.[18]

In the early seventeenth century, the Dutch also followed the Spanish lead in looking across the Atlantic Ocean to the Americas, establishing the fur trapping territory of New Netherlands in the north and dyewood and sugar plantations in Brazil. The Spanish had initially viewed the continent as a source of raw materials, especially the silver of the Viceroyalty of Peru and the Viceroyalty of New Spain. By the end of the sixteenth century, they also recognized the geographic value of America for the goods imported from East Asia via the Pacific. They could avoid the vulnerable Portuguese route around the Cape of Good Hope and instead use Manila as the gathering point for the regional trade of the South China Sea. The introduction of the galleon trade across the Pacific in 1565 resulted in the flow of silk, porcelain, lacquer, and spices across the Pacific to Acapulco. There the cargoes could be distributed throughout the Spanish Americas or carried overland to Vera Cruz and then shipped on to Spain. Silversmiths working in Mexico or Peru often added silver mounts and feet to the lacquered coffers and chests before sending the value-added objects back to Spain, where they served as reliquary containers and affirmed the connections between Spain, the Americas, and East Asia (fig. 3.9). The Spanish also became interested in goods produced in the New World, such as

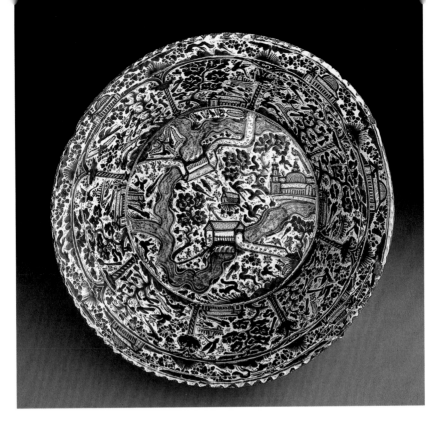

Fig. 3.10. *Lebrillo* (basin), Puebla, Mexico, late seventeenth century; wheel-thrown earthenware with tin glaze and cobalt underglaze decoration on front and lead glaze on back. Collection of Franz Mayer Museum, Mexico City.

American lacquerwork (see fig. 2.40), Puebla tin-glazed earthenware (fig. 3.10), and finely woven camelid textiles from Peru (see fig. 1.17). As in Dutch Asia, Spanish artisans migrated to New Spain and set up shops that often employed Indigenous makers who combined local and Spanish traditions.[19]

The British attitude toward the Atlantic Ocean offered a different scenario: they prioritized wholesale settler colonialism in which they seized the lands from the Native populations and recreated a familiar political structure and culture in the seventeenth century. While some of the settlers were skilled artisans who continued making work in familiar British regional traditions, mobility within the colonies resulted in a blending of these British fashions, with the constant injection of imports from London. In the late seventeenth century, the "Industrious Revolution" in Britain led to the expansion of British manufacturing, especially ceramics, textiles, and base metals, and British merchants began to view the American colonies as the ideal market for these goods (figs. 3.11, 3.12; also see fig. 1.6).[20]

In South Asia, the British government followed the Dutch model rather than their American model. They allowed a private corporation, the East India

Fig. 3.11. Samples of harrateen (a worsted wool), Norwich, England, ca. 1740. From a sample book assembled by John Holker of Lancashire. The watered effect, in imitation of silk, is achieved with the use of coarser wefts. In finishing, the cloth was doubled on itself and put under great pressure, producing a wavy, watered finish. Musée des Arts Décoratifs, Paris.

Fig. 3.12. Furniture escutcheon plate, Birmingham, England, ca. 1765; cast, hand-chased, and burnished brass with golden-tinted varnish coating. Collection of Joan Parcher.

Company, to oversee expansion into the subcontinent and the domination of local states. Initially the company seemed more interested in the extortion of jewels and precious metals, but it soon reaped great profits from the trade in textiles and spices for the European market and, subsequently, the shipping of opium to China.[21]

This summary of some of the major trading systems underscores the lack of a single model for the movement of goods and explains why objects flowed in decidedly nonlinear ways. In many of the Central Asian, Indian Ocean, and Saharan networks, local merchants oversaw regional trade; finished goods were packaged and transported to a variety of destinations, where some settled into use and others were picked up by additional traders who carried them into different networks. Some nation-states, like the Roman Empire, saw the trade of objects as an important way of creating a common culture through export of home products, while others, such as Spain and Portugal, viewed trade as a source of economic expansion, whereby they took over and coordinated regional networks or developed exclusive trading rights. Export or import of objects became an important part of the political economy. Yet the Netherlands and other nation-states subcontracted out their investment in trade to minimize their financial commitment.

## Transmission through Objects

In providing materials, products, and markets, the Americas emerged at the turn of the seventeenth century as the last link in connecting various regional and nation-state trading networks, in some ways making the material world fully round and allowing for many different paths of circulation. However, it is important not simply to think about trade in aggregate or to chart a diffusionist flow from a center to a periphery. Rather, one might begin to develop some degree of specificity, to identify and interpret certain objects that impacted production in a different context. For example, finely chased and silver-inlaid copper alloy bowls produced as status objects for domestic use by Mamluk makers in the thirteenth or fourteenth centuries, and carried as part of the trans-Saharan trade to western Africa, became coveted objects, used for burials, ritualistic purposes, or memory vessels. Examples like one found in a burial site at Durbi Takusheyi, Nigeria, prompted local metalsmiths in the Offin River area of Ghana to make their own versions several centuries later, continuing the swelled form, but substituting invented script and Akan creatures for the Mamluk details (figs. 3.13, 3.14).[22]

The transformation of a consumer good by local craftsmen can also be seen in colonial Virginia and South Carolina after transatlantic trade accelerated in the mid-eighteenth century. African American and Native American potters saw the refined creamware punch bowls imported from Staffordshire and translated these forms into their own system of production: using local clay they coiled bowls, working them into thin-walled vessels, burnished the surfaces rather than glazing them, and then fired them in the open air rather than within a kiln. The resulting bowl was not really a knock-off of the British

Fig. 3.13. Bowl, probably Egypt, thirteenth–fourteenth centuries; raised brass with chased decoration. National Commission for Museums and Monuments, Abuja, Nigeria.

Fig. 3.14. Bowl, Asante, Offin River region, Ghana, sixteenth–eighteenth centuries; raised brass with chased decoration. British Museum, London, Af1955,05.225.

example but a different object all together. Rather than being used in imitation of Anglo foodways and entertainment, it served a more spiritual purpose as a conjuring or divination bowl. Examples that have been recovered from the bottoms of rivers have often displayed African cosmological signs scratched into their bottoms and have been punctured with holes, a context that speaks to their link to the afterlife (figs. 3.15, 3.16).[23]

The impact of global routes is clear in the relationship between two caskets covered with mother-of-pearl. In Gujarat, artisans nailed shaped mother-of-

Fig. 3.15. Punch bowl, Leeds, England, ca. 1770; wheel-thrown refined creamware with overglaze painted enamel decoration. Victoria and Albert Museum, London, c.22–1978.

Fig. 3.16. Footed bowl, South Carolina, 1740–1860; coiled, burnished, and incised earthenware. Chipstone Foundation, Milwaukee, WI, 2017.26.

pearl shingles to a sandalwood casket form based on European prototypes, distinguished by the canted sides of the top, for export to the Islamic market as well as royal collections in Europe, where such boxes often functioned as reliquary chests (fig. 3.17). Portuguese traders must have carried some of these coffers to Nagasaki, where Japanese lacquerers adapted their own raden mother-of-pearl technique to the Gujarati composition (fig. 3.18). Rather than nailing thick shell shingles to the substrate, they adhered thinner pieces of shell to the wood carcass with rice paste and then built up the lacquer around the

Fig. 3.17. Coffer, Gujarat, India, early seventeenth century; nailed sandalwood, mother-of-pearl sheathing, copper nails, brass escutcheon. © Islamic Arts Museum, Kuala Lumpur, Malaysia.

Fig. 3.18. Reliquary chest, Nagasaki, Japan, 1580–1630; hinoki cypress, black urushi lacquer, gold maki-e lacquer, raden (mother-of-pearl overlay), copper mounts. Parroquial Church of San Miguel y San Julián, Valladolid, Spain.

shell. The dense shingling of the shell contrasted with local raden traditions that used small dispersed pieces of nacre in conjunction with gold and silver powders. Yet the lacquerer preserved the local maki-e lacquer tradition on the inside of the lid. This particular example was then carried back to Spain and given to a Jesuit church there.[24]

In the seventeenth century, a certain type of Chinese silk embroidery was exported to Japan via the regional carrying trade, to Europe via India, and to the Americas via the transpacific galleon trade and used in a variety of religious and domestic contexts. These textiles featured an Iberian composition—a central rondel in a rectangular panel surrounded by multiple borders of different widths—with Asian motifs such as paired phoenixes around a peony in the middle and a variety of animals and birds including deer, tigers, elephants, and a blue qilin and white xiezhi (the latter two supernatural creatures looking fierce with flames shooting off their backs) in the borders (fig. 3.19). Working from close study of an imported example, Portuguese embroiderers of the eighteenth century executed a version on a linen ground, using silk and silk wrapped with gilt paper (fig. 3.20). In the Spanish Viceroyalty of Peru, Indigenous weavers translated the silk embroidered form into a tapestry woven textile, with wefts of cochineal-dyed camelid fibers from the higher altitude region

Fig. 3.19. Panel with flowers, birds, and animals, China, seventeenth century; silk ground with silk and gilt-paper-wrapped silk embroidery. Metropolitan Museum of Art, New York, bequest of Catherine D. Wentworth, 1948, 48.187.614.

Fig. 3.20. Panel, Portugal, eighteenth century; linen ground with silk and gilt-paper-wrapped silk embroidery. Museum of Portuguese Decorative Arts, Ricardo do Espírito Santo Silva Foundation, Lisbon.

of Peru and some silk threads that were either imported through the galleon trade or sourced from unraveled imported silk textiles and warps of cotton from Peru's dry coastal area. Nevertheless, the Andean weavers maintained the central peony encircled by a pair of phoenixes and multiple borders with real and fantastical creatures (fig. 3.21). This woven textile clearly demonstrates that sophisticated makers could see an object produced elsewhere with different materials and techniques and successfully translate it into a local product.[25]

Another example of the impact of a specific sort of object is the English linen press imported by the wealthy Boston merchant Charles Apthorp in the 1740s (fig. 3.22). The swelled lower section, referred to as a bombé shape by contemporary collectors, is a very particular form of mid-eighteenth-century case furniture. Local Boston cabinetmakers like Benjamin Frothingham and George Bright saw this possession of a prominent tastemaker and began to

Fig. 3.21. Cover, Peru, late seventeenth to early eighteenth century; tapestry woven with wool, silk, cotton, and linen threads. Museum of Fine Arts, Boston, Denman Waldo Ross Collection, 11.1264.

produce their own versions. But they adapted it to their own circumstances, substituting readily available solid mahogany brought in from the Caribbean trade for mahogany veneer, incorporating a writing desk surmounted by a bookcase behind mirrored doors in lieu of an upper section of full-width drawers behind doors, and applying the shaped base to a variety of smaller storage forms like desks and chests of drawers (see fig. 1.26). The taste for swelled sides did not catch on in Britain or any other British colonial centers, but the form remained a distinctive part of the Boston style embraced by several shops for the next half century.[26]

The provenance of objects helps to chart the flow of objects and the influence they had on production elsewhere in the world. Knowing a history of an object is crucial not simply for where it may have originated and where it was purchased, but also for the impact it had as it entered other networks. An

Fig. 3.22. Linen press, England, 1740–58; dovetailed, joined, and nailed mahogany, mahogany veneer, oak, fir. Museum of Fine Arts, Boston, gift of Albert Sack, 1971.737.

Iberian casket or writing cabinet carried to Goa and Serat could inspire the making of a local version of the form, which could then lead to a Japanese version that was subsequently embraced as a unique, different sort of object back in Spain.

## Transmission through Mobility of Makers

Certainly, the appearance of specific imported objects had an impact on local production, but it is also important to look beyond the movement of objects alone. The conceptual parts of realization also flowed, both from a metropolitan center to the provincial periphery and from the edge to the center, through a variety of ways. Fundamental to this sort of exchange was the movement of craftspeople who carried with them the conceptual aspects of their work—composition, deep knowledge of materials in an era before standardized ingredients and precision instruments, problem solving, and resourcefulness—and even some specific regulating tools like molds or templates that would permit continuation of certain approaches. In some cases, for example, the mobility was forced and in others makers sought opportunities elsewhere. Huguenot

silk weavers fleeing religious persecution in France in the late seventeenth century settled in the Spitalfields neighborhood of East London, where they established a vibrant British silk weaving trade in the early eighteenth century. They did not carry their equipment with them, but drew on their deep knowledge of and familiarity with the trade to recreate it in the garrets of London (fig. 3.23).[27]

The Mongol invasion of Central Asia in the early thirteenth century forced many skilled metalworkers from Herat, in Khurasan, to seek work in safer areas to the west. Those who settled in Cairo worked for the Mamluk court, continuing the chased and inlaid tradition, but adjusting their work to local preferences. Unlike the traditional taste for figural scenes of hunters and rulers, poetic inscriptions, and arabesque and geometric bands found in Herat and Mosul, the Cairo artisans working for the Sultan al-Nasir Muhammad and his court relied on epigraphic blazons and radial calligraphic dedications to the ruler and the owner, all set within rosettes and chinoiserie floral designs. A tray stand made for the sultan's son bears a blazon with an inlaid cup of copper, signifying his role as cupbearer to his father (fig. 3.24). Encircling the cup is a wreath of peonies and lotus blossoms, holdovers from the Chinese influence on the work of Herat more than a century earlier. Although the Cairo shops

Fig. 3.23. Dress fabric, Spitalfields, London, 1724–25; silk ground with supplemental silk weft. Victoria and Albert Museum, London, T.18 to B-1969.

Fig. 3.24. Tray stand, Cairo, Egypt, mid-fourteenth century; raised brass, chased and inlaid with copper, silver, and niello. Metropolitan Museum of Art, New York, Edward C. Moore Collection, bequest of Edward C. Moore, 1891, 91.1.601.

Fig. 3.25. Cabinet, probably Pulicat, Coromandel Coast, India, 1680–1700; joined and dovetailed ebony carcass, turned legs, and carved decoration. Rijksmuseum, Amsterdam, BK-1968-48.

did produce work with figural courtly scenes and astrological signs for the Yemen court and for Europeans, they developed a new style with some older elements for al-Nasir's circle.[28]

Sometimes imperial subjects in the metropole recognized skill in distant lands and sought to bring such artisans back to the capital. Beginning in the seventh century, Chinese imperial workshops from the Tang through the Yuan dynasties relied significantly on skilled Sogdian and then Uighur weavers from Central Asia and Persian weavers from West Asia, all of whom brought sophisticated weaving techniques and familiarity with motifs from Persian and

Fig. 3.26. Sherds of teapots in the "pineapple" pattern, John Bartlam's pottery, Cain Hoy, South Carolina, 1765–70; slip-cast creamware with underglaze coloration. Charleston Museum, Charleston, South Carolina.

Fig. 3.27. Tea bowl, John Bartlam's pottery, Cain Hoy, South Carolina, 1765–69; wheel-thrown porcelain with painted cobalt blue decoration. Chipstone Foundation, Milwaukee, WI, 2010.15.

Hellenistic design to the court.[29] In the sixteenth century, Portuguese traders sufficiently valued the talents of Bengali embroiderers and South Asian silversmiths that they brought them back to Portugal even though the city already featured excellent established artisans in both media.[30] In imperial China and Portugal, consumers who sought skillfully made and distinctive work often looked to the edge of empire for new talent.

In other cases, artisans set up shops far from their home country and recruited local makers to produce work for colonial officials and traders who worked in the colonial system or for locals who aspired to be like the foreigners. Dutch cabinetmakers who journeyed with the VOC to the Coromandel Coast and Batavia established shops (also called factories in the period) staffed with local woodworkers who made Dutch forms from local materials like teak and ebony and relied on familiar types of carving for ornament. While the Dutch artisans controlled the compositional context of work and the sales, the local craftsmen controlled the materials, tools, and techniques. The results were true hybrid objects that were neither Dutch nor Indigenous, but executed at a high level of expertise (fig. 3.25).[31]

Other artisans seemed to exercise free will, moving in pursuit of new economic opportunities and carrying distinctive skills with them. The Staffordshire-trained potter John Bartlam moved from Britain to South Carolina in 1763, sensing opportunity to satisfy growing colonial American demand for refined earthenware tablewares in the British styles. He brought his knowledge of the proper ingredients for creamware and even soft paste porcelain, skill in making molds and press molding bodies, and an understanding of underglaze

Fig. 3.28. Armoire, Pierre Roux, Vincennes, Indiana, ca. 1795; joined, dovetailed, and nailed cherry, poplar, and walnut. Missouri Historical Society, St. Louis, MO, 1950.84.1.

painting and coloring. He found a source for white clay in North Carolina and set up a pottery whose works are virtually indistinguishable from Staffordshire work of the same period (fig. 3.26). He also produced the first porcelain in the American colonies (fig. 3.27).[32]

In the French-settled town of Vincennes in the Upper Valley of Louisiana, several French-trained cabinetmakers made furniture that preserved French forms and decorative conventions well after British colonial occupation in 1764. Pierre Roux, trained in Geneva, came to the region around 1790 and made fashionable French-style rococo armoires—characterized by scroll feet, carved central shells in the curvilinear beaded skirt, rounded carcass corners, pronounced concave cornice moldings, applied moldings in the skirt and upper rail, and applied initials—from local cherry, walnut, and yellow poplar for the prominent Creole families who consciously sought to retain their Franco identity among the dominant Anglo-American culture of the early national period (fig. 3.28). The sophistication of the dovetailing and joinery underscores the refined workmanship Roux practiced on the Mississippi frontier and distinguishes it from that of other artisans in the Illinois region.[33]

In an era of intensive application of low technology, possessing a craft skill could open up opportunities and build connections between distant

places and traditions. Certain rulers like the Tang or the Portuguese actively recruited skilled artisans from elsewhere in an effort to expand a range of stylish goods. Makers such as John Bartlam or the VOC craft workers parlayed their tacit knowledge into entrepreneurial activity in a new setting. They seem to have initiated their new ventures. Other artisans, like the Huguenot weavers forced from their homes, relied on their skills to make a living in a new setting. Whatever the cause of their movement, these craftsmen in motion encountered new expectations and demands, gained experience with new or slightly different materials, and were exposed to new styles or approaches. To borrow from the ideas of the art historian George Kubler, their skill provided a "good entrance" that played an important role in the dynamics of artistic tradition and innovation.[34] The mobility of craftspeople did not always parallel the flow of traded objects and thus provided an additional channel for the flow of ideas and practices.

## Transmission of Imagery and Style

Just as we pay attention to the movement of objects and makers, we should also expand our notions about the circulation and use of images. The standard practice for iconographically driven decorative arts scholarship has been to assume a proper center of a style or fashion, find a source, which is usually a print or painting, and then conduct a comparison of the pairing. Unfortunately, such an exercise merely reinforces the center/periphery or metropole/vernacular distinction of colonial perspectives. Work produced away from the center is often considered unoriginal slavish imitation, as in the case of British critiques of South Asian makers, or aberrant or bizarre misunderstood attempts at copying, as scholars often portray vernacular work from the American colonial period. The search for a print source also reinforces the hierarchical order of media that privileges the two-dimensional image over the three-dimensional object.[35]

More recent iconographical studies have demonstrated how small, portable items like coins, medals, books, bookplates, prints, and jewelry played important roles in the circulation of decorative motifs, but we need to pay attention to how the maker would have used those items. Objects and images responded to each other in lived processes of negotiation and translation. Prints and other forms of imagery were often understood and responded to within local practices.[36]

Porcelain from China and cottons from South Asia, the dominant global commodities that emerged in the fourteenth century, actively participated in the transmission of object realization. Chinese porcelain producers drew on the circulation of images, objects in various media, and awareness of distant

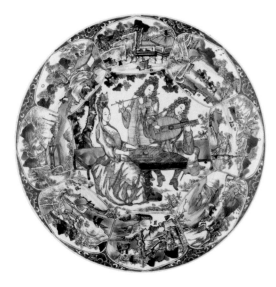

Fig. 3.29. Bottle, Jingdezhen, China, 1552; wheel-thrown porcelain with cobalt blue underglaze painting. A double register of Portuguese words, upside-down and with errors, states, "Jorge Alvrz had this made at the time of 1552." Walters Art Museum, Baltimore, MD, 49.1616.

Fig. 3.30. Plate, Jingdezhen, China, early eighteenth century; drape-molded and wheel-trimmed porcelain with cobalt blue painted underglaze decoration. The central scene is from an engraving by the French artist Nicolas Bonnart, with more typical Chinese landscapes decorating the rim. Asian Civilizations Museum, Singapore, ACM 2014–00435.

markets to cater to court commissions, local and national consumption, and the greater Asian and European markets. For the latter, porcelain painters in Jingdezhen decorating under glaze initially blended imagery from bookplates and individualized emblems with local decorative elements, but inevitably issues of translation cropped up as images traveled long distances and entered a different language system. A bottle for a Portuguese merchant featured a double band of upside-down Portuguese writing with several errors. Apparently, the decorator, who was working in Jingdezhen and painting the pot with underglaze blue, was given the phrase, but no oversight in the proper orientation or lettering was provided. The Portuguese script was viewed merely as a form of ornamental pattern and artistic experimentation (fig. 3.29). It was difficult to control work over a distance unless the patron's representative sat by each artisan that touched the commissioned piece. It also proved challenging to match the precise lines of engraved drawing when painting underglaze blue, as some of the early examples of print-inspired imagery contain crowded, cloudy scenes (fig. 3.30).[37]

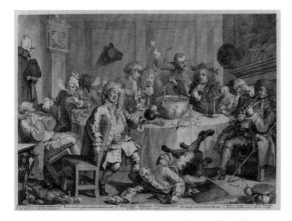

Fig. 3.31. William Hogarth, *A Midnight Modern Conversation*, London, 1732–33; engraving on paper. Yale Center for British Art, New Haven, CT, Paul Mellon Collection, B1981.25.1409.

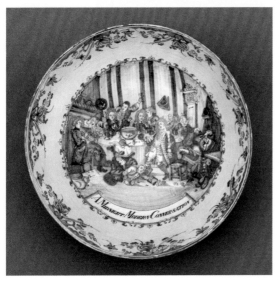

Fig. 3.32. Punch bowl, *A Midnight Modern Conversation*, Liverpool, England, 1750–60; wheel-thrown earthenware with tin glaze and underglaze blue painting. Courtesy of Winterthur Museum, Winterthur, DE, museum purchase with funds provided by Mr. and Mrs. John Mayer and Mrs. Lammot du Pont Copeland, 1984.0030.

In the middle of the eighteenth century, the growth of European demand, expansion of European print production, and development of overglaze enamel decoration in Guangzhou fostered more sophisticated translations of print imagery on porcelain and copper. William Hogarth's 1732–33 engraving, *A Midnight Modern Conversation*, became one of the most popular prints for the decoration of objects, particularly punch bowls, since the image commented on the misbehavior of drunken professionals and businessmen (fig. 3.31). When an English ceramic painter adapted the imagery to the bottom of a tin-glazed punch bowl, the same technical problems encountered by the Chinese painters working underglaze in Jingdezhen arose. The decorator crowded the image into a dense, concave space and could not effectively control the lines of the underglaze blue (fig. 3.32). In contrast, a Guangzhou

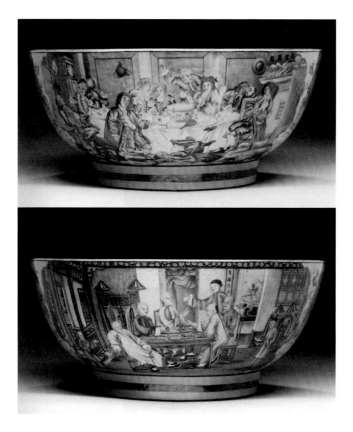

Fig. 3.33. Punch bowl, Jingdezhen and Guangzhou (Canton), China, ca. 1770; wheel-thrown porcelain with enamel overglaze painting. Chen Art Gallery, Torrance, CA.

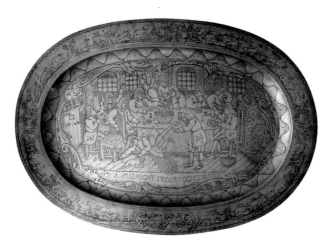

Fig. 3.34. Platter, Nicolai Hindrich Ludvik Hagelsten, Haderslev, Denmark, ca. 1805; cast pewter with engraved decoration. Courtesy of Pewtersellers, Alford, Scotland, and Kingston, MA.

overglaze enamel painter deftly spread the same composition over the convex exterior of a bowl, opening up the scene (fig. 3.33). Moreover, the picture of English debauchery was paired with another image of gentlemanly behavior on the opposite side: a comparable group of Chinese men sitting around a table in a more respectable manner. The scene is one also found on reverse painting on glass for the local market, suggesting a local composition for local consumers, affirming the local painter's control over the product and the local market for Guangzhou work—what the art historian Yeewan Koon refers to as "the convergence of a shared pictorial language."[38] A related Chinese punch bowl with the Hogarth image on it has a ship portrait and Danish script and cyphers on the opposite side, implying that a Hogarth bowl was a stock item that could be customized on the reverse side for different customers. It also underscores that the Hogarth image was not simply an example of an image that circulated between Guangzhou and Britain but also extended into the Nordic countries as well. The bowl for the Danish merchant was one example, but a later pewter platter also highlights the enduring power of the image (fig. 3.34). The strong northern European tradition of engraved pewter used the Hogarth composition within a border of hunting scenes.[39]

The prestige of porcelain and fritware also led to interconnected markets and a sharing of different motifs between the Chinese and Ottoman traditions as each center of production responded to the market of the other. Chinese porcelain for the Islamic market, like the bottle for a Portuguese patron, used the foreign Arabic script as a decorative device, emphasizing the fluidity of the calligraphic strokes without being true Arabic writing. It merely suggests a Qur'anic verse (fig. 3.35). Chinese painters also incorporated cypress trees as a border motif as found on Iznik examples, and Ottoman potteries in turn borrowed from Jingdezhen objects. Among the most popular motifs for large

Fig. 3.35. Dish, Zhangzhou kilns, China, early seventeenth century; drape-molded and wheel-trimmed porcelain with underglaze blue painted decoration. Asian Civilizations Museum, Singapore, 2007–00869.

Fig. 3.36. Plate with grapes and floral sprays, Jingdezhen, China, Ming dynasty, Xuande reign, 1426–35; press-molded porcelain with underglaze cobalt blue decoration. Cleveland Museum of Art, Cleveland, OH, anonymous gift, 1953.127.

Fig. 3.37. Dish, made in Turkey, probably Iznik, second quarter of the sixteenth century; press-molded fritware with cobalt blue decoration. Metropolitan Museum of Art, New York, Harris Brisbane Dick Fund, 1966, 66.4.10.

dishes was a bunch of grapes, found in Chinese porcelain made in the early fifteenth century and sold in the Islamic market (fig. 3.36). Iznik potters in the sixteenth century copied the central grape motif and the Ming-style floral spray decoration of the cavetto and riffed on a Yuan-style wave-and-rock border design (fig. 3.37). Iznik potters created their own version of the border and also added green pigments underglaze to distinguish their work further.[40]

To expand their market, Chinese artisans working both in porcelain and enameled copper also drew from other three-dimensional media, particularly South Asian and Islamic metalwork (figs. 3.38, 3.39). One particularly popular form, the pear-shaped ewer, was based on South Asian brass and bidriware (fig. 3.40; also see fig. 7.1). Chinese makers adapted the form and the floral decoration for both the external market, for use in ablution in the mosque or at home, as well as for local use as a wine pitcher. This similarity of forms in different media is a good example of skeuomorphism, in which vessels in one medium consciously evoke the materials, techniques, decoration, or use of a vessel in another medium.[41]

Owing to their role as both trade good and a form of currency, textiles circulated throughout the world and offered another effective system of visual transmission in their own right. Lightweight, portable, durable, and more widespread than works on paper, they could incorporate imagery from various visual culture sources and transmit that imagery over distance. Embroiderers in Bengal and Gujarat incorporated biblical, classical mythological, and

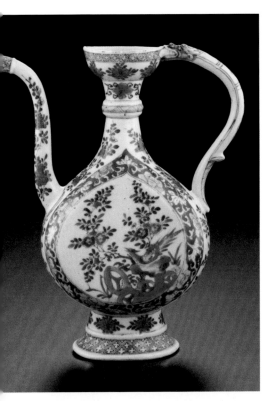

Fig. 3.38. Ewer, Jingdezhen, China, seventeenth or early eighteenth century; press-molded porcelain with underglaze cobalt blue painted decoration. Asian Civilizations Museum, Singapore, 2002.00096.

Fig. 3.39. Ewer, Guangzhou, China, mid-eighteenth century; fabricated copper vessel with enamel painting. Courtesy of Amir Mohtashemi, London.

Fig. 3.40. Ewer, Deccan region, India, mid-seventeenth century; cast zinc alloy inlaid with silver and copper. Victoria and Albert Museum, London, 1479–1904.

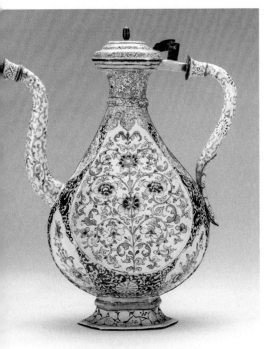

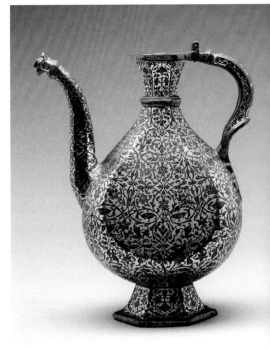

Fig. 3.41. Textile fragment, Gujarat, India, probably 1500s; plain woven cotton with block-printed and drawn resist decoration. Made for the Egyptian market. Courtesy of Royal Ontario Museum, Toronto, Canada, 978.76.140.

Fig. 3.42. Skirt cloth, Coromandel Coast, India, eighteenth century; plain woven cotton with hand-drawn mordant and resist dye decoration. Asian Civilizations Museum, Singapore, 2009–02053.

Hindu imagery drawn from a variety of sources—European print sources (not always from high-style prints and Bibles but often a more popular version thereof), tapestries, other textiles like linen damasks, and terra-cotta plaques— to produce large colchas, coverlets, or hangings that still maintained local conventions of fabrication. In Bengal, female needleworkers used wild silk, often a single light color such as yellow or white, to chain stitch designs on a solid-colored cotton ground. While some used Portuguese heraldic devices in the center, others substituted biblical scenes such as the Judgment of Solomon, used incidents from the book of Judith, drew on mythological stories of Actaeon and Hercules to create narrative borders, and incorporated local imagery such as hunting scenes and the story of Matsya (see fig. 3.8).[42]

Often textiles produced in one area influenced or responded to those produced in another region. Gujarati textile decorators had a particularly keen sense of their distant markets, producing block-printed and painted cottons with pseudo Arabic script for the Egyptian market in the fifteenth century

(fig. 3.41). Coromandel Coast painters produced long skirt cloths with saw-tooth ends (bamboo shoots or the *pucuk rebung* motif) and series of block-printed borders for the Indonesian market (fig. 3.42), and Gujarati artisans wove elaborate double ikat patolu ceremonial cloths for the same consumers (see fig. 2.24). These cloths in turn influenced local ikat and batik production in Indonesia in the eighteenth and nineteenth centuries (fig. 3.43).[43] Thai importers established very strict criteria for their imports, specifying cloth, width, and design, often communicated with examples. They turned to painted cottons from the Coromandel Coast as well as intricately woven silks from Iran. An example of the latter demonstrates the effectiveness of this practice: woven of local silk dyed in the colors of blue, green, and salmon achieved with local dyestuffs, the multilayered borders and *tumpal* (the teardrop-shaped motifs) are stock elements of the Thai repertoire (fig. 3.44).[44]

Prints, literature, small portable objects, textiles, and actual objects all impacted the design language of artisans. Makers often demonstrated sophisticated visual knowledge in abstracting and assembling images and motifs from prints, texts, objects in a variety of media, the built environment, and popular culture.[45] Yet, even when ordered as a specific commission or with strict instruction, as seen in the Iranian silks for the Thai market, the compositions were interpreted and executed on a local level with local materials and expertise. Artisanal performance was never totally subservient to an idealized commission, so the practice of searching for a single inspirational print source or a "correct" prototype is ill-founded.

Fig. 3.43. Detail of sarong, Lasem, Java, 1860–80; plain woven cotton with hand-drawn wax resist, vat dyed. Collection of the Bureau of the Royal Household, Inv. 222, Queen Sirikit Museum of Textiles, Bangkok, Thailand.

Fig. 3.44. Detail of cloth, Isfahan, Iran, early eighteenth century; silk, metal-wrapped thread. Textile Museum, Washington, DC, 3.313A&B. Acquired by George Hewitt Myers in 1952.

# Interchange

Trade and transmission help to identify the basic routes and mechanics of objects in circulation, but the objects do not simply reflect the trace patterns of trade. Rather, they embody and structure particular actions of cultural and identity negotiation. As the products of multilayered cultural know-how, they emerged from dynamic, nonlinear interchanges that often lacked a specific center or starting point and involved makers, traders, and consumers, all of whom engaged in an active process of give-and-take and translation. Whereas exchange implies a specific direction of movement, interchange suggests a swirling development of ideas and decenters concepts like top-down diffusion or hierarchical influence. Even objects that did not themselves travel possessed the impact of tacit knowledge from other regions, cultures, and time periods. Knowledge development resulted from artisanal experimentation in response to new materials, newly arrived craftsmen who brought new skills into the community, new consumers, or new objects, all introduced through the move-ment of objects and people. However, it is important to note that these cata-lysts did not occur in sequence and could often overlap; new ideas emerged from specific contexts at specific times.[46] Stepping back from the particulars of individual objects and thinking about types or categories of objects, one can

conceptualize a number of different framing lenses for interchange, ranging from imitation to entanglement. These terms tend to overlap and blend into one another, but used in a nuanced way they can be productive tools to interpret the material world. Each focuses on a specific group of people and set of issues and is suggestive rather than comprehensive.

A common aphorism is that copying or imitation is the highest form of flattery. While modernist aesthetics and current copyright law emphasize and protect originality and demonize imitation, copying historically had positive associations. From a maker's perspective, copying was a time-honored way of learning skills, demonstrating mastery, or developing new ideas. The ability to copy demonstrated high levels of comprehension and skill and sometimes even signified a threatening form of competition, such as the skilled woodworkers of the Coromandel Coast represented to British furnituremakers in the early eighteenth century.[47] Copying was also a way of developing a mutually understood formal language between maker and client. Consumers felt comfortable ordering a copy, often requesting something like the one they had seen at a neighbor's or relative's abode. Immigrant artisans or responses to imported objects often constituted the most explicit form of copying. Only with industrial standardization and homogenization, reinforced through image saturation, has a concern for originality and authenticity undermined the value of copying.[48]

Related to copying is emulation, which tends to represent the perspective of the consumer and is most often associated with a top-down consumption theory. In emulation, people with lesser means try to surround themselves with products that look at first glance to be the same as those owned by the better sort, but in fact are less expensive versions that simply have the same visual effect. Good examples of objects operating under emulation theory are watered worsted wool, where the threads and weave structure provide a textured surface that when folded, pressed, and heated provides the effect of moiré silk (see fig. 3.11); cast pewter teapots, creamers, and sugar bowls that looked like polished raised silver vessels; cast paktong candlesticks made in China with pseudo hallmarks that resembled British silver examples, but at a fraction of the cost of materials and labor (see fig. 1.22); and the graining of local relatively plain woods to simulate the figure of imported tropical woods (see fig. 2.35).[49]

While emulation is primarily concerned with outward appearance and substitution effect, the scholar Marta Ajmar has developed the concept of "material mimesis," a shop floor–based approach that focuses on the adaptation of material and technological histories and choices. To Ajmar, objects possess a "global DNA" developed over time and space. Makers apply their cognitive skills in responding to existing work and then contributing to this cumulative

evolution.[50] One of the media she spotlights is lacquer, a distinct product of East Asia, that is often treated simply as an exotic product of another culture. When seeing lacquer for the first time, Europeans drew on familiar associations, describing it as a form of varnish, equating its sensuous surface with gilded leather or the surface of an oil painting, and comparing its hard, shiny surface to ceramic glaze (see fig. 2.38). Basically a natural, premodern plastic, lacquer was a durable and decorative wonder material that also possessed associations with a distant land. On the other hand, Japanese lacquerers saw what sorts of objects the Portuguese brought with them in the mid-sixteenth century—mother-of-pearl veneered cabinets from Gujarat, carved and gilded work from Goa—and adapted their own production in response to their perception of dense and glittery Portuguese aesthetics.[51]

The true lacquer of East Asia proved impossible to transport as a raw material back to Europe, so European artisans experimented with their own local materials to approximate the technological and visual effect of lacquer, while still maintaining affinities with lacquer's decorative composition and application of layers. In northern Europe, ornamental painters heated up amber to create a relatively clear protective finish (see fig. 6.11), while in the Netherlands and Britain, a more opaque varnishing system called "japanning" was preferred (see fig. 2.39). Here red or black pigments, sometimes combined to produce a tortoiseshell effect, set in an oil-based varnish, served as the ground for gilded or silvered decoration built up over the initial opaque finish. In South and Central America, two Indigenous forms of lacquering paralleled these other techniques (see figs. 2.40, 2.41). In Peru, the sap of the mopa mopa tree could be cleaned, colored, and burnished onto wood or gourd objects to produce *barniz de Pasto*, a durable, colorful, polymerized skin akin to true lacquer, while in New Spain chia oil and aje oil (a waxy substance achieved by

Fig. 3.45. Casket, Pasto, Colombia, ca. 1670; butted wooden carcass with *barniz de Pasto* lacquer decoration and iron mounts. Courtesy of Thomas Coulborn & Sons, Sutton Coldfield, England.

Fig. 3.46. Wrap, Kashmiri region, Asia, before 1815; pashmina wool in twill tapestry weave. Cleveland Museum of Art, Cleveland, OH, museum appropriation, 1961.452.

boiling female insects) were combined to produce *maque*, an opaque Mexican varnish. This overall black varnish was either inlaid with colored varnish details to create a composition or was painted upon. As Asian lacquer flowed across the Pacific in the galleon trade, the American craftspeople were exposed to Japanese lacquer and adapted some of their own techniques to produce work that resembled the imported compositions (fig. 3.45).[52]

Appropriation is yet another process through which material and aesthetic cognition operates, but one that derives from an imperial perspective in which a more powerful society exploits or profits from the materials or motifs of an "inferior" one, decontextualizing those local conventions in the process. A classic example of appropriation is the Kashmiri shawl. In the Kashmir district of South Asia, weavers relied on the fine neck hair of local pashmina goats to produce sash belts and wraps for males (fig. 3.46). At the turn of the nineteenth century, Europeans responded favorably to the soft, lightweight fabric and finely woven boteh (almond-shaped) motifs on the end panels, but repurposed them as shawls for women. The success of this fashionable use spawned European imitations, including wool examples woven in Paisley, Scotland, and silk versions in Lyon, France. The former became so popular that the decorative motif of the boteh is now commonly called paisley outside of South Asia (fig. 3.47).[53]

A more complex and long-lasting example of appropriation is chinoiserie.[54] Europeans in the early modern period became fascinated with the distant exotic lands of the Far East, especially China. Few could actually travel there, so instead they had to depend on literature and objects to satisfy their

Fig. 3.47. Shawl, Paisley, Scotland, ca. 1835–45; silk warp with worsted wool weft. Victoria and Albert Museum, London, given by Mrs. B. A. Tracy, T.78–1981.

curiosity and stimulate their imagination. Porcelain, lacquer, and silk imports grew significantly, while local producers responded to the interest in the exotic by incorporating Chinese motifs into Western forms produced with Western techniques. Robed-scholar figures sitting in unmistakable hilly Asian land-scapes decorated British tin-glazed earthenware (see fig. 2.14); pagoda-roofed structures, bridges, and robed figures with parasols enlivened the surfaces of japanned furniture and copperplate-printed cottons (see fig. 2.39); fretwork and pagoda-shaped finials ornamented furniture; and brass drawer pulls for large case furniture offered unmistakable references to Chinese imagery (see fig. 3.12). The producers in Europe felt they could adopt any of this imagery for their own work, a domestication process that asserted the consumers' superi-ority over the Chinese civilization. Even though China was never colonized, Europeans viewed it as a constant source of stylistic innovation, commodifying the exotic imagery. This obsession with design drawn from China became an essential part of a mercantilist or imperial aesthetic throughout Europe.

However, appropriation was not neat and tidy in the concept of chi-noiserie. Chinese artisans in Guangzhou in particular took full advantage of Western details to expand their market. They made furniture forms like chests

of drawers and sewing tables that were unknown in China, provided large matched porcelain tea and dinner services with Western imagery like coats of arms or sailing vessels, and applied lacquered or enameled views of Guangzhou on a variety of objects. Imperial artisans also liberally appropriated European motifs and ideas to assert the glory of the Chinese culture. This "Euroiserie," as Jonathan Hay calls it, may also be considered a form of appropriation, in which Chinese artisans exoticized the European other to expand their own global reach or to satisfy the emperor and the court's interest in worldly fashions.[55] Shifting the focus away from a Eurocentric point of view helps to point out the complexities of appropriation as a form of interchange.

Related to but distinct from appropriation is acculturation, which occurs when a colonized people turn their backs on local traditions and either accept or are coerced to accept the dominant colonizing culture. Many makers conscripted into service in Goa, Lima, Mexico City, Calcutta, Beijing, or other imperial centers likely had little option but to conform and work at the direction of a governing authority. While some in these workshops passively assimilated, others might have been willing to enter into the act of acculturation for economic reasons, since it might afford them opportunities for new ideas or markets. Such opportunities seemed more available outside of colonial centers or in areas at the confluence of several trade routes, such the Coromandel Coast in South Asia or Manila.[56]

The agency of the maker is clearer in the concept of adaptation, in which a local artisan might make use of an imported material or object but add value to it or rework it for a different purpose or product. In the New Spain, metalsmiths added silver or iron mounts and clasps to both imported Japanese Nanban examples and local *barniz de Pasto* work; the finished boxes were then shipped across the Atlantic and became used as reliquaries (see fig. 3.9). Tailors in New Spain likewise transformed South Asian painted cottons, called *indianilla*, into fashionable women's skirts and men's housecoats, while a tailor in Tibet combined Sogdian and Chinese silk textiles to produce a coat for a local elite (see fig. 3.2). In the Netherlands, Germany, and France cabinetmakers cut up lacquered case furniture and screens and used the parts as panels for more European style cabinets (fig. 3.48).[57]

The most complex process of interchange is entanglement, one which combines elements of the previous concepts. In characterizing this dynamic model that links production and consumption through selection and recombination or blending, the term "entanglement" highlights the agency of both makers and clients, allows for ambivalence, and can accommodate resistance. Just as it distributed the agency among several groups, entanglement also accounts for the impact of certain imported finished goods, the transformation of imported materials, and the local production of a foreign form in local materials. Entan-

Fig. 3.48. Cabinet, lacquered panels from Kyoto, Japan, cabinet carcass from the Netherlands, 1700–1705; joined and dovetailed oak and alder, with olive wood, cedar, purpleheart, and box-wood veneers, and lacquered panels. Rijksmuseum, Amsterdam, BK-1979–21.

glement as a process does not necessarily reinforce the structures of colonial power or disenfranchise the colonized but rather offers a way in which people might actively filter ideas and goods from a variety of sources.[58]

The example of blue-and-white ceramics provides a clear example of the complexity of such material interchange. By the early ninth century, Chinese thinly potted white stoneware was being shipped to the Abbasid Empire, catering to Abbasid taste in forms and decoration. The Iraq potters were produc-

Fig. 3.49. Dish, Basra, Iraq, ninth century; wheel-thrown earthenware with tin glaze and cobalt blue decoration. Asian Civilizations Museum, Singapore, 2011–00612.

Fig. 3.50. Dish with lozenge and foliate motifs, Gongxian kilns, China, ca. 830 CE; wheel-thrown stoneware with clear glaze and cobalt blue decoration. Asian Civilizations Museum, Singapore, Tang Shipwreck Collection, 2005.1.00474.

ing a yellow-glazed fine ceramicware at this time but then in reaction to the Chinese stoneware adjusted their glazes, adding tin and perhaps some quartz to the alkali-lead glazes to produce a white, smooth, semi-opaque surface. Like Chinese potters, the Abbasid craftsmen threw their vessels on a wheel, then placed the form over a mold on the wheel to create a uniform interior surface and to trim the exterior to uniform thickness. The clay body was local, but the lead was imported from the Arabian Peninsula and the tin from Southeast Asia. The Abbasid artisans, who demonstrated great prowess in glazing, then decorated the white bodies over the glaze with metallic oxides, not only luster but also cobalt gathered in Greater Iran. With firing, the overglaze painting blended into the glazed body, the blue of the cobalt affixing to the tin oxide glaze. Some of these blue-on-white wares, a distinct Abbasid product, were then shipped to China, where they impacted the development of blue-on-white ware at the Gongxian kilns in the second quarter of the ninth century (figs. 3.49, 3.50). But blue-and-white stoneware never really became a viable product in China.[59]

However, the real surge in blue-and-white ceramics began in the early fourteenth century, but as parallel developments facilitated by the Mongol occupation of Greater Iran. In Kashan and other potteries, artisans began painting cobalt blue underglaze on fritware bodies. Fritware, which did not

require a tin oxide glaze or white slip, provided a whiter surface that accentuated the cobalt blue that was mined in the region. At the same time, potters in Jingdezhen in Jiangxi Province built on the porcelain knowledge and underglaze decoration technology of earlier kilns in Cizhou and Jizou to develop blue-and-white porcelains with fine, underglaze brushed decoration. Mesopotamian potters covered the fritware body with a quartz-based slip, allowed the slip to dry before painting with a pigment blended with glass frit, and then covered the whole body with a clear glaze. The underglaze decoration allowed crisper lines, and the use of frit throughout provided brilliance. The technique was further refined in Iznik and other Ottoman potteries in the fifteenth and sixteenth centuries.[60]

The Jingdezhen potters began to paint porcelain underglaze with cobalt blue pigments in the second quarter of the fourteenth century. While they had easy access to clay, fuel, and glazing materials, they had to import cobalt from Yuan Province or from Greater Iran. The latter was preferred and became known as "Muslim blue," which further underscores the connections between the two centers of blue-and-white fine ceramics. Much of the earliest Chinese blue-and-white porcelain relied on Islamic metalware shapes, motifs, and layout, as they targeted the Islamic market in particular, suggesting that market's familiarity with and taste for blue-and-white ceramics. Decorative interchange paralleled the technical interchange. In the fifteenth and sixteenth centuries, Jingdezhen and Iznik potteries drew closer as each produced objects with motifs and designs drawn from the other and entered similar collections and households.[61]

While trade through Central Asia and the Indian Ocean linked Jingdezhen and Islamic centers such as Kashan and Iznik in the fourteenth and fifteenth centuries, the brief cessation of Chinese exports in the sixteenth century fueled the expansion of Ottoman underglaze blue fritware and contributed to the fluorescence of underglaze blue–decorated stoneware in Vietnam during the late fifteenth and sixteenth centuries. Kilns around Hanoi produced blue-and-white stoneware for the regional market of the Philippines, Thailand, and Indonesia but also found some success among Islamic collections as well. Vietnamese painters developed their own looser, more ethereal style of landscape and favored lotus-petaled borders, while also using overglaze green enamels to decorate the scenes (fig. 3.51). However, once Chinese potteries resumed exporting their work, the Vietnamese lost their share of the regional market and dramatically reduced their blue-and-white output.[62]

The exportation of Chinese porcelain to Europe in the latter part of the sixteenth century also impacted production there. In the 1610s, Portuguese potteries near Lisbon developed a particular type of tin-glazed earthenware in imitation of the Chinese blue-and-white porcelain with Wanli-period (late

Fig. 3.51. Dish, Vietnam, late fifteenth or sixteenth centuries; wheel-thrown stoneware with underglaze blue decoration and overglaze green decoration. Asian Civilizations Museum, 1996-00171.

Ming dynasty) patterns that was imported by Portuguese traders.[63] In the second half of the century, Portuguese potters also developed hybrid styles characterized by Wanli, or kraak-style, borders—in which a series of painted rectangular panels, with alternating floral devices in the middle of each, decorated the rim—and Portuguese center designs such as coats of arms or people in European dress. A second type featured borders of *aranhões* (artemisia leaves) and pairs of peaches surrounding a central design of a single animal like a hare or a bird (see fig. 1.5). The Portuguese work could be very accomplished, closer in weight, look, and feel to real Chinese porcelain than the later Dutch and English examples.

In the 1620s, Dutch potters in Delft began to shift their tin-glazed production from polychromed geometric designs based on Italian majolica to blue-and-white work based on Chinese porcelain prototypes and Portuguese tin-glazed adaptations. However, the Dutch blue-and-white ware did not really take off until the mid-seventeenth century, when the Chinese potteries were closed and rising demand for blue-and-white ceramics created a strong market in the Netherlands and its trading sphere for the locally produced wares. For plates and dishes, Dutch potters favored the kraak-style rim, surrounding a central design element of foliage or birds set within the middle of the dish (fig. 3.52).[64]

Tin-glazed blue-and-white earthenware also became popular in the Americas. The Spanish galleon trade across the Pacific, from Manila to Acapulco, brought Chinese blue-and-white porcelain to the ports, where consumers from Peru to New Spain eagerly purchased it. The imports also exerted an influence on local Puebla potters trained in the Iberian tradition, who continued making

Fig. 3.52. Dish, Netherlands, ca. 1630; wheel-thrown earthenware with lead-glazed back and tin-glazed front with cobalt blue decoration. Yale University Art Gallery, New Haven, CT, purchased with a gift from Lulu C. and Anthony W. Wang, B.A. 1965, 2000.10.1.

familiar tin-glazed forms, such as *lebrillos* (basins) and *albarellos* (jars), but developed their own fusion of Islamic, Chinese, and Indigenous blue-and-white imagery. One *lebrillo* (see fig. 3.10) underscores the complexities of the Puebla producers: the basin form and decoration on the back are derived from Islamic Iberian tin-glazed earthenware examples; the blue-and-white decoration is paneled like kraak wares; the density of the decoration and arcaded panels are more akin to Iznik ceramics; the map motif evokes Indigenous mapping traditions; and the steep, flaring sides and coggle-decorated rim are typical Puebla features.[65]

While British tin-glazed potteries were well established in the late seventeenth century on the south bank of the Thames, in Lambeth and Southwark, and in port towns such as Bristol, it was Josiah Wedgwood's development of refined earthenware with a blue-tinted lead glaze, called "China glaze" or "pearl white" at the time, and transfer-printed decoration that sparked a true revolution in blue-and-white ceramics. Staffordshire rapidly became the equal of Jingdezhen in terms of quantity and impact. The Spode Ceramics Works

Fig. 3.53. Plate, Spode Ceramic Works, Stoke-on-Trent, England, 1800–1820; molded earthenware with China glaze and transfer decoration. Victoria and Albert Museum, London, given by Miss E. J. Hipkins, C.847–1925.

Fig. 3.54. Hot water plate, Jingdezhen, China, 1830–70; molded porcelain with underglaze cobalt blue painted decoration. Courtesy of Winterthur Museum, Winterthur, DE, bequest of Jean Fitzgerald McBride, 2003.0012.031.

Fig. 3.55. Plate, Jingdezhen, China, 1810–20; molded porcelain with underglaze cobalt blue painted decoration. Courtesy of Winterthur Museum, Winterthur, DE, bequest of Wilhelmina Laird Craven, 2010.0008.014.

developed a specific sort of invented Chinese design, called the "Willow" pattern, which featured a landscape with a bridge, pagoda-roofed buildings set into trees, a boat, and flying birds (fig. 3.53). This pattern was copied not only throughout British potteries, which developed their own transfer patterns, but even by Chinese potters, who copied the British invented versions of their own porcelains but did so with underglaze painted decoration (fig. 3.54). The close connection between British transfer-decorated China glaze wares and Chinese hand-painted porcelain is most obvious in the "Fitzhugh" pattern porcelains produced in Jingdezhen, where the segmented composition and painting technique explicitly refer to the look of transfer decoration, even though the ornamentation was hand-painted underglaze (fig. 3.55).[66]

## Conclusion

Objects and the evidence of their making clearly reveal how material experiences and interchanges flowed through the world from an early period. Exploring the concepts of circulation and interchange, paying particular attention to available materials and processes of making, allows us to move beyond a Eurocentric diffusionist view of artistic progress, a reliance on the linear path that assumes accepted centers influence and displaces local knowledge, or a consideration of European, Asian, African, and American histories of art as discrete units of development and study. It also gives equal agency to maker and consumer. The historian of science Pamela Smith characterizes this nonlinear, circuitous, and often crisscrossing flow as "entangled itineraries" in which the understanding of making and familiarity with the resulting objects become a mosaic of making and knowledge. Knowledge was not something transmitted solely through dictionaries, astronomical or mathematical treatises, medical texts, Jesuit scholars, the Epistles of the Ikhwan al-Safa', or Denis Diderot's *Encyclopédie*. Knowledge acquisition was also driven by material and technical engagements with everyday objects.[67]

Chinese silks and South Asian cottons not only moved throughout the world, but they also provided a means of transmitting decorative imagery, inspiring local makers in other regions, stimulating natural history interest in sericulture, and fostering advances in dyeing and chemistry. Potters also developed greater sophistication about glaze chemistry and kiln building that contributed to material science and natural philosophy. The mobility of ceramics makes it nearly impossible to sort out the specifics of direct influence. Rather, the notion of entanglement sums up well how potters in different regions studied and learned from materials and techniques developed elsewhere. Copper alloy metals, particularly those made in Islamic world, were some of the most valued metallic objects, even exerting a significant impact on

ceramic designs. In that way, they resembled textiles as transmitters of fashion and taste. Movement of materials also widened the possibilities of woodworking. For example, northern European woodworkers, restricted initially to oak, fir, and birch, suddenly had access to a variety of tropical woods such as ebony, teak, and mahogany—timbers whose physical properties, such as density and strength-to-weight ratio, made them ideal cabinetmaking stock; whose internal structure made them take the cut of a carving tool smoothly; and whose figure provided aesthetic richness.

Knowledge, especially material knowledge and material literacy, was constituted in significant part by movement and interchange. Exposure to and manipulation of a wider variety of materials and techniques of workmanship increased experiences and choices, which in turn led to increased skill and knowledge. The art historian Glenn Adamson refers to this deep understanding of materials and the material world and the know-how required to give meaningful form to these materials as "material intelligence," and laments how we have lost that particular skill to a consumerist mentality, reliance on jigged machinery, and a fascination with digital representation.[68] In reuniting objects and knowledge, Adamson thus reminds us about the broad impact of interchange.

# Chapter 4 Function

      As objects circulated, they not only contributed to the development of artisanal knowledge of materials and technologies, but they also participated in a human ecology, what the anthropologist Mary Douglas calls a "live information system." Largely neutral by themselves, objects became activated with significance when in use within a social context, so in this chapter I turn my attention to the user of objects. In addition to offering convenience, beauty, and variety, they also communicated information, carried social meaning, and sustained relationships. In a time of mobility, they helped establish or enhance the complexity of social connections, allowing for inclusion, competitive display, exclusion, or differentiation based on class, race, or gender. When deployed, either in use or display, an assemblage of objects makes "physical, visible statements about the hierarchy of values" to which their purchaser or owner subscribes.[1]

    In serving a cultural purpose or fulfilling a social need, functional objects had use value and symbolic value as well as exchange value. A perceived need or desire, often conditioned by mobility, changing fortunes, or exposure to different types of objects, provides an important link between production and consumption, between realization and function. Scholars interested in the field of perception, such as James Gibson, have developed the concept of "affordance" to describe such a link between object and user. According to Gibson, an object possesses concrete, formal clues about the way it should be handled or deployed, but users bring their own experience, intent, and capability to the act of physical engagement.[2] For example, a British ceramic teapot (see

fig. 1.6) was conceived for the polite consumption of that beverage along with other proper equipage. Its handle, spout opposite it from which liquid would flow, and removable cover that permitted the pouring of ingredients and water into the vessel combined to satisfy that need. The use of transfer decoration, often depicting scenes of proper behavior, would also permit matching decoration on other elements of the tea service, the matched set being another sign of gentility. But some consumers may have purchased the teapot as a single object and used it for other beverages or even as a spouted pap boat, a vessel that allowed older or infirm people to drink without fear of spilling.[3] The concept of affordance thus enables us to see function as essentially situational and particular.

Modern design theory has attempted to fix and stabilize the notion of function as the catalyst for a certain aesthetic formalism. The maxim "form follows function" privileges the authority of the industrial designer or architect, pays less attention to context, and often restricts the impact of precedence, input of makers, or needs of the consumer.[4] It is a top-down view of function. Such elitism also colors many scholars' approach to the historical purchase or acquisition of objects. We need to overcome a reliance only on the provenanced objects of the elite, privileging of scarcity as the driving force in value, and conception of acquisition only as patronage; these are legacies of the art historical canon that focuses on objects of the highest aesthetic content and artist-patron relationships in the commissioning of painting, sculpture, or architecture. Archaeological work, archival documents, regional collections, and artifactual evidence all help to expand our notion of function as it relates to a fuller spectrum of everyday objects made of readily available materials.

A single object such as a copper alloy covered pitcher provided different affordances to different people at the same time or to the same person at different points in time (fig. 4.1). Cast of bronze in England during the late fourteenth century, it explicitly proclaimed its local roots with decoration consisting of the royal arms of England under the spout, six rondels with a spread-winged falcon around the neck, and a Richard II heraldic motif consisting of a lion surmounting a stag couchant on each facet of the lid. The vessel was the work of a sophisticated foundry, likely in London, that had the equipment and knowledge to cast the body with integral ornament and lettering. The casting of bells, mortars, grain measures, and other durable forms required this same material and technique. Large and heavy, the pitcher was not a tableware item but more likely a valued storage vessel from a royal residence or large manor house with close ties to the king. Its size and weight linked it to the heavy furnishings of the period such as large oak tables, heavy wool and linen tapestries, and wooden and metal plates and bowls. The elaborate decoration, including a

poem, elevated it above mere liquid storage, ensured that it could be properly inventoried, and indicated its importance as a message-bearing luxury for an aristocratic household. Yet its size and weight also placed a burden on the household staff who actually used it, cleaned it, and maintained it.[5]

At some later point in its history, it turned up in West Africa, brought either through the trans-Saharan trade that channeled gold to Europe in exchange for European goods or through Portuguese traders who brought in copper bracelets and other copper objects to West Africa. The pitcher had apparently lost its functional or symbolic value in England and was considered expendable. In the Asante kingdom, where copper and copper alloys were highly esteemed, the pitcher took on a new function—the role of charm, carried for good luck by troops heading into battle, or sacral vessel, positioned with other symbolic vessels in shrinelike clusters under a sacred tree at the Manhyia Palace in Kumasi. In West Africa, the iconography lacked the same explicit power it had back in England; rather, the pitcher simply gained affective power by its origins in a distant, exotic land unknown to the Asante and by its copper-based material. The material, weight, and patina all contributed to its talismanic power in West Africa. When the British army sacked the palace during the 1896 Anglo-Ashanti War, Major General Charles St. Leger Barter seized it as plunder and sent it back to Britain, where it entered the collections of the British Museum and was put on view in a vitrine as the *Asante Jug*. Its original English origins pushed to the background and its African spirit and power denied by the museum environment, the vessel thus took on yet another function, an assertion of Britain's imperial power and racial superiority, a form of material reclamation.[6]

The example of the covered pitcher demonstrates how affordance can be a productive concept in exploring the social history of an object. It emphasizes that objects can be both relational and situational, accruing new meanings as they circulate, function, and are displayed over time. In this process, some objects continue to be used in consistent ways, others gain additional power as social props, and yet others shed their original intent or are repurposed. This chapter focuses on the broader categories of function within the household, palace, or cultural institution, whereas the following chapter explores in greater detail a more abstract notion of function, the object as site of memory or gift.

In considering everyday objects we need to recognize how context determines and shapes form *and* function. In grounding function in this manner, it is useful to distinguish between use value, social value, and symbolic value, the first concerned primarily with the physical environment, the second with the construction and maintenance of the social system, and the third with ideology and ritual. The anthropologist Lewis Binford referred to these three

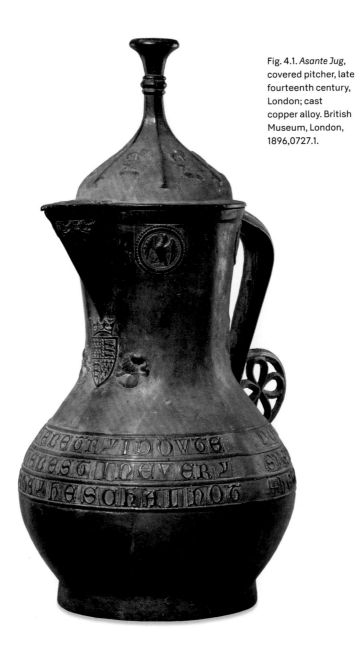

Fig. 4.1. *Asante Jug*, covered pitcher, late fourteenth century, London; cast copper alloy. British Museum, London, 1896,0727.1.

as "technomic," "socio-technic," and "ideo-technic."[7] When objects are at work in the world, these categories are neither sequential nor discrete. In fact, they often overlap.

"Function" is not a neutral term, as the word "ergonomics" might suggest, but rather is encoded with certain cultural attitudes or preferences. To refine Binford's notions more clearly, we might break down the concept of function into three categories, the boundaries between which may vary over

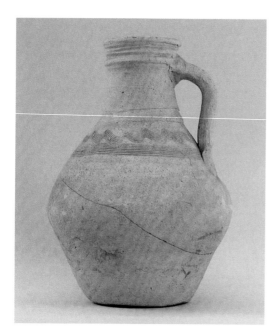

Fig. 4.2. Ewer, Nishapur, Iran, eleventh century; wheel-thrown body and pulled handle of slip-covered, unglazed earthenware. Metropolitan Museum of Art, New York, 40.170.195.

time, space, and class: necessities, improvements, and luxuries.[8] This spectrum of function has implications in terms of materials, realization, levels of finish, numbers, sizes, and linkage to other objects and resources. For example, in medieval Greater Iran cultures, pitchers for water and ablutions could range from a simple-handled, generic, earthenware pitcher acquired locally and that was easily replaceable (fig. 4.2) to an elaborate copper alloy pitcher inlaid with specific silver, gold, and niello dedications (see fig. 2.30). Other options in between would include a more elaborated local fritware ewer based on metalwork examples (fig. 4.3) or a stylish, imported, glazed porcelain vessel that featured a white body and painted decoration made in a specialized pottery (see fig. 3.38).

Formal variations can also signal the different levels of use. Local woodworkers might produce a basic nailed chest of boards to provide raw storage, but a more specialized woodworker, the joiner, might use paneled construction to make a chest with drawers, providing more opportunities to separate different types of goods and facilitate retrieval. But the drawers are usually similar in size. An even more specialized form of storage would be a large, dovetailed carcass made with exotic materials or surfaces on the exterior and multiple drawers of different sizes according to different uses. But one must be careful not to project an aspirational ethos to the categories and assume that everyone sought to progress from one level to the next. Rather, local culture and social structure impact the suitability of each category.

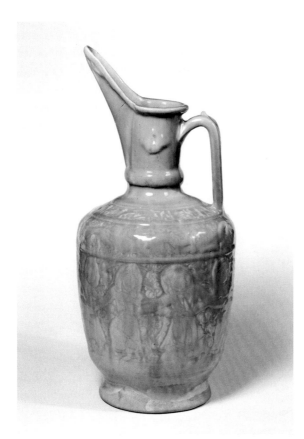

Fig. 4.3. Ewer, Kashan, Iran, ca. 1220; press-molded fritware with glazed surface. Victoria and Albert Museum, London, Ades Family Collection, accepted under the Cultural Gifts Scheme by HM Government and allocated to the V&A, 2019, ME.113–2019.

## Necessities

Necessities are often linked to life-sustaining elements such as shelter, fuel, food, and storage; they permit subsistence. Objects that are necessities tend to be temporary, low-risk, or efficient solutions. But they were not necessarily shoddy; they could possess, indeed depended on, a high degree of direct workmanship. Furthermore, they are often multipurpose objects made locally as part of a social economy and therefore easily replaced, providing work for local artisans and further tightening bonds of interaction and interdependence.[9]

Baskets woven from local plant materials or large vessels of drape-molded earthenware provide easy, portable storage, while low-fired earthenware pots are used for storage, transport, cooking, and serving. Iroquois cooking pots with round bottoms were intended to be propped up on small rocks set within embers (see fig. 1.3); African or Southwest American water jars with tapered necks minimized spilling when being carried (see fig. 2.6); and Incan *urpus* of varying sizes, used to transport or serve the chicha corn beer of the area, had

Fig. 4.4. *Urpu* (large vessel for liquid), Cuzco area, Peru, fifteenth–early sixteenth centuries; coiled earthenware with slip. Metropolitan Museum of Art, New York, Michael C. Rockefeller Memorial Collection, purchase, Nelson A. Rockefeller gift, 1961, 1978.412.68.

added looped handles and lugs to help secure the carrying straps of human porters and bottoms shaped to allow easy resting on the ground (fig. 4.4). Felted wool, barkcloth, or woven textiles served a variety of purposes, from shelter and transport to floor covering and clothing. For the Mongols of the Central Asian steppe, felt was the most valued material, used in very straightforward ways for shelter, clothing, and flooring.

In heavily wooded areas such as northern Europe and northern North America, wooden vessels dominated until the late seventeenth century, when pewter and ceramics became more available, and wood has traditionally served as the preferred material for furniture. Clear woods like birch and alder were ideal for turning, hewn burls provided durable vessels, and a wide range of woods could be used to make chests and tables. With fewer possessions, there was little need for complex, organized storage, so a simple large woven textile or nailed board chest could hold many personal possessions; sorting or retrieval was not thought to be a problem. Chests could even double as seating and table surfaces. Perhaps the ultimate multifunctional personal object was the kerf bent box of the Pacific Northwest (fig. 4.5). Left plain, these lidded boxes were used for storage, transport, sitting, and even cooking, since they were watertight and could accommodate a hot rock added to a liquid in the box. With painted or carved decoration, which added time and therefore expense to their realization, they became luxuries, assuming distinct symbolic

function with the addition of clan crests and use in certain ritualistic performances (see fig. 2.34).[10]

While made primarily by free workmanship from local materials, these objects were not necessarily plain, utilitarian wares but demonstrated attention to ornament and finish commensurate with cost and use. Function and aesthetics were not mutually exclusive. Ceramics were decorated with modeled or textured surfaces or painted with slip, wood could feature animalistic shapes or geometric incised decoration, and textiles were colored with natural dyes. The link between production and acquisition, reliance on local materials, commonly understood decoration, and shared understanding of how to use the objects thus drew the community closer together in a web of interrelationships and mutual needs. These wares were typical for people not fully engaged with external markets or those who traveled lightly as they made seasonal rounds, such as the Indigenous populations of North America.

While one can place individual objects along the functional spectrum, it is also important to consider artifactual assemblages or groupings—the manner in which objects work together. As attention shifts from individual objects to sets or assemblages of objects integrated with activities, one can apply a more sociological perspective, exploring how objects utilized together in a domestic setting might establish, affirm, alter, or critique certain cultural values about identity, status, gender, and privacy. This allows exploration of the social value of objects, that is, how they embody aspirations or networks and mediate relationships between people. Following the work of the sociologist Erving

Fig. 4.5. Oil box, Tlingit people, Pacific Northwest, 1899; kerf bent cedar body with solid inset base of cedar and painted decoration. Courtesy of Peabody Museum of Natural History, Yale University, New Haven, CT, YPM ANT001396.

Goffman, material culture scholars often apply a theatrical model in regard to deployment, using terms such as "scenes," "actors," and "props," and distinguish between more formal, polite, "front" activity and the informal everyday support work of "back" activity. The former took place in the entertainment spaces and featured the most stylish or showy objects, while the latter took place in service areas or more private spaces and placed greater value on functional fit. Such a perspective helps animate the objects in use, as the script of usage retains a dynamic, situational quality, as described by Bruno Latour's actor-network theory.[11]

Social activity is not always structured by or subject to behavioral codes dictated by objects. For example, privacy and leisure are culturally constructed concepts that entail different things among different people.[12] In applying Edward Hall's notion of "proxemics," the study of human use of space and objects for interpersonal relationships, we can see that some people are content with basic necessities, intensively organizing and using a small number of multipurpose objects, because either of cultural values—such as the importance of mobility or uncluttered interior space—or economic circumstances. They rely on internalized notions of distance and personal space rather than material props to structure their interactions. For example, many people do not spend significant portions of their days indoors, so the enhancement of the domestic environment is not a high priority; it is merely a place to retreat to in the dark of night. This can be seen in the realm of lighting. Basic necessities include a wood- or dung-fueled fire, splints or wooden lengths that provide light for a limited time, or oil lamps in which ceramic or metal receptacles hold animal fat or wax with a thread wick in it. The candlepower is limited in strength and duration, and the lamps often produce smelly smoke. For the most part, such people orient their days toward sunlight, maximizing activities under natural light and retreating inside only during inclement weather or the night.

The concept of leisure provides another way to think about necessities. Some people simply seize the moment among task-oriented rhythms and find privacy, relaxation, or sociability through shared conversation, song, dance, or drink without specialized objects. They adapt basic earthenware vessels, available furniture, cloth, and metalwork to the general needs of that moment. Drinking fermented beverages, playing music, or participating in board games while working in fields or woods or in a public space like a tavern are typical of such activities. They can be democratic and spontaneous, more linked to informal, casual conduct than to formal, genteel behavior. Consuming fermented drinks, particularly in eras when potable water was not consistently available, could serve a variety of purposes: medicinal, stimulant, escapist, catalyst for flights of imagination, or as the basis for social bonds. Scenes in Greek

mythology, Netherlandish tavern scenes, and William Hogarth prints all point to the casual, informal, and universal activity centered around local fermented beverages such as beer, ale, cider, sake, or chicha. Smoking, card playing, and other similar games of chance often accompanied this public-based world of drink. These games tended to be immediate, inclusive, and fluid.

## Improvements

Improvements can make life appreciably easier, indicate a crossing of the threshold of permanence, and codify the use of certain objects to create or establish social identity and distinction.[13] Rather than rely on internalized notions of privacy and leisure, those who seek improvements consciously orchestrate their relationships through objects. Investment in greater numbers, more substantial, more specialized, and varied types of possessions requires motivation, means, and opportunity. These objects also typically have very purpose-designed functions. Settlement, continuity across generations, interest in long-term solutions, and access to a larger market provide necessary conditions for improvements.

Changes in production also played a role in accessibility to improvements. Beginning with Chinese potteries in the eleventh and twelfth centuries, increased craft specialization, referred to in Britain as the Industrious Revolution, or more efficient production with task specialization, jigs, or nonhuman power sources, also helped increase the availability of goods to a broader population. In the case of cooking vessels, iron and copper alloy cooking vessels produced in fuel- and labor-intensive foundries provided a competitive alternative to ceramic pots. In the seventeenth and early eighteenth centuries, European metal cookware, circulated through the fur trade, undermined Indigenous ceramic vessel production throughout much of North America. The growth in personal possessions also necessitated more specialized storage forms with more compartmentalized sections and better retrieval systems. Drawered chests and wardrobes catered to the increased amount of clothing and textiles. Refined ceramics produced in centralized potteries, inherently more vulnerable and subject to fashion, replaced wooden treen on the table, a development that resulted from efficient production and marketing and consumer desire for more regimented eating.

The effect of market-driven improvements is clearly evident in a 1761 drawing by Ezra Stiles of the interior of the dwelling owned by Phoebe and Eliza Moheage in Niantic, Connecticut (fig. 4.6). Within a traditional wigwam constructed with a bent sapling framework covered in tree bark, reed mats, or animal skins, Stiles noted the customary Indigenous interior: a central fire, sleeping and living platforms raised above the dirt floor, and mats for

Fig. 4.6. Drawing of a wigwam interior in Niantic, Connecticut, Ezra Stiles, 1761; pen on paper. Ezra Stiles Papers, General Collection, Beinecke Rare Book and Manuscript Library, Yale University, New Haven, CT.

bedding. The structure, ten feet five inches high and seventeen feet four inches by twelve feet in plan, provided a home to five men and eight women. For privacy within this small structure, they relied on internalized notions of personal space. However, other items Stiles recorded reveal the encroachment of external notions of improvement: a shelf with plates (which were likely ceramic but could also have been pewter) and a bottle, a dresser for the storage of other tableware, handled metal pots hanging on wooden hooks, two chests in which to store belongings, a tea table and chair, and a second table with plates.[14]

Connected to improvements was the desire to construct and implement physical and psychological comfort, a recognition of the desire to exert control over natural forces.[15] This can be seen not only in the increased specialization of rooms but also in the types of objects to fill these spaces. A major improvement was lighting, necessary to make usable interiors from spaces that, owing to the limitations of building materials or the need for heat retention, had few windows or other sources of natural light. Dependable lighting became increasingly important as people extended their activity into the night or entertained within the home. Increased production of candlesticks in metal or ceramic, improved beeswax candles, and use of looking glasses to amplify light were signs of this sort of improvement.[16]

Seating is another form of culturally constructed improvement. Humans do not naturally perch on fabricated seats sixteen inches above the ground. Rather, our basic instinct is to sit on the ground or floor, perhaps on a textile, or on a natural available object like a stump or rock. Or we simply squat. The concept of a dedicated piece of furniture to elevate a person up off the floor began with stools and couches in the classical Mediterranean world and then developed into singular forms that often denoted rank, such as thrones or couches that doubled as beds. Seating furniture remained uncommon until the early modern period, when a less peripatetic lifestyle and increased artisanal activity fostered new conventions in which people owned sets of chairs so that everyone could rest above the floor.[17]

However, some people constructed or sought specialized activities with dedicated objects to foster exclusive societal bonds, affirm family identity, or follow gendered norms. Importing fermented beverages or distilled beverages from afar set up a different dynamic, one more of exclusivity than inclusiveness. Wine often was associated with bronze and then fine ceramic ewers in China, while copper alloy ewers were most common in South Asia and glass bottles and glasses in the European world. Equals of higher classes tended to be the participants in wine collecting and the rituals of wine drinking. Distilled spirits, much more potent than fermented beverages, also became a beverage whose potency was thought appropriate only for the refined upper classes. The late seventeenth and eighteenth centuries were a time in which punch, initially an Indian beverage, became a global drink when East India Company men brought it back to Britain. Punch mixed gin from Europe, rum from the Caribbean, or arrack from South Asia with water, lemon or orange juice from the Iberian Peninsula, sugar from the Caribbean, and spices from Southeast Asia. Certain equipage was thought to be appropriate for this new social lubricant: a punch bowl into which to mix the contents, silver or copper metal strainers to keep pulp and other unwanted elements out, ladles to hoist the punch from the bowl, and specific sorts of glasses with greater capacity than wine glasses.[18]

Another activity for which more specialized equipage developed to aid in the scripting of exclusionary behavior was card playing, which became a very codified game among Europeans in the seventeenth and eighteenth century. Played often at night using elaborate cards and employing specific tables that featured soft textile surfaces, carved oval recesses to hold mother-of-pearl counters, and square recesses for silver or brass candlesticks, games like whist brought together elites of mixed genders who could revel in their leisure, flirt, showcase their expensive clothes, build alliances, and flaunt their discretionary money in the waging of bets. A nocturnal activity carried out in sumptuously furnished parlors, card playing signified a detachment from agrarian time, informal card playing at the tavern, and multipurpose rooms (fig. 4.7).[19]

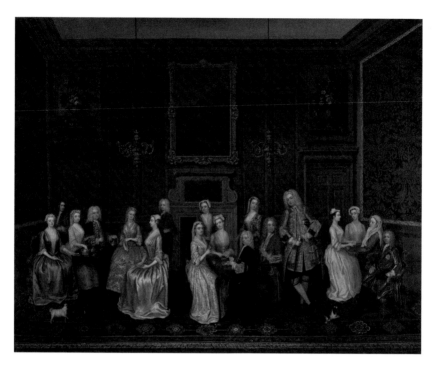

Fig. 4.7. *Tea Party at Lord Harrington's House, St. James*, Charles Philips, ca. 1730; oil on canvas. Yale Center for British Art, New Haven, CT, Paul Mellon Collection, B1981.25.503.

The consumption of hot beverages provided another opportunity for social differentiation based on location and equipage. Although drinking tea in China, coffee in the Arab world, or chocolate in the Americas occurred among a variety of social groups for many purposes—including medicinal, stimulant, or ritual—and employed brewing and drinking vessels of assorted expense, these beverages took on a different profiles as they traveled with traders (particularly in the seventeenth century), were mixed with sugar, and became part of codified behavior. Coffee initially became more of a public drink served in coffeehouses and played an important part in political culture, following Arab tradition, but then in Europe and North America became a more privatized domestic drink, but never the dominant one. Hot chocolate was another domestic hot beverage that developed a strong tradition in the Iberian world, where silver and copper vessels, silver straws and cups, and tin-glazed and porcelain cups with handles were part of the cacao culture. Tea became the dominant drink in England, where the interest in matched sets of ceramic pots, creamers, sugar bowls, slop bowls, and cups and saucers or matched silver serving pieces raised the social stakes of tea drinking as a performative, exclusionary social pursuit. In fact, many British paintings of the

Fig. 4.8. *Fond of Tea Gatherings* (*Chanoyu kō*), from the series *Twenty-Four Enjoyments of Beauties of the Present Day* (*Nijūshi kō tōji no hanamono*), Utagawa Kunisada I and Ryōko, Japan, 1863; woodblock print (*nishiki-e*), ink and color on paper. Museum of Fine Arts, Boston, William Sturgis Bigelow Collection, 11.43074.

mid-eighteenth century show genteel citizens playing cards, drinking tea, and engaged in needlework, all attributes of that leisured gentry class.

The Anglo version of tea drinking contrasted with the rather small, private nature of the Japanese tea ceremony based on Chinese practice and codified in the sixteenth century, which emphasized the importance of different materials for each implement, the value of engagement with those materials, and a more intimate experience (fig. 4.8). The tea master would heat water in an iron pot (*kama*), use a bamboo scoop (*chashaku*) to retrieve powdered tea from a lacquered tea caddy (*natsume*) and empty it into a stoneware tea bowl (*chawan*), dip a bamboo ladle (*hishaku*) into the iron pot to gather hot water to pour into the tea bowl, and then froth the liquid with a bamboo whisk (*chasen*). Old *chawans* were valued for their historical associations.[20]

Equipage was crucial to Anglo and Japanese tea drinking, but in different ways. In the Anglo version, the practice provided an opportunity to showcase the ability to amass a matching new, fashionable service. The emphasis was on one's consumptive power, the ability to purchase a coordinated set all at once. A coherent set linked a group of social equals while elevating them above others. Japanese tea drinking prioritized the contemplation of different materials suited for different ingredients or uses and demanded aesthetic reflection. But it could be a highly performative aesthetic practice that often became the site of competition among warrior or literati classes. It relied more on collecting and material discernment, an ability to acquire the correct Chinese storage jars, seek out bowls made in certain potteries, and search for special imported textiles in which to wrap the ceramic bowls.[21]

Fig. 4.9. Cupboard, unknown maker, Philadelphia, Pennsylvania, 1800; white pine and cedar. Courtesy of Winterthur Museum, Winterthur, DE, bequest of Henry Francis du Pont, 1959.1126.

Fig. 4.10. Étagère, George Croome, Boston, Massachusetts, 1861–65; joined mahogany, rosewood, black walnut, marble, mirror glass; carved decoration. Museum of Fine Arts, Boston, H. E. Bolles Fund, 1977.753.

The increased number of objects led also to the conscious display of certain objects removed from quotidian or even social use. For some special objects of improvement, use tended to be more episodic and presentation became more important. Display implied temporary removal from traditional use and an emphasis on visual appreciation from a critical distance removed from daily function. Middle-class consumers developed display strategies that would showcase their best consumer goods at rest, for the eye rather than the hand. Decorated ceramics oriented in a vertical plane and copper alloy vessels and lighting devices stood on top of case furniture or on mantles; some plates even had holes drilled in their feet to facilitate hanging on the walls. Built-in architectural cupboards became very specific display cabinets, replete with glazed doors and shaped interior shelves that might feature plates resting vertically in grooves or against a molding and where bowls or cups would sit in front of the plates or even on special round projecting shelves (fig. 4.9). In these cupboards, objects served a static purpose to proclaim status through consumption, yet the objects could be taken from the shelves and used for

tea drinking or dining. The further extension of this display strategy was the nineteenth-century étagère, in which shelving backed by mirrors permitted visual study in the round, promoted deep contemplation, and contributed to visual self-fashioning (fig. 4.10).

Codification of social practices with specific, elaborated assemblages was one way of using material improvements to develop exclusive networks, but another was through the use of specific motifs or forms. Embroidery of textiles was one obvious way to mark familial ties and associations, whether it was West African women embroidering raffia cloth woven by male craftsmen with dyed raffia threads to ensure proper affiliation in the afterlife or Bengali women stitching their names or personalizing kantha cloth with their own selection of motifs (see fig. 2.26).[22] Special orders with specific instructions were another way to draw connections, as is seen in Chinese porcelain decorated with heraldic devices for specific European clients (see fig. 1.9).

Workshops also used imagery to develop or appeal to emerging markets. After the United States declared independence, the brass industry in Birmingham began to stamp out escutcheons for furniture and potters in Staffordshire and Bristol developed transfer decoration for pitchers and plates that featured patriots such as George Washington and Benjamin Franklin or patriotic imagery such as the eagle or the seal of the United States. These brass foundries and potteries recognized the vast potential of the American market and quickly put aside political resentments (fig. 4.11).[23] Among the Inca, weavers producing tunics and lacquerers decorating keros (drinking cups) often ornamented their

Fig. 4.11. Pitcher, Herculaneum Pottery, 1800–1807; press-molded refined earthenware with transfer decoration depicting the laying out of Washington, DC, the Great Seal of the United States, and the apotheosis of George Washington. Yale University Art Gallery, New Haven, CT, Mabel Brady Garvan Collection,1931.1966.

Fig. 4.12. Armchair, London, 1685–1705; joined, turned, and carved walnut frame with cane. Part of a suite of twelve chairs ordered from London by the Hartford, Connecticut, merchant and magistrate Samuel Wyllys, son of Governor George Wyllys. Samuel owned an interest in several West Indies sugar plantations. Connecticut Historical Society, Hartford, CT, gift of Daniel Wadsworth, Esq., 1844.69.1.

objects with *tocapus*, glyphs that were crests of family or rank (see fig. 1.17). This sort of decoration established clear associational ties to those who understood the visual language.[24]

Another, slightly subtler, way of communicating affiliation was through certain forms. In China tall, shallow tables with everted ends (curving up and outward) were often used for the examination of scrolls and square tables for the study of bronzes. Thus, these forms developed associations with the educated literati (see fig. 7.6).[25] Tall-backed cane chairs, a type that originated in late-seventeenth-century Netherlands and France, quickly became the specialty of chairmakers in London. They organized a very decentralized but coordinated outwork system of production among woodworkers such as turners, carvers, chairmakers, and caners. These English artisans combined imported styles and materials like cane with English woods into a stylish distinctive English product. That the chairs were suitably priced for export to merchants and magistrates throughout the newly established and quickly growing global British Empire further underscored this mercantilist aesthetic (fig. 4.12).[26]

## Luxuries

Luxuries, related to but distinct from improvements, embodied an excessive investment in the material world not simply for physical comfort and social affiliation, but for the purpose of power and prestige. For much of human his-

Fig. 4.13. *The Palanquin*, designed by John Vanderbank, woven by the Great Wardrobe, London, ca. 1700; wool and silk tapestry. Part of a marriage set for Elihu Yale's daughter Catherine. Yale University Art Gallery, New Haven, CT, gift of Edward S. Harkness, 1932.130.

tory, status has been achieved through the purchase, acquisition, and deployment of sheer numbers of things, artifacts made out of rare or costly materials, or items in a current style or fashion. Luxuries tended to be larger, made with more expensive materials and more costly labor, and comprised larger sets of related objects.[27] In this way they could be considered an extension or intensification of improvements, but at a higher level. The ability of a successful businessman like Elihu Yale to commission his own set of tapestry hangings, in "the Indian manner" that references his career in Madras, provides one such example of a luxury (fig. 4.13). He did not purchase stock hangings, which itself would have been a statement of status, but sought one-off exclusivity. Private commissions constituted one form of luxurious function. Rather than being linked to subsistence and the local sphere, such objects celebrated a lack of concern with the everyday and demonstrated a greater interest in fashion

or style as defined elsewhere. In the phrase made famous by the sociologist Thorstein Veblen, they were objects of "conspicuous consumption," intended explicitly to signal an abundance of discretionary assets, whether to consolidate existing status or to demonstrate aspirational goals.[28]

The impulse toward luxuries was not simply the result of the Industrial Revolution and the wider availability of merchandise but has a longer and deeper history rooted in the interchange of goods. Court cultures since the classical period have relied on expensive objects or exotic materials to assert their power and authority, whether it be a Greek ruler dedicating a gold drinking vessel (*phiale*) to a god or amassing expensive goods in a treasury to seek favor with a god; a medieval king purchasing sets of large tapestries for the walls of his abode; a Chinese ruler establishing a Hall of Ancestors with paintings, tapestries, and rare objects; or the Hapsburgs assembling and giving away Japanese lacquer, Chinese porcelain, or American featherwork acquired throughout their expanding empire. Royal courts also established special workshops to create singular work for their residences and public spaces. Increased trade and the Industrious and Industrial Revolutions simply expanded the range of people who might pursue some form of luxury, albeit on variety of scales. Luxuries, which tended to be more expressive and often of limited or restricted use, were other-directed objects, whereas necessities were inner-directed and often founded on tradition.[29]

In widening the category of luxuries beyond precious materials or greater number of goods and focusing on luxurious function rather than simply the luxury object, we need to consider the associational and contextual impact of objects. In spite of a formal reference to use, some objects were totally removed from everyday handling and deployed only for visual effect. The emphasis on display, based on access to the desirable material and an emphasis on the function of decoration, can be seen in the use of Chinese porcelain plates and dishes in different contexts. In the Santos Palace in Lisbon, a successful nobleman installed approximately 260 Chinese porcelain plates in a pyramidal ceiling between 1664 and 1687. The Lancastie family displayed its taste and ability to purchase fashionable imported wares but then removed them from strict functional value, highlighting their superfluous function (fig. 4.14). The plates were arranged aesthetically, to be visually consumed rather than handled. In the eighteenth century, traders on the Swahili Coast of East Africa, whose role in the Indian Ocean trade linked them to South Asia and East Asia, also used Chinese porcelain plates in a dense decorative manner to signify status and trading connections (fig. 4.15). Color, shiny surface, and fixed massing trumped table usage. In both examples, the display was a conscious arrangement rather than a few pieces of ceramics displayed in a cupboard, on the mantle, or along a plate rail molding.[30]

Fig. 4.14. Pyramidal ceiling of the Porcelain Room in the Santos Palace, Lisbon, Portugal; installed between 1664 and 1687.

Fig. 4.15. Photograph of an eighteenth-century merchant mansion in Lamu, Kenya, 1884. National Library of Scotland.

Removal from original context and recontextualization also characterizes another aspect of luxurious function. In a time when long-distance travel was arduous and risky, the publication of illustrated travel narratives and circulation of foreign objects stimulated people's imagined geography. Unfamiliar objects from afar gained the notion of exotic, whether they were European goods in Japan or the Kongo, or Kongo or Japanese goods in Europe. The asymmetries of valuation worked in both directions: each culture perceived that the other did not understand the highly desirable objects they took for granted.[31] *Nanbanmono* in Japan, a term applied to objects arriving from South Asia and beyond, or *asiatique* in France, an adjective used for superfluous luxury, point to the manner in which curiosities accrued value from geographic and cultural distance.[32] With the rise of the *chanoyu* tea ceremony in Japan during the late sixteenth century, practitioners paid particular attention to collecting textiles from various locales to use for covers of tea caddies or for wrappers of other paraphernalia. These members of the merchant and military classes collected samples including Gujarat block-printed cottons, Mughal woven silks, and Chinese woven silks and referred to them as *meibutsugire* (famed fabrics). A surviving piece of Mughal weaving illustrates this transformation. Originally part of a shawl and likely carried by Ryuku or Portuguese traders to Japan, this type of striped fabric became a popular choice for tea caddy covers and tea

Fig. 4.16. *Isaac Royall and Family*, Robert Feke, Boston, Massachusetts, 1741; oil on canvas. Harvard Law School Library, Historical and Special Collections, Cambridge, MA.

Fig. 4.17. Bell tower of Nossa Senhora da Conceição do Monte, Cachoeira, Brazil, built in the eighteenth century. Roof is tiled with Chinese porcelain plates and dishes.

equipage wrapping. Referred to as *moru*, a term translated as "Mughal cloth," the weave consisted of pashmina wool with supplemental weft brocade of silk thread wrapped with gold or silver leaf.[33]

A European example of recontextualized objects were the tapestry woven carpets made in the Ottoman Empire and Central Asia. Intended as floor coverings and seating areas, these textiles left the ground in English use during the second half of the seventeenth century. Anglos used them as table covers or upholstery fabric to showcase their foreign origins and referred to them as "turkey carpets," an essentializing term tied to a broad geography. Draped over a table, the carpet's color and pattern covered a plain wooden surface when the owner wanted to impress visitors. Certainly, the rather thick pile did not improve the utilitarian function of the table, so it participated in the semiotic value of objects (fig. 4.16).[34]

A final, unexpected example of objects being transformed into symbolic items might be the use of sherds of Chinese porcelain plates to cover the bell towers of colonial Portuguese churches in South America, such as the mid-eighteenth-century Church of Nossa Senhora da Conceição do Monte in Cachoeira, Brazil (fig. 4.17). Instead of locally sourced earthenware roof tiles or wood shingles, the use of an imported luxury commodity as a building material seems strange. Perhaps the sherds were simply casualties of the rugged transport networks that brought the porcelain across the Pacific via the galleon trade and then to Brazil via coastal vessels and overland shipping.

But the use of decorative tile, referred to as *embrechado* in Portuguese, might have accorded the plates a ritualistic value rather than one of recycling. One of the most common imports on the galleon trade, porcelain may have been consciously used in the highest points of the churches. There is a distinct deliberateness in the deployment of the whole plates along the ridge lines and broken pieces along the surfaces in between. The builders chose to install whole plates far up above the usual resting place of porcelains on tables or in display cabinets. Perhaps the display of a luxury import close to God attested to the Christian good works undertaken here on earth in the colonial world and was a point of civic pride. This use of imported ceramics to symbolize Christian conquest and assert a regional identity tied to commercial success parallels the use of *bacini*, or ceramic bowls, as architectural ornament on the religious structures of eleventh-century Pisa. These bowls, made in various pottery centers of the Islamic Mediterranean and featuring high-gloss lead and tin glazes, including stylish lusterware from Egypt, were set into the brick and stone exteriors.[35]

Key to understanding the notion of luxurious function is the distinction between acquisition, accumulation, and collection. While acquisition assumes a simple transaction, a purchase or exchange, for a perceived need or desire, accumulation is the mounting effect of several acquisitions and often correlates with improvements. Many assemblages of objects with social value were used in scripted performances that bordered on rituals, but certain other objects took on ever greater symbolic value that transcended straightforward exclusionary or identity functions when they were intentionally retired from physical use. These were collected objects. Collection suggests a different sort of motive and function from acquisition, one based on qualities such as organizing, classifying, and presenting material knowledge, or satisfying psychological needs or emotional desires. The humanist Susan Stewart describes collection as the "total aestheticization of use value." Collected objects occupy a space that can be delineated as "conceptual" in function, where an everyday form becomes an idea and the user a viewing audience. The commodity thus becomes the fetish.[36]

Class provided the structure for the collecting impulse based on empiricism that gained prominence in the early modern period. At that time, the knowledge acquired through observation and deduction drove members of royal courts, aristocrats, and others of means to collect natural history specimens, items made in distant lands such as lacquer or porcelain, historical objects such as Roman coins, and books. All these categories gained acceptance as legitimate pursuits for gaining knowledge. Scientific and historical knowledge were of a single piece in natural philosophy that connected curiosity, careful study, and wonder.[37] A late example of this combination of collecting

and science is the work of Edward Sylvester Morse, a Boston-based zoologist specializing in brachiopods who assembled a collection of Japanese ceramics in the last quarter of the nineteenth century. His morphological method of collection, classification, and display guided his work in the natural world and the artisanal world.[38]

Western individuals developed and maintained whole rooms or cabinets on stands, referred to as *Kunstkammers* and *Kunstkabinetts*, that provided amusement and entertainment as well as expressing ways of knowing.[39] A late-sixteenth-century treatise on collecting encouraged the collection of sculpture, painting, coins, and "curious items from home and abroad" made of a variety of media.[40] A slightly earlier explanation of collecting specified a whole class of objects, including cast metalwork of any sort by artisans; work by turners, weavers, embroiderers, and others; wondrous objects that were either rare or distant in time or space from their origins; and "foreign vessels, made of metal, earthenware, sculpted, wooden." Skilled workmanship, associations with distance and age, and an ability to stimulate curiosity all were prized criteria for collection. Many objects of interchange possessed that hard-to-define sense of the curious and marvelous and played a prominent role as functional luxuries.[41]

In China, the eighteenth-century Qing court placed great value on *duobaoge*, a curio cabinet with complexly arranged shelves that displayed historical and contemporary ceramics, ancient bronzes, and other precious materials, which were considered scholarly objects worthy of study and contemplation by antiquarians interested in ancient Chinese history and connoisseurs more concerned with the collection of objects for pleasure and as exemplars of good taste. The Qianlong emperor had one installed in his study in the Forbidden City, and the display practice even influenced the development of a two-dimensional painted version, called a *chaekgeori*, in late-eighteenth-century Joseon Korea.[42]

Among rulers throughout Europe and Asia, Chinese porcelain earned special attention as marvelous curiosities: in 1611, the Safavid ruler Shah Abbas presented over one thousand pieces of porcelain to be installed as a *chini-khaneh* (house of porcelain) in the shrine dedicated to Shaykh Safi al-din in Ardabil (fig. 4.18). In this monument, the porcelain, as well as painted fritware, was displayed in vaulted gilt niches, out of reach of pilgrims and thereby establishing authority within a large region and stimulating wonder. In Charlottenburg Palace in Berlin, Frederick I established a porcelain chamber on the occasion of his elevation from elector to king of Prussia around 1700. To showcase the new king's Chinese and Japanese blue-and-white porcelain, Eosander von Göethe designed a porcelain room with bands of mounted plates acting as a frieze above mirrored shelving and display niches, replete with

Fig. 4.18. *Chini-khaneh* (house of porcelain) in the shrine of Shaykh Safi al-din, Ardabil, Iran, built in 1611.

relief caricatures of East Asian people and chinoiserie scenes. He grouped like forms together and arranged the ensemble to display conspicuous consumption, stimulate awe and fantasy, and assert Frederick's kingly authority. He also designed the room as a physical reworking of a group of foreign objects to affirm the king's Enlightened understanding of a global aesthetic (fig. 4.19).[43]

Many of these early royal collections shifted objects out of traditional cycles of use and focused on their classification. Organizing objects by material, technique, origin, decoration, or history and recording this information for posterity signaled a different sort of function. It necessitated knowledge, resources to acquire, time and expertise to catalog, and extra space to store and display. The Rajput Maharajas in Jaipur collected and cataloged various types of Persian and Mughal textiles, not to decorate their palaces but rather as a reference collection to reinforce their hereditary descent and cultured background.[44]

Royal and aristocratic collections also inspired the Western development of institutional collecting and display in national or academic settings. Whereas paintings, natural history specimens, and objects might have coexisted in collections up through the eighteenth century, these three different categories began to split into different institutional collections over the course of the nineteenth century. The fine arts of painting and sculpture were gathered

Fig. 4.19. Porcelain room in Old Charlottenburg Palace, Berlin, designed and installed in 1701.

together in dedicated art museums, while natural history and anthropology museums emerged to house specimens and curiosities.[45]

The destiny of objects was not as clear. In Britain, the 1851 Great Exhibition in the Crystal Palace was arguably the first grand institutional display of international objects. Organized by nation-states and with taxonomies that divided up material types, ranging from natural resources to consumer goods, the exhibition attracted significant crowds, showcased cultural imperialism, and led to the establishment of the South Kensington Museum in 1852.[46] Founded to guide and inspire designers to keep British manufacturers as world leaders and to improve the aesthetic judgment of consumers, the museum embraced a different mission from the National Gallery of Art, which concentrated on the fine arts of painting and sculpture. Other European nation-states followed suit and established applied arts museums such as those in Vienna in the 1860s, Frankfurt in the 1870s, and Budapest in the 1890s, to cite a few. In colonial India, museums such as Albert Hall in Jaipur also followed the South Kensington model, collecting electrotypes of iconic examples of European applied arts as well as examples of Jaipur work in a variety of media. In each of these museums dedicated to the intersection of art and industry, curators distinguished applied or decorative arts from other forms of artistic endeavors, relied on an initial classifying system based on materials, and focused on European works or the historical work from the nation's colonies.[47]

Other types of museums began to classify applied or decorative arts differently. The universal art museums that emerged in the United States in the 1870s collected some applied arts but often separated the Western examples from their contemporary fine arts in display. Collections of Asian and Islamic art, on the other hand, tended to bring together all forms of artistic production. Objects from Indigenous cultures or colonized, less developed, or what were considered racially inferior cultures were directed into anthropology or natural history museums. This bifurcation became even more troublesome when some art museums began to divide up their collections so that paintings and sculpture were grouped by nation and style to tell a developmental, chronological narrative; some decorative arts divided by nation and time period; and other decorative arts classified by media. For example, textiles remained a separate entity because of storage and light exposure requirements. An additional complication was the manner in which objects made in one place, but owned in another place, fell between the cracks. Some were exhibited with objects from the place of origin, while others with objects from the place of use. This classification and organizational system that emerged in the early twentieth century precluded an easy way to address an interconnected comparative history of objects.[48]

## Conclusion

This chapter has demonstrated how we might take a broad view of the function of everyday objects. While objects need to be understood on the grounds of their ability to fulfill certain utilitarian needs—vessels need to hold liquids, chairs need to support seated humans, textiles need to retain their structure while providing cover, and fabricated metals need effective joining of parts to provide durable service—they also serve a variety of occasional or even nonutilitarian needs. The concept of a spectrum of function helps to expand the possibilities of an object's physical meanings. Alone or as part of an assemblage, the object at work fulfills many different social and cultural demands, particularly as it moves across space and time.

But we also want to pay attention to the work of the object in ideological terms. Objects not only support, direct, facilitate, and restrict human interaction, but they also embody cultural values, often providing clues to ideas that may not be expressed in standard archives that privilege the imperial or elite perspective. Knowledge of available materials, techniques, complementary and competitive forms, and ornamental motifs in specific contexts permits a deeper understanding of conscious choice or rejection. What is not valued or incorporated is as important as what is valued and embraced. In tracking the flow of object ideas in the process of interchange, scholars often invoke the

term "translation," but we might also apply the word "editing" to emphasize an interest in the reception of the object. While makers tend to translate the various inputs of precedent and new fashion within available materials and their own technical repertoire, purchasers or users control the editorial process of selection and suggestions for revision. They ultimately determine the success of the endeavor. Key to this editing process is a different sort of evaluative process, related to but distinct from the skills of the makers. While the latter relied on a variety of senses in constant assessment of and feedback from their artisanal maneuvers in the process of realization, the former depended on a variety of senses to determine their judgment of the object. They used memory, sight, and touch in a different manner. The next three chapters delve into the way these senses contributed to this editing metaphor.

# III. MEANING

# Chapter 5 Memory and Gift

Raffia cloth filled many different functions along the Kongo and Loango Coasts of West Africa. Used for clothing (skirts and long coats in particular), wall hangings, and carpets, it also had important economic utility as a medium of exchange within the region and political power as gift. Kings and rulers stored the finest examples and gave them away to establish allies or reward loyal subjects. When the Portuguese first engaged with this region in the late fifteenth century, they expressed admiration for the technical skill and artistic accomplishments found in these fine cloths. In the early sixteenth century, one Portuguese writer described fabrics "with a surface like velvet and some worked like velvety satin, so beautiful that those made in Italy do not surpass them in workmanship."[1] Responding to this admiration, the Kongo kings presented examples of the high-quality cloth to the king of Portugal in an attempt to gain certain privileges from a fellow ruler. Close contextual analysis of such work permits a broader consideration of how objects could be understood and value translated across cultures amidst asymmetrical power relationships.

When the king of Kongo converted to Christianity in 1491 and became João I Nzinga Nkuwu, he did so in part to gain the protection of the Portuguese in an attempt to consolidate his own power and authority in a region beset by infighting. Like the Indigenous people of Sri Lanka presenting the Portuguese rulers with ivory caskets, João I offered a local product that he knew the Europeans coveted and that to him represented acknowledgment of equal status between rulers.[2] When subsequent Kongo kings grew dissatis-

fied with the Portuguese unwillingness to give them total autonomy, they sent ambassadors and raffia textiles to the Vatican and the Dutch to seek such status within other European political units. The local Kongo artisans adjusted their skills for this foreign market. Rather than weave three lengths of cloth together to make a skirt, they converted a single length into a type of object they understood to be valued by the Europeans: a cushion cover. Apparently studying European examples, they wove a plush cloth and then sewed the edge seams with the case turned inside out, stitched on their own raffia cord along the outside of those seams, and knotted their own tassels. The cushion cover looked like a European example, but in terms of material and weaving technique it was totally Kongo. Some of these gifted textiles subsequently entered royal and noble collections throughout Europe, exchanged and given to become parts of kunstkammers and treasuries. While the purpose of a diplomatic gift remained the same, European racial attitudes and unequal power structures removed the Kongo connection and projected a different genealogy. A raffia cushion cover in the Swedish Royal collection (fig. 5.1) was originally cataloged in 1670 as Portuguese, the likely original European source, and then in the eighteenth century as Southeast Asian.[3]

The function of objects, whether used for basic or improved livelihoods, control of social interactions and activities, or assemblages to signify taste or status, has traditionally been connected to purchase or sales. As commodities of desire, objects have gained value from a commercial transaction based on negotiation or bargaining between producer and consumer, either implicit in shared values or explicit in a decision to purchase. The marketplace determines what is a commonly agreed-upon value.[4] A person wanted or needed a certain item for a perceived function and set about to acquire it. As the sociologist Arjun Appadurai states, "economic exchange creates value." The main focus of scholars like Appadurai and Igor Kopytoff, who have explored what Appadurai calls "the social life of things," has been on the object as commodity, from when it is first placed in its intended location and use through its changing economic value over time.[5] However, it is important to recognize that as an object moves through space and time, the original or a subsequent owner might decide to deploy it in an unanticipated manner, wear and tear might require additions or repairs, and various people interacting with it might bring their own experiences and perspectives to bear on it. It might be more accurate to speak about "the social lives of an object." After acquisition and original purpose, objects like a raffia cushion cover began another form of circulation over time and across different audiences and cultures. The Kongo king applied the familiar concept of raffia cloth to the necessity of negotiations with new non-African kingdoms; the Kongo weavers used European examples as models from which they could produce a new raffia type that would impress

Fig. 5.1. Front of cushion cover. Kongo people, sixteenth–seventeenth centuries; woven raffia with cut pile supplementary weft. Inventoried in the Swedish Royal Collection in 1670. The Royal Court, Sweden, HGK, Tx 1, 164.

the Europeans; the original European recipients saw the cushions as tokens of Kongo fealty to European superiority; and subsequent collectors denied the possibility of Kongo artisanship. The raffia cushion lacked stability in meaning as it circulated through various hands.

A porcelain spouted vessel offers an additional instructive case study of such a complex diachronic biography of an object (fig. 5.2).[6] The Portuguese merchant Antonio Peixoto, who traded in China and Japan in the 1540s, did not merely pick up an available piece of Chinese porcelain during his commercial travels. Remarkably, he commissioned this ewer during a period when

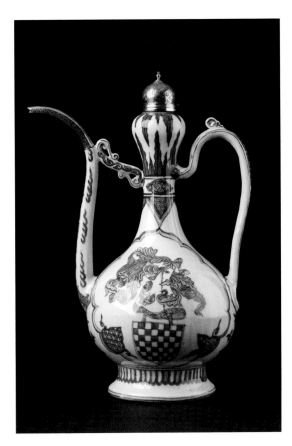

Fig. 5.2. Ewer with Portuguese coat of arms, Jingdezhen, China, 1522–66; wheel-thrown and modeled porcelain with cobalt blue underglaze decoration. Silver spout tip and top added back in Iran. Victoria and Albert Museum, London, Gulland Bequest, C.222-1931.

Chinese officials prohibited direct trade with foreigners, providing a heraldic image and instructing the pottery to decorate the vessel in cobalt blue under the glaze with his coat of arms. The decoration, in addition to the very form of the ewer, based on western Iranian copper alloy versions, made the ewer an entangled object that explicitly asserted his personal ties to the distant land. Soon after his acquisition, perhaps on his way back to Portugal, the spout broke and the lid was misplaced, and Peixoto had an Iranian silversmith provide a silver repair and replacement part, respectively, thereby re-Islamicizing the form. The fragility of the object and the manner in which the shape dictated the repair speaks to the inherent power of the object itself. Once in Europe, the ewer likely would have been used as a coffee pot for the consumption of that hot beverage, quite different from a ewer's Islamic use for water in ablutions and its Chinese use for wine. The roots and path of the vessel thus encompass multiple cultures, uses, and locations.

Indigenous objects also often take on different meanings over time, particularly after they pass from the hands of their original culture. In the late

Fig. 5.3. Bowl, Anishinaabe artisan, Michigan, Wisconsin, or Ontario, ca. 1800; hewn maple. Metropolitan Museum of Art, New York, Charles and Valerie Diker Collection of Native American Art, gift of Charles and Valerie Diker, 2019, 2019.456.15.

eighteenth century, a once-known Anishinaabe artisan used local maple and metal edge tools to hollow out and carve a feast bowl used for ritual dining (fig. 5.3). To protect the consecrated contents, the woodworker carved the head of a manitou, a powerful supernatural being, at one end. In its original context and use, the manitou gave this bowl substantial power and value. However, settler colonists who began to occupy the land in the nineteenth century did not understand the object's use or the guardian power of the head. Instead they viewed such a bowl as a primitive object, inferior to the refined earthenware ceramics they used for their own dining. Such bowls then became part of ethnographic collections in natural history museums, where they were buried in storage or displayed in vitrines with similar types of vessels or carved human figures. There they symbolized the culture of the vanished Indigenous Americans. Only recently has the decolonization of such museums through consultation with Indigenous communities led to a deeper understanding of the power of such objects. Even though they may remain encased in a Plexiglas vitrine, labels and programming can hint at the spirit contained within them.[7]

The examples of the Peixoto ewer and the Anishinaabe bowl reveal the impact of moving from the human framing of an object to a consideration of objects as active agents in their own right, possessing certain inherent qualities of material, form, and ornament that allow for multiple interpretations that might stimulate or direct human action. As the products of human decisions regarding materials and labor as well as evidence of human performance in use, objects are more than just "things" in an vague abstract sense but possess a materiality that contributes to these multivalent meanings.[8] Choices of forms, materials, and decoration, as well as perceptions about those choices and the entanglements of these perceptions as a specific item circulates, all contribute to the ultimate dynamic power of an object to embody and shape everyday

life.[9] In describing his own personal pursuit of the history of porcelain, the potter and writer Edmund de Waal used the term "pilgrimage." For de Waal, pilgrimage evoked a purposeful process of movement, one structured by objects to mark the journey, protect the pilgrim, and provide evocative evidence of the trip.[10] His use of the word to describe the interconnections of process, product, and people in motion over space and time seems appropriate as we think about the social lives of objects. In pivoting from a synchronic approach to objects to a diachronic one, a focus on the concepts of memory and gift provide a helpful framework.

## Memory

The common use of the phrase "vessel of memory" underscores the role that objects play as receptacles of lived experiences. Objects of all sorts, not just vessels, can provide the embodiment of what the nineteenth-century educator Samuel Griswold Goodrich called "mental furniture," the cumulative sensory experiences that would provide a memory bank to guide emotion, cognition, knowledge acquisition, and behavior.[11] Not simply found relics or natural specimens culled from the landscape, fabricated objects, through active use and circulation, gain specific power to evoke certain people, times, or events. People construct memories through the active processes of fabrication, use, identification and collection, and maintenance. It is this very act of handling and conscious manipulation that distinguishes objects from relics or specimens even though these latter could also stimulate memory or provide knowledge. Objects provide a specific sort of associative power because their physicality, execution, and bodily connection provide a chain of associations.[12] They may have existed as part of a display collection, but they have a far greater impact as storytellers, with multiple tales that accrued potency and were continually stored up and released intermittently. As such, memory can be a motivation for collections of relics and natural specimens, but it possesses a different sort of power when associated with made objects.[13]

Some objects, such as memory jugs, are straightforward explicit holders of memories from their very origins. Common in African American culture in the American South in the late nineteenth and twentieth centuries, these ceramic vases were filled and encrusted with small everyday objects, in effect bottled up and denied use since there were no openings, and placed at a gravesite or in a specific location at home (fig. 5.4). Related to the *nkisi* tradition of conjuring figures in West Africa and face jugs in the American Southeast, a jug eased the deceased's spirit and facilitated his or her journey to heaven, warded off evil spirits, protected its owners from harm, and possessed healing powers.[14]

Fig. 5.4. Memory vase, United States, possibly southern, 1885–1900; wheel-thrown earthenware encrusted with found objects (buttons, eyeglasses, nails, pins, buckles, pen nibs, pipes, thimbles, mouth harp). Chipstone Foundation, Milwaukee, WI, 2015.34.

Other objects were less explicit placeholders of memory. How might such items communicate or trigger memory and narrative? Memory could be built in by conscious collection or purchase, often referred to as a souvenir; making and inscribing something to provide an artifactual record of accomplishment for subsequent generations' use; or preserving and maintaining an item's associative presence. Conscious labor infused each of these approaches with meaning and power, which could either be discharged by the object itself or tapped by a person coming into contact with it.

During times of increasing trade and cultural contact, objects often signaled more than mere difference or the exoticism of another. Purchasing objects while traveling often provided a sense of time, place, or set of experiences that stirred memories and provided means of group identification back home. For example, many officers of the British East India Company who served in South Asia purchased painted cottons from the Coromandel Coast or ivory inlaid or veneered furniture from the same area while they were stationed there. The local artisans incorporated British fashion or concepts but still relied on their traditional materials and techniques. The British carried these placeholders back to their home country, where the chintz and furniture set within British homes in an entirely different climate provided an artifactual associational link with other East India men (fig. 5.5).[15] Similarly, Dutch traders in Japan took great interest in local ceramics and lacquer, and Japanese artisans astutely sized up what these foreigners valued and responded on

Fig. 5.5. Pair of side chairs, Vizagapatam, India, 1690–1710; joined, turned, and carved ebony, inlaid with ivory; new rosewood spindles in backs and restored caned seats. Originally owned by Edward Harrison, Governor of Fort St. George, 1711–17. H. Blairman & Sons, London.

Fig. 5.6. Charger with VOC emblem, Arita, Japan, late seventeenth century; drape-molded and wheel-trimmed porcelain with underglaze cobalt blue decoration. The VOC monogram is for the Vereenigde Oostindische Compagnie (Dutch East India Company). Courtesy of Peabody Essex Museum, Salem, MA, museum purchase, made possible by an anonymous donor, 1992, E83830.

Fig. 5.7. Rug, Navajo Nation, 1880–85; cotton warp and wool weft woven in tapestry technique. Lucke Collection.

their own terms. Members of the Dutch East India Company (VOC) eagerly purchased Japanese porcelain with the company's cypher on them or Japanese lacquerwork with cartouche scenes that distinguished them from the dense floral maki-e and raden motifs for the Portuguese market (fig. 5.6). However, such works should not be viewed simply as Asian export ware in which the Europeans dictated their desires to passive local artisans. Rather, the objects served both makers and purchasers. The former drew on their own knowledge, materials, and traditions to expand into additional markets, thereby adding to their design repertoire, while the latter gained a physical reminder of their arduous travels or distant experiences.[16]

Souvenirs also played an important part in North American settler colonists' interactions with Indigenous peoples. In the nineteenth and early twentieth centuries Americans and Canadians traveling through the Native lands or in the West often purchased items such as Pueblo pottery or Navajo textiles and

silverwork in the Southwest, miniature totem poles in the Northwest, bead-work in the Great Lakes area, or baskets in many places (fig. 5.7). They viewed these items as authentic portable trappings of a disappearing culture with con-nections to distant history. For their part, Indigenous makers embraced the economic opportunities these tourists provided but also used the production of them as a means to train and educate younger members of their community in the local traditions and values that the settler governments were trying to abolish. Navajo women relied on traditional techniques and design elements to pass along skills to younger weavers but used "Germantown wools," ani-line-dyed wools from textile producers on the East Coast, and incorporated current imagery—like cattle and the trains and warehouses along the tracks that served as the basis of the economy—to appeal to non-Native audiences. Souvenirs, like the heritage industry in general, could thus be both a form of exploitation and a form of resistance, depending on your point of view.[17]

Other objects were preserved and valued because of their specific associ-ation with people or events. While the possessions of prominent historical fig-ures like royal families or George Washington have been carefully preserved, less prominent people have also been remembered through their objects. The tablewares owned by the Reverend Eliphalet Williams, a minister in East Hartford, Connecticut, and member of the Connecticut Valley's River Gods, were preserved for generations and embodied the fashionable prestige of the Williams family (fig. 5.8; also see fig. 2.8). As the writer Henry James argued about nostalgia in 1908, objects provided "delight in a palpable imaginable visitable past." Similarly, a joined oak cradle became the symbol of Pilgrim piety and resiliency in seventeenth-century America (fig. 5.9). Initially thought to have been made in England and carried across the Atlantic on the *May-flower*, it became a featured object at the American Centennial Exhibition in Philadelphia in 1876; was collected and venerated by Wallace Nutting, who romanticized early colonial America; and then became part of the collections of the Wadsworth Atheneum. Only in the past forty years has it been proved that the cradle was made in Massachusetts during the second half of the sev-enteenth century, thereby undermining the apocryphal history. Antiquarian-ism, in which later owners wrote purported histories on the objects or affixed paper labels or even brass plaques, helped to construct such notions of a usable artifactual past. Provenance, the genealogical account of an object's life that emphasized specific owners, allowed for certain historical narratives to be developed, passed along, and adapted to different contexts.[18]

A related sort of memory object associated with historic people and events arose during times of imperial conflict. Plunder, seized goods, and contra-band often accrued different meanings and served as placeholders of pivotal moments, particularly for victors. For example, the possessions of Tipu Sultan,

Fig. 5.8. Tea bowl and saucer, attributed to Josiah Wedgwood and Sons with decoration after an engraving by Robert Hancock, Staffordshire, England, ca. 1770; transfer-decorated, wheel-thrown refined earthenware with creamware glaze. Originally owned by Rev. Eliphalet Williams of East Hartford, Connecticut. Wadsworth Atheneum Museum of Art, Hartford, CT, bequest of Mrs. Gurdon Trumbull, 1934.133.

Fig. 5.9. Cradle, south-eastern Massachusetts, 1660–90. Red oak, white pine, and maple. Wadsworth Atheneum Museum of Art, Hartford, CT, Wallace Nutting Collection, gift of J. Pierpont Morgan, 1926.365.

the Tiger of Mysore, who baffled the soldiers of the British East India Company until his death at the Battle of Srirangapatna in 1799, were eagerly seized by the victorious British soldiers and their allies who ransacked the capital. General Richard Wellesley, the commander at Srirangapatna, was one such person who plundered the royal palace and seized a number of items such as the textile

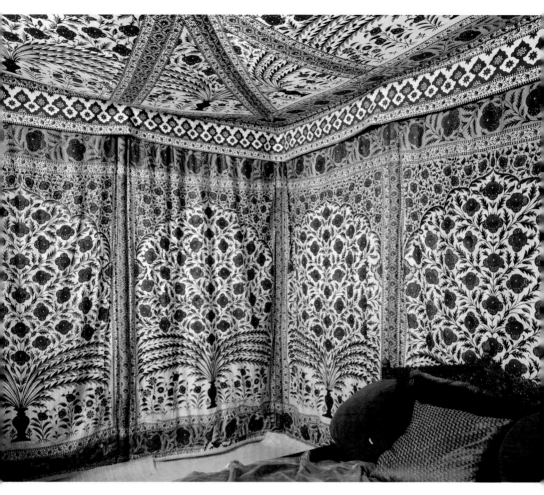

Fig. 5.10. Tent, Coromandel Coast, India, ca. 1750; painted and block-printed cotton. Originally owned by Tipu Sultan, the Tiger of Mysore, who defeated British armies in southern India until his death at the battle of Srirangapatna in 1799. Acquired then by Edward Clive, governor of Madras and member of the East India Company. Powis Castle and Garden, Wales.

tent of the ruler, which he presented to Edward Clive, the earl of Powis and the governor of Madras at that time (fig. 5.10).[19]

The medieval English bronze ewer (see fig. 4.1) and the brass plaques, currently referred to as the Benin bronzes, seized during the 1896 Anglo-Ashanti War, offer another example of looted objects that became placeholders of a particular colonial memory later in the life of the objects, one which ignored the violence of acquisition and instead emphasized the superiority of the culture that seized them and the museum that cared for and displayed them. Many European museums are currently reexamining the ethics of their collections

Fig. 5.11. Sampler, Nabby Martin, Providence, Rhode Island, 1786; plain woven linen ground with silk and metallic-wrapped yarn embroidery. "To Colleges and Schools ye Youths repair / Improve each precious Moment while youre there" and "Let Virtue be a Guide to thee." Courtesy of RISD Museum of Art, Providence, RI, Museum Appropriation Fund, 17.361.

and struggling with the correct approach to cultural patrimony that had been seized during a colonial period. The drive for restitution of African objects, currently scattered across the world, is a particularly fraught example of this repatriation.[20]

Rather than simply assigning the power of memory to an object later in its life, the potential for memory can be inscribed in the very process of making. Female needlework, whether samplers or pictures in the Anglo-American context or kantha in the Bengali context, were often marked by their makers, a rare instance where females could express themselves in the public record and thereby ensure their remembrance. While young needleworkers like Nabby Martin followed prescriptive designs in academies like Mary Balch's, the girls internalized the meanings of terms like "virtue," "honor," and "improvement" and filled their samplers with images of genteel behavior, vases with flowers, and local architecture (fig. 5.11). In Bengal, women took cloth from old saris, used embroidery techniques to depict scenes of life and ritual, and then quilted the decorated top and plain bottom. The resulting blanket was used as bedding, baby blankets, or even for puja (see fig. 2.26). Like samplers, these kanthas descended along female lines of a family and became powerful heirlooms that preserved a female perspective and presence. Samplers, kanthas, and similar worked cloth channeled the voices of their makers to remind subsequent generations of female actors of their heritage and responsibilities.[21]

Fig. 5.12. Vase made from 75-mm artillery shell casing by Sgt. First Class Jack J. Clarke of an armored division for his girlfriend Myrtle, ca. 1918. Chased imagery includes World War I French armored insignia, Advanced Sector "Man in Service" icon, and his sergeant chevrons. Private collection.

Making and signing objects also became a way of processing and expressing the traumas of war, the inhumanity of imprisonment, or the effects of therapy. One of the classic examples of this is World War I trench art made from brass shell casings, a repurposing of war materiel for domestic use as a flower vase with embossed memories. While French and Belgian *poilus* (infantrymen) and Ottoman metalworkers behind the battle lines made stock souvenirs by chasing in the names and dates of battles, some British and American soldiers with metalworking experience, from their jobs or manual training in school, decorated shells in a more individualistic way. They crimped the base of the shells with the cogged wheels of a howitzer's elevating mechanism, traced motifs from uniforms, insignias, or publications, and then worked the shell with steel from nails, firing pins from German rifles, or airplane engine push rods to depict more personal imagery like unit patches, flowers such as roses, their own names, and even their intended recipients (fig. 5.12). Chasing and engraving these casings helped pass the boring days of inactivity, used material readily at hand, sparked creativity, and helped soften the brutality and *unheimlich* sense of war.[22]

Objects could also be vulnerable and susceptible to damage, whether wood split as it repeatedly expanded and contracted as a result of changes in humidity, ceramics broke, metal dented, or cloth wore out or ripped. Oftentimes, objects were not discarded but rather were repaired, had prosthetics

added, or were reworked. The cost or rarity of the object was one catalyst for such intervention, seen in the greater rate of repair for porcelain than for earthenware, but the power of memory was another one. These alterations or interventions did not compromise authenticity, contrary to many collectors' and antiquarians' urge to strip off later accretions and take the object back to its original state, but were important acts of preservation. Checks on wooden treenware were often mended with staples or sheets of brass, thereby trans-forming a simple bowl into a mazer for ritualistic use through the addition of a silver rim or base and embossed medallions on the inside (fig. 5.13).[23]

Repair of ceramics often involved the addition of silver, brass, pewter, or tin elements to replace broken parts like handles or spouts or the use of wire stitching, metal staples, or fused glass to reattached broken pieces (fig. 5.14). For porcelain, which tended to be an expensive import, such measures seem appropriate, but similar techniques were also used on tin-glazed and lead-glazed earthenwares.[24] Since riveting only provided cosmetic relief, especially for vessels and dishes that might hold liquids, such repairs suggest the impor-tance of perceived wholeness that would allow for the continuation of stories of acquisition, original owners, or the incident that caused the damage. For Japanese tea ceremony tea bowls, repairs with gold lacquer became a desirable way to enhance the item's age and suggest a noble history (fig. 5.15). The gold lines drew attention to the irregular beauty of the tea bowl and contributed

Fig. 5.13. Mazer, England, ca. 1340; turned burl maple with gilt silver rim and print. Silver sheet and wire staple repairs added later. The print at the bottom of the bowl features an embossed figure of the Virgin and Child. Loaned to Canterbury Museums and Galleries by St. Nicholas Hospital at Harbledown, England.

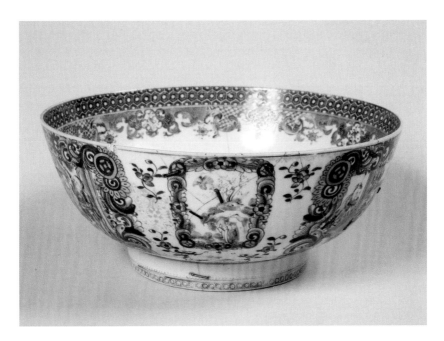

Fig. 5.14. Punch bowl, Jingdezhen, China, ca. 1780; wheel-thrown porcelain with underglaze cobalt blue decoration and overglaze enamel painting. Riveted repairs performed by Edward Coombs, of Bristol, England, in 1802. Bristol Museum and Art Gallery, UK.

Fig. 5.15. Tea bowl, Gyeongsangnam-go Province, Korea, Joseon period, second half of sixteenth century; wheel-thrown porcelain, gold lacquer repairs. Freer Gallery of Art, Smithsonian Institution, Washington, DC, gift of Charles Lang Freer, 1897.87.

to the mindfulness so valued in the tea-drinking ritual. This repair tradition, referred to as *kintsugi*, allowed the continued use of the bowl with heightened impact.[25]

Valued textiles found new lives when subsequent owners reworked them. The Fifield family bed hangings discussed in the introduction demonstrate the affective power of repurposing (see fig. 0.5). A full set of hangings, which required forty-three to fifty yards of fabric in total, comprised valances along the perimeter of the tester frame set atop the four posts of the bedstead, a tester cloth set within this frame that served as the soft ceiling of the bedstead, a headcloth that hung behind the headboard, long curtains that hung from the tester frame and could close off the other three sides, a counterpane that covered the mattress, and bases or skirts along the lower edge of the bedstead frame. The sheer yardage enabled a subsequent generation of female Fifield descendants to make four quilts in the early nineteenth century, each composed of two long curtains and valances sewn together.[26]

## Gift: Diplomatic Gift

Another way to examine the inherent power of the object over time, as an active force in its own right outside of commercial transactions, is to understand its role in the social practice of gift exchange, which could often contribute to an object's power of memory or association. While we often think of giving presents as voluntary, spontaneous, or without self-interest, the anthropologist Marcel Mauss looked more carefully at the motivations and implications of gift giving. He articulated how gifts are rarely neutral but function as loaded objects that carry with them an obligation to repay, a demand for reciprocity, or an expectation to give again. In short, a gift constitutes part of a quid pro quo response. In this sense, gifts are planned, obligatory, self-interested, and often long lasting in effect. The gift economy does not necessarily enhance the absolute financial wealth of those involved in the exchange, even though one of its goals might be advantageous commercial relations, nor is it necessary for subsistence. Rather, it provides strategic, emotional, or moral value outside of mere purchase or sale. This sort of symbolic gesture could ensure protection from distant powers for local rivalry, garner favor or status, win trade concessions, secure territorial beachheads, affirm interpersonal relationships, establish new relationships, project a sense of largesse or financial means, or reveal thoughtfulness. Gifts, gift giving, and regifting can thus lead to both short-term and long-term chains of obligations and desires as objects circulate and link people over time and space. As objects crossed distance and time, they could provide either connections and commonality or hierarchies and distinctions.[27] The category of gift can be further divided into diplomatic

gifts, often involving rulers, religious emissaries, and traders, and interpersonal gifts, those more associated with individuals and not tied to relationships between courts or institutions.

While diplomatic gifts were often connected with trade missions to expand commercial markets, they usually were given away outside of a sales transaction. Looking for the appropriate sort of gift to establish commercial relations, pay tribute to a central authority, seek privileges to establish a religious or commercial post, or gain protection of a distant power to strengthen one's regional power could be a fraught endeavor. Different cultures had developed different gifting practices and thus anticipating what was valued in different courts and geographies proved difficult, resulting in numerous misunderstandings. While precious goods like silver and jewels, exotic animals, weapons, and even specialty foods had relatively universal value, other sorts of goods fared less successfully. For example, European wools did not find favor in the hotter climates of South Asia, and Mexican obsidian was not fully understood by the Spanish.[28]

Nevertheless, there were certain products that found favor in diplomatic missions. Textiles were a common lingua franca, as the raffia cushion cover discussed at the beginning of the chapter illustrates. In the Andes, the Incan king turned to *accalacunas*, the most talented women weavers, who used a tapestry weaving technique with fine thread count (one hundred threads per centimeter), to produce and give the finest tunics to loyal officials. Replete with the various *tocapus* (clan or group motifs) that expressed unity with the king, the tunics affirmed imperial relations (see fig. 1.17).[29] Ottoman rulers invoked older Abbasid-era practices when they distributed elaborately woven silk kaftans to other Islamic courts and to European empires. Safavid textiles achieved significant value with Mughal and Japanese leaders. In turn, Dutch, Flemish, and French tapestries were common gifts of various western European courts to each other and to the Ottoman Empire.

But in many cases the textiles were not always understood or simply accepted as is. Heavy wool tapestries did not always find a welcome reception outside of European diplomatic exchange. Even within Europe, it could prove hard to promote such work. John Maurits, who served as the Dutch governor general of Brazil from 1637 to 1644, hired the artists Frans Post and Albert Eckhoudt to paint scenes of local South American inhabitants and nature with the expectation that he could then promote the artists' paintings and designs to various courts back in Europe. To gain access to the upper levels of society, he relied on the symbolic value and historical themes of the tapestry medium and schemed to convert these images into courtly tapestries. In 1668, he succeeded in getting the grand elector Friedrich Wilhelm van Brandenburg to commission the Delft weaver Maximiliaan van der Gucht to make an

Fig. 5.16. Tapestry, *Le cheval rayé* from the *Tenture des Indes* cycle, designs by Frans Post and Albert Eckhoudt, woven by Gobelins Manufactory, Paris, 1687–89; tapestry woven wool and silk. Musée du Louvre, Paris, OAR 24.

eight-part sequence titled *Tenture des Indes*, which emphasized the imagined abundance and curiosities of the New World. In 1679, Maurits presented the design templates as a gift to Louis XIV, and Gobelins, the royal tapestry shop, began a set in 1687 (fig. 5.16). He believed that such a gift to the king would open up other orders. Sets subsequently entered into royal collections in Malta, St. Petersburg, and Rome.[30]

The Ottoman rulers gained fame as the most prominent material diplomats in the sixteenth century. With access to local producers of significant works of textile, ceramic, metal, and wood and close connections to the textiles and lacquerwork of the Safavid Empire to the east, the high-ranking officials in Constantinople were rarely impressed with the offerings of European courts, who sent coins, silver pieces, clocks, and glass objects to the Ottoman center in attempts to open up wider commercial networks. Such items did not earn the Europeans higher status. In return, the Ottoman emissaries offered horses, weapons, jewels, and textiles. One of the standard gifts were *khil'at*, robes of honor that the Ottomans viewed as symbols of vassalage but that Europeans viewed as prestigious, sumptuous garments from equals. A silk kaftan given to Holy Roman Emperor Matthias, who proudly wore it in his coronation painting (fig. 5.17), underscores how such gifts could be misconstrued.[31]

Fig. 5.17. *Portrait of Emperor Matthias*, Hans von Aachen, 1613; oil on canvas. Kunsthistorisches Museum, Vienna.

While the Ottoman kaftans were gifted as tribute and accepted as honorifics, Safavid silk textiles comprised another type of diplomatic offering. Often gifted to rulers and merchants from other lands to gain favorable trading rights, such finely woven textiles became a source of local power. The Mughal emperor Jahangir eagerly collected these figural silks as part of court negotiations. Portuguese merchants accompanying Jesuit missionaries to East Asia in the sixteenth century often picked up objects along the way to use as presentation gifts or tradable items. Safavid and Chinese silks, Gujarati and Chinese furniture, and Chinese porcelains were some items which in turn inspired local production and repurposing in Japan. A piece of sixteenth-century Safavid silk tapestry, intended to cover a table or drape over cushions, fulfilled different needs in Japan. A Japanese tailor used it as raw yardage for a *jinbaori* vest (a surcoat worn over armor when in camp off the battlefield) for the great warlord Toyotomi Hideyoshi (fig. 5.18). Although there was significant local silk weaving, the warlords viewed imported silks as symbols of power and status, their prowess as fighters reinforced through the imagery of animals in combat and animal heads depicted as trophies. Throughout Eurasia, depiction of the hunt and fighting animals contributed important imagery to displays of rulership and kinship and thus could be found on numerous diplomatic gifts and

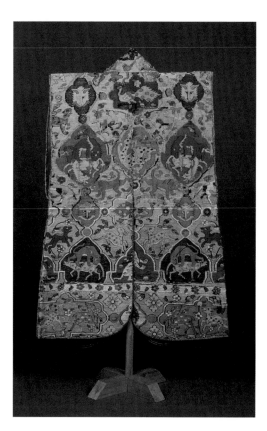

Fig. 5.18. *Jinbaori* (surcoat), textile woven in Kashan, Safavid Empire, mid-sixteenth century, tailored in Japan, late sixteenth century; silk tapestry weave. Kodai-ji Temple, Kyoto, Japan.

objects of interchange. The *jinbaori* thus did not serve a real use function but signaled Hideyoshi's ability to purchase and repurpose luxury objects, affirm his extensive connections, and assert his rulership.[32] Textiles were particularly susceptible to this sort of endeavor because they were both object and raw material. Chinese silk textiles shipped across the Pacific on Spanish galleons then became a source of silk thread in the Americas, where sericulture was not possible. Instead, Andean weavers and Mexican embroiderers picked apart some Chinese silks to use that thread along with their local cotton and camelid fibers. In this context, where local weavers provided high-quality cloth, the silk was more important as a raw material than as a finished good.[33]

While textiles were the most common materials used in diplomacy, other media were also deployed in such service. To honor Queen Victoria on the occasion of her diamond jubilee in 1897, many of her subjects in India sent the Empress of India carved wooden boxes, referred to as caskets, that would hold manuscript messages within. Typically, they would highlight local materials and techniques, such as rosewood and teak from the southern part of India, or sandalwood or blackwood from the northern regions. For example, the Sikh

Fig. 5.19. Casket, Hoshiarpur District, Punjab, India, 1887; bakul wood, inlaid with ivory. Royal Collection Trust, London, inv. #74489; V&A Loan Royal 616.

community in the Hoshiarpur district of the Punjab sent a locally made lidded box of bakul inlaid with ivory in the expectation that the queen would treat them with respect and protect them (fig. 5.19). The cover of the box featured a very fine Mughal floral design, and the address that accompanied it also drew from the Islamic cultural heritage of the region. Written in Urdu, the illuminated manuscript is framed by a polychrome floral border supporting a multifoil Mughal arch with gilt flowers on a blue background and topped by two minarets and a central British device of a pair of lions holding a crown. The use of a casket to convey equality and mutuality, rather than fealty, had a long history in South Asia, as seen in the Lankan gifting of carved ivory caskets to the Portuguese king in the sixteenth century. While the gift was selected and offered with the intent of reciprocity of rights, leader to leader or citizen to leader, the reception of the gift and its meaning in the theater of the European court was considered an act of colonial obedience. This asymmetry of caskets and raffia pillow cushions reveals the misunderstandings inherent in gifting across cultural and racial borders.[34]

Related to diplomatic gifts as vehicles of negotiation or connectors of social bonding were religious gifts that were repurposed domestic objects that might bestow status on the donor in perpetuity and affirm the far-reaching connections of a religious organization. Spanish inhabitants of New Spain who gained access to Japanese Nanban lacquerwork through the Manila galleon trade valued the luminosity of the chests. During a century-long layover in

the New World, owners added silver mounts and jewels from New Spain to amplify their visual impact and affix another layer of "otherness" to the objects before sending them across the Atlantic to serve as containers for the Host or relics in churches in the Basque region from which they had come (see fig. 3.18).[35]

Fraternal affirmation was another related form of organizational gifting practice. Samuel Shaw, an officer in the Continental Army during the American Revolution who helped organize the Order of Cincinnati as a fellowship of officers who left their normal jobs to fight for liberty, served as the supercargo (chief of commercial concerns) on the *Empress of China*, the first American merchant vessel to reach Canton. Upon his arrival in 1784, he commissioned a 302-piece dinner and tea service featuring a painted enamel image of the organization's medal. Shaw took with him a painted drawing of the society's emblem by Charles L'Enfant and three engravings of figures to guide the Chinese painters depicting Minerva, Fame, and an American soldier. The decorators could not paint the figures to Shaw's satisfaction, so he settled for the painting of the medal only (accompanied by a trumpeting angel). He sold part of that set to George Washington and then, on a subsequent voyage in 1786, commissioned approximately ten more forty-five-piece services for other members of the organization. Such commissioning and presenting of these porcelains reaffirmed the members' bonds as they returned to peacetime occupations and worked to establish the new nation (see fig. 2.15).[36]

One of the classic examples of gift giving is the potlach ceremony among the Indigenous people in the Northwest Coast region of North America. There,

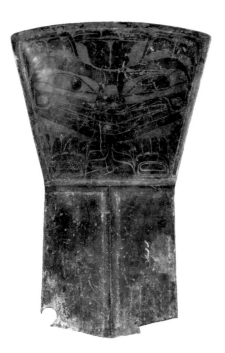

Fig. 5.20. Copper, engraved by Albert Edward Edenshaw, Haida culture, British Columbia, third quarter of nineteenth century; wrought sheet copper, painted and engraved. Canadian Museum of History, Quebec, VIIB-1595, CD1994-0619-001.

heads of clans would organize celebrations to build or maintain their position of respect within the community and region. The celebrations would include the gifting of trade goods such as blankets, enameled metal basins, or bracelets to all invitees. While the cost of these goods could be quite high, the giving of them affirmed a value system that prized relationships, manifest in song and dance, as the most important inalienable property guarded by the clan. The most valued items were not functional material objects but performative actions that bespoke oral history and temporal fluidity that linked past, present, and future. As revealed in many North American Indigenous languages, verbs were more common than nouns, actions about relationships and processes valued more than physical possessions. Coppers, shieldlike pieces of sheet copper that were painted black and featured engraved clan crests in the upper section and a T-shaped hammered ridge in the lower section, were the most highly valued objects, exchanged among clan leaders to seal certain social connections (fig. 5.20). Often brought out at the end of a potlatch, the copper served witness to events and transactions, thereby embodying tradition, power, honor, prestige, and oral history. Not conforming to capitalist notions of spending and consumption, the potlatch was considered wasteful consumerism by the Canadian government, who banned it in the 1884 Indian Act.[37]

## Gift: Interpersonal Transferal

The gift economy's wide range of expectations, rights, and obligations, what Nicholas Thomas calls "mutual entanglements," operated in both specie-poor economies or those lacking commodity exchange, as well as fully developed commercial economies. Within the family network, motivations such as thanks, honor, celebration, or reminders might have been more prominent than negotiated status. Such gifts also often bordered on the terrain of memory. Rather than being used by human agents to build relationships or construct identity, objects had their own agency to communicate and affirm existing affective ones. Personalized portable possessions nurtured familial bonds over distance and generations.[38]

The associational power is most explicit in laws and gendered customs that dictated the distribution of private property. In the Anglo-American context, wills reveal that land, homes, animals, and tools of trades typically passed down through male lines, while females inherited most personal possessions. In moving from the woman's family of origin to her family of creation, these inherited possessions played an important economic and emotional role. They helped in the setting up of a new household while also serving as reminders more than obligations.[39] In other cultures, custom also regulated transmission of household goods through female lines. In the KwaZulu-Natal region

of South Africa, women made ceramic beer pots and storage vessels, often with raised bump decoration that specified their family, and then passed them along to daughters. Numbers of ceramic vessels often indicated status within their community.⁴⁰

For the upper classes, the use of a family crest provided an obvious way to signal continuity and assert legacy. While often associated with the engraved decoration of silver, the ultimate medium for presentation and gift, heraldry can be found on a wide variety of materials—engraved on base metals, worked into textiles, carved or painted on furniture, and applied to ceramic bodies—and across a number of cultures, such as the Japanese *kamon*, the Chinese embroidered badges, and the American Northwest Coast painted or carved clan crests. Such motifs not only signaled family rank or status but also provided identity and connection across generations or distance. Those who eagerly sought out specialty works from distant shops often went to great lengths to have their commissions personalized in this manner. Straight-sided basins and capstan-shaped candlesticks, standard products of Islamic metalsmiths, became popular personalized items in the fourteenth and fifteenth centuries and influenced local forms throughout Europe. Elizabeth of Carinthia, queen of Sicily, purchased a basin made in Syria or Egypt that featured typical Islamic chased decoration along the inside of the upper section, complete

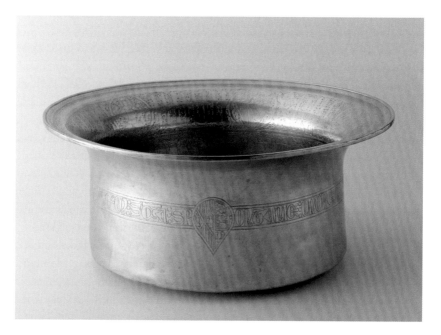

Fig. 5.21. Basin, Mamluk Empire, Syria or Egypt, 1322–50; raised copper alloy with chased and engraved decoration. Rijksmuseum, Amsterdam, BK-NM-7474.

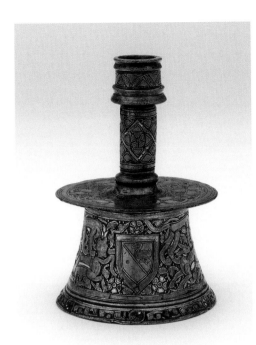

Fig. 5.22. Candlestick, Damascus, Syria, ca. 1400; cast copper alloy with chased decoration inlaid with gold and silver. British Museum, London, 1878,1230.721.

with rondels containing images of Western kings, then had a European artisan engrave the outside with a Latin inscription and her coat of arms in a Mamluk blazon (fig. 5.21). A member of the Boldü family, like other Venice merchants who traded with the Mamluk and Ottoman Empires, had a Damascus crafts-man inlay their coat of arms among more traditional Islamic motifs and cal-ligraphy on a candlestick (fig. 5.22).[41]

In textiles, both expensive tapestry wall hangings and linen damask tablecloths and napkins incorporated coats of arms. Use of heraldic devices was not limited to court patrons only; merchants also sought to affirm their presence (fig. 5.23). An even less expansive technique of personalizing the lat-ter was through the use of cross-stitched initials. Full heraldic devices were less common on furniture, most appearing in the seventeenth and eighteenth centuries (fig. 5.24). Chinese porcelain intended for export to Europe or the Americas increasingly featured coats of arms and contributed to the rise of a specific genre of porcelain referred to today as armorial porcelain. Whereas earlier porcelains featured underglaze blue crests painted at the potteries (see fig. 1.9); and then, from the first half of the eighteenth century, overglaze enamel crests characterized by multiple colors, a variety of borders, and large-scaled emblems (fig. 5.25); production became quite systematized toward the end of the eighteenth century as crests became smaller, the range of colors on

Fig. 5.23. Napkin, Flanders, 1730–45; woven linen damask. Conjoined arms of Pieter de Wolff Pieters and Ursula van Mekeren. Rijksmuseum, Amsterdam, BK-1975-53.

a particular design reduced, and the variety of borders limited as most of the customization took place in Guangzhou (fig. 5.26).[42]

Another practice of affection can be found in presents that mark significant moments of transitions in life such as birth or marriage. As in the case with heraldic blazons, engraved silver was not the only medium for such expression. In eighteenth-century Britain, the birth of a child could be commemorated with tin-glazed earthenware plates in which the underglaze dedication, which had to be done in the pottery before firing, signaled the express purpose of the purchase (fig. 5.27). Weddings provided another important moment worthy of an expressive object. While oftentimes we only have an account book reference to a father purchasing furniture as part of a dowry to set up his daughter's new home, other examples point out a more explicit form of gifting.

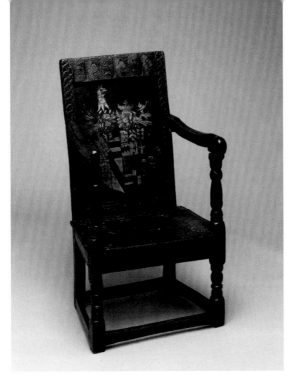

Fig. 5.24. Armchair, Cheshire, England, ca. 1621; joined, carved, and painted oak. The back panel features the crest of Sir Richard Wilbraham. Bryan Collection, USA.

Fig. 5.25. Tea bowl and saucer, Jingdezhen and Guangzhou (Canton), China, 1728; wheel-thrown porcelain with overglaze painted enamel decoration. Image derived from a Dutch silver ducatoon (coin), first struck in 1728, the same year direct trade between the Netherlands and Canton began. Victoria and Albert Museum, London, given by Mrs. Julia C. Gulland, 645&A-1907.

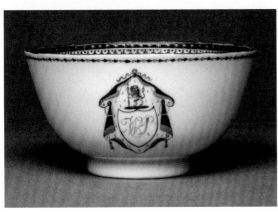

Fig. 5.26. Tea bowl, Jingdezhen and Guangzhou (Canton), China, 1785–95; wheel-thrown porcelain with gilt and blue enamel overglaze painting. Courtesy of Winterthur Museum, Winterthur, DE, bequest of Henry Francis du Pont, 1963.0766.021.

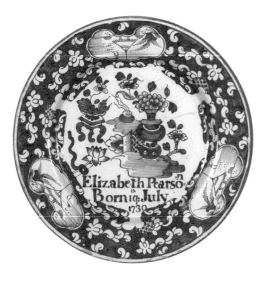

Fig. 5.27. Plate, Bristol, England, ca. 1730; drape-molded and wheel-trimmed tin-glazed earthenware with underglaze cobalt blue decoration. Bryan Collection, USA.

Fig. 5.28. Court cupboard, owned by Hannah Barnard, Hadley, Massachusetts, 1710–20; joined oak and pine with painted decoration. From the Collections of the Henry Ford, Dearborn, MI.

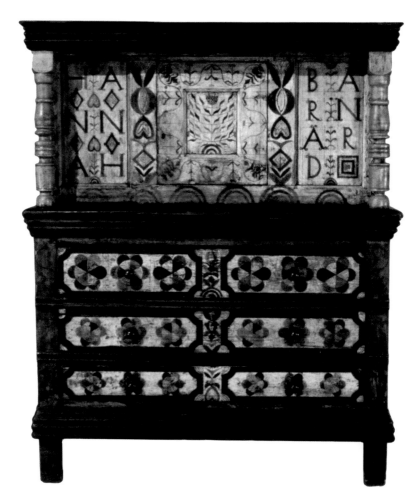

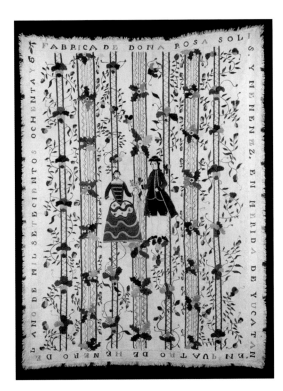

Fig. 5.29. Coverlet (colcha), Doña Rosa Solís Menéndez, Mérida, Mexico, 1786; plain woven cotton with silk embroidery. Metropolitan Museum of Art, New York, purchase, Everfast Fabrics Inc. gift, 1971, 1971.20.

In the upper Connecticut River Valley of early-eighteenth-century Massachusetts, joiners would carve or paint the bride's initials or full maiden name as a father's exhortation to remind her of her family of origin (fig. 5.28). A woman might also retain her maiden name on a piece of needlework marking her marriage. In 1786, Rosa Solís Menéndez, member of a prominent creole family in Mérida, decorated a coverlet marking her 1778 marriage to the Spanish-born Gabriel Milanés (fig. 5.29).[43] On other occasions the groom might commission an object as an affirmation of affection, such as the sgraffito inscription on a Pennsylvania redware plate given to Polly Warner (fig. 5.30).

Small objects were often thought of as "free gifts," proffered as an extension of friendship or collegiality that reinforced traditional structures rather than redefining relational terms. A handheld brass tobacco or snuff box inscribed in such a way between two male friends (fig. 5.31) emphasizes the social ligaments permitted by such a small item. The taking of tobacco powder as snuff was an exclusive genteel endeavor, distinct from chewing or smoking tobacco, which was considered the purview of the rougher sort. Elihu Yale, a governor of Fort St. George on the Coromandel Coast in the late seventeenth century who became a member of the British gentry and benefactor of the college bearing his name, owned at least 406 snuffboxes, obviously not all used by him

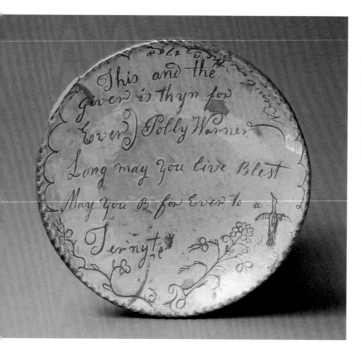

Fig. 5.30. Dish, Bucks County, Pennsylvania, 1788; lead-glazed, drape-molded earthenware with sgraffito decoration. Inscription reads: "This and the giver is thyn for / Ever Polly Warner / Long may you live Blest / May you B for Ever to a / Ternytey / November 31, 1788." Philadelphia Museum of Art, purchased with the Baugh-Barber Fund, 1974, 1974-107-3.

personally. Snuffboxes were among the personal items most likely to have a name or initials and a date engraved on them. Consequently, they might be thought of as durable calling cards that allowed for the enlarging of social networks.[44]

## Conclusion

When considered as receptacles and conveyors of memory and gift exchange, objects were not simply passive commodities to be activated and recontextualized solely by human action for the purpose of status and identity.[45] A biopolitical term like "regime of value" denies the inherent power of the object itself to influence human thought and action. In carefully considering the materials and process of making, and connecting process to product and people, we can begin to recognize how the objects themselves acted on those who looked at, used, or acquired those very items. They retained traces of their intensely local fabrication profile while absorbing additional meanings and impacting people in both anticipated and unexpected ways. As such, they straddle the local and the global. In offering a corrective to the assertions of the commodity perspective, the anthropologist Alfred Gell has introduced the instructive notion of an object's "agency," the ability to stimulate an emotional response and exert an impact on a human being. To him, an object can both

Fig. 5.31. Tobacco or snuff box, England, ca. 1716; brazed sheet brass. Engraved: "March 16 171⁶/₇ / A Free Gift / of Ralph Meddow / to Samˡ Waterworth." Bryan Collection, USA.

assume an identity as a commodity and symbol of wealth or status and impact those who come into contact with it. Agency can be shared among and distributed between humans and objects.[46]

While arguing for an equivalence in agency, it is nevertheless important not to see exact equivalence between human and object. While traditional ecological knowledge recognizes the spirit of natural materials and cultures—the Toraja of central Sulawesi revere *maa'* or ancestor cloths to embody mythologies and histories, provide protection, and mark life transitions—these objects are not humans. Rather, they perform actions that make them humanlike. Scholars such as Aileen Moreton-Robinson use the term "relationality" to describe this interconnectedness between humans and other-than-human beings, the latter category including land, natural resources, and fabricated objects. Indigenous cultures recognize the power of objects by using the language of human intentionality to empower objects that, in use and preservation, ensure the retention and continuity of core values.[47]

Rather than preserve the binary of subject and object, we might return to Edmund de Waal's notion of a pilgrimage, in which he focused on how travelers deploy and respond to locally associated objects along their journey. The people and the objects are co-travelers, each contributing to the experience of the other in their own way. The objects of pilgrimage produce personal effects, usually by association, formal complexity, and technical virtuosity, that draw humans in. Along his own journey, de Waal accumulated lumps of clay, sherds, and complete objects to understand the life of porcelain. This assemblage provided knowledge, comfort, and inspiration. The fascination of objects, what Gell refers to as their power of "enchantment," is not simply an example of cross-cultural visuality but rather a cross-cultural materiality mediated by physical engagement and interaction. The basis of this material enchantment is concentrated primarily in appearance and touch, the subjects of the next two chapters.

Chapter 6　Appearance

In thinking of humans and objects as co-creators who work together to fabricate meaningful and memorable experiences, we can return to the importance of materials and techniques to unpack the agency of the object to direct viewers' or users' responses to it, including their need, desire, appreciation, and wonder. The specific properties of materials often dictate a range of possibilities, while technique contributes to the power that a form holds over us.[1] As Alfred Gell points out, objects enchant viewers and users in part through the dexterous skill evident in the handling of the material and the ingenuity, sometime visible and oftentimes invisible, of the technical process of making. Makers oversee the potential of what Gell calls "the technology of enchantment," that is, the system of production in which an object's workmanship or decoration, its explicit virtuosity, elicits absorption. The audience, in turn, responds to the effect produced by the technical achievements as if overcome by a spell and views the world in a wondrous way. Gell refers to this as "the enchantment of technology." The relationship between making or technology and the wonder or enchantment realized by the object are interdependent and rely on multisensorial engagement. No single sense can account for the depth of a response to an object, but, rather, wonder arises from a cumulative awareness of and experience with the built environment and material world. Aesthetics is ultimately perceived and felt, a visual and physical experience with three-dimensional works of art. In this chapter, I focus on the appearance of an object and, in the next, the user's engagement with it through touch.[2]

Appearance directs us to engage with a finished object from the perspective of the object itself. Objects work on us. As a term, "appearance" can be particular, how an object looks at a specific moment in time, but it also allows for metamorphosis of shape or use. It provides a link between the realization of an object and how it gains meaning as it circulates and ages. Our first visual encounter with an object typically involves its size and suggested function, its ornament or decoration, and its cumulative surfaces. Its material presence focuses our attention on the physicality of what is evident, perceptible, or apprehensible. The object communicates with viewers or users who see the outermost shell of an artifact and begin their own personal assessment and response to it. We see an object, and we see into it and around it as well, but the object dictates this initial response. Its physical relationship to function suggests how one might approach the object, its visible materials and workmanship draw forth associations with comparable forms, and its dimensionality insists on close engagement. These formal reactions can arise from either familiarity or strangeness. But at the same time, those associations might generate a series of cumulative memories and feelings unrelated to the form or intended function. Objects possess a powerful affective presence.

A focus on appearance allows for a combination of different types of visual perception and avoids our current tendency in a world of computer screens to zero in on an image of a thing displayed on a two-dimensional surface, which constitutes only a part of appearance. Modernist design theory emphasizes the primacy and purity of cladding at the expense of ornament, which is considered useless and degenerate, and argues for a visual interpretation of surface, one that is explicitly honest, rather than an experiential one. As a result, in the twenty-first century we hold conflicting attitudes toward the exterior skin of an object. On the one hand, surface can have positive associations, such as a protective or decorative finish, but more often it possesses a negative connotation, such as a deceitful veneer or glaze that hides inferior workmanship or materials.[3] Rather than being confined by a narrow view of surface, we should instead pay attention to the multiple ways that material appearance contributes to or perhaps alters an object's functions, meanings, and values.

As chapters 3 and 4 suggest, form often arises from interchange and determines or responds to function. Handles and handle placement, flat or round bottoms, volumetric capacity, drawer arrangement, seat height, or the width or length of a cloth contribute to the appearance of a finished object. For example, an earthenware teapot made by John Griffith in New Jersey in the first quarter of the nineteenth century (fig. 6.1) suggests its functional intentions. The lidded opening to the body allows the introduction of loose tea leaves and hot water, the profile of the easily grasped handle echoes the shape of the

body, a spout permits accurate pouring into a small cup, a flat foot allows it to stand securely on a flat table, and its size suggests intimacy, holding only a few cups of tea. Furthermore, the fluting on the body and the floral decoration on the shoulder resemble the repoussé-chased ornament on silver teapots from the same period, a cross-medial reference that signifies the gentility of the object's use.[4]

While form and decoration contribute to an initial assessment of the teapot, further attention to the surface reveals additional import. The Griffith teapot features a shiny, reflective lead glaze made dark through the addition of manganese and iron. This external layer not only seals the porous earthenware, making it possible to hold liquids without sweating, but it also provides a level of reflectivity that parallels, but does not imitate, silver or glass, and a polished uniform finish that minimizes the fragility of the material and elevates the earthenware above rough utilitarian storage ware. The glaze ensures that the teapot can take its rightful place on the polished wood surface of a table and participate in the social ritual of tea drinking just as a piece of fashionable Staffordshire refined earthenware does. The maker employed his skill to create an affordable object whose form and smooth, genteel appearance communicate the social value of the object to the user or viewer.

The assertive power of the Griffith teapot reminds us to pay attention to the material language with which an object communicates its meanings. While chapter 3 explores the various ways in which interchange affected the realization of different forms and decorative conventions, this chapter shifts the focus to the agency invested during that realization. An object's visible physical properties, its appearance, directly impacts its social and cultural value, whether it is appreciated or not. To flesh this out, this chapter argues for an in-depth consideration of the object's appearance while in use and circulation. We can investigate how technology enchants by breaking down a few key elements: form, ornament, and surfaces.

## Form: The Technology of Size

Artisans' reliance on local materials, techniques, and preferences, or openness to imported materials, new techniques, and alternative taste provides a range of options that guided their realization performance. The completed object exerts its visual impact in a number of ways: the general form proposes a use, the profile or ornament establishes its style or expressive code, and the variations within this stylistic code reveal a specific social purpose.[5] The overall form might provide the novelty of a new or unfamiliar function. The folding lacquer chair examined in the introduction (see fig. 0.1) seemed wondrous to the Japanese, who sat on mats or the ground, as did the introduction of

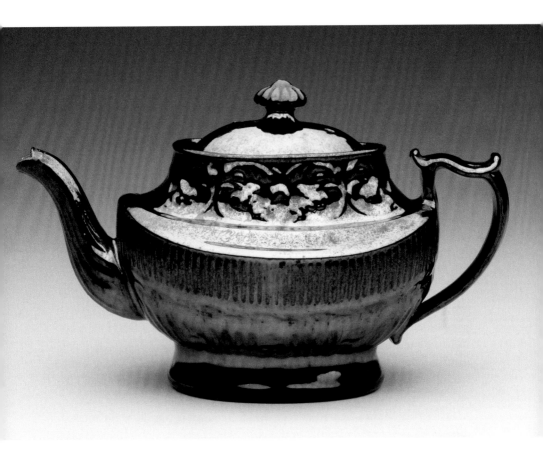

Fig. 6.1. Teapot, John Griffith, Elizabethtown, New Jersey, 1800–1820; press-molded earthenware with lead glaze. Yale University Art Gallery, New Haven, CT, Mabel Brady Garvan Collection, 1978.52.

lightweight, handled and spouted Chinese stoneware teapots to seventeenth-century England, where residents were more accustomed to heavy earthenware vessels.

In addition to stimulating engagement through functional possibilities, the size or complexity of the final product also elicits fascination. Larger or smaller size provides the impetus for awe in different ways, overwhelming viewers or users or else drawing them into a more intimate experience.[6] Most obviously a large object demonstrates the considerable resources of its owner: it consumes more materials, requires more workmanship to assemble, and dominates its immediate environment. It projects the financial power of the owner, who could ask for the best materials and intensive, skilled craftwork, but it also entails certain obligations. The owner needs sufficient space to display, use, or store it properly, requirements that emphasize its luxurious function.[7]

The dominant object can be a single item or a matched set. In addition to its status as an imported object from a distant land that blended imagery from Asia and Europe, an embroidered colcha owned in Portugal (see fig. 3.8) was a large textile of desirable rare materials like cotton and silk with a significant amount of detailed handwork. It required a large, well-appointed bedstead to serve as the proper stage; even if folded up and put away, it would require significant storage space. The porcelain dinner service commissioned by Samuel Shaw in 1784 (see fig. 2.15) provides another example of a large object, in this case a collective assemblage, that showcased the ability to purchase a matching set unified by material, imagery, and function. However, its role was limited to certain ritualistic gatherings, and when not in use at the dining table required secure, safe storage so it would not be damaged.

Other objects relied on a more intimate sense of awe, in which scaling down required a more intensive engagement. These objects tended to be hand-held, more portable, or personal gifts. The snuffbox discussed at the end of the previous chapter (see fig. 5.31) offers a rather unadorned example of the small object of enchantment in which memory plays a significant role, but other examples showcase the virtuosity of the maker. The small, carved Chinese lacquer cup (see fig. 2.2) demanded that users appreciate the fine detail of the carving as they drank from the vessel. Japanese tea bowls celebrated the accidental properties of the clay, throwing, or firing. Imperfections were not mistakes but unexpected gifts to be discovered and by which to be amazed. The willfulness of the material or the skill of the maker could produce objects of wonder.

A final comparison to illustrate the technology of size involves tapestry weaving. While heavy wool wall hangings produced in the Low Countries in the sixteenth and seventeenth centuries gained great favor among the European courts, particularly for their size, explicit celebration of European culture, and pomposity, evident even in the bold size of the knotted threads (see fig. 5.16), they were often considered crude in other regions like South Asia and China, where alternative textile cultures worked to different standards. Patolus, double ikat silk weavings produced in Gujarat, initially for expensive clothing for special occasions but then as an export item for the Southeast Asian market during the sixteenth century, provide a useful contrast (see fig. 2.24). Highly valued for the use of silk, fine details achieved with the complex, time-consuming technique of planning, tying, and dyeing both the warp and weft, and attentive tight weaving that ensured the patterns aligned, these patolus became prestige cloths among the rulers of that region. Their power lay not simply in the imagery of crowned figures riding on ornamented elephants while on a tiger hunt, a universal imagery of royal authority in the region, but also in the acknowledgment and appreciation of fine detail. Smaller in

scale and lacking the bravura of the European wall hangings, their subtlety demanded close attention.[8]

## Ornament: The Technology of Decoration

Ornament constitutes an object's primary means of communication. Material choices and motifs have the ability to engage viewers and users, both visually and associatively.[9] In considering decorated surfaces in this chapter, I focus on the additive technologies and visual appearance of the object's surface; objects subject more to subtractive technologies and manipulation are the subject of the next chapter, on touch. Appearance as a form of nonverbal expression can evoke either the application of mastery or the ingenuity of mimicry, both dependent on artisanal command of the material language.

Mastery of specific materials and processes, and attention to the decorative practices behind the object, played a significant role in the potential of an object to enchant a viewer or user. Painted cottons from the Coromandel Coast of India, which combined direct application on the cloth as well as resist and mordant dyeing, and furniture painted with pigments set in varnish, offer a straightforward example of ornamental application to a stable substrate (see figs. 1.16, 2.36). Usually a different artisan from the one who fabricated the object executed this ornamental work; that person's skill was in the handling of dyes and pigments applied to the work of a weaver or furnituremaker. The ability to lay decoration over the surface provided a great deal of flexibility in adjusting to different markets and engaging specific audiences. Like a chameleon's skin, painted cotton could feature one design for the French market, a different one for the Indonesian trade, and a third for Japanese clientele without altering the actual woven substrate or reducing the fascination with the fine, lightweight material, the colorfast palette, and the attention to the shading detail of leaves and flowers. Ornamental painters who decorated furniture like the cassones of Renaissance Florence exploited different ways to engage users or viewers in contemplation of the chests: for the elite they depicted courtly scenes of love and heroism on the front and sides and valuable imported Ottoman silks on the back. In the early nineteenth century, decorative painters who worked on American furniture could customize a simply constructed form by painting portraits of country estates or covering the surface with the most up-to-date neoclassical decoration. The main cost of this work was the painted surface, which often used shading and paint to simulate relief, a visual effect that drew its audience in for a closer look (fig. 6.2).[10]

Like painted cottons, enamel painting with glass powders on porcelain or copper offers another prime example of added surface decoration to enhance the material of the body and target different markets. The enamel painters in

Fig. 6.2. Sideboard, designed by Benjamin Latrobe, made by John Aitken, painted and marbleized by George Bridport, Philadelphia, Pennsylvania, 1808; joined yellow poplar, nailed pine corner blocks and backboards, gilded, painted, and marbleized decoration, brass rosettes. Philadelphia Museum of Art, purchased with the gift (by exchange) of Mrs. Alex Simpson, Jr., and A. Carson Simpson, and with funds contributed by Mr. and Mrs. Robert L. Raley and various donors, 1986, 1986-126-3.

Guangzhou occupied a particular role between the outlying production centers of the bodies and the local consumers, both Chinese and traders from distant lands. The dense ornament of these wares featured bright colors that sparkled and could depict Chinese landscapes and people, European people derived from print sources, birds and flowers, or motifs and borders from a wide range of cultures (fig. 6.3). Intense hues and gradations of color found eager audiences in far-flung markets and served as vehicles of wonderment, whether displayed on a shelf or used at the table. The majority of these wares were designed for dining or tea drinking, where they could show off the owner's stylishness and glisten under candlelight.[11]

Distinct from an added layer, chemical transformations of the substrate, as found in dyed cloth, bidriware, and patinated base metals, provide another means of decorating the surface (see figs. 1.24, 2.23). Use of mordants, muds, and wax for resist dyeing allows for designs with complex contrasting colors or even shades of the same color. The intrigue of these cloths cannot be attributed to a choice between figural and pattern decoration but with the very wonder of coaxing so many varied colors and shades out of natural materials. With bidriware, the use of a paste of ammonium chloride, the specific regional soil, and water blackens the whitish zinc alloy body without affecting the inlaid silver. In fact, the blackening emphasizes the contrasting silver designs. Base metal artisans use certain chemical formulas to alter the tone and gloss of the material, particularly of copper, without affecting the integrity of the object's body. The early-twentieth-century metalsmith Marie Zimmermann used different patination formulas to color the surface of her copper objects to resemble celadon or oxblood red ceramics. With all these media, deep knowledge about the effects of different substances on one another was crucial to success.[12]

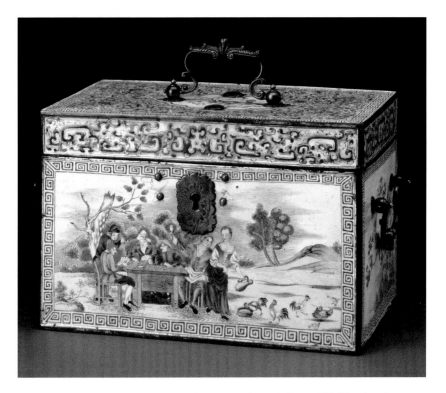

Fig. 6.3. Tea caddy with European figures, Guangzhou (Canton), China, 1736–95; painted polychrome enamel on fabricated copper. Collection of Hong Kong Museum of Art.

Certain lacquering techniques, such as Andean *barniz de Pasto* and Japanese maki-e, rely on internalized knowledge of the raw materials, their working characteristics, the ability to color them, and the use of heat to season layers or provide adhesion (see figs. 2.38, 2.40). In the former, sheets of mopa mopa lacquer are colored, cut up, warmed, and applied over a gourd or wooden substrate. The final composition is like a marquetry jigsaw puzzle. In the latter, setting pieces of mother-of-pearl or coral within layers of urushi lacquer (raden) and sprinkling gold or silver power into the wet lacquer as layers were built up (maki-e) results in pictorial and geometric designs suspended within a luminous and mysterious black ground that suggests depth. Both types of lacquering are an additive process of building up a surface to satisfy a particular market and encourage close looking.[13]

Like the variability of size, the ingenuity of mastery could be full of bombast or incredibly subtle. A pair of "commode card tables" that the upwardly mobile Philadelphia merchant John Cadwalader ordered in 1770 from the cabinetmaker Thomas Affleck, an immigrant craftsman from Scotland, make up part of a parlor suite with a large sofa, two smaller sofas, an easy chair, four

Fig. 6.4. Card table, Thomas Affleck (cabinetmaker) and James Reynolds (carver), Philadelphia, Pennsylvania, 1770; joined mahogany, oak, hard pine, brass hardware, iron hinges. Dietrich American Foundation, Philadelphia Museum of Art, 8.3.2.778.

Fig. 6.5. Pier table, northeastern United States, 1835–50; joined, glued, and nailed eastern white pine and yellow poplar, mahogany, mahogany veneer; marble top. Yale University Art Gallery, New Haven, CT, 1974.64.1.

fire screens, and seven chairs (fig. 6.4). All the pieces in the suite had similar extensive carving by the London-trained immigrant carver James Reynolds. Cadwalader must have been particularly proud of his pair of card tables, as Charles Willson Peale's 1772 portrait of Cadwalader, his wife, and daughter features him leaning on one of the pair. Their book-matched mahogany tops, ribbon-and-flower carved edge, central asymmetrical carved elements, scrolled knee carving, and hairy paw feet make them exemplars of the cabinetmaker's and carver's collaborative art. However, the emphasis is all on the carving, as the construction is straightforward mortise and tenon joinery reinforced with nailed-in corner blocks. The table is in essence an armature for the display of carving.[14]

In contrast to the rough construction and elaborate carving of the Cadwalader table is the simple form and complex joinery of a Chinese table from a century earlier (see fig. 1.25). It features no carving but rather relies on shaped feet, stretchers, and aprons to highlight the form. In contrast, the joinery, with miter joints concealing a complex interlocking series of mortise and tenon joints that lock together the legs, skirt, and top, requires significant three-dimensional visualization on the part of the maker when laying it out and cutting. Technically complex, this excellence remains hidden from view. The table demands quiet engagement, instilling a marvel about the simple exterior masking skillful technology. One has to know about what lies behind the miter joint to truly appreciate the mastery.[15]

In paying attention to possible markets and maintaining economic viability, makers also engage in the ingenuity of mimicry, in which their knowledge of materials leads them to experiment with material substitutions or innovative techniques to communicate materially. They are not necessarily cheapening their work but rather using their material knowledge to their own advantage in order to expand opportunities. To lower the cost of an object without sacrificing its appearance or associations with a luxury good, craftspeople developed techniques to hide inexpensive materials as they sought to tap expanding markets. For example, in the early nineteenth century, the demand for tropical woods and the high cost of making furniture from solid pieces of these exotic species, coupled with a fashion for the taut, flat surfaces of neoclassicism and mechanized sawing technologies that allowed thin cuts of veneer, led to widespread use of veneer on carcasses made from common local woods. Instead of the highly figured burl veneers framed by banding that were found on high-end furniture of the late seventeenth century, middling veneered furniture in the early nineteenth century used plain cuts of tropical timber that resembled solid boards. Furnituremakers applied these veneers wholesale, without framing veneer borders, upon simply constructed frames that were often pieces of local wood glued or screwed together (fig. 6.5).[16]

Fused silver plate of the late eighteenth century and electroplated silver of the mid-nineteenth century—where a lamination of silver and copper is rolled into sheets and worked like silver or silver deposited on a base metal form (usually brass or a nickel alloy) through electrical charge, respectively—offer other examples of decorative layering in which a more expensive material is laid over a less expensive body as a way of reducing the production costs while retaining the appearance of the solid work (figs. 6.6, 6.7). While we think of plated silver as ersatz silver, in the late eighteenth and nineteenth centuries, plated silver was considered technologically sophisticated, a blending of art and science. Fused and plated base metals replaced pewter and paktong as the preferred shiny metal when the expense of silver was prohibitive. The potential

Fig. 6.6. Teapot, Sheffield, England, ca. 1800; rolled and brazed Sheffield plate (fused copper and silver), ebonized holly handle. Victoria and Albert Museum, London, Wolseley Bequest, M.240–1920.

Fig. 6.7. Card receiver, Rogers, Smith and Company, West Meriden, Connecticut, ca. 1880; cast and stamped white metal with electroplated silver and gilt surface. Yale University Art Gallery, New Haven, CT, Jeanette S. Cressler Fund, 1984.67.

for broader markets also led to much more experimentation in terms of forms that could be plated.[17]

While veneering and plating used the actual expensive material on the exterior, other surfaces demonstrate how less expensive materials could be substituted to mimic the desirable luxuries. In response to the fashion for furniture made from imported tropical woods, some vernacular furniture-makers hired decorative painters who used stains and varnishes to grain local common woods, making them appear to be made from expensive timber like mahogany or rosewood. They even painted yellow lines to simulate the look of lightwood inlay (fig. 6.8).[18] An interest in the blackness of lacquer and ebony led to the popularity of several faux finishes over time, particularly ebonizing. In the eighteenth and early nineteenth centuries, silversmiths often had wood-workers make carved teapot handles out of locally available fruitwoods (whose interlocking grain made them ideal for strength) and color them with varnish and lamp black so that they looked like the ebony found on the best silver. In the late nineteenth century, designers such as E. W. Godwin and William Morris in England and furnituremakers like Herter Brothers and Kimbel & Cabus in New York offered ebonized furniture in which lamp black and varnish were

applied to cherry or maple frames to simulate the lustrous effects of lacquer (fig. 6.9).[19]

Another example of experimentation with existing technology to mimic expensive imported material was the British response to the qualities of silk. The shiny silk thread and sinuous satin weave captivated much of the world, but the difficulty of raising silk worms, particularly in northern Europe and the Americas, and the fluctuations of the trade in raw silk from China and the Ottoman Empire, prompted some wool weavers in Norwich, England, to develop a class of wools referred to as "camlets" or "harrateens" in the early eighteenth century. These worsteds, which featured a smooth, hard surface, were calendared, that is, either folded up and pressed under heat or run through ribbed or engraved rollers, to produce a rippled lustrous surface that simulated moiré silk (see fig. 3.11). Heavier and scratchier than silk, the resulting fabric was more suited to upholstery and curtains than to dress. Like

Fig. 6.8. Side chair, Walter Corey, Portland, Maine, ca. 1850; maple with rosewood graining and yellow striping. Yale University Art Gallery, New Haven, CT, gift of Mr. and Mrs. Charles F. Montgomery, 1970.70.

Fig. 6.9. Secretary, Herter Brothers, New York, 1882; joined and dovetailed ebonized cherry and mahogany, red cedar, and butternut interior with marquetry decoration of various woods; brass drawer pulls. Made for the Jay Gould house in New York City. Metropolitan Museum of Art, New York, gift of Paul Martini, 1969, 69.1463.

veneering, plating, and faux finishes, worsteds thus represented an imitative but innovative aesthetic response rather than a true substitution effect.[20]

Ceramics and decorative lacquer offer a slightly different, more emulative response. From the sixteenth through the eighteenth centuries, a global fascination with the whiteness, light weight, and flexibility of underglaze blue and overglaze enamel painted decoration of Chinese porcelain inspired a number of European simulations using local materials to keep costs down and make these types of wares more readily available. But the blue-and-white colors and unfamiliar motifs of porcelain from East Asia accounted for only part of the allure. The high, durable gloss of the exterior, where compositional similarities of body and glaze led to a strong fused surface, also played a prominent role in porcelain's reputation as "white gold." Beginning in the early sixteenth century, European potters relied on the Abbasid-developed technique of tin-glazed earthenware, using existing ceramic technology to develop less expensive substitutes for the imported wares, but their products tended to be heavy, and the tin glaze was prone to chipping (see figs. 1.5, 2.13, 3.52).[21]

The drive to develop lighter and more durable white ceramic forms in which the body and glaze were more similar in material, as in Chinese porcelain, also led in the mid-eighteenth century to Josiah Wedgwood's innovative development of creamware and pearlware, refined lightweight earthenware bodies that were then encased in a white clay and lead glaze. This sort of technological breakthrough, accompanied by the introduction of transfer decoration and bold marketing strategies allowed Staffordshire's refined earthenwares to compete successfully with the imported Chinese porcelain (see figs. 3.53, 3.54, 3.55).[22]

Fascination with the gloss and hardness of imported decorative East Asian lacquer also led to European and American attempts to replicate it in the seventeenth and eighteenth centuries, relying on local materials to reproduce the effect of true lacquer. In the Anglo-American and Dutch worlds, decorators developed techniques referred to as japanning, an essentializing term that lumped all types of lacquer under that single generic heading even though Japan, Korea, China, the Ryuku Islands, India, and Southeast Asia each had its own distinct traditions. Craftsmen such as Willem Kick in Amsterdam (fig. 6.10) and Robert Davis in Boston (see fig. 2.39) used stains and varnishes, gesso, and gold and silver powders to simulate the look of translucent lacquer, but the result was rather flat and opaque in comparison with the luminosity and depth of true lacquer. Kick compensated for this by incorporating the wells of broken Chinese porcelain plates into the annuli (bottom round rings) of turned wooden plates and japanning the rims in a style that resembled Chinese kraak porcelains, but in the black-and-gold palette. Other decorative artists, for example, Martin Schell of Dresden, searched for comparable materials and developed a substitute of amber-based varnishes that provided

Fig. 6.10. One of a set of six plates, Willem Kick, Amsterdam, Netherlands, 1620–25; turned plane wood with black varnish, gold leaf, and polychrome glazes with inset pieces of Chinese porcelain from 1600–1620. Gustavanium, Uppsala University Museum, inv. UUK 0392–0397.

Fig. 6.11. Cabinet-on-stand, Martin Schell, Dresden, Germany, ca. 1715; joined and dovetailed oak carcass with alder veneer, black and red amber lacquer, paste relief work, metallic powders, gold leaf, fire-gilded brass mounts. Inv. GFL-2006–2. © Museum für Lackkunst, Munster, Germany.

greater luminosity than did the japanned work but still fell short of actual lacquer (fig. 6.11). The black-and-gold exterior of his cabinet closely emulated Japanese export lacquer, but he decorated the shelfed interior in more of an Anglo japanning tradition with red background and gold chinoiserie motifs to provide a suitable background for the display of Chinese blue-and-white porcelain. In each of these examples, the painstaking layering and necessary knowledge of the interactions of the materials in each layer restricted this type of decorative work to the level of fashionable luxury commodity. Lacquer in this way might be considered to be "black gold."[23]

## Surfaces: The Technology of Gloss and Hardness

Lacquer and porcelain underscore how surfaces of an object consisted of layers that interact with each other to contribute to the depth of aesthetic content or intent. Layers of lacquer with metal powders or elements of coral or mother-of-pearl intermixed, clear varnishes over layers of flat paint, or combinations of dye stuffs or supplementary wefts all emphasize the uppermost layer while relying on a series of layers to produce that effect. More abstractly, surfaces may possess associative qualities that might trigger comparisons, emotions, or memories. The art historian Jonathan Hay refers to this contextual variation as a "surfacescape," suggesting that the meaning of the surface may not be entirely stable and depends on the intent of the maker and the reaction of the viewer/user. Production and reception equally contribute to the lasting impact of surface.[24]

At their most basic level, surfaces provide a protective outer coating that encases the core of the object for preservation, unification of the exterior appearance, and improvement of its functionality. The exteriors of wooden furniture and treen tend to be coated with beeswax, a penetrating oil, varnish, or shellac to protect the open-grained wood from moisture penetration, minimize the visual effects of abrasion, and create a uniform surface. By sealing the open pores of the wood grain, these finishes preserve the integrity of the material, prevent stains and discoloration from penetrating the organic elements, and increase the ease of use and maintenance.[25] Hardness, smoothness, and visual coherence are thus intertwined. The ultimate in a durable finish for wood is monochromatic black or red urushi lacquer, which polymerizes upon sustained contact with air and establishes a sheathing impervious to moisture or even jostling and light abrasion. In Japan and China, plain lacquer covers many everyday utensils made from wood, cloth, or leather cores (fig. 6.12).[26]

Like lacquer covering a wood substrate, a glaze on a ceramic body can provide a watertight and protective skin. Salt-glazed stoneware from the Cologne area and the green-glazed earthenware found throughout medieval Europe

Fig. 6.12. Cups, China, eleventh–twelfth centuries; black lacquer on wood core. Metropolitan Museum of Art, New York, gift of Florence and Herbert Irving, 2015, 2015.500.1.100.

are long-lasting examples of this type of protective glazing for very utilitarian wares. The glazing of these pots, either through the vaporization of salt or the application of lead glazes, respectively, encases rather brittle bodies, increasing their durability and ability to hold liquids. Tin-glazed earthenware found favor not only as a more affordable white surface that resembles porcelain and provides an effective ground for painted decoration, but as the preferred finish for galley pots and *albarellos*, utilitarian containers to hold medicinal ointments and concoctions. The glaze on the inside of the jars makes it easier to see and judge the contents; is not susceptible to corrosion and deterioration when in contact with acids, salts, or other salve ingredients; and facilitates cleanup.[27]

"Glazing," a term to describe the use of one substance or process to seal and stabilize a substrate of another material, is also applied to textiles. In the late eighteenth century, European textile shops developed glazing for plain woven printed cottons to compete with the colorfast dyed cottons of South Asia. Lacking the dyeing materials and skills that made Indian cotton a superior product, Europeans printed with inferior dyestuffs and, instead of using multiple resist and discharge baths, printed directly on the surface, encased the decorated cloth with starch, wax, or resin, and then ran the cloth between heated rollers to seal the covering over the decorative pattern. The result was stable colors and a lustrous finish that wore well (fig. 6.13).[28] For other fibers, textile makers did not add a top layer but rather manipulated the substance of the body to improve the integrity of the surface and its function. For example, wool fibers tend to be rather springy and airy. When knit for sweaters or scarves, these qualities provide desirable insulation, but untreated woven wool cloth tends to be loose, lumpy, or uneven. Therefore, it was often fulled, that is, immersed in hot water and then beaten with wooden mallets to compress the wool fibers tighter, thereby producing a smoother and stronger cloth that was also more waterproof. Some of these worsted woolens were then run through

Fig. 6.13. Back cover for a sofa, designed by Richard Ovey, printed at Bannister Hall, Lancashire, England, ca. 1818; plain woven cotton with block-printed decoration and glazed finish. Courtesy of Historic New England, Boston, MA, gift of William Sumner Appleton, 1914.244A.

rollers to provide the shimmering appearance of glazing, in this case to resemble the luster of silk (see fig. 3.11).[29]

Artisans working with base metals do not add additional substances to articulate a surface but rather finish off their work by applying tools to the surface to strengthen it and make it more uniform. A metalworker can improve the look of a raised copper or brass vessel by using a planishing hammer with a flat face to press down the peaks left by the heavier round-faced raising hammer, approximate a rounded skin, and improve the reflectivity of the surface. Planishing can also harden the metal and help preserve structural integrity of the form. Some pewterers even hammered the exterior of the boog of a plate, the rounded element between the bottom and the rim, to strengthen that transition. Metalsmiths working with casting techniques often use a handheld scraping hook to clean up the rough surface left by the casting sand or the lines along the seam of the molds or, if the object is symmetrical in cross section, mount it on a strap-driven shaft lathe and skim the surface with a turning gouge. This scraping, in conjunction with filing, results in a smooth uniform surface.[30]

But it is the communicative power of surfaces that demands attention. Surfaces convey information about the history of the object, enact distance, or embody deeper values. While all of the preceding examples attest to a conscious creation of surfaces and layers, the temporal surface may be unintentional, the result of time or wear. Patina, tarnish, oxidation, and discoloration can all be considered temporal registers of an object's life. Although in our

contemporary consumerist world we privilege the new and fashionable over the old and traditional and the clean over the dirty, such values have not always been paramount. As the anthropologist Grant McCracken reminds us, patina once signified high status, as it signaled long-term possession and status over generations. Artisans subsequently developed specific processes to simulate patina, oxidation, or age, particularly for metalwork or wood. Just as metal-smiths might use chemicals to provide an associational decorative surface reminiscent of other media, they might also use patination to make copper or copper alloys green or brown to simulate the effect of oxidation over time. Another clear example of this deliberate aging is Japanese Negoro lacquer, in which the maker lays down thick, black lacquer layers; covers them with a thin, red layer of lacquer; and then lightly wipes that top layer, resulting in uneven coloration that suggests long use. Such unlayering bestows the object with what Tanizaki Jun'ichirō referred to as the "sheen of antiquity," an implied sense of status, and mirrors the Japanese appreciation of imperfections in tea bowls (fig. 6.14).[31]

In an age when travel and communication took far longer than the developments of the past two centuries now allow, surfaces also possessed important communicative power. Exoticism, the strangeness and fascination with others, flowed in multiple directions. Objects produced elsewhere stood out as rare and hard to understand fully or as talismans of an unknowable other, whether

Fig. 6.14. *Kakeban* (nobleman's meal table), Japan, fourteenth–fifteenth centuries; joined wooden frame with rubbed red lacquer over black lacquer. Yale University Art Gallery, New Haven, CT, Leonard C. Hanna, Jr., Class of 1913, Fund, 2002.88.1.

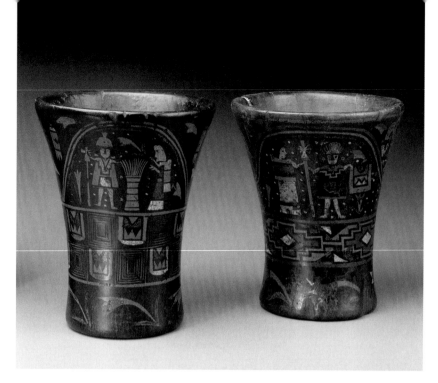

Fig. 6.15. Pair of kero cups, Peru, late sixteenth–seventeenth centuries; hewn wood with mopa mopa lacquer and inlay. Brooklyn Museum, Brooklyn, NY, gift of Dr. Werner Muensterberger, 64.210.2 (*left*) and Brooklyn Museum, Museum Expedition 1941, Frank L. Babbot Fund, 41.1275.5 (*right*).

it was Chinese porcelain or lacquer in Europe, European chairs in Asia, British wool cloth in India, ivory inlaid furniture in Britain, Gujarati mother-of-pearl clad caskets in the Ottoman Empire, Japanese lacquer in Gujarat, African raffia cloth in Europe, or British bronze vessels in Africa. Surfaces connoted distance and difference yet also bound the world together in a collective mutually reinforcing imaginary.[32]

Nor should we restrict ourselves to a binary form of communication. The surface interplay between Indigenous traditions, distant objects, and new colonial markets can be clearly seen in the keros produced by the Andean lacquerers working with mopa mopa. Responding to Spanish fascination with Japanese lacquer obtained via the Pacific galleon trade, the Andean craftsmen preserved the wooden kero shape, their incised layout of design, and their lacquering technique. But they turned from geometric composition to a combination of geometric and pictorial layouts in which they scratched the design into the wood substrate, filled these shallow lines in with mopa mopa lacquer, and then added additional layers of mopa mopa over this inlay to depict Indigenous figures for non-Indigenous customers, who used the vessels not for ritual consumption of chicha but for the social consumption of European alcohol (fig. 6.15). The lacquerers also covered locally made European coffer forms

with scenes of conquest for the Spanish rulers. The interplay of local materials and techniques used to satisfy the desires of a nonlocal client inspired by an imported good played out primarily on the surface. Local artisans who knew how to work the resin and understood what had attracted the Spanish to Japanese lacquer were able to satisfy a new market.[33]

Nanban lacquer brought together a variety of worlds in nonlinear ways. While Japanese maki-e lacquer with mother-of-pearl had been used on temple interior decoration, it was not common on domestic objects, which tended to have gold nature scenes with plenty of black lacquer. But the Iberian domed-top chests, Gujarati mother-of-pearl clad coffers, and Goan richly decorated writing cabinets that arrived in Japan aboard the annual Portuguese "black ship" provided a good sense of Portuguese aesthetic values. Japanese lacquerers had been attuned to external opportunities since the eighth century and simply viewed the Portuguese as the latest in a series of foreign influences they could incorporate on their own terms. Seeing the spiritual impact of the Jesuits who accompanied merchants, the Japanese makers used the maki-e and raden aesthetic to develop densely composed surfaces that were further distinguished by framing elements that made the objects look as if they were veneered in burled woods with plain cross banding around the panels. In short, they made a local Japanese craft look familiar to a European visitor.[34] What endowed them with a special aura? Ultimately it was the gloss and luster of a familiarly conceived form more than the exotic origins of this lacquer that made the work so prestigious back in Europe.[35]

Surface ornament not only has the power to enhance the appearance or make the object more desirable or fashionable, but it can also reveal deeper beliefs. Lacquer provides a rich example of how a single material could reveal cultural and spiritual differences. In valuing the Negoro lacquering technique, the Japanese expressed their Buddhist beliefs in impermanence and imperfection. They embraced fragility and wear. At the same time, Europeans looked at lacquer in a different manner, emphasizing its durable, seamless surface. To Catholics, the smooth, mirrorlike surface provided an ideal numinous tool for conversion, a veritable mirror to the soul that worked among Japanese and Europeans. The ability to look into lacquer and see the familiarity of your face and the wonderment of the flawless surface reminded the viewer of the perfection of divine order and human subservience to a greater being. In contrast, an Enlightenment perspective focused instead on the human role, the time and skill necessary for seamless facture, and recognized a lacquered object as a fabricated marvel akin to the smooth surfaces and invisible brushwork of Flemish oil painting. Its luminosity and durability made it ideally suited for the expression of political power. Smoothness, according to the eighteenth-century British philosopher Edmund Burke, defined beauty because a polished

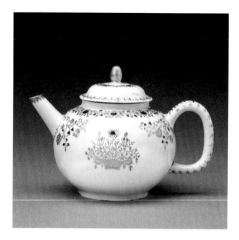

Fig. 6.16. Teapot and cover, Meissen Porcelain, Meissen, Germany, ca. 1713–15; wheel-thrown and cast porcelain embellished with overglaze gilding and silvering by George Funcke. Sold at Bonhams, December 6, 2018.

surface embodied the seemingly effortless genteel lifestyle made possible by the invisible toil of others. Object and personality were intertwined.[36]

Attention to surfaces also linked embodied artisanal knowledge and early empirical scientific work. Royal courts and gentlemen scientists of the late seventeenth and early eighteenth centuries constantly sought to develop the materials and technologies to recreate the wonders of Chinese porcelain, to produce lightweight, shiny white ceramics. For example, in Saxony, Augustus bought great quantities of Chinese and Japanese porcelains but also funded the research of the mathematician Ehrenfried von Tschirnhaus and the apothecary Johann Friedrich Böttger to develop Saxon porcelain, which they did in 1708 (fig. 6.16).[37]

Rulers and natural scientists from the seventeenth through the eighteenth centuries also engaged with ornamental turning to explore mathematical principles while cutting and piercing the exterior skins of exotic wood or ivory. A continuous rotary drive system and a rose engine lathe, a sophisticated tool that moved the suspended work piece while cutting, allowed precise geometric cutting and shaping. This sort of turning required significant preplanning, command of geometry, and attention to perspective. Members of royal courts throughout Europe collaborated with skilled turners to explore the many possibilities (fig. 6.17). In the seventeenth century, Duke Maximilian of Bavaria and Jesuit missionaries from Bavaria presented ornamental turnings to the Chinese court, where they became valued items for display in the Palace of Heavenly Purity in the Forbidden City. The "pleasure in looking" noted by the Chinese grew from the distinctiveness of the technology; Chinese turners had relied on a reciprocating drive system dependent on a strap wrapped around a shaft, the work being turned mounted to the end of the shaft. This was ideal for bowls and basic geometric shapes, but the reciprocating drive did not allow

fine, regulated geometric cuts. Once Europeans introduced the rotary-driven rose engine lathe to China in the early eighteenth century, Chinese turners also explored ornamental turning in exotic woods and ivories.[38]

Perhaps the most vibrant example of the connection between surface and science was the use of highly figured "oyster" or burl veneers in the late seventeenth century (fig. 6.18; also see fig. 2.43). However, these were not what the art historian George Kubler referred to as "weak surfaces," in which veneers made efficient use of precious stocks of wood or concealed tawdry construction.[39] In fact, during that period wood was plentiful, and veneering, which required sawing a board by hand into thin sections less than one-eighth inch thick, was time-consuming, and labor was the most expensive part of furniture production.[40] What then might explain the interest in the dazzling effect of vibrant luminous surfaces? Not simply a graphic decoration placed as a facade for representational impact alone, veneer provided a multisensorial dimension to bring pleasure and delight to the eye, stimulated the

Fig. 6.17. Temple, Wilhelm of Hesse, Copenhagen, Denmark, ca. 1760; turned and colored ivory, carved ivory. Made by Wilhelm as a birthday present for Frederik V, the temple features a bust of King Frederik V by Johan Ephraim Bauert. Royal Danish Collection, Rosenborg Castle, Copenhagen.

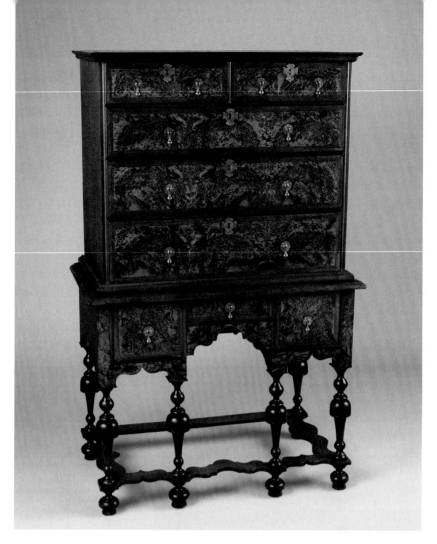

Fig. 6.18. High chest of drawers, Boston, Massachusetts, 1690–1710; dovetailed and joined black walnut, burl maple veneer, turned curly maple, eastern white pine interior, and brass hardware. Metropolitan Museum of Art, New York, Gift of Mrs. Russell Sage, 1909, 10.125.704.

imagination, and demonstrated human control over nature. In the late seventeenth century, veneer was also the embodiment of a conceptual interest in technologies of vision and visualization, during an era in which art and science were intertwined and knowledge was gained through detailed observation of the physical world through microscopic lenses. Just as Robert Hooke used print imagery to illustrate sections and close-up details of natural specimens to make the unseen world available to a broader audience, veneer presented the small-scale world of wood grain and structure to nonscientists. The density and contrasts of highly figured veneers offered natural examples of depth, shadow, and reflection sought by scientific illustrators, and the feather banding

Fig. 6.19. Dressing cabinet, probably Jerusalem, ca. 1720; cypress with mother-of-pearl veneer, dark wood inlay, bone, and silver hardware. Coats of arms of the Mendoza family in the lower section. Museum of Fine Arts, Boston, Henry H. and Zoe Oliver Sherman Fund, 2014.1471.

and crossbanding that surrounded the figured panels provided framing and contrasting elements.[41]

This interest in the depth, shadow, and reflection of wood emerged not only from scientific illustration but also from exposure to imported mother-of-pearl and lacquer from East and South Asia. The iridescent nacre of the green turban shell (*Turbo marmoratus*) and other mollusks from the Indian Ocean and the tropical western Pacific and the deep luminosity and liveliness of true lacquer from East Asia were strange, and they inspired scientific curiosity about physical qualities and origins of the materials.[42] Artisans in the Levant and Peru in particular explored the visual possibilities of mother-of-pearl as an overall veneer (fig. 6.19), and lacquered storage furniture achieved such auspicious value that such pieces became used for reliquary safekeeping in churches, monasteries, and royal treasuries.

# Conclusion

Shifting our focus from an object's singular surface to its appearance highlights the inadequacy of our desire to impose artificial taxonomies through the use of such terms as "applied art" or "decorative art" on the works discussed in this volume. It is not appropriate to think of patterned or figural elements as features added on to an armature to satisfy fashion without regard to the form or structure. Arising in mid-nineteenth-century Europe, hierarchical terms like "applied arts" not only revealed prevailing notions of taste but also implied that functional objects lacked the noble aspirations and humanistic depth of painting, sculpture, and architecture. In a period of heightened production and consumption, increased alienation from materials and fabrication led to a prioritization on representation and eye appeal, culminating in the rise of various modernisms, when the pure form of the autonomous object was celebrated.[43]

Along with the rise of "the thing," that is, the representation of an object, over the course of the twentieth century has been competition from a new sort of technology of enchantment, one founded on the intoxicating anticipation of the future and new manufactured materials and processes that lacked widespread familiarity. This was the world of plastics and synthetics. Whereas the geographic and cultural specificity of materials and the widespread common knowledge of artisanal practice had contributed to a rich mosaic in which objects embodied a sense of place yet interacted, the development of synthetics in the early twentieth century contributed to a certain homogenization of the material world that telescopes distance, denies the past, and makes the object a placeless commodity. The result is not an interconnected series of material worlds but a leveled world in which ubiquity and lack of specificity prevails.[44]

In the rise of synthetics, the impact of petroleum-based plastics in the 1920s and 1930s eroded the role of ceramics and even some copper alloys. Bakelite and Catalin, polymers introduced in the late 1920s, and chemical compounds and polyethylenes such as melamine and Tupperware, introduced after World War II, are manufactured materials produced in laboratories and formed with high-technology mechanized processes like injection molding. Natural fibers also face competition from laboratory-developed materials. Rayon, a cellulose-based synthetic fiber, became widespread in the early 1930s, followed by nylon in 1938 and acrylic in 1944. Lurex, a synthetic fiber with a vaporized metallic surface, replaced drawn metal threads or threads wrapped in silver or gold leaf. Laminated plywood, produced in standardized sheets, dependent on strong epoxies, and valued for its stability, replaced solid wood for many uses and eventually gave way to more molded plastic furniture, the latter allowing greater flexibility in shaping. Aluminum and stainless steel, neither of which

could be prepared in small shops, replaced copper alloys. Each of these new materials arose from modern laboratory science rather than the natural world, thereby restricting broad general knowledge. Their manufacture has led to universal availability and wide distribution.[45] As a result, manufactured plastics are driving many local potteries out of business, synthetic fibers have restricted spinning and weaving of local fibers primarily to small shop craftspeople and amateurs, and large producers of metal housewares and the rising costs of metals have forced many metalsmiths out of business or restricted their production to small items like jewelry.

To overcome the marginalized nature of these objects, it is crucial to think about appearance as a complex and dynamic assemblage. Objects are ultimately a negotiated form of communication, the interface of various material conversations between the maker and the external world of purchaser, user, and viewer. The choice of materials and techniques, increased repertoire of forms made possible by the wide circulation of finished goods, and basic shared tenets of artisanal processes in a time of low technology combine to endow surfaces with great potency. Surfaces comprise more than just the imagery of the surface but include the substrate, the materials of the layers and imagery, and the context in which that imagery is developed and then deployed. Such embedded complexity is informed by deep artisanal knowledge of the materials at hand and of the possibilities of new formal variations. In many ways it is makers, who control the nature of work, who have the greatest impact on the appearance of the final product. As the contemporary furnituremaker Hank Gilpin succinctly explained, as a craftsperson you "do what somebody else wants your way."[46]

In charting the development of meaning in the complex surface of an object, we can see that the artisan exerts great control over the appearance of an object, which is then appreciated by the owner, often within a different place or culture. Japanese lacquerers responded to a variety of external ideas offered by the Portuguese and developed their own aesthetic that was eagerly embraced by the Portuguese, while European ornamental painters responded to the imported wares to develop their own version of lacquer. Josiah Wedgwood responded to the surfaces of porcelains made in highly organized Jingdezhen potteries, which in turn responded to the various surfaces produced in Staffordshire in order to maintain market share. While makers maintain greater control over the material and visual meaning of the technology of enchantment through their workmanship, the user and viewer receive the work and develop their own enchantment of that technology not only through visual analysis of the object but by actual physical interaction with it. The primary means through which they develop their own understanding is through handling and touch, the subject of the next chapter.

# Chapter 7 Touch

In the widely acclaimed *The Hare with the Amber Eye*, the potter/writer Edmund de Waal describes how the simple act of rolling a small, carved wooden netsuke between his fingers inside in his pocket triggered a flood of familial memories and connections. Just as music or food might activate memories through sound or taste, de Waal specifies the importance of touch as an affective sense that connects body and mind, crosses time and space, and links the concrete and the abstract.[1] As a potter he is attuned to the importance of handling an object as an essential experiential step in creating, assessing, and understanding that item. He values a corporal connection that connects the hand and the mind through the act of touch in making, but as a maker he also acknowledges the importance of touch in use and appreciation when he is a viewer or user. His description alerts us to the importance of the tactile in understanding the enchantments made possible by technology. One gains knowledge through haptic engagement and biomechanical feedback, and the brain then processes this input through comparison with similar tactile experiences.

Although a netsuke is a small, handheld object that facilitates easy touching, larger objects offer similar possibilities to link hand and mind, experience and idea, for both maker and user. For example, a Mughal brass ewer balances its role between the visual self-enclosed aesthetic form and the touched, experienced functional object used for ablution, the washing of hands (fig. 7.1). In the Muslim faith, one washes hands before each prayer session as well as before and after eating. For households, ewers and basins therefore played an essential

Fig. 7.1. Ewer, northern India, seventeenth century; cast and chased copper alloy.
Courtesy of Michael Backman Ltd., London.

role in ritual before the widespread availability of running water. The ewer
contains, protects, and pours water easily, but at rest it provides visual engage-
ment and ornamental beauty. The chased teardrop-shaped cartouche in the
middle of the body echoes the pear shape of the body. The spout acknowledges
the animal world through the tiger-headed end of the spout and the chased
chevrons resembling cobra scales along the side, while the handle incorporates
the flower world with vine imagery and a lotus bud as the terminal. In a com-
positional sense, the handle also flips the profile of the teardrop-shaped body,
the inner curve of the handle following the inverted swell of the vessel, and
contributes to a harmonious whole. One can fill oneself with an appreciation
of aesthetic balance and beauty while pouring out cleansing water at various
parts of the day.[2]

The sociologist Georg Simmel recognized that a metal vessel could be "tangible, weighable, and incorporated into both the ways and contexts of the surrounding world" while also being a "detached and self-contained" work of art. The handle is the key to this duality. The grasping, lifting, and tilting of the handle links the outside world of the user to the aesthetic content of the vessel. It is an extension of the hand, yet also an integral and functional part of the vessel's body. One accesses and feels the purpose and meaning of the vessel by holding the handle. Furthermore, it provides balance to the spout, where the contents flow out. The handle thus plays a role in the transferal of ideas to purpose, from brain to fluid.[3]

While a multisensory approach to objects is desirable, this chapter focuses specifically on touch because it is fundamental to the perception and understanding of the functional object. The input of our fingers and hands plays an important role in a person's somatic experience and is crucial to our cumulative material literacy in the physical world. The many nerve endings on our fingers, the ability to grip made possible by a rotating thumb and independently flexible fingers, and the muscle memory of repeated physical interaction with materials and finished goods are key to our personal understanding of the material world. In fact, engagement with objects and the memory of touch enhances our visual assessment of works of art; we can imagine how we might hold or use something or what it might feel like against our skin.[4]

While chapter 2 stresses the hand skills of artisanal agency in the process of realization, what the art historian Margaret Graves has referred to as the "intellect of the hand," touch also plays an important role in the individual user's engagement, both at the time of an object's initial point of purchase or consumption and subsequently over the course of its lifetime in circulation. Throughout our lives we handle and touch a wide array of objects. We hold, caress, turn over, tip, fold, store, move, drop, and throw away objects; hands and touch play an intermediary role in all of our relationships with objects. Touch is crucial for the development of material memory as well as appearance, but it also warrants a more directed analysis, particularly in regard to consumption, function, and circulation.[5]

## Touch and Consumption

The decision to purchase or acquire an object is a conscious action based on a number of different factors, including need, desire, availability, perceived rarity, and association. The sensory order of a culture or a receiving individual shapes the parameters of this activity, and facture plays a role in that order. Scholars of works of fine art have traditionally looked at facture, observable physical evidence of the process of making, as a means for attributions or taxo-

nomical classification. More recent scholarship, such as that of Joseph Koerner, examines the deeper implications of the elevation of ideas and aesthetics above skilled workmanship during the European Renaissance, emphasizing how accomplished facture allowed the best painters or sculptors to conceal the evidence of their technique and raise the status of their work above craft. With the traces of human workmanship removed, the final artistic product took on the appearance of divine work. Skill thus served only as a disappearing means to a more laudable end, not only in painting but also in East Asian lacquer imported into Europe.[6] Objects function according to different criteria, concerned more with economy and function than with divinity. The initial consumer of an object usually responds to facture according to different goals, more akin to developed expectations of fitness, quality, and suitability. When seeking out goods in local markets or workshops, sellers and buyers seem to agree on the role of touching: merchants encouraging people to pick up something and imagine their use of it so they are more likely to want it, and wary consumers wanting to be sure of quality and authenticity before committing to purchase (fig. 7.2). For domestic objects, touch is the common language of the marketplace; it typically precedes exchange.

At a time when travel was limited, advertising found only in brief newspaper descriptions, and mail-order and online catalogs nonexistent, much

Fig. 7.2. Agostino Brunias, *Linen Market, Dominica*, ca. 1780; oil on canvas. Yale Center for British Art, New Haven, CT, Paul Mellon Collection, B1981.25.76.

Fig. 7.3. Nanban six-fold screen depicting the arrival of a Portuguese ship for trade, Edo period, Japan, ca. 1700; wooden frame with ink, color, and gold leaf on paper. Private collection.

depended on the firsthand knowledge of a few merchants, ship captains, and supercargoes. Scenes of Portuguese merchants arriving in Japan at the turn of the seventeenth century often depict the unpacking of Chinese textiles and ceramics for inspection or Japanese consumers feeling locally woven silks offered for sale in the nearby shops (fig. 7.3). Tactility and turning things over played an important role in these purchase decisions. European merchants and supercargoes looking at merchandise in Guangzhou in the eighteenth century also carefully inspected potential purchases by picking them up and examining the product for its condition, weight, and workmanship (fig. 7.4). These foreign purchasers relied on a cumulative sense of the range of products along their route and needed to make accurate judgments about quality and price on the spot. Failure to pay attention to the condition and details of their goods would result in economic losses.

During such trading ventures, these merchants developed their own knowledge of materials and fabrication techniques, often aided by the sellers or makers, to share with their clients back home. When possible, they carried small samples back home to drum up future orders. But material literacy did not always translate easily into words. Evidence of tacit knowledge and standards of workmanship could not be expressed succinctly, so most written

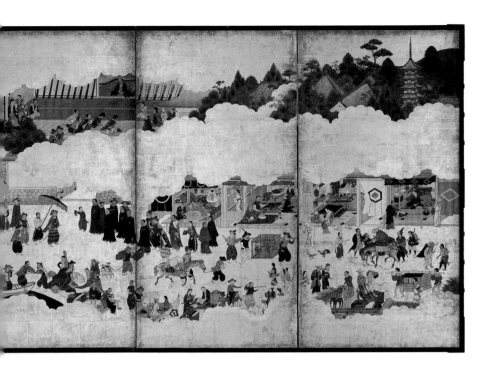

Fig. 7.4. Tea bowl and saucer, made in Jingdezhen and decorated in Canton, China, ca. 1750; wheel-thrown bowl and molded saucer with overglaze enamel and gilt decoration. Dietrich American Foundation, Philadelphia Museum of Art, 2.1.HRD.1819.

Fig. 7.5. *In the Copper Souk*, Nicola Forcella, before 1868; oil on canvas. Private collection.

descriptions relied on basic terms like color, size, material, and perhaps a brief comparison to an equivalent object. This makes the written record of material encounters sparse and argues for careful comparison of surviving objects to infer what traders might have known and who held the power of the transaction.[7]

As travel became more widespread and attracted tourists who sought distinctive keepsakes or souvenirs to mark their trips to foreign places, artisans did not always have the necessary language skills. They relied on touch as a form of communication and marketing strategy for visitors from afar, getting potential buyers to hold and look at objects while the selling artisan educated them about what they were looking at and feeling (fig. 7.5). Touch became the common shared language, often demonstrated by the maker and then copied by the consumer. This strategy of sales through demonstration and handling became the hallmark of many international and colonial exhibitions of the second half of the nineteenth century.[8]

The tactile consumption of material knowledge also played a significant role in the identity of the antiquarian and connoisseur, an upper-class collector of antiques and works of art who develops historical understanding and discerning judgment through firsthand examination of surviving objects. While antiquarians pursue the study of objects as indices of a distant history, connoisseurs consider objects as signs of their own material comfort and evidence of their taste and status. Explicating the intent and meaning of material

Fig. 7.6. *Ancient Erudition*, Zhang Hong, from the album *Figures in Settings*, 1649; album leaf, ink and color on silk. Allen Memorial Art Museum, Oberlin College, Oberlin, OH.

culture, that is, providing the rationale and structure for one's seemingly sub-jective reactions to an object, is a pursuit with deep roots. In China, the *zapin* connoisseurly literature began in the thirteenth-century work of Zhao Xigu, whose *Dong tiang qing lu* provided instructions about collecting, ranking, and authenticating objects through attention to decorative patterns, inscriptions, craftsmanship, colors, smells, and a variety of other sensory engagements. Antiquarians and connoisseurs held objects, felt their weight, turned them over to examine evidence of fabrication, and used their fingers to understand surface and probe interior details not easily seen or illustrated (fig. 7.6).[9]

British gentlemen of the eighteenth century followed similar criteria. In his *Two Discourses*, first published in 1719 and then revised and republished in 1792, Jonathan Richardson encouraged gentlemen to develop clear, exact thinking and reasoning in assessing pictures and drawings. He recommended that a viewer begin with the overall effect, then start to zero in on more details such as composition, color, and technique. The goal of such a systematic object-centered evaluative pursuit, to discern the quality of a picture and offer comparative judgment, was closely connected to class identity. The leisure time necessary to look at and compare works of art and the resulting ability to dif-ferentiate between good and outstanding examples reflected a person's social

standing. It was these very same steps that earlier Chinese scholars undertook when examining bronzes, ceramics, and scrolls.[10]

However, one must be careful not to judge tactile value only through the cost of materials or the sophistication of the technical skills of fabrication. Mughal emperors such as Akbar or Jahangir, who could afford sumptuous silks and gold and silver brocades, placed greater significance on sensory qualities such as softness, saturation of color, coolness on the skin, and poetic power. Fine Bengali cottons, Rajasthani tie-dyed sashes and turbans, and Kashmiri pashmina sashes and shawls all possessed distinct regional associations within the empire and met sensory desires. Writers of the period reinforced the value of these qualities through their poetry, in which they extolled the texture, movement, and sound of these cloths. Other humble objects made of local materials, such as the red cedar furniture of Bermuda or the raffia textiles of the Kongo, maintained high value among the prominent members of those regions, even though these elites could afford to import and flaunt more expensive materials or exquisitely made objects.[11]

## Touch and Function

Once acquired and domesticated, many objects continue to rely on tactility to match their physical qualities to their function. While I began with a discussion of the handled vessel, the simplest type of object in which touch plays a central role is one intended to be held and caressed directly in one's hand or hands. Its felt physical qualities are critical to its intended function. Many ceramic vessels depended on their forms to suggest proper handling. Beer pots in South Africa relied on the width of users' shoulders to determine the ideal diameter of the form. Held in two hands with arms outstretched, they were more easily passed around when the drinkers' hands were placed that far apart. Lacking handles, the body of these pots swelled around the shoulders, further suggesting how one should hold it effectively. The ollas, or water jars, of the American Southwest were similarly proportioned, to ease the handling of liquid containers and prevent spilling. These vessels rarely had large, flat feet but were either relatively rounded to allow level sitting on the ground rather than a flat table, or slightly concave on the very bottom to permit carrying on one's head. In this case, the crown of the head would bear the weight of the vessel.[12]

In addition to swelled shapes, glaze can also contribute to the haptic functionality of utilitarian ceramics. German salt-glazed stoneware, which featured thick walls and a vitrified body, was favored for durable storage and transportation use. The materials made it ideal for that function, but the citrus peel–like surface contributed to its suitability as well. The slightly rough texture of this

skin facilitated one's grip on the heavy objects that were shipped throughout the world. The use of molded decorative surfaces on these and other vessels also permitted users to access haptically the depicted woodland spirits or themes of the hunt or romance (see fig. 1.7). When handling the objects in use, users could literally feel these stories with their fingers. Just as stained-glass windows in churches provided a visual theology, molded surfaces facilitated a felt folklore.[13]

Asymmetrical, slightly distorted, thick-walled tea bowls for the Japanese tea ceremony encouraged tactile exploration of the irregular form, an essential part of the mindful, introspective part of the *wabi-sabi* aesthetic, a physical presence that accompanies the visual irregularity of the firing marks on the glaze. In this example of the uniting of object and philosophy, the agency of the material and maker is celebrated as divine, the reverse of Koerner's notion of Renaissance facture.[14] These felt irregularities also became the identifying basis of the specific names associated with particularly esteemed bowls and tea caddies; providing names like "Pine Bloom" endowed the ceramic vessels with a spirit. These valued vessels fit within an inward-directed practice among a small group. In contrast, the tea cups of eighteenth-century Anglo-American tea practice tended to be regular, refined, thinly potted vessels, part of a matching set that required care in handling but were ultimately interchangeable within that set. Creating bonds of social exclusivity among the numerous participants, they emphasized the outward-directed nature of tea drinking in the parlor.[15]

Like tea drinking, dining in early modern Japan was an intellectual and artistic practice that highlighted beauty and meaning in food production and consumption, particularly as seen in the *honzen* banquet tradition that emerged in the late fifteenth century. Dining from a series of individual trays dates back to the eighth century in Japan, ranging from simple chestnut boards on the ground to red lacquered trays with canted corners set on stands. Eating depended on a variety of materials and textures to help focus attention on the aesthetics of the food and its presentation. Food served more than nutritional and gastronomical value, and through its source, presentation, and even shape stimulated the imagination or referenced sexual pleasure. The textures of the objects also contributed to the sensorial impact of dining: trays tended to be lacquer or wood; rice and soup were often served in lacquer; lacquer sake stands raised sake cups off the floor; sake bottles could be smooth porcelain or lacquer; sake cups were made from rough earthenware or stoneware or smooth porcelain, depending on when the drink was consumed; and fish and pickled food were often served on small, rough stoneware plates. A variation for less formal occasions, still found in Kochi, featured large porcelain platters to serve a variety of food somewhat in a buffet style, but a range of rough and smooth

Fig. 7.7. Tapestry, Andean culture, late sixteenth or early seventeenth century; tapestry woven with cotton warp and camelid and silk weft. Textile Museum, Washington, DC, 91.50, acquired by George Hewitt Myers in 1951.

materials still surrounded these platters. The variety of shapes and textures paralleled the many tastes and textures highlighted in a multicourse meal.[16]

Japanese practice differed from Chinese traditions, where a single, large, rectangular table held shared plates and larger porcelain ewers in the middle and placed a limited number of small dishes and cups of the same material in front of each diner. European dining tended to be communal until the late seventeenth century, when the elite began to follow a different practice, preferring set individual places at a table, with matching chairs; ceramic plates, bowls, and serving dishes for food consumption; glassware for drinking; and flatware for eating. Each diner had his or her own dining equipage, but it looked exactly the same as that used by every other person at the table. Individuality, uniformity, interchangeability, and exclusivity were linked.[17]

The importance of touch and elements that should be grasped also plays a role in the assertive power of an armchair, a seating form distinguished from cushions, stools, or side chairs and often associated with patriarchal authority. Consumers have sought imposing chairs that explicitly display greater size, expensive materials, and expressive decoration for thrones, or the head of a dining table. Artisans often paid particular attention to the arms and hand-

holds, articulating knuckles or robust termini on the latter. This detail encouraged sitters to assume an authoritarian posture, upright, resting their arms, and grasping the ends of the arms in a manner that bespoke command but also allowed a structural reference to the occupants in their absence. In an anthropomorphic manner, the chair had legs, a back, a crest, and arms, and therefore could project rulership even without a human body in it.[18]

While the handheld or hand-gripped object offers one example of the functional role of touch, the feel or texture of an object offers another. Textiles provide an instructive case of the desirability of softness and lightness. One of the main reasons why South Asian cotton cloth gained a global market was its softness. For example, in the early seventeenth century, the British East India Company attempted to sell heavy, drearily colored, scratchy wool tapestries in South Asia. Accustomed to soft, wall-hung carpets composed of silk warps and soft pashmina wool wefts, the local market demonstrated no interest in the ill-suited European work. While wool never achieved widespread demand outside of the colder climates of northern countries in Eurasia and America, cotton gained a global market owing to its lightweight softness, suitable for a wide range of uses, from clothing to hangings. Cotton from South Asia threatened the dominance of English and French wool and silk manufacturers over their local markets. In the early eighteenth century, the former petitioned Parliament for protection, claiming that imports of Indian colored cottons drained valuable bullion from Britain and undercut the profits of English textile manufacture.[19]

Softness also helps explain European taste for varieties of woolen textiles made elsewhere. In the Viceroyalty of Peru, Spanish officials and high-ranking mestizos sought wall hangings and bedcovers made by the skilled Indigenous weavers from the soft, camelid fiber of the region. Using local cotton from the coast and camelid fiber from the higher elevations, the makers provided a warm textile, softer than the imported wool cloth from Spain, and they adapted Spanish motifs such as interlaced latticework in the central panel and urns and scrolled foliage around the borders. But they also drew on their own traditions, using *tocapu* elements as joints in the latticework, including several white-footed blue viscachas around the border, and tapestry-weaving a very fine cloth (fig. 7.7).[20] In Gujarat, weavers used silk warps and cotton wefts in a satin structure to create a striped fabric called *mashru* silk. Meaning "permitted" in Arabic, *mashru* highlights the specific niche of this fabric. To counter Islamic custom prohibiting the wearing of silk against one's skin, the weavers developed a permissible mixed cloth in which the satin weave resulted in the cotton weft providing a soft surface against the skin while the longer silk warps resulted in a lustrous, colorfully striped exterior. The inner face of the textile satisfied one need; the exterior, another.[21]

Related to softness, texture provides another clue to use and market level. Objects with the roughest texture typically can be found in spaces of everyday life, used for storage, food preparation, or basic activities. Given their hard, steady use and risk for damage, they rarely reveal a high degree of finish; that would have made them too expensive for a quotidian object. Their workmanship embodies the commensurate fitness to their purpose. Earthenware with irregular edges and lumpy slip decoration; heavy, cast copper alloy cooking vessels with evident sprue lines; scratchy wool with the variation of handspun fibers; furniture that showed the uneven texture of ring-porous woods like oak and wavy-grained species like elm; and quickly turned treenware with ridged gouge marks characterized the quotidian goods found in kitchens, cellars, and lesser bedrooms.

In contrast to utilitarian roughness, European upper classes increasingly sought soft and smooth objects that offered no resistance to touch. According to the eighteenth-century British philosopher Edmund Burke, visual and tactile smoothness defined beauty. In contrast to smooth and polished surfaces, he argued that "a broken and rugged surface" was not pleasing. In addition to cost, rarity, or evocation of distance, smooth materials like porcelain, tropical woods like mahogany or zitan, silk, and polished brass contributed to the high desirability of certain objects. However, contrary to Burke, rough surfaces did not necessarily signify lower classes; a coarse object did not necessarily signify a coarse person. Certain more expensive goods, including those in more polite spaces, could be rough to the touch. Tin-glazed earthenware often featured a bubbly surface related to the thickness of the glaze, and scratchy wool or horsehair textiles were favored fabrics for European upholstery and hangings through much of the eighteenth century.[22]

Furniture, especially case furniture, combined a variety of textures, a quality that suited its balancing of display and utilitarian purposes. Beginning at the turn of the eighteenth century, exteriors of Anglo-American furniture featured shaped and carved dense woods like mahogany that provided sculptural highlights and shadowed depth while remaining smooth to the touch. One could easily run a hand over the modeled surface of blockfront drawers, shell-carved knees, or fluted pilasters and feel its polished coherence. Just as a wood's figure might provide visual stimulation, the tight grain and carved surfaces encouraged touch and physical interaction. Even the use of brass handles and escutcheons provided a polished accent, a cold smoothness that contrasted with the warmth of the wood, and served as the primary point of tactile contact. But inside the piece, less-finished surfaces were common in drawer linings and bottoms. As items were placed within or removed from drawers, users would encounter and feel the remnants of the steps of processing, including riven, sawn, or planed faces of boards. The subtle ridge lines of jack planes, the

rough saw kerfs not smoothed by planing, or even the tear-out left by riving can be found on most drawers, concealed behind the smooth polish of the exterior show wood. The extra time and cost of finely smoothing all those elements could not be recovered in the price. The assumption was that the polite face was evident to all, while only the owner or domestic help would come into contact with the rougher elements. Rough surfaces abounded through many homes, but the desire for smoothness became an aspirational external symbol of polite lifestyles, of the will to tame nature.

Another desirable functional quality perceived through touch is weight. For some objects like cotton, consumers prized lightness, while for others substance and heft were important. One of the key characteristics of Japanese Nanban lacquerwork, in addition to its durable polymerized surface and association with distance and travel, was its incredibly light weight. The thin pieces of cypress, pinned and lacquered together, made the coffers and writing cabinets extremely light without losing strength, a contrast to the heavy, over-engineered, joined oak furniture typical of Europe at that time.[23] In the American Northwest, kerf bent boxes, made of cedar that was grooved, steamed, and bent, offered a similar advantage. The weight-to-strength ratio of cedar and the use of a single board to make the sides resulted in a lightweight piece of furniture that could be used for storage, sitting, and even cooking. Most non-Indigenous case furniture from the late seventeenth century forward would have heavier, finely finished species for the exterior display wood, and lighter varieties of secondary wood for the less-finished interiors and backs.

Porcelain and fritware offer other examples of media valued for their lightness and durability. While tin-glazed earthenware approximated the look of porcelain and fritware, the former was considerably thicker in body, heavier in weight, and often less even in surface. The fine clay and petuntse body of porcelain and quartz body of fritware resulted in wares considerably lighter than common earthenware and German stoneware. Particularly for tablewares and the refined activities associated with dining, lightness and smoothness to touch were extremely important. From our current hypervisual perspective, we emphasize the exotic appearance of goods from East Asia, but the advantages of a lightweight object and the pleasure derived from the smooth consistent surface were important haptic elements of their consumption in Europe.[24]

While lightness in some cases could be positive, for other materials it risked failure or signaled cost cutting. Potters working with common earthenware recognized that they had to maintain a certain mass, because the low firing temperature made the bodies quite fragile. Only when the Staffordshire potteries began to clean and refine their earthenware clays at the end of the seventeenth century did thin-bodied earthenwares become successful. Seventeenth-century joined, London-made furniture often had very elaborate

facades, but side panels and drawer linings were typically composed of thin pieces of riven, low-grade oak. The emphasis on outward showiness made the cabinets look substantial when seen head on, but the sides, interiors, and backs revealed a flimsy structure behind that fashionable front.

In contrast to textiles and ceramics, metal was often valued for its heft and substance. The equipage for puja (worship ceremonies) in Bengal consists of a tray with bowls and glasses (beakers). The most favored material for these forms has traditionally been bell metal. It is considered preferable to fragile earthenware and superior to lighter-weight copper or stainless steel. It resembles gold, does not tarnish, and offers a bell-like sound when struck, but it also provides appropriate heft.[25]

Weight and solidity also imbued the ebony furniture made in the seventeenth century on the Coromandel Coast with a strong visual and material presence. The density and natural sheen of the material were marvels to Europeans, who eagerly sought substantial furniture made of it, but its ability to be carved crisply also contributed to the desire of the foreigners, whose own furniture relied more on oak and conifers and emphasized the visual aesthetics of veneer, applied moldings, and low relief carving. Extensive deep carving on ebony cabinets and chairs provided not simply a visual form of decoration but also a tactile one. Sitting in the chairs would also result in a bodily encounter with the textured carving and turned elements while opening the doors or drawers would bring users into direct contact with the carved surface.[26] In China the heavy dark wood zitan gained favor for its stability (it did not check or expand and contract) and ease of carving and became the specialty of imperial workshops. Like ebony, the combination of weight and suitability for carving contributed to ornate objects that beckon to the hand and touch.[27] Carving was not simply a visual form of fashion and style but a locus of haptic interaction, where consumers or users might run their hands or fingers over a surface, mapping its terrain to understand the object's message.

## Touch and Circulation

Once objects begin to circulate, touch plays an important role in an object's history of use as it passed from hand to hand. In the chapter on memory and gift, I explored how touch provided a connective indexical feature that could transport someone across generations or space or to the imagined shop of fabrication, but it is important to pause as well on the connection between touch and portability. Handheld objects could be easily carried and exchanged at a time when cargo capacity of ships and caravans paled in comparison to that of today's container ships, cargo jets, and semi-trailers. Small Nanban coffers, Gujarati writing cabinets, and stacked Chinese ceramic bowls and cups fit

neatly into ships' holds, and textiles folded into compact bundles and shipped within trunks. The scale of many trade goods responded to both ease of transport and personal connection. Furthermore, they were easy to pass along from hand to hand as a gift.

Manipulation of an object after forming its structural core, to highlight relief or depth either through additive or subtractive means, provides additional means to encourage and permit tactility. Textiles can be subject to the manipulation of the cloth ground through an additive process to achieve a subtle dimensionality. Setting in supplemental wefts to provide additional color and pattern, embroidering naturalistic motifs onto a plain woven cloth, or stitching smaller pieces of appliqué onto a large cloth adds visual and haptic texture to a cloth surface (see figs. 2.20, 2.26, 2.27). In other media, the artisan does not have to add a layer. Removing wood or clay through carving or modeling is a direct form of subtractive manipulation (see fig. 2.7), while chasing metal, embossing designs by using hammers and small steel punches, transforms the surface by moving it without removing metal (see fig. 2.30). Layering and cutting constitutes yet another method of using surface as a location of sculptural decoration. Chinese lacquerers built up layers, sometimes with different colors, and then cut through them to create vibrant relief work (see fig. 2.2). Potters like those working in late-seventeenth-century North Devon, England, used a technique referred to as sgraffito, in which they dipped their red earthenware form into a whitish slip, let the slip dry to a leathery texture, and then carved motifs through the slip revealing the red body. The scratched elements became slight depressions in the glossy, glazed surface, not clearly seen but felt when running a hand across the surface (see fig. 2.10).[28]

Relief work achieved through these various means enlivens the surface by emphasizing geometric or natural patterns but also focuses attention on the changing perspectives of users or viewers as they behold and engage with the work, turning it over in their hands, folding it, or pulling out a drawer. Each action stimulates a number of senses, driven primarily by touch. The interactive possibilities of haptic as well as visual engagement kindle imagination and associationism, and argue for the need to pay attention to sculpturality as well as visuality when examining a work of art.[29] Material culture and sculpture share an uneasy relationship, one that can be characterized by elastic boundaries and shifting classification values. By its sheer physicality, material culture is sculptural in that it occupies three-dimensional space. Yet it is often the more ornamented luxury object that qualifies as a sculptural object. Objects with less overt or less fashionable decoration have rarely garnered such descriptors until recently, when the "expanded field" of sculpture, to use Rosalind Krauss's phrase, embraced minimalist sculpture that suggested function, such as the work of Scott Burton or Donald Judd.[30] At the same time, artists recognized as

sculptors have modeled objects usually referred to as decorative arts or forms of usable sculpture. Rather than look at sculpture as a tidy category of art making, we should acknowledge the full complexity of three-dimensional works within their own logic of making and circulation rather than within an arbitrarily imposed sense of aesthetic hierarchy.[31]

Texture can also convey narratives about objects. Often makers or owners inscribed their names, initials, or special dates on objects to note the time of manufacture or a moment in the stages of their lives: birth and childhood, courtship and marriage, professional identity, friendship, and death and legacy. While there are examples of using the surface to date an object—painting under glaze on ceramics or inlaying into wood or metal—other means of recording a specific time or owner were executed in relief and appealed to touch as well as sight. Joiners and cabinetmakers carved dates and initials into a piece of furniture, but subsequent owners often inscribed their initials to mark their presence in the history of the object and to document a social relationship that one could see and feel.[32]

Artisans working in metal produced textural narrative in a variety of ways. Metal snuff or tobacco boxes often featured engraved initials and dates, but the sharp lines of the cut surface softened with time and implied constant handling and polishing. Prized not simply because of the fashionable act of taking snuff, these containers proliferated because owners could hold them, personalize them with initials, touch those inscriptions, and pass them along as a gesture of friendship or affection, yielding a sense of connection and presence. Braziers casting bronze objects could add integral names, dates, poems, and decorative imagery during the mold set up stage. Like a typesetter, they set stock individual lettering into the mold, resulting in a body with raised lettering and motifs. Such objects prove readable; users felt the text and imagery (see fig. 4.1). Islamic metalsmiths used chasing and silver inlay to write dedications, religious exhortations, or their own names on various types of objects. The inlay stood slightly above the plane and provided a faintly modeled surface that could be seen and felt (see fig. 2.30).

The texture of cloth can also reveal histories. Cloth's mobility and high value led not only to maintenance and repurposing but also a desire to mark authorship. Cross-stitched initials or names on samplers or pictures and embroidered names and dedications on cloths like kanthas provided raised documentation of the original female needleworkers, who lacked other means to record their presence, and ensured their legacy over generations. Quilting stitches to secure the batting between the front and back of a bedcover also provided a very subtle bumpy texture in kantha and quilts. Inscriptions and alterations of reworked textiles also permitted continuity with the past while satisfying current needs.[33]

Texture also can play a role in aesthetics. Just as patina addresses the relationship of time and surface, softened wear reflects the connection between time and texture. In contrast to the Burkean emphasis on smoothness, beauty, and refinement, other aesthetic philosophers, like Sen no Rikyu in sixteenth-century Japan, John Ruskin in nineteenth-century Britain, and Yanagi Mumeyoshi in early-twentieth-century Japan, have extolled the virtues of irregular surfaces that engage the user, emphasize history, and honor the virtues of well-loved use.[34] Rather than signal class distinction, which patina and smoothness often did, consciously textured objects tended to speak to different values, such as resisting the changefulness of the fashion system encouraged by conspicuous consumption and embracing the humanity of making rather than the precision of industrial capitalism. Objects with dents and chips enabled the person who touched them to imagine a past and to feel a connection to the maker or the life enjoyed by the object. Roughly but well-made objects like ceramic *kalshis* (water jugs) in South Asia or wooden drinking bowls in early modern England, products David Pye attributed to the maker's "free workmanship," satisfied a certain type of quotidian ware in eras before mass production overwhelmed local production.[35]

However, there are no universally accepted notions of touch. Objects that pass from hand to hand between people from different classes or cultures often elicit unforeseen or unanticipated responses. In the late nineteenth century, many Europeans and Americans viewed the roughness of Japanese ceramic tea bowls and cast-iron vessels as primitive work, the products of a less civilized culture, and favored the exacting precision and availability of consumer goods produced in factories. Only a few among the cultural elites understood the philosophical import of irregular workmanship and valued it more as inspiration for new design. Such examples document how what had been fashionable at one moment in time or among a certain group have not earned universal appreciation.[36]

Some traveling objects were preserved and accompanied by stories that could be accessed or highlighted by touch, while others were touched too much, becoming worn or broken and, as a result, discarded. This interrupted or ended the narrative potential of the object. But these discards often take on new lives as the source material of archaeologists conducting fieldwork in ruins, historical privies, and landfill sites. Their materials, facture, and surfaces analyzed and interpreted, these fragments begin to speak through the work of scholars and thereby provide new narratives. Their textural qualities often provide invaluable clues about historical values and use.[37] Hands played an integral role in the social lives of objects, both literally and abstractly. A haptic approach contributes to insights into an object—whether it was intended for use or as a relic, dilapidated through frequency of use or neglect, or destroyed

intentionally or unintentionally. Thus, touch provides an important entry into an object's history; it is much more than a static observed and appreciated entity.

## Conclusion

The critic Adam Gopnik has referred to touch as the "unsung sense," arguing that every other sense has an art form associated with it: sight has art, hearing music, smell perfume, and taste gastronomy. However, according to Gopnik, touch has none.[38] The thrust of this chapter, indeed this whole volume, argues that Gopnik's observation is flawed and reveals the biases of what Susan Stewart has referred to as the "empire of sight" or what Constance Classen and David Howes refer to "ocular centrism."[39] The developmental narrative, which charts the rise from touch to vision as an example of the evolution from the ancient system of perception to a modern one, has informed the very foundations of the discipline of art history. As Fiona Candlin has pointed out, the works of Alois Riegl, Heinrich Wölfflin, Bernard Berenson, and Erwin Panofsky all equated the history of art with a history of vision and asserted that the best examples are those that rely on a rational sense of visual representation, either producing images so convincingly three-dimensional that they stimulate the tactile sense or so abstract that they transcend the subjectivity of touch. However, it is a white, European, Christian perspective that connects race, geography, and even religion to visual literacy and considers reliance on tactility to be an indication of inferior race, culture, or belief system.[40]

Today we tend to confirm our knowledge of the material world through photographs or other representations of those objects or by mediated viewing in visually oriented museums, where objects are often placed at unnatural heights on platforms or under Plexiglas vitrines to prevent visitors from touching. Such museological practices, developed for the display of paintings and sculpture in institutional settings, privilege the visual appeal of objects and restrict visitors' ability to understand levels of workmanship, social use, or environmental context. These means of presentation steer us to engage with the objects as autonomous works of aesthetic value, an experience that more closely resembles shopping or browsing rather than using and understanding. The denial of touch and reliance on vision distances and disconnects people from objects, which become decontextualized and abstracted from imagined everyday interaction.

This visual display system of the museum reflects a hierarchy of sense in which touch, smell, and taste are considered the lowest form of sensory engagement. They are considered animalistic, bodily, and base, in contrast to high-minded attitudes toward sight, which is more closely associated with

rational knowledge and intellect. The rise of such a hypervisual culture began with the notion of the picture frame, which separated the object under consideration from the experienced world and permitted a detached imaginative space, and has accelerated in the past century through various visual technologies, particularly as we now receive the bulk of our knowledge through a screen rather than via direct experience.[41] Tacit knowledge has been replaced by book knowledge, doing by watching. But such privileging of sight also reinforces certain hierarchies of objects. Museums send subtle colonial messages regarding value: the greater reliance on sight and limited physical access denotes a higher form of art, a certain type of aesthetic uselessness and autonomy that elevates an object. Even ethnographic museums impose a visual order on objects, limiting multisensory dynamics and denying the spirit or context of the objects in captivity.[42]

However, objects demand that we use a full battery of senses. We may recognize something visually, but we process, understand, sort, and remember through physical engagement. Objects are not simply two-dimensional flat surfaces to be read or decoded but are three-dimensional entities to be held, turned over, or experienced. It is not so much what objects say as what they do; use and context establish the sensory system of a culture. While we may currently value living in a flat world, clear in its contours and conducive to the ease of movement and predictable production, flatness is a modern conceit of the Anthropocene. We rely on manufactured unnatural materials and seek to demonstrate our control over, or even disregard for, nature and natural materials. Yet for much of human history working with natural materials, rather than on them, and approximating flatness prevailed.[43] In adapting an interest in corporality and psychology, we might profit from European theories of *einfühlung*, or empathy, and *unheimlich*, or uncanny, to describe the combination of the haptic, the kinesthetic, and "the remembered" to describe our approach to deep engagement that is not merely reading nor looking nor handling nor using, but all of this and more.[44]

Hands and touch, fundamental in both the making of objects and in the reception, use, and understanding of them, help to correct Gopnik's assumptions. We might instead assert that the art form accurately associated with touch is the object with a rich and complex surface, either well decorated or subtly simple, begging to be seen and, more important, experienced and understood by the hand. In an era when we suffer from a poverty of material intelligence, we should restore touch to its proper place.[45] While vision, sound, smell, and even taste are important sensorial tools for the full understanding of objects, touch remains the most important tool of them all.

# Conclusion

I have written this volume not as a comprehensive history that charts the complete ebb and flow of objects over time but rather as a thematically driven, suggestive guide that offers an open-ended approach to the principles of material literacy that might inspire scholars with expertise in particular media, regions, or time periods or students just delving into the material world for the first time. Through a wide variety of themes and examples, I provide the technical and conceptual tools to make sense of a multidirectional world of movements, translations, and entanglements. Eschewing traditional binary cardinal divisions of East versus West or North versus South, the concept of national styles, or the privileging of luxury goods over other kinds of objects, the chapters instead embrace the messiness of objects that move in multiple trajectories, sometimes paralleling other objects but often passing others going in different directions. In addition, objects did not always move nonstop, but traveled through several hubs or experienced layovers.

At the core of the endeavor is a move away from traditional art historical formal analysis, which typically begins with an overall assessment of the whole—its style—and then zeroes in on the details that support an interpretation. When applied to objects, this sort of item-centered approach characterizes the traditional connoisseur-driven obsession with aesthetic quality, authentication, and stylistic typology as well as the generalized cultural explanations of early anthropological approaches to material culture. These scholarly traditions typically viewed objects as passive reflections of a time and place and contextualized them simplistically. Instead, this volume emphasizes

comparative object-driven inquiry in which material knowledge, that is, the full understanding of the possibilities and properties of different materials and processes at a specific moment in time, is key to the study of an object on its own terms and understanding the active role these objects played in their various environments. Working from the inside out informs the initial inquiry, the framing of analytical questions, the deployment of appropriate theory, and the very proof of an argument. However, a scholar should avoid either a linear centrifugal model in which one begins with the object under consideration and then moves outward to find a convenient, simplistic, historical backdrop that provides "context," or a linear centripetal model in which one develops a theory about a specific moment in time and then selectively searches out the objects that illustrate those preconceived ideas in a tautological manner.[1]

Rather, we should develop a more dynamic approach to objects, in which we deploy a series of ideas/theories/instincts that together serve as an overarching and open-ended research agenda. Such a constellation of questions might be drawn from cumulative looking at related objects; historical issues surrounding production, consumption, and circulation; new scientific or documentary evidence about certain objects; or appropriate theoretical models concerning the world of objects in other disciplines like anthropology, psychology, or sociology. The scholar then tests these questions or instincts by interrogating the materials, techniques, interiors, and exteriors of objects, rejecting and refining some of those initial parameters. Driven by questions that arise from the physical evidence of the objects themselves, the scholar returns back to the guiding questions to rethink their assumptions, undertake additional reading or research, and search for other relevant theoretical models. Having rethought the research agenda, the scholar then returns to the object to plumb its depths again.

This in-and-out process, a continuous circuit in which the scholar recalibrates the research agenda slightly each time, allows the objects not simply to provide evidence, but also to spark ideas. Such a proposal more explicitly acknowledges the unconscious work that often precedes the investigation of the object as well as the ability to move back and forth between object as evidence, object as generator of additional avenues of exploration, history/theory as generator of ideas, and history/theory as evidence. This dynamic model resembles the reflexivity methodology of Henri Lefebvre: the object is a social product that arises from specific quotidian practices and perceptions, relates to period theorization of objects as implied in representations or descriptions of those types, responds to the artifactual imagination, and possesses the potential for constant transformations.[2] The role of a "gentle empiricist," as Goethe called it, positions this scholarly endeavor as a parallel to the creation of the object.[3]

Fig. 8.1. Hanging or palampore, Machilipatnam, India, mid-eighteenth century; plain woven cotton with drawn design, painted and resist and mordant dyed. British Museum, London, 1998,0505,0.1.

A few concluding examples, one from each of the media discussed in this book, highlight the limitations of traditional, taxonomic, formalist approaches and suggest possible gains of such an object-driven strategy. A large palampore, or hanging, produced around 1770 in Machilipatnam on the Coromandel Coast of South Asia is more than a textile with a densely packed ornamental program; it defies categorization along cultural or national lines

(fig. 8.1). It is South Asian, East Asian, and European, all at once. But it is not the product of derivative misunderstanding or copying. The skilled painters, astutely aware of distant markets, combined a multiplicity of possible imagery to respond to foreign expectations. In the center and each of the corners they placed a heraldic device of a crowned and rampant lion, implying that this was a special commission for a European noble family. The remainder of the imagery essentializes a variety of Asian motifs in an attempt to conform to non-Asian perceptions and desires: the bamboo shoots, peonies, and song-birds are stock Chinese tropes but are executed in a dense manner more typical of South Asian textiles; the four large images of robed women sitting on drum stools and adjusting their hair exemplify an exoticized femininity; the erotic scenes portrayed at the corners inside the border further the salacious sense of the exotic; and the outer border replicates the gold-leaf colors and lively streetscape imagery found on Japanese screens depicting urban settings. The border just inside this band consists of a row of marching European soldiers, likely a comment on the mid-eighteenth-century battles of Wandiwash and Pondicherry between the French and British on the Coromandel Coast and the increased European military presence on the subcontinent. On the reverse of the cloth, Arabic numbers are rendered in Cyrillic script. This, plus its history of ownership in St. Petersburg by 1772, suggests that the palampore was a commission for the Russian market. The colors and control of technique speak to the deep knowledge of the artisans, while the conscious, original combination of motifs reveals how they knowingly understood and responded to various notions of European exoticism on their own terms.[4]

A clothes press with secretary drawer provides another example of a complex object that complicates typical classification systems (fig. 8.2). The form—a two-section storage unit with bracket feet, in which the lower part consists of open shelving behind doors with a secretary drawer above, and the upper section contains sliding fronted trays behind doors—is purely British, reminiscent of work from around the 1770s. However, the broken scroll pediment with anthemion (fan-shaped palmette) finial is an unusual feature of this example; almost all British and British-influenced clothes presses in the Americas feature flat tops. The materials also differ from those typically employed. Whereas the British would have used mahogany as the primary wood and oak and fir as secondary woods, this example is made from Chinese elm and finished with a lacquered surface. The lacquer, particularly the extensive use of grape leaves and tendrils, characterizes a popular approach found on Guangzhou lacquered furniture at the turn of the nineteenth century.[5] The panels in the doors of the upper section document a third influence: they are reverse painting on glass of South Asian subjects, executed in a South Asian manner. While Guangzhou artisans specialized in the reverse painting

Fig. 8.2. Secretaire cabinet, Guangzhou (Canton), China, 1790–1810; elm, lacquer, and reverse painting on glass.

technique, these particular examples do not resemble typical Chinese work or Chinese versions of South Asian subjects. Rather, the close relationship to Mughal miniature painting, including the borders around the images replicating the effect of paper borders, the three-quarter views of the main subjects and profiles of the minor subjects, and the clothing, all suggest a South Asian artist or someone fully steeped in the Mughal painting tradition. A number of Chinese painters did work in Kolkata (Calcutta), and this raises the question of how the glass panels came to be part of a Guangzhou piece of furniture. Did the cabinetmaker procure the paintings independently and decide to use them in the furniture? Was the buyer a native of Guangzhou who sought affiliation

with European taste locally expressed? Or perhaps the client was an East India Company customer or a British merchant who arrived from Kolkata with glass in hand, seeking to create travel memorabilia, who then shipped it back to Britain? The history of the clothes press is unknown, but there are a variety of possible explanations that a simple label such as "Chinese export ware" does not encompass.[6]

A third object with complicated meanings over time is a form popularly called a face jug (fig. 8.3). A white owner of a pottery in Edgefield, South Carolina, referred to such works, the products of enslaved potters, as "weird looking water jugs, roughly modeled on the front in the form of a grotesque human face,—evidently intended to portray the African features." Projecting racist perspectives onto the vessels, the whites of the region dismissed the work as "aboriginal art" that embodied the uncivilized nature of enslaved Black laborers.[7] While whites have considered the form to be curious caricatures of African physiognomy or crude adaptations of British "Toby jugs" (jugs in the form of a seated person), thereby denying them any deep meaning, the vessels held particular power in the Edgefield area during the last forty years of the nineteenth century. In the early twentieth century, white potters in the region appropriated the form, enlarging the vessels and marketing them as regional folk art. In appropriating the form as their own tradition, they negated the deeper meaning of the jugs, one tied to African culture. African spiritual beliefs became important vehicles of survival and resistance among the enslaved in the South, a means to function outside the restraint of the slave system and to assert independence from white authority. However, the jug represents more than the direct transmission of African beliefs; it combined elements of Kongo spiritual practice, African American circumstances of enslavement, and local South Carolina resources and technologies such as the clay, the pottery wheel, and ash glazing. Enslaved African Americans were the primary craftspeople working in the stoneware potteries of Edgefield, turning storage crocks, jars, and jugs on a wheel and firing them in kilns. In 1858, a group of enslaved Kikongo people arrived at Jekyll Island, Georgia, and several were sold to Edgefield owners. Apparently, these recent arrivals from West Africa reinvigorated the power of conjuring beliefs, the use of material charms to communicate with dead spirits, heal the sick, protect the vulnerable, or even cast a spell on the ruling whites.[8]

Rather than turning to carved wooden *nkisi* (human figures with added nails and other materials that activated the charm's energy) or low-fired coiled earthenware vessels, local enslaved potters in America transformed the Kongo tradition, and it emerged as a new material presence—the stoneware face vessel. Considerably smaller than a standard jug, often standing only five-to-six inches in height, the face jug possessed great power among the enslaved. In

Fig. 8.3. Face jug, Edgefield, South Carolina, 1860–70; wheel-thrown and modeled alkaline glazed stoneware with kaolin eyes and teeth. Found in an archaeological context of a home in Germantown, Philadelphia, Pennsylvania, where descendants of Edgefield families, including some who worked at the Palmetto Fire Brick Works, lived. Private collection.

Kongo belief, the head was the main force of life and container of spiritual power. The use of local white kaolin clay for the eyes and teeth linked the association of the color white with spirits and therefore allowed the vessel to see and speak with spirits. The vessel form also permitted the activation of the conjuring object with hair, nail clippings, fragments of personal possessions, and roots stored safely within. Kept among their few possessions or placed in burial grounds, the face jug preserved and transformed African beliefs into a coded spiritual practice that provided comfort and solace in inhumane conditions.

A final example also reveals misperceptions from a Eurocentric world. When the Spanish conquered the Andean civilizations in the sixteenth century, they were particularly entranced by the amount of gold and silver on display and sought to seize as much of it as they could. In their greedy view of the Indigenous resources, they viewed it as a precious commodity, valued for its liquidity, use in luxury objects, and as the favored medium of exchange. They did not understand the local cultures' interest in the associative properties of the material—gold represented the warm, shiny rays of the sun, while silver represented the luminosity of the moon—nor did they think the Indigenous metalworkers sophisticated. The Spanish viewed gold keros at face value (fig. 8.4).[9]

However, much of what the Spanish encountered was not solid gold. Andean metalworkers developed sophisticated copper alloy skills with low-technology smelting around the ninth century. Tumbaga, a copper alloy composed of at least 60 percent copper and significantly smaller quantities of gold, was used for both utilitarian and luxury or ritualistic objects. The

Conclusion

Fig. 8.4. Kero, Lambayeque culture, 800–1300; raised and repoussé chased tumbaga. Museo Larco, Lima, Peru, ML100107.

greater proportion of copper provided desirable working properties; vessels could be raised and shaped easily while retaining proper structure and integrity. To achieve the desired look of gold, the metalsmiths did not simply use an additive process, applying gold leaf to cover the copper body, to produce high reflectivity and a gold color. Rather, they developed a depletion system, using acid to remove unwanted surface elements of the copper and to highlight the gold elements of the alloy. The development of this technology did not stem from a desire to improve the durability or utility of the finished product or to celebrate technological achievement for its own sake but rather grew from a symbolic or ideological system that viewed color as something more than a visual quality. The color of the gold left by the depletion system was the essence of gold, the external manifestation of the metal's inner nature.[10]

The necessity of material literacy informed by cultural curiosity underscores the fact that our field is object-driven and based on collections of objects, whether in a domestic, institutional, or public setting. But collection, comparison, and taxonomy constitute only one part of the scholarly enterprise; we need to pay equal attention to the complementary exercise of theoretical experimentalism to probe possible specific meanings.[11] This theoretical charge and the examples in this volume provide a kit of tools for future complex constructions of history. In emphasizing a global, horizontal history of the transregional world, we build off of and move past vertical regional history driven by geography, nation-states, and time period. We ourselves are comfortable in an interconnected world, so we should use objects to serve as a foundation for an interconnected art history.

# Acknowledgments

This volume is the result of an Americanist following the various trails of materials and, over time, acquiring deeper knowledge of those materials throughout the world. When I began teaching at Yale in 1992, I sought to expand the purview of American decorative arts beyond its traditional focus on objects made in the thirteen original American colonies. I wanted to understand objects used in America, including imports from throughout the world as well as works made and used by a variety of Americans, encompassing Indigenous people, enslaved and free African Americans, French and Spanish colonists, and creoles inhabiting a wide area from the original colonies along the East Coast to New France and the Mississippi Valley, New Spain, and the Caribbean. In a time of multiculturalism, I was committed to teaching students about the breadth of material culture of the colonial Americas outside of the standard nationalism born of nativisitic antiquarianism and the arts and crafts movement in the late nineteenth century. As I searched the Slide Library looking for images, I found myself toggling from a section devoted to the minor arts, to sections on Britain, France, China, and Africa. I also found myself searching for images in books shelved throughout the libraries. The peripatetic nature of my image accumulation paralleled the mobility of the historic objects. Through preparation for teaching and conversations with many colleagues in the History of Art Department and the Yale University Art Gallery, I slowly built up my knowledge of the histories of different media.

Increasing my understanding of the production and flow of objects over a broad period of time and from a wide geography required considerable generosity and collegiality from many scholars. In the early 2000s, I collaborated with Nancy Berliner on an exhibition on Chinese furniture at the Peabody Essex Museum. We spent many hours looking at pieces together, and I built up detailed knowledge of that venerable field. Accompanying my wife, Carol, on a business trip to India in 2007, I met Ruby Palchoudhuri of the West Bengal Crafts Council and began to pay closer attention to the textiles, metalwork, woodwork, and ceramics of South Asia. Conversations with Nancy, Ruby, and others whom I met made me realize that the questions that scholars of American material culture asked were eagerly embraced and needed elsewhere. I continued to educate myself through travel and spending time in different parts of large museums like the Metropolitan Museum of Art in New York City, the Victoria and Albert Museum in London, the Museu Nacional de Arte Antiga in Lisbon, and the

Asian Civilizations Museum in Singapore. Field work in India during 2010 and 2015, organized by Ruby Palchoudhuri, Dipti Khera, Holly Shaffer, and Ami Potter, provided invaluable exposure to the techniques and attitudes of contemporary artisans working in traditional techniques. Traveling with them and delving into craft histories of West Bengal, Rajasthan, Maharashtra, and Gujarat were fundamental to this volume.

When the Department of the History of Art began to debate the issue of what constituted a proper introductory survey in the early 2010s, there was considerable discussion about the problems of the traditional Western and non-Western divide in the curriculum. Sensing an opportunity to sidestep this debate, I offered to teach a survey about global objects that had neither a chronological developmental narrative nor a nation-by-nation accounting. Seeking to overturn hierarchies and emphasize commonalities, I decided to begin with the materials and build outward toward themes generated by the fabrication and movement of these materials. While radical in structure, the goal of a survey remained intact: a course designed to develop sustained and rigorous engagement with original works of art that would be accessible to majors and non-majors alike. The course fostered visual *and* material literacy and provided the foundation for a curiosity about and tolerance for varied cultural expression. I believed these were important goals for an introductory humanities course.

I first taught this survey in the spring of 2013 and immediately saw the benefits of the course—to the undergraduate students who enrolled in it and began to see the world around them differently; to the graduate students who got to teach with objects rather than merely in front of them and who thus developed a wider range of interpretive skills; and to me, who had to keep expanding my knowledge. Trying to find effective readings from different continents and time periods and using lectures to tie together these rather disparate pieces of the puzzle, I soon realized it would be best if I could write a book that would weave these different threads together.

I am grateful for the support of many Yale colleagues past and present who have shared thoughts and readings with me, brought objects to my attention, and encouraged my explorations: Carol Armstrong, Ruth Barnes, Molly Brunson, Kate Ezra, Joanna Fiduccia, Gillian Forrester, Cécile Fromont, John Stuart Gordon, Jacqueline Jung, Pat Kane, Larry Kanter, Denise Leidy, Mary Miller, Barbara Mundy, Robert Nelson, Sadako Ohki, Ruth Phillips, Ami Potter, Kishwar Rizvi, Tamara Sears, Katie Trumpner, Lillian Tseng, and Mimi Yiengpruksawan in particular. Tim Barringer has generously folded me into several travel seminars to explore the material culture of far-flung parts of the British Empire and has always supported and encouraged my efforts to take this novel path. Early on in writing the manuscript I was buoyed by the collegial support of Marisa Bass and Milette Gaifman as we met to exchange our writings and worked to

make our scholarship appeal to wider audiences. Workshopping chapters with them helped build up my momentum and confidence early in the writing phase.

Fellow laborers in the field of craft knowledge have also been instrumental in the development of the ideas in this volume. Glenn Adamson has been a trusted colleague throughout our many endeavors as we push to expand the field of craft studies. Jon Prown at the Chipstone Foundation provided a wonderful experiential environment in which I could test out various classroom strategies for understanding materials and processes. Other members of the Chipstone circle, especially Sarah Anne Carter, Ethan Lasser, and Sarah Fayen Scarlett, have been generous sounding boards. Pamela Smith's "Making and Knowing" project has provided inspiration, and I was grateful for the opportunity to participate in the 2019 "Weaving Knowledge Workshop" in Thailand, where my immersion in dyeing and weaving, including time at the loom, helped unlock some of the mysteries of textiles. Another valuable forum for broadening my horizons has been the Global Interchange Seminar established by Kee Il Choi in 2020 to counter the isolation of the COVID pandemic. Scholarly generosity by presenters and participants have contributed greatly to the expansion of my knowledge and refinement of my ideas. Finally, I have also learned so much from the insights of living makers, especially Clarence Cruz, Jarrod Dahl, Ram Kishor Chhipa Derawala, Peter Follansbee, Bhalchandra Kadu, Ahmad Abdulrazak Khatri, John Marston, Joan Parcher, Mark Potter, and Penelope Van Grinsven.

In presenting or commenting on related material at various conferences over the years, I gained invaluable input from a number of scholars. In 2011 at the "Material Culture, Craft and Community" conference at the University of Alberta, I benefited from discussing textiles with Eiluned Edwards, Adrienne Hood, and Beverly Lemire. Abigail McGowan and I exchanged ideas about craft in South Asia at the 2013 American Historical Association conference in New Orleans. The next year Romita Ray invited me to talk at "Transformations in South Asian Folk Arts, Aesthetics, and Commodities," a conference at Syracuse University organized around the collection of Ruth Reeves. Romita, Pika Ghosh, and Rebecca Brown responded favorably to an interloper from another field and buoyed my confidence in reaching beyond my own specialty. The same year, a conference titled "Between the New World and Asia: Trans-Pacific and Trans-Atlantic Exchanges in the Early Modern Era," organized by Dennis Carr and Tom Cummins at the Museum of Fine Arts, Boston and Harvard, provided an opportunity to talk about Nanban lacquer. A 2014 research trip to Lisbon and a conference the following year, "CHAM2015: Knowledge Transfer and Cultural Exchanges," allowed extensive conversations with Zoltan Bidermann, Pedro Concela de Abreu, Alexandra Curvelo, Luisa Vinhais, and Jorge Welsh. As a discussant at a 2019 College Art Association panel on "Ceramics and the Global Turn," Feng He, Meghan Jones, and Elizabeth Perrill generously shared

their work on the circulation and meanings of ceramics. The opportunity to teach a course at Yale-NUS Singapore in 2019 allowed me to present my ideas at a research forum at the university, where Emanuel Mayer, Sujatha Meegama, and Nozomi Naoi provided wonderful feedback. While in Singapore, I also benefited from looking at objects with Peter Lee.

My greatest debt was been to a number of graduate students with whom I have worked closely as students in class, advisees, or teaching fellows for the survey course. It is to them that I dedicate this volume. Their feedback and scholarship has been of immeasurable help to my learning curve and has inspired me. These students include Mal Ahern, Andres Bustamonte, Dennis Carr, Yong Cho, Christine DeLucia, Ruthie Dibble, Manon Gaudet, Daniel Greenberg, Soffia Gunnarsdotter, Philippe Halbert, Andrew Hamilton, Lily Higgins, Sylvia Houghteling, Sophia Kitlinski, Cindy Kok, Julia Lum, Sam Luterbacher, Sequoia Miller, Nathalie Mirival, Anya Montiel, Christine Olsen, Kate Phillips, Lidia Plaza, Shweta Raghu, Holly Shaffer, Heeryoon Shin, Emma Stein, and Ingrid Yeung. Many of them kindly took the time to read all or parts of the manuscript to make sure I got the details correct and argued the larger points effectively. In particular I would like to thank Yong Cho, Andrew Hamilton, Sylvia Houghteling, Sam Luterbacher, Sequoia Miller, and Holly Shaffer for their perceptive comments and recommendations. Kee Il Choi, Ben Cooke, and Denise Leidy also kindly read parts of the manuscript. The feedback from the three outside readers—Pika Ghosh, Margaret Graves, and Michael Yonan—provided immensely helpful comments and corrections, which I hope have been addressed in the final version.

It has been a pleasure to work with Princeton University Press. I am deeply grateful for the support and encouragement of Michelle Komie, who, right from the start, understood the potential of this book and shepherded it throughout the different stages of writing and production. That kind of commitment, also seen in the support of Christie Henry, the press's director, and the editorial board, was crucial to the successful completion of the manuscript. The production team of Kenneth Guay, Sara Lerner, and Steven Sears smoothly steered the project; they are also true craftspeople. Beth Gianfagna cast a careful eye on the manuscript as copy editor and polished the final product. For obtaining photographs and permissions, I was fortunate to team up again with Laurel Peterson, who deftly navigated the world of rights and reproductions and kept the project on schedule.

The final writing of this volume took place during the isolation of COVID-19. I am so grateful for the understanding and patience of my family, who gave me the time and space to focus on the completion of this book: Carol, Rachel, Ben, and Tracy all provided unflagging support, encouragement, and love. And it was wonderful to welcome Mac to the family just after I finished the first draft. I hope that this virtual travel log takes them to new places.

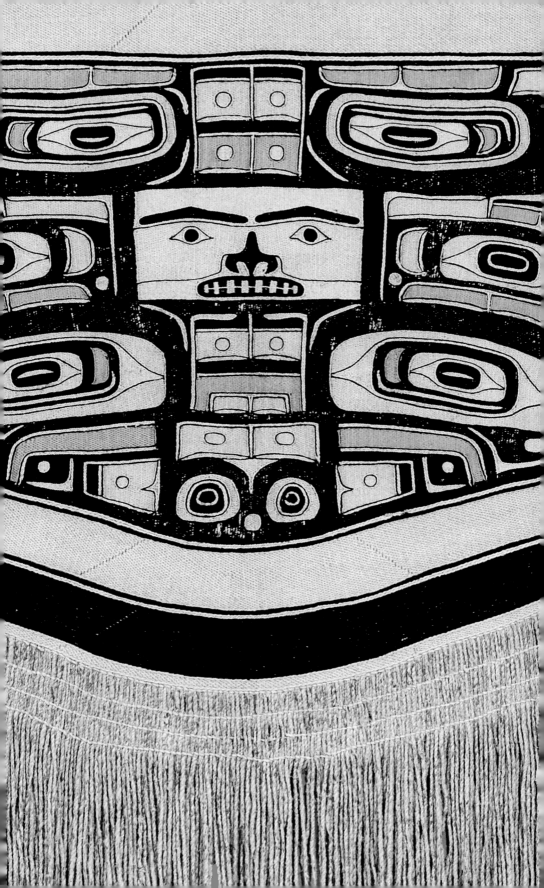

# Glossary

**appliqué:** A quilting technique in which the maker secures textile swatches onto a plain cloth ground to create geometric or figurative designs.

**backstrap loom:** A weaving tool in which the warp tension is achieved by the weaver wrapping a belt attached to the cloth beam behind his or her back. The other end of the warp is secured to a loom bar, and the weaver leans back to achieve proper tension. This technique requires less fixed equipment than a frame loom and allows for the portability of weaving.

**barniz de Pasto:** Lacquer tradition in Colombia in which the sap of the mopa mopa plant is collected and heated. The gelatinous mass is then stretched out and thinned by using teeth and fingers. Can have color added to it. The sheets are then cut up into decorative elements or figural parts and burnished to a wood substrate.

**bast:** Strong cellulose fibers such as flax, jute, hemp, or raffia palm.

**bidriware:** Zinc alloy with a little copper, cast in a sand mold. The casting is darkened with a copper sulfate, then a design is scratched on and engraved. After sheet silver or silver wire is let into the channels, the surface is filed smooth and then immersed in ammonium chloride, which turns the alloy black. Most commonly produced in the Deccan region of central India from the thirteenth century onward. Vessels and hookah bases are the most common objects made with this technique.

**blast furnace:** A large, purpose-built structure for melting iron or copper ore. Fuel, ore, and flux are all mixed together and heated. Ore and slag settle to the bottom of the vertical structure. Can be used continuously, resulting in greater production than that of a bloomery.

**blockfront:** A decorative feature of eighteenth-century furniture in which the front facade consists of two projecting pilasters flanking a central recessed niche. Requires a thick piece of wood for the drawer fronts to achieve this convex/concave rhythm.

**block printing:** A form of textile decoration in which carved wooden blocks are inked with color or mordant (a chemical that fixes a dye in or on a substance by combining with the dye to form an insoluble compound) and then applied to a plain-woven cloth with a repeating pattern or image. Originally printers used carved wooden blocks that were inked with vegetable dyes that were set and transformed with mordants or indigo. Often the full design was achieved with the use of several different blocks and various baths to set or change colors. This was a hand-based workmanship of certainty that allowed the quick decoration of cotton cloth in particular. Centers were Gujarat and Rajasthan. Later, direct printing with pigments of specific colors took the place of dyed block printing. The technique is distinct from painting on cloth or copperplate printing.

**bloomery:** A small clay furnace for melting iron or copper ore and the creation of a rough bloom of pig iron or copper. Used for limited batch production, in contrast to the larger, industrial furnace.

**bombé:** A case furniture form with a swelled or kettle-shaped base. Found in Boston in the second half of the eighteenth century.

**bookmatch:** A way of sawing solid wood or veneer in which the two parts are opened up to reveal bilateral symmetry along the spine of the cut.

**brazing:** A construction technique used for metal-working in which the maker secures the seam of two pieces of metal by melting another metal with a lower melting temperature along that seam and relying on capillary action to spread out and provide a secure bond.

**burin:** A small hand-held engraving tool that cuts into metal.

**burl:** The interlocked grain of a diseased part of a tree (often ash, oak, maple, or walnut) that was hewn for bowls by indigenous makers or sawed into veneers for use on stylish case furniture in the seventeenth and early eighteenth centuries. For the former, it provided a strong body unlikely to crack and warp, while for the latter it provided significant visual luminosity.

**burnish:** A polishing technique that includes rubbing slip with rounded stone or sherd on ceramics or using a flat-faced planishing hammer to finish the surface of a metal object.

**camelid:** An Andean protein fiber from animals such as llamas, alpacas, and vicuñas, characterized

by long, fine fibers. Key to the high-quality textiles of Andean weaving.

**carding:** The process by which wool or cotton fibers are aligned prior to spinning. Often accomplished with two rectangular wooden paddles with wire loops or slips on one side. The paddles are pulled in opposite directions, an action that combs the fibers.

**chair bodger:** A peripatetic woodworker who moved through a forest, cutting some trees down and then splitting the wood, shaving it, and using a pole lathe to produce cylindrical chair parts. A form of sustainable forest harvesting. Most often associated with the Chiltern Forests to the west of London.

**chasing:** Decorative cold work on metal. Using a light chasing hammer (long, springy handle) and a series of small punches the size of nails to tap impressions into the metal body from the outside surface. This embossing technique moves the metal rather than removing it, as engraving does. The artisan needs to place the work against a pillow or pitch (or fill a vessel with pitch) in order to preserve the structural integrity of the form. Often used in conjunction with repoussé work, which pushes metal out from the inside or back side.

**chay root:** The root of the *Oldenlandia umbellata* plant, native to the Coromandel Coast of India, used to dye cloth red. Requires a mordant such as alum to adhere to the cloth.

**chuck:** A wooden shape, or pattern, used for spinning sheet metal on a lathe. The chuck is attached to the headstock of the lathe.

**coiling:** A ceramic technique for making vessels in which the potter rolls out snakes of clay that they then coil to build up the wall of a vessel. Using fingers and thumbs, the potter works the coils together and thins out the wall. The piece can be scraped slightly with a shell or stone to develop additional smoothness. Often combined with open-air firing.

**coppicing:** A traditional technique of woodland management used to procure small-dimensioned wood without cutting down a tree. Trees such as beech, willow, ash, and oak can be cut back near the ground or at the head of the trunk (the latter referred to as pollarding) to promote new shoots that can be harvested without harming the tree.

**dovetail:** An angled finger joint used to join two pieces of wood. Used to construct light carcasses (frames) of case furniture and to secure drawer sides to front and backs. Introduced to Muslim Iberian furniture in the sixteenth century and European furniture in the mid-seventeenth century. By the eighteenth century, this was the preferred method of drawer construction and carcass construction, having replaced mortise and tenon panel construction.

**drape molding:** The process of rolling clay to a uniform thickness, draping it over a wooden or terra-cotta mold, and then trimming off the excess. Also sometimes referred to as "hump molding."

**edge tools:** A variety of woodworking tools with sharp steel cutting edges used to size and finish timber. Can be preparatory tools such as axes, hatchets, or adzes; surfacing tools such as drawknives and bench planes; or finish tools such as molding planes that cut molding profiles on edges.

**embroidery:** A textile decorative technique that occurs off the loom. An embroiderer uses thread and a series of stitches such as cross, running, or chain stitches to create imagery on a cloth ground.

**faceplate turning:** A shaft type of axis system, in which the work being turned is mounted to the end of a shaft. Usually the power source is a reciprocating strap driven by feet or hands. This is ideal for bowls, plates, and geometric shapes.

**figure:** The appearance of a piece of wood, often on its tangential or radial axis. Different from its cellular structure or grain, although these play a role in appearance.

**floor loom:** A more elaborate tool for weaving than a backstrap loom. Requires either a framed wooden apparatus that is more costly and more fixed in place, or a pit loom in which a partial frame for the cloth bar, heddles, and treadles is combined with a loom bar set up with adjustable tension.

**free workmanship:** A term coined by David Pye to refer to freehand work, dependent primarily on the skill of the maker, along with the choice and control of the appropriate tool. It is contrasted with the workmanship of certainty, where regulating tools and devices ensure a predictable result.

**fritware:** A ceramic body consisting of ground quartz, glass frit, and white china clay. It tends to be molded rather than thrown on a wheel when the ground quartz proportion is great (lacks plasticity). Developed in eleventh-century Egypt and perfected in Greater Iran in the thirteenth century and Ottoman potteries in the fourteenth century, it provides an ideal white surface for underglaze cobalt blue painted decoration. Fired at a relatively low temperature, around 900 degrees Celsius.

**gauge:** A term used for the thickness of a metal.

**glaze:** A fluid suspension composed of silica, alumina, a flux or melting agent, mineral colorants, and water that is applied over a ceramic before

firing to provide a glossy protective covering. Common types include lead, tin, and ash.

**hackle:** A board with iron nails set into it that is used to clean and align flax or hemp fibers prior to spinning.

**heddle:** A framed assembly with wire or thread loops through which the warp threads on a floor loom pass. It raises warp threads to create the shed through which the weft will pass.

**ikat:** A form of weaving in which the warps are dyed in multiple stages before setting up the loom, thereby producing a geometric or stylized pattern. The layout work is laborious. Most common in Gujarat (frame looms) and Indonesia (backstrap looms). The area of Patan (north of Ahmedabad) in Gujarat has long been recognized for its high-quality double ikat silk sari cloth, called patola (both warp and weft dyed before weaving).

**indigo:** The blue penetrating dye made by soaking the leaves of the tropical plant *Indigofera* in water, adding lime and aerating the mixture, and then straining it to produce a cake. The cake is added to boiling water to produce a dye bath.

**inlay:** A technique used in works of wood or metal to insert a contrasting material into a groove cut in the body of the form, by gluing in a differing wood or hammering in a soft, contrasting metal. Distinct from marquetry, in which the maker composes a picture with small pieces of exotic and local veneers.

**japanning:** A late-seventeenth- / early-eighteenth-century term referring to Anglo-American imitations of lacquer. It approximates the look of real urushi lacquer with lamp black and varnish, resulting in an opaque appearance, and relies on fanciful exoticized images of East Asia imagined through illustrations in books. "Japanning" is an essentializing term that referred to lacquerwork from Japan, China, and India.

**jiggering:** A ceramic technique used primarily for plates in which a profiling tool is levered onto a clay body set over a mold rotating on a potter's wheel. The mold shapes the inner face, while the jigger shapes the outer face and foot. A related technique, jollying, is used for forming small hollowware vessels such as cups and bowls. Jiggering and jollying are faster ways than throwing to produce the same form consistently with a similar level of finish.

**Jingdezhen:** The center of the Chinese porcelain industry from the late thirteenth century onward. Located near necessary materials (white china clay and petuntse) and with easy access to Guangzhou (Canton) for export, the industry relies on highly organized groups of specialists (clay prepara-

tors, turners, painters, glazers, modelers, etc.) to make great quantities of work. Although the manufacture depends on handskills, it is organized like an assembly line.

**jollying:** A ceramic technique used primarily for vessels in which a piston or profiling tool is levered into the interior of a clay body set within a mold rotating on a potter's wheel. The mold shapes the exterior while the tool shapes the interior, the reverse of jiggering.

**kerf bent:** A steam bending technique used by the Northwest Coast people to make boxes. On a dressed cedar plank, three grooves are cut perpendicular to the grain. After steaming the plank, the woodworker bends the board to form the skin of a box. Only one corner is rabbeted and pegged. A bottom with a rabbeted edge is fit within this carcass.

**kiln:** A purpose-built structure in which to fire ceramics. The fire box for fuel is usually separated from the area where the works are placed, and the flow of oxygen is controlled in various ways.

**knotted-pile weaving:** A carpet technique in which discontinuous weft threads are knotted individually on the warp and then trimmed to produce a flat weave. Used by South Asian, Central Asian, and Navajo weavers to make rugs.

**kraak porcelain:** A type of seventeenth-century Chinese porcelain distinct for its borders—a series of painted rectangular panels, with alternating floral devices in the middle of each—and central designs of a flower, animal, or person. The term is derived from a corruption of "carrack," a type of Portuguese merchant ship engaged in the East Asian trade. Kraak porcelains were the first significant type of Chinese pottery imported into Europe and influenced Portuguese and Dutch tin-glazed earthenware.

**lacquer:** A tough finish on wood, achieved by applying natural materials such as sap from the urushi tree (in East Asia) or secretions from lac insects (South and Southeast Asia). Mother-of-pearl or gold powders can also be set into the lacquer as the layers are built up.

**linen:** A textile made of cellulose fiber from flax. The flax plant is pulled, retted (soaked to loosen fibers from the stalk), broken up, combed with a hackle, and then spun—a labor-intensive process that produces a light and lustrous thread. The fabric is durable and strong but can be tricky to work because it is not as elastic as wool or cotton. In Europe it was the favored cloth for a hot climate but has now been replaced by cotton.

**lost wax casting:** A metal casting technique in which a wax image is shaped (sometimes around a

ceramic core) and then covered with a clay casing. After drying, the wax is melted out and molten metal is poured into the cavity.

**madder:** The root of the *Rubia tinctorum* plant, used to dye cloth red. Requires a mordant such as alum to adhere to the cloth.

**mahogany:** A tropical wood initially found in the Caribbean—Cuba, Jamaica, and the Mosquito Coast (Belize). The Spanish used it to build ships in the seventeenth century, but in the 1720s it became prized for its deep reddish-brown color and figure. It became the favored primary wood for much eighteenth-century Anglo-American furniture. Its weight-to-strength ratio and easy of working made it a favorite of cabinetmakers. It was harvested by slave labor clearing island lands for sugar production or logging the Belize forests.

**maki-e lacquer:** A technique used in Japanese lacquer that uses gold and silver powders to create images that are then covered by additional layers of clear lacquer.

**marquetry:** A composition of multiple pieces of different species of veneer that are arranged to provide a flat picture on the surface of a piece of wood. Often used for floral imagery, heraldic or national symbols, or even trompe l'oeil effect. A very time-consuming and skilled form of veneer decoration.

**metal spinning:** A process of forming metal vessels on a lathe in which a sheet of metal is snugged onto a wooden chuck or pattern attached to the lathe's headstock by tightening the tailstock up against it. The spinner then uses a steel tool levered against a vertical pin in the horizontal tool rest to push the metal over the wooden pattern. The method came into common use with the widespread availability of rolled sheets of metal (having a consistent gauge or thickness) and the advent of steam power in the 1830s. Used for brass, copper, and pewter. This procedure is more efficient than raising and is appropriate for making many items of the same shape.

**mortise and tenon:** A woodworking joint in which an extending tenon is cut and pared on one piece of wood and then inserted into a rectangular hole cut into another piece of wood to be glued or pinned. Commonly used for panel construction and for attaching rails to legs of chairs, tables, and case furniture. A strong, durable joint, particularly popular in the seventeenth century.

**paktong:** A copper alloy (80 percent copper, 15 percent nickel, and 5 percent zinc) the color of which resembles silver. Cast to make teapots, candlesticks, and andirons. In the eighteenth century, its production was centered in China,

but in the nineteenth century, Germany became the dominant manufacturer, and the metal was then referred to as "German silver."

**patchwork:** A quilting technique in which the maker sews together several pieces of fabric, stitched along folded seams, to make a single covering cloth, which is then laid over a batting and a backcloth and stitched together. Different from appliqué.

**patolu:** A double ikat woven textile, often of silk, used for high-end saris and prestigious trade cloth. The premier patolu weavers have worked in Patan, Gujarat.

**pewter:** An alloy that is 85–95 percent tin, with traces of copper, antimony, and lead. Less lead makes it a higher-quality pewter, which was marketed in early-nineteenth-century America as "Britannia." Cast in bronze or iron molds, pewter found great favor for plates and bowls, tankards and mugs, and a variety of other tablewares (candlesticks, teapots, creamers, sugar bowls, etc.). Old or damaged pewter could be turned in as a credit toward new pewter, because it could be melted and recast. As a result, it retained some value and contributed to the supply of the material. It was a preferred northern European and English material in the seventeenth and early eighteenth centuries and retained its cultural value among German and Dutch populations well into the nineteenth century.

**pinching:** The most direct form of working clay, by modeling it with fingers and thumbs. Used for small vessels as well as parts, such as strap handles or lugs.

**plain sawn:** Lumber from a log simply sawn into boards without adjusting the log. Different from quartersawn.

**press-molded:** An example of the workmanship of certainty in clay that relies on plaster molds. A thin sheet of clay is pressed into a plaster mold, allowed to dry to a leather state, and removed from the mold. Vessels are often formed with two-part molds, while plates are press-molded to produce the front but then skimmed with a jolly on a potter's wheel to produce the back side. This process permits the replication of modeled or relief-decorated surfaces and the production of duplicate objects or sets. Can be found as early as late-period Roman flasks.

**puddle casting:** A method most commonly used to produce ingots for wrought work. Liquid metal from a bloomery or blast furnace is allowed to flow into channels dug into casting sand.

**quartersawn:** Lumber sawn from a log while rotating it so that the saw is always cutting along

the radial axis of the log, resulting in annual rings that are nearly at right angles to the wide face of the board. A log is typically sawn into quarters, and then each quarter is flat sawn.

**raden:** A Japanese lacquer technique in which thin pieces of mother-of-pearl are set within layers of lacquer. Often used in conjunction with maki-e techniques.

**raffia:** Fiber material from the leaves of the raffia palm. Primarily used in West Central Africa, but also found in Madagascar and the Philippines. It is cut, stripped, and separated to make thread that is woven into cloth, which is then softened with a wooden mortar and pestle. Used for everyday clothing and for ritualistic purposes like burial.

**raising:** A metalworking technique to form a vessel by hammering a sheet of metal over a stake with a polished steel surface. The metal is hammered from the center outward to gently shape the container. The maker will often need to heat and anneal (cool by quenching in water) the piece before beginning another round of hammering. The final product is also referred to as "wrought work."

**reduction firing:** Denying oxygen during the firing of ceramics. For open-air firing, this is often achieved by piling sand on the hot pile of ceramics and fuel. This carbonizes the surface and turns it black. In a kiln, the ventilation can be controlled after a certain temperature is achieved by closing off all vents and allowing the carbon monoxide to interact with the clay and glazes.

**reeling:** The winding of spun thread around an armed mechanism that then allows easy transferal to skeins or shuttle pins. For silk, the threads of several cocoons are pulled together and then wound onto a reel.

**repoussé chasing:** A metalworking technique to develop higher embossed relief. Using a snarling iron, the artisan first pushes metal out from the inside or backside of the object, then uses chasing tools and techniques on the exterior or front side to define the pushed-out areas.

**resist dyeing:** A coloring technique that relies on a mud paste or wax to prohibit the absorption of dye into cloth, often used with indigo blue. Particularly important to South Asian textiles, it contrasts with mordant dyeing (the use of mordants to attract colors like madder red) or discharge dyeing (the bleaching of blue cloth to permit other coloration).

**rive:** To split out lengths of wood rather than to saw them. Most common in green woodworking.

**sand casting:** A process by which metal objects are produced. A pattern is pressed into a box of fine sand, leaving a cavity into which molten metal is poured. Complex shapes require that the mold be assembled in two parts, the cope (top) and drag (bottom).

**sgraffito:** A ceramic decorative technique in which the body of an object is covered with slip and then, after drying, cut through to reveal the color of the body underneath the slip.

**slip:** A very liquidy clay used for the decoration of a ceramic body, either by trailing it as a thread or covering a surface entirely. Distinct from glaze, which often provides a protective layer over the slip.

**slub:** A lump in a thread caused by uneven spinning.

**snarling iron:** A bar used by a metalsmith to push the wall of a vessel from the inside through vibrating repercussion.

**spindle turning:** A process in which a piece of wood is suspended and secured on its center axis between two points, and while it spins, the craftsperson cuts along the horizontal axis between the headstock and tailstock (balusters and columns). In the past, before motorization, the apparatus was operated by a leg-driven treadle (a pole lathe) or a continuous rotary power source (a cranked wheel) that provided continuous application of the edge tool.

**spinning:** The use of a spindle or wheel to twist together fiber to provide longer lengths of thread, suitable for weaving, knitting, or embroidery.

**Staffordshire:** A community of potteries around the area of Stoke-on-Trent in England that became a ceramic center in the late seventeenth century when its members first began to produce tableware with a "combed" pattern decoration. Proximity to coal, which fueled the kilns, and a variety of clays gave this area a natural advantage that was further strengthened by a canal that opened in 1771, allowing reliable shipment of finished goods to Liverpool for export and easier importation of white Cornwall clay. In the 1760s, Josiah Wedgwood pioneered the development of creamware and then pearlware, transfer decoration, and extensive marketing. By 1800, Staffordshire challenged and soon surpassed Jingdezhen as the production center for global ceramic markets.

**swage:** A depression in a stump or a steel die into which a metalworker can hammer a sheet to develop a rounded shape or impart relief decoration.

**tapestry weaving:** A weaving system in which discontinuous weft knotting on warp results in a textile picture. The weaver fills in color areas rather than simply building up the weft as a

continuous horizontal line. Can be produced on either an upright vertical loom (Navajo Nation, South Asia, or western Europe) or on a backstrap loom (Peru). Usually worked on vertical looms. In the fourteenth and fifteenth centuries, Flanders and the Netherlands were the centers of production.

**terra sigillata:** A red Roman earthenware with a glossy surface slip. Made throughout the empire, it is characterized by standard sizes and shapes and large-scale production.

**tie-dyeing:** A form of textile decoration in which one ties the fabric before immersing it in a coloring bath such as indigo or madder root (alizarin). This technique results in undyed areas or tonal differences in colors.

**tin glaze:** A tin oxide glaze that covers an earthenware body with a white skin and permits blue painting under the clear glaze. Inexpensive imitation of porcelain. Labeled "maiolica" in Italy and Spain, "faience" in France, and "delftware" in the Netherlands and England. Most popular in Abbasid pottery from the ninth to the twelfth centuries and in European potteries during the seventeenth and eighteenth centuries.

**transfer decoration:** A ceramic decorating technique developed during the 1750s in England. Engraved copper plates are inked, tissue is placed over them and trimmed to fit the form, and then placed inked side down to the biscuit-fired plate. The decorator brushes and sponges the tissue, transferring the pigment to the plate. The tissue is washed away in cold running water, leaving the pigment behind. The dish is then glazed and fired. Less expensive and more predictable than hand-painted decoration, it also encouraged the growth of matching sets. Most commonly found on the refined earthenware: creamware and pearlware.

**treen:** A word used for turned wooden plates and bowls.

**tumbaga:** A copper-gold alloy for jewelry and vessels consisting of about 80 percent copper, 10–15 percent silver, and 5–10 percent gold in which depletion gilding removed the copper near the surface, making the object look like solid gold. Common in the Andes and in other Indigenous communities across much of the Americas.

**turning:** A shaping technique used for either clay or wood. For the former, a clay vessel is turned on a potter's wheel by pulling a lump of clay up into shape. Many people now refer to this a "throwing" a pot, but "turning" is the proper historic term. For woodworking, turning refers to the shaping of a piece of wood on a lathe in which the turner presses a sharp tool against the wood and cuts the wood into its final shape.

**veneer:** A thin sheet of wood or precious material that is glued to a lesser wood substrate. Originally, burls, richly figured tropical woods, ivory, and mother-of-pearl were common materials used for veneers. Veneers of different woods or materials could also be cut up into different shapes to create patterns or images, a technique referred to as "marquetry." Only in the early nineteenth century did veneer become a sign of cheaper work. Until then it was associated with high-end work.

**warp:** The vertical structural part of a textile. Warps are usually secured in place, and then the weft is woven over or under the warp. Heddles are usually knotted to the warp and connected to foot treadles that raise or lower the warp.

**weft:** The horizontal structural part of a textile. It is passed through the shed, or opening between warps, with a shuttle or by hand. Can be continuous or discontinuous.

**workmanship of certainty:** A phrase introduced by David Pye to describe highly regulated craftwork in which molds and specialized jigs integrate form and ornament and thereby ensure a consistent product. It is contrasted with free workmanship.

**wrought:** A term that refers either to embroidered work in textiles or raised metalwork.

# Notes

## Introduction

**1** The chair is discussed by Namiko Takeuchi in "Two Examples of Japanese Export Lacquer Chairs," https://www.google.com/url?sa=i&url =https%3A%2F%2Fjournals.ub.uni-heidelberg .de%2Findex.php%2Ficomoshefte%2Farticle %2Fdownload%2F21337%2F15110&psig= AOvVaw1z5s1-Wy8MTNgXezy_FA8j&ust= 1591479323259000&source=images&cd=vfe& ved=0CAMQjB1qFwoTCIC65s_Q6-kCFQ AAAAdAAAAABAF 21337-Artikeltext-56186 -1-10-20150622.pdf, accessed June 5, 2020. For a discussion of the Dutch folding chair, see Reinier Baarasen, *Furniture in Holland's Golden Age* (Amsterdam: Rijksmuseum, 2007), 74–75. *Nanban* was the Japanese term for outsiders, first used to describe those from South Asia but then expanded to include Europeans. For discussion of the multiple meanings of Japanese lacquer at this time, see Oliver Impey and Christiaan Jörg, *Japanese Export Lacquer: 1580–1850* (Amsterdam: Hotei, 2005); Teresa Canepa, *Silk, Porcelain and Lacquer: China and Japan and Their Trade with Western Europe and the New World, 1500–1644* (London: Paul Holberton, 2016), 324–405; and Samuel Luterbacher, "Surfaces for Reflection: Nanban Lacquer in the Iberian World," *Journal of Early Modern History* 23, nos. 2–3 (May 2019): 152–90.

**2** On Awatovi, see Ross Gordon Montgomery et al., *Franciscan Awatovi: The Excavation and Conjectural Restoration of a 17th-Century Spanish Mission Establishment at a Hopi Indian Town in Northeastern Arizona* (Cambridge, MA: Peabody Museum of Archaeology and Ethnology at Harvard University, 1949).

**3** Matthew Liebmann discusses the complexity of Pueblo ceramic production for the Franciscans in "Parsing Hybridity: Archaeologies of Amalgamation in Seventeenth-Century New Mexico," in Jeb Card, ed., *The Archaeology of Hybrid Material Culture* (Carbondale: Southern Illinois University Press, 2013), 25–49. The importance of recognizing unfree skilled work in the Americas is emphasized by Ananda Cohen-Aponte, "Decolonizing the Global Renaissance," in Daniel Savoy, ed., *The Globalization of Renaissance Art: A Critical Review* (Leiden: Brill, 2017), 67–94.

**4** For a detailed discussion of the Fifield hangings, see Edward Cooke, Jr., *Inventing Boston: Design, Production, and Consumption, 1680–1720* (New Haven, CT: Yale University Press, 2019), 112–15.

**5** Giorgio Riello, "The Globalization of Cotton Textiles: Indian Cottons, Europe, and the Atlantic World, 1600–1850," in Giorgio Riello and Prasannan Parthasarathi, eds., *The Spinning World: A Global History of Cotton Textiles, 1300–1850* (Oxford: Oxford University Press, 2009), 261–88; Sylvia Houghteling, "Origins in Entanglement: Connections between English Crewel Embroidery and Indian Chintz," in Sarah Fee, ed., *Cloth That Changed the World: The Art and Fashion of Indian Chintz* (Toronto: Royal Ontario Museum, 2019), 192–201; Avalon Fotheringham, *The Indian Textile Sourcebook: Patterns and Techniques* (London: Thames and Hudson, 2019), 32–33; and Pika Ghosh, *Making Kantha, Making Home: Women at Work in Colonial Bengal* (Seattle: University of Washington Press, 2020), esp. 32–33, 40–41. An excellent discussion of women's needlework in colonial Boston is Pamela Parmal, *Women's Work: Embroidery in Colonial Boston* (Boston: Museum of Fine Arts, Boston, 2012), esp. 7–21, 32–61.

**6** The nationalistic sense of material culture studies has its origins in the late nineteenth century, when European and American scholars began to amass and collect types to demonstrate regional or national traditions; see Peter Miller, ed., *The Museum in the Human Sciences: Collecting, Displaying, and Interpreting Material Culture* (New York: Bard Graduate Center, 2021).

**7** For a critique of the Eurocentric evolutionary perspective and how it can lead to misunderstanding of other contexts, see Aaron Hyman, "Inventing Painting: Cristóbal de Villalpando, Juan Correa, and New Spain's Transatlantic Canon," *Art Bulletin* 99, no. 2 (June 2017): 102–35. One magisterial attempt to break down the neighborhoods of art history is David Summers, *Real Spaces: World Art History and the Rise of Western Modernism* (London: Phaidon, 2003), but even this volume has a modernist angle.

**8** Michael Yonan, "Toward a Fusion of Art History and Material Culture Studies," *West 86th:*

A Journal of Decorative Arts, Design History, and Material Culture 18, no. 2 (Fall–Winter 2011): 232–48.

**9** Henry Glassie, *The Potter's Art* (Bloomington: Indiana University Press, 1999), 18.

**10** A helpful account of Kantian ideas is Larry Shiner, *The Invention of Art: A Cultural History* (Chicago: University of Chicago Press, 2001). A useful recent discussion of the sixteenth-century separation of specific technical knowledge and abstract thinking is Alessandro Russo, "An Artistic Humanity: New Positions on Art and Freedom in the Context of Iberian Expansion, 1500–1600," *RES: Anthropology and Aesthetics* 65/66 (2014/2015): 352–63.

**11** Yuka Kadoi, *Islamic Chinoiserie: The Art of Mongol Iran* (Edinburgh: Edinburgh University Press, 2009), 79–86; Eva Hoffman, "Christian-Islamic Encounters on Thirteenth-Century Ayyubid Metalwork: Local Culture, Authenticity, and Memory," *Gesta* 43, no. 2 (2004): esp. 129–33; and Sheila Canby, Deniz Beyazit, Martina Rugiadi, and A.C.S. Peacock, *Court and Cosmos: The Great Age of the Seljuqs* (New York: Metropolitan Museum of Art, 2016), 62–63, 155–56.

**12** See Eva Baer, *Ayyubid Metalwork with Christian Images* (Leiden: Brill, 1989); Rachel Ward, ""Style versus Substance: The Christian Iconography on Two Vessels Made for the Ayyabid Sultan al-Sahik Ayyub," in Bernard O'Kane, ed., *The Iconography of Islamic Art: Studies on Honour of Robert Hillenbrand* (Edinburgh: Edinburgh University Press, 2005), 309–24; and Sheila Canby et al., *Court and Cosmos*, 265–66.

**13** I use the term "low technology" to describe intensive application of skilled handwork for the making of an object suitable to its original purpose. I adapt the term from the work of John Worrell, "Ceramic Production in the Exchange Network of an Agricultural Neighborhood," paper presented to the Society for Historical Archaeology, Philadelphia, 1982; and Douglas Harper, *Working Knowledge: Skill and Community in a Small Shop* (Chicago: University of Chicago Press, 1987).

**14** For a concise statement about the preference of the term "global art history" instead of "world art history," see Thomas DaCosta Kaufmann, "Reflections of World Art History," in Thomas DaCosta Kaufmann, Catherine Dossin, and Béatrice Joyeux-Prunel, eds., *Circulations in the Global History of Art* (New York: Routledge, 2015), esp. 34–38. Another helpful introduction to the need to move away from Eurocentrism is Daniel Savoy's "Introduction" in *The Globalization of Renaissance Art*, 1–13.

**15** On thing theory, see Martin Heidegger, "The Thing," in *Poetry, Language, Thought* (New York:

Harper Row, 1971), 163–80; and Bill Brown, ed., *Things* (Chicago: University of Chicago Press, 2004). Robin Bernstein, influenced by Heidegger and Brown, incorrectly claims that "things, but not objects, script actions"; see her "Dances with Things: Material Culture and the Performance of Race," *Social Text 101* 27, no. 4 (Winter 2009): 69. For the broad strokes of things and goods, see Frank Trentmann, "Materiality in the Future of History: Things, Practices, and Politics," *Journal of British Studies* 48 (April 2009): 283–307; Anne Gerritsen and Giorgio Riello, eds., *The Global Lives of Things: The Material Culture of Connections in the Early Modern World* (New York: Routledge, 2016); and Maxine Berg, ed., *Goods from the East, 1600–1800: Trading Eurasia* (New York: Palgrave Macmillan, 2015).

**16** For an example of a traditionally organized history of decorative arts, see Pat Kirkham and Susan Weber Soros, eds., *History of Design: Decorative Arts and Material Culture 1400–2000* (New York: Bard Graduate Center for Studies in Decorative Arts, Design & Culture, 2013).

**17** My use of "global" is similar to the historian Zoltán Biedermann's notion of "glocal," as a corrective to the problem of scale inherent in many connected histories; see his *(Dis)connected Empires: Imperial Portugal, Sri Lankan Diplomacy, and the Making of a Hapsburg Conquest in Asia* (New York: Oxford University Press, 2018), 15. Another helpful essay on the concept of global art history is Sugata Ray, "Introduction: Translation as Art History," *Ars Orientalis* 48 (2018): 1–19.

**18** On the single commodity focus, see Mark Kurlansky, *Cod: A Biography of the Fish That Changed the World* (New York: Walker and Co., 1997); Giorgio Riello, *Cotton: The Fabric That Made the Modern World* (Cambridge: Cambridge University Press, 2013); and Jennifer Anderson, *Mahogany: The Costs of Luxury in Early America* (Cambridge, MA: Harvard University Press, 2012). Studies of objects in motion include Jennifer Roberts, *Transporting Visions: The Movement of Images in Early America* (Berkeley: University of California Press, 2014); and Meredith Martin and Daniela Bleichmar, eds., *Objects in Motion in the Early Modern World* (Chichester, UK: Wiley Blackwell, 2016). The history through objects genre began with Neil MacGregor, *A History of the World in 100 Objects* (London: Allen Lane, 2010).

**19** For a discussion about how materials shaped makers, see Chris Gosden, "What Do Objects Want?," *Journal of Archaeological Method and Theory* 12, no. 3 (September 2005): 193–211; and Tim Ingold, "Materials against Materiality," *Archaeological Dialogues* 14, no. 1 (June 2007): 1–16.

**20**  See Yonan, "Toward a Fusion of Art History and Material Culture Studies," 239. An article that points out the fallacies of "reading" objects and the importance of understanding the maker's point of view is Michelle Wang, "Woven Writing in Early China," *Art History* 42, no. 5 (November 2019): 836–61. Joanna Fiduccia generously brought this article to my attention.

**21**  For helpful discussions of material intelligence, see Tim Ingold, *Making: Anthropology, Archaeology, Art and Architecture* (New York: Routledge, 2013); and Glenn Adamson, *Fewer, Better Things: The Hidden Wisdom of Objects* (New York: Bloomsbury, 2018).

**22**  While the study is historical, similar "low-technology" work continues today in different contexts. I consciously do not use the Western time periods of medieval, Renaissance, and early modern in order to emphasize non-Eurocentric interconnections.

**23**  For the link between production and survival, see Oliver Watson, "Ceramics and Circulation, 800–1250," in Finbarr Barry Flood and Gülru Necipoğlu, eds., *A Companion to Islamic Art and Architecture* (Hoboken, NJ: Wiley Blackwell, 2017), 478–79.

**24**  See Robert Finlay, *The Pilgrim Art: Cultures of Porcelain in World History* (Berkeley: University of California Press, 2010); and Beverly Lemire, *Cotton* (New York: Berg, 2011). Also pertinent is the recent work on Indigenous attitudes toward materials; see Melissa Nelson and Dan Shilling, eds., *Traditional Ecological Knowledge: Learning from Indigenous Practices for Environmental Sustainability* (Cambridge: Cambridge University Press, 2018).

**25**  Suggestive examples include Kenneth Ames, "Meaning in Artifacts: Hall Furnishings in Victorian America," *Journal of Interdisciplinary History* 9, no. 1 (Summer 1978): 19–46; François Lissarrague, *The Aesthetics of the Greek Banquet: Images of Wine and Ritual* (Princeton, NJ: Princeton University Press, 1990); Beverly Straube, "European Ceramics in the New World: The Jamestown Example," in Robert Hunter, ed., *Ceramics in America 2001* (Milwaukee, WI: Chipstone Foundation, 2001), 47–71; and Giorgio Riello and Tirthankar Roy, eds., *How India Clothed the World: The World of South Asian Textiles, 1500–1850* (Leiden: Brill, 2009).

**26**  Suzanne Preston Blier, "Imagining Otherness in Ivory: African Portrayals of the Portuguese ca. 1492," *Art Bulletin* 75, no. 3 (September 1993): 375–96; Tim Barringer and Tom Flynn, eds., *Colonialism and the Object: Empire, Material Culture and the Museum* (New York: Routledge, 1998); and Ruth Phillips, *Trading Identities: The Souvenir in Native North American Art from*

the Northeast, 1700–1900 (Seattle: University of Washington Press, 1998).

**27**  The classic text is Marcel Mauss, *The Gift: The Form and Reason for Exchange in Archaic Societies* (1950; reprint ed., New York: W. W. Norton, 1990), but see also Pika Ghosh, "From Rags to Riches: Valuing Kanthas in Bengali Households," in Darielle Mason, ed., *Kantha: The Embroidered Quilts of Bengal* (New Haven, CT: Yale University Press, 2010), 31–57.

**28**  Jonathan Hay, *Sensuous Surfaces: The Decorative Object in Early Modern China* (London: Reaktion, 2009); and Glenn Adamson and Victoria Kelley, *Surface Tensions: Surface, Finish and the Meaning of Objects* (Manchester: Manchester University Press, 2009).

**29**  Beverly Gordon, "Intimacy and Objects: A Proxemic Analysis of Gender-Based Response to the Material World," in Katherine Martinez and Kenneth L. Ames, eds., *The Material Culture of Gender, the Gender of Material Culture* (Winterthur, DE: Henry Francis du Pont Winterthur Museum, 1997), 237–52; and Constance Classen and David Howes, "The Museum as Sensescape: Western Sensibilities and Indigenous Artifacts," in Elizabeth Edwards, Chris Gosden, and Ruth Phillips, eds., *Sensible Objects: Colonialism, Museums, and Material Culture* (Oxford: Berg, 2006), 199–222.

# Chapter 1. Materials

**1**  Ann-Sophie Lehmann, "Kneading, Wedging, Dabbing and Dragging: How Motions, Tools and Materials Make Art," in Barbara Baert and Trees de Mits, eds., *Folded Stones* (Leuven: Acco, 2009), 41–59; and Lehmann, "The Matter of the Medium: Some Tools for an Art-Theoretical Interpretation of Materials," in Christy Anderson, Anne Dunlop, and Pamela Smith, eds., *The Matter of Art: Materials, Practices, Cultural Logics, c. 1250–1750* (Manchester: Manchester University Press, 2014), 21–41.

**2**  On the importance of materials, see Tim Ingold, "Materials against Materiality," *Archaeological Dialogues* 14, no. 1 (June 2007): 1–16; and Ingold, "Toward an Ecology of Materials," *Annual Review of Anthropology* 41 (2012): 427–42. On the structural logic of building, see Henry Glassie, *Folk Housing in Middle Virginia: A Structural Analysis of Historic Artifacts* (Knoxville: University of Tennessee Press, 1975), 145–75. Helpful discussions of the differences between elevation and plan, between exterior and interior, between front and back include Christian Norberg-Schulz, *Intentions in Architecture* (Cambridge, MA: MIT Press, 1968); and Erving

Goffman, *The Presentation of Self in Everyday Life* (Garden City, NY: Doubleday Anchor, 1959).

**3** In the past decade, art historians and research scientists have demonstrated greater interest in the materials used for painting and their sources, while historians of science have plumbed manuals and recipe books to explore the way material intelligence contributed to scientific knowledge. But much of this exciting new work has drawn from textual sources to identify a particular range of raw ingredients for painters, sculptors, and natural philosophers. For example, see Anderson, Dunlop, and Smith, *The Matter of Art*; Pamela Smith, *The Body of the Artisan: Art and Experience in the Scientific Revolution* (Chicago: University of Chicago Press, 2004); and "Art and Trade in the Age of Global Encounters, 1492–1800," Mari-Tere Álvarez and Charlene Villaseñor-Black, eds. special issue, *Journal of Interdisciplinary History* 45, no. 3 (Winter 2015). Within the past few decades, research scientists have been analyzing ceramic bodies and glazes, dye stuffs, wood species, and alloy composition, but their findings now need to be linked to any textual evidence and incorporated within interpretive work. For a recent example, see Moujan Martin, "Appendix: The Technology of Medieval Islamic Ceramics: A Study of Two Persian Manuscripts," in Oliver Watson, *Ceramics of Iran* (New Haven, CT: Yale University Press, 2020), 459–87.

**4** See Lehmann, "Kneading, Wedging, Dabbing, and Dragging," 42. A recent exhibition at the Metropolitan Museum of Art, *Relative Values: The Cost of Art in the Northern Renaissance*, draws attention to the disconnect between production cost and market valuation, both during the sixteenth century and now, by showing how we privilege expensive materials, celebrate virtuosity and technological innovation, and fixate on rarity.

**5** Watson, *Ceramics of Iran*, 304–5; and J. E. Pearce, A. G. Vince, and M. A. Jenner, "A Dated Type-Series of London Medieval Pottery: Part 2, London Type Ware," *London and Middlesex Archaeological Society Special Paper No. 6* (1985).

**6** Lehmann, "The Matter of the Medium."

**7** Robert Finlay, *The Pilgrim Art: Cultures of Porcelain in World History* (Berkeley: University of California Press, 2010). With its exportation from the fourteenth century onward, China became known as the center of porcelain, but Korea and Japan also supported porcelain production, primarily for medium-distance trade within East and Southeast Asia. Only when Chinese potteries were inactive in the mid-seventeenth century because of internal regional conflict did Japan export porcelain to Europe in an appreciable number. Nicole Coolidge Rousmaniere, *Vessels of Influence:*

*China and the Birth of Porcelain in Medieval and Early Modern Japan* (London: Bristol Classical Press, 2012).

**8** Classification of crafts by the media in which artisans work has roots in guild and caste systems but continues to be followed by contemporary craftspeople as well.

**9** The distinctive characteristics of ceramics is succinctly covered in Oliver Watson, "Ceramics and Circulation," in Finbarr Barry Flood and Gülru Necipoğlu, eds., *A Companion to Islamic Art and Architecture* (London: John Wiley & Sons, 2017), esp. 478–81. Good overviews of the ceramic bodies are *Unearthing New England's Past: The Ceramic Evidence* (Lexington, MA: Museum of Our National Heritage, 1984); W. David Kingery and Pamela Vandiver, *Ceramic Masterpieces: Art, Structure, Technology* (New York: Free Press, 1986); and M. S. Tite, "Ceramic Production, Provenance and Use—A Review," *Archaeometry* 50, no. 2 (2008): 216–31.

**10** A useful collection of essays on earthenware can be found in Ivor Noel Hume, *If These Pots Could Talk* (Milwaukee, WI: Chipstone Foundation, 2001).

**11** Helpful sources on European stoneware include David Gaimster, *German Stoneware 1200–1900: Archaeology and Cultural History* (London: British Museum Press, 1997); and Janine Skerry and Suzanne Findlen Hood, *Salt-Glazed Stoneware in Early America* (Williamsburg, VA: Colonial Williamsburg Foundation, 2009). On Chinese white-and-green stoneware, see Regina Krahl, John Guy, J. Keith Wilson, and Julian Raby, eds., *Shipwrecked: Tang Treasures and Monsoon Winds* (Washington, DC: Arthur Sackler Gallery, 2010), 184–207; and Alan Chong and Stephen A. Murphy, eds., *The Tang Shipwreck: Art and Exchange in the 9th Century* (Singapore: Asian Civilizations Museum, 2017), 80–141.

**12** On "art de la localité," see Jan Douwe van der Ploeg, "Potatoes and Knowledge," in Mark Hobart, ed., *An Anthropological Critique of Development: The Growth of Ignorance* (London: Routledge, 1993), 209–27. On Staffordshire's and Jingdezhen's material advantages and cumulative expertise, see David Barber, " 'The Usual Classes of Useful Articles': Staffordshire Ceramics Reconsidered," in Robert Hunter, ed., *Ceramics in America 2001* (Milwaukee, WI: Chipstone Foundation, 2001), 72–93; and Anne Gerritsen, *City of Blue and White: Chinese Porcelain and the Early Modern World* (Cambridge: Cambridge University Press, 2020).

**13** A valuable introduction to porcelain is Finlay, *The Pilgrim Art*. See also Regina Krahl, "Tang Blue-and-White," in Krahl et al., *Shipwrecked*, 208–11; Jianfeng Cui et al., "Chemical Analysis of

White Porcelains from the Ding Kiln Site, Hebei Province, China," *Journal of Archaeological Science* 39 (2012): 818–27; and Gerritsen, *City of Blue and White*, 39–113.

**14** M. S. Tite, S. Wolf, and R. B. Mason, "The Technological Development of Stonepaste Ceramics from the Islamic Middle East," *Journal of Archaeological Science* 38, no. 3 (March 2011): 570–71; and Watson, *Ceramics of Iran*, 459–87.

**15** On fritware, see Nurhan Atasoy and Julian Raby, *Iznik: The Pottery of Ottoman Turkey* (London: Thames and Hudson, 1989); and Watson, *Ceramics of Iran*, 18, 147–51.

**16** Useful introductions to textile terms include Elena Phipps, *Looking at Textiles: A Guide to Technical Terms* (Los Angeles: J. Paul Getty Museum, 2012); and Anika Reineke et al., eds., *Textile Terms: A Glossary* (Emsdetten, Germany: Edition Imorde, 2017).

**17** On barkcloth, see Nicholas Thomas and Julie Adams, eds., *Tapa: Barkcloth Paintings from the Pacific* (Birmingham, UK: Ikon Gallery, 2013).

**18** Cheryl Samuel, *The Chilkat Dancing Blanket* (Seattle, WA: Pacific Search Press, 1982).

**19** See Jan Vansina, "Raffia Cloth in West Central Africa, 1500–1800," in Maureen Fennell Mazzaoui, ed., *Textiles: Production, Trade and Demand* (Aldershot, UK: Ashgate, 1998), 263–81; and Alisa LaGamma, "Out of Kongo and into the Kunstkammer," in Alisa LaGamma, ed., *Kongo: Power and Majesty* (New York: Metropolitan Museum of Art, 2015), 131–59.

**20** Adrienne Hood covers linen quite well in *The Weaver's Craft: Cloth, Commerce, and Industry in Early Pennsylvania* (Philadelphia: University of Pennsylvania Press, 2003), 41–57.

**21** Giorgio Riello, *Cotton: The Fabric That Made the Modern World* (Cambridge: Cambridge University Press, 2013). See also Beverly Lemire, *Cotton* (New York: Berg, 2011); Giorgio Riello and Prasannan Parthasarathi, eds., *The Spinning World: A Global History of Cotton Textiles, 1200–1850* (Oxford: Oxford University Press, 2009); and Sven Beckert, *Empire of Cotton: A Global History* (New York: Knopf, 2014).

**22** A good introduction to wool is Hood, *The Weaver's Craft*, 57–62.

**23** Informative overviews on Chinese silk include Shelagh Vainker, *Chinese Silk: A Cultural History* (London: British Museum Press, 2004); and Dieter Kuhn, ed., *Chinese Silks* (New Haven, CT: Yale University Press, 2012).

**24** On the transvaluation of gold and silver in the colonial context, see Tom Cummins, "Competing and Commensurate Values in Colonial Conditions: How They Are Expressed and Registered in the Sixteenth-Century Andes," in John Papadopoulos and Gary Upton, eds., *The*

*Construction of Value in the Ancient World* (Los Angeles: Cotsen Institute of Archaeology Press, 2012), 406–23.

**25** Oppi Untracht surveys the different types of base metals in *Metal Techniques for Craftsmen: A Basic Manual on the Methods of Forming and Decorating Metals* (London: Robert Hale, 1969), but see also Charles Montgomery, *A History of American Pewter* (New York: Praeger, 1973); and Donald Fennimore, *Metal Work in Early America: Copper and Its Alloys from the Winterthur Museum* (Woodbridge, UK: Antique Collectors' Club, 1996).

**26** Untracht, *Metal Techniques for Craftsmen*, 16–17; and Fennimore, *Metal Work in Early America*, 12–29.

**27** Untracht, *Metal Techniques for Craftsmen*, 22–26.

**28** On the fluidity of alloy compositions and difficulty of differentiating between different alloys, particularly evident in written records, see Ittai Weinryb, *The Bronze Object in the Middle Ages* (Cambridge: Cambridge University Press, 2016), 4–5. However, artisans likely could differentiate between them based on experience, color, weight, and sound. Maikel Kuijpers, *An Archaeology of Skill: Metalworking Skill and Material Specialization in Early Bronze Age Central Europe* (New York: Routledge, 2018).

**29** Kuijpers, *An Archaeology of Skill*, 18, 28–29; Fennimore, *Metal Work in Early America*, 197, 202–3, 211, 217; Meera Mukherjee, *Metalcraftsmen of India* (Calcutta: Anthropological Survey of India, 1978); Lee Horne, "Making Metal in West Bengal," in Pika Ghosh et al., *Cooking for the Gods: The Art of Home Ritual in Bengal* (Newark, NJ: Newark Museum, 1995), 33–38; Keith Pinn, *Paktong: The Chinese Alloy in Europe 1680–1820* (Woodbridge, UK: Antique Collectors' Club, 1999); and Mei Jianjun, "The History, Metallurgy and Spread of Paktong," *Bulletin of the Metals Museum* 24 (November 1995): 43–55.

**30** William Root, "Gold-Copper Alloys in Ancient America," *Journal of Chemical Education* 28, no. 2 (February 1951): 76–78; and Heather Lechtman, "The Materials Science of Material Culture: Examples from the Andean Past," in David Scott and Pieter Meyers, eds., *Archaeology of Pre-Columbian Sites and Artifacts* (Los Angeles: Getty Conservation Institute, 1994), 3–12.

**31** Montgomery, *A History of American Pewter*; Susan Stronge, *Bidri Ware: Inlaid Metalwork from India* (London: V&A, 1985); Rehaman Patel, *Bidri Art* (Dharwad: Karnataka Historical Research Society, 2017); and Mark Zebrowski, *Gold, Silver and Bronze from Mughal India* (London: Alexandria Press, 1997).

**32** Bruce Hoadley, *Identifying Wood: Accurate*

*Results with Simple Tools* (Newtown, CT: Taunton Press, 1990).

**33**  On wood technology in general, see Bruce Hoadley, *Understanding Wood: A Craftsman's Guide to Wood Technology* (Newtown, CT: Taunton Press, 1980).

**34**  The interest in economic botany and awareness of best uses of different species is evident in François André Michaux, *The North American Sylva* (Paris: C. D'Hautel, 1817). For a consideration of the cultural context of timber use on furniture, see Edward Cooke, Jr., "Beyond Aesthetics: Wood Choice in Historical Furniture," in Scott Landis, ed., *Conservation by Design* (Providence: Museum of Art, Rhode Island School of Design; Easthampton, MA: Woodworkers Alliance for Rainforest Protection, 1993), 18–27. On mahogany, see Jennifer Anderson, *Mahogany: The Costs of Luxury in Early America* (Cambridge, MA: Harvard University Press, 2012).

**35**  Eugene Borza, "Timber and Politics in the Ancient World: Macedon and the Greeks," *Proceedings of the American Philosophical Society* 131, no. 1 (March 1987): 32–52; and Alan Mikhail, "Anatolian Timber and Egyptian Grain: Things That Made the Ottoman Empire," in Paula Findlen, ed., *Early Modern Things: Objects and Their Histories, 1500–1800* (New York: Routledge, 2013), 345–66.

**36**  The wide extent of available species in Britain alone is obvious in Adam Bowett's large volume, *Woods in British Furniture-Making 1400–1900: An Illustrated History* (Wetherby, UK: Oblong Creative, Ltd. and Royal Botanic Gardens, Kew, 2012).

**37**  Edward S. Cooke, Jr., *Making Furniture in Preindustrial America* (Baltimore, MD: Johns Hopkins University Press, 1996); Brock Jobe and Myrna Kaye, *New England Furniture: The Colonial Era* (Boston: Houghton Mifflin, 1986); and Nancy Berliner, "Considering Influences from Afar: The Impact of Foreign Cultures on Chinese Furniture," in Nancy Berliner and Edward Cooke, Jr., *Inspired by China: Contemporary Furnituremakers Explore Chinese Traditions* (Salem, MA: Peabody Essex Museum, 2006), esp. 32.

**38**  On the different woods in Windsor chairs, see Nancy Goyne Evans, *Windsor-Chair Making in America: From Craft Shop to Consumer* (Hanover, NH: University Press of New England, 2006), 81–92; and Drew Langsner, *The Chairmaker's Workshop: Handcrafting Windsor & Post-and-Rung Chairs* (New York: Lark Books, 1997).

**39**  Elena Phipps, "Garments and Identity in the Colonial Andes," in Elena Phipps et al., *The Colonial Andes: Tapestries and Silverwork, 1530–1830* (New York: Metropolitan Museum of Art, 2004), 27.

**40**  Riello, *Cotton*, esp. 110–34.

**41**  On the "deindustrialization" of India, see Tirthankar Roy, *Traditional Industry in the Economy of Colonial India* (Cambridge: Cambridge University Press, 1999). A good source on Liberty and Co. is Stephen Calloway, *The House of Liberty: Masters of Style and Decoration* (London: Thames and Hudson, 1992).

**42**  The tendency to overlook the importance of material's agency is stressed by Ingold in "Materials against Materiality" and "Toward an Ecology of Materials."

# Chapter 2. Realization

**1**  William Morris, "Art and Industry in the Fourteenth Century" (1890), in May Morris, ed., *The Collected Works of William Morris* (London: Longmans, Green, and Co., 1910–15), 22:375–90; and Carl Bridenbaugh, *The Colonial Craftsman* (New York: New York University Press, 1950).

**2**  On low technology, its reliance on skilled flexibility, and its contextual practice, see John Worrell, "Ceramic Production in the Exchange Network of an Agricultural Neighborhood," paper presented to the Society for Historical Archaeology, Philadelphia, 1982; and Douglas Harper, *Working Knowledge: Skill and Community in a Small Shop* (Chicago: University of Chicago Press, 1987).

**3**  Robin Wood, *The Wooden Bowl* (Ammanford, Wales: Stobart Davies, 2005), 111–22.

**4**  Denise Patry Leidy "Cinnabar: The Chinese Art of Carved Lacquer," *Arts of Asia* 45, no. 6 (November/December 2015): 76–87.

**5**  David Pye, *The Nature and Art of Workmanship* (Cambridge: University of Cambridge Press, 1969); Edward Cooke, Jr., "The Study of American Furniture from the Perspective of the Maker," in Gerald Ward, ed., *Perspectives on American Furniture* (New York: W. W. Norton, 1988), 113–26; Edward Cooke, Jr., *Making Furniture in Pre-industrial America: The Social Economy of Newtown and Woodbury, Connecticut* (Baltimore, MD: Johns Hopkins University Press, 1996), 33–48; Tim Ingold, *Making: Anthropology, Archaeology, Art and Architecture* (New York: Routledge, 2013); and Alexander Langlands, *Cræft: An Inquiry into the Origins and True Meaning of Traditional Crafts* (New York: Norton, 2017).

**6**  This definition of composition draws from the idea of transformational grammar offered by Henry Glassie in *Folk Housing in Middle Virginia: A Structural Analysis of Historic Artifacts* (Knoxville: University of Tennessee Press, 1975). See also Bernard Herman, "The Bricoleur Revisited," in Ann Smart Martin and Ritchie

Garrison, eds., *American Material Culture: The Shape of the Field* (Winterthur, DE: Winterthur Museum, 1997), 37–64; and Trevor Marchand, "Introduction," in Trevor Marchand, ed., *Craftwork as Problem Solving: Ethnographic Studies of Design and Making* (New York: Routledge, 2016), 1–29. For Barthes's discussion of weaving, see Roland Barthes, *The Preparation of the Novel: Lecture Courses and Seminars at the Collège de France, 1978–1979 and 1979–1980* (New York: Columbia University Press, 2010), 52, 170.

**7**  Tim Ingold, *The Perception of the Environment: Essays on Livelihood, Dwelling and Skill* (London: Routledge, 2000), 289–419; Emanuel Mayer, *The Ancient Middle Classes: Urban Life and Aesthetics in the Roman Empire, 100 BCE–250 CE* (Cambridge, MA: Harvard University Press, 2012); and Robert Finlay, *The Pilgrim Art: Cultures of Porcelain in World History* (Berkeley: University of California Press, 2010), 17–46. On the levels of workmanship—workmanship of risk, workmanship of certainty, and free workmanship—see Pye, *The Nature and Art of Workmanship.*

**8**  Langlands, *Cræft*, 38; emphasis in the original. Helpful studies of workmanship include Jeannette Lasansky, *To Draw, Upset and Weld: The Work of the Pennsylvania Rural Blacksmith, 1742–1935* (Lewisburg, PA: Oral Traditions Project of the Union County Historical Society, 1980); Arnold Pacey, *Technology in World Civilization: A Thousand-Year History* (Oxford: Basil Blackwell, 1990); and Harper, *Working Knowledge.*

**9**  A helpful introduction to a performance perspective is Dell Upton, "Towards a Performance Theory of Vernacular Culture: Early Tidewater Virginia as a Case Study," *Folklore Forum* 12, nos. 2/3 (1979): 173–96. See also Catherine Bishir, "Jacob W. Holt: An American Builder," *Winterthur Portfolio* 16, no. 1 (Spring 1981): 1–31; and Harper, *Working Knowledge.*

**10**  On design economics, see Michael Ettema, "Technological Innovation and Design Economics in Furniture Manufacture," *Winterthur Portfolio* 16, nos. 2/3 (Summer/Autumn 1981): 197–223. On Japanese wabi-sabi, see Muneyosh Yanagi, *Folk-Crafts in Japan* (Tokyo: Kokusai Bunka Shinkokai, 1936).

**11**  Edward Cooke, Jr., "The Ideology of the Wheel," in Martina Droth, Glenn Adamson, and Simon Olding, eds., *Things of Beauty Growing: British Studio Pottery* (New Haven, CT: Yale University Press, 2017), 57–71; Marguerite Wildenhain, *Pottery: Form and Expression* (New York: Reinhold, 1959); Philip Rawson, *Ceramics* (London: Oxford University Press, 1971); and Clary Illian, *A Potter's Workbook* (Iowa City: University of Iowa Press, 1999).

**12**  Stephen Trimble, *Talking with the Clay: The Art of Pueblo Pottery* (Santa Fe, NM: School of American Research Press, 1987); Christopher Roy, ed., *Clay and Fire: Pottery in Africa* (Iowa City: University of Iowa Press, 2000); Moira Vincentelli, *Women and Ceramics: Gendered Vessels* (Manchester, UK: Manchester University Press, 2000); and Elizabeth Perrill, *Zulu Pottery* (Western Cape, South Africa: Print Matters, 2012). On the connection between labor and child-rearing demands, see Judith Brown, "A Note on the Division of Labor by Sex," *American Anthropologist* 72, no. 5 (October 1970): 1073–78.

**13**  Joanna Brown, "Tradition and Adaptation in Moravian Press-Molded Earthenware," and Michelle Erickson, Robert Hunter, and Caroline M. Hannah, "Making a Moravian Squirrel Bottle," in Robert Hunter, ed., *Ceramics in America 2009* (Milwaukee, WI: Chipstone Foundation, 2009), 72–93.

**14**  David Barker and Pat Halfpenny, *Unearthing Staffordshire: Towards a New Understanding of 18th Century Ceramics* (Stoke-on-Trent, UK: City of Stoke-on-Trent Museum & Art Gallery, 1990), 28–29; and Robert Copeland, *Manufacturing Processes of Tableware during the Eighteenth and Nineteenth Centuries* (Cumbria, UK: Northern Ceramics Society, 2009).

**15**  Copeland, *Manufacturing Processes*, 37–62. Useful works on American vernacular potters include Ralph Rinzler and Robert Sayers, *The Meaders Family: North Georgia Potters* (Washington, DC: Smithsonian Institution Press, 1980); John Burrison, *Brothers in Clay: The Story of Georgia Folk Pottery* (Athens: University of Georgia Press, 1983); and Charles Zug, *Turners and Burners: The Folk Potters of North Carolina* (Chapel Hill: University of North Carolina Press, 1986).

**16**  Trimble, *Talking with the Clay*, 18–20; and Perrill, *Zulu Pottery.*

**17**  For a helpful introduction to glazes, see W. David Kingery and Pamela Vandiver, *Ceramic Masterpieces: Art, Structure, Technology* (New York: Free Press, 1986), 261–77.

**18**  Copeland, *Manufacturing Processes*, 29–35, 63–96, 104–5. Discussions of the impact of different types of modeling (sprig molding, impressing, adding, carving) include Barker and Halfpenny, *Unearthing Staffordshire*; David Gaimster, *German Stoneware 1200–1900: Archaeology and Cultural History* (London: British Museum Press, 1997); and Mark Newell with Peter Lenzo, "Making Faces: Archaeological Evidence of African-American Face Jug Production," in Robert Hunter, ed., *Ceramics in America 2006* (Milwaukee, WI: Chipstone Foundation, 2006): 122–38.

**19**  Trimble, *Talking with the Clay*, 22–24; and Jonathan Batkin, *Pottery of the Pueblos of New*

Mexico 1700–1940 (Colorado Springs, CO: Taylor Museum of the Colorado Springs Fine Arts Center, 1987), 16–18, 92–187.

**20** Joseph Veach Noble, *The Techniques of Painted Attic Pottery* (1965; rev. ed., London: Thames and Hudson, 1988); and Andrew Clark et al., *Understanding Greek Vases: A Guide to Terms, Styles, and Techniques* (Los Angeles: J. Paul Getty Museum, 2002).

**21** Michelle Erickson and Robert Hunter, "Dots, Dashes, and Squiggles: Early English Slipware Technology," in Robert Hunter, ed., *Ceramics in America 2001* (Milwaukee, WI: Chipstone Foundation, 2001), 95–114; and Merry Outlaw, "Scratched in Clay: Seventeenth-Century North Devon Slipware at Jamestown, Virginia," in Robert Hunter, ed., *Ceramics in America 2002* (Milwaukee, WI: Chipstone Foundation, 2002), 17–38.

**22** Namwon Jang, "Introduction and Development of Koryo Celadon" and Soyonbg Lee, "Ceramics and Culture in Choson Korea," in J. P. Park, ed., *A Companion to Korean Art* (Hoboken, NJ: John Wiley & Sons, 2020), 147–49, 326–28.

**23** N. Wood et al., "A Technological Examination of Ninth-Century AD Abbasid Blue-and-White Ware from Iraq, and Its Comparison with Eighth Century AD Chinese Blue-and-White *Sancai* Ware," *Archaeometry* 49, no. 4 (2007): 655–56, 678–83; Oliver Watson, "Ceramics and Circulation," in Finbarr Barry Flood and Gülru Necipoğlu, eds., *A Companion to Islamic Art and Architecture* (London: John Wiley & Sons, 2017), 493–95; and Oliver Watson, *Ceramics of Iran* (New Haven, CT: Yale University Press, 2020), 16–19, 41–95, 201–37.

**24** See Ulla Houkjaer, *Tin-Glazed Earthenware 1300–1750: Spain—Italy—France* (Copenhagen: Danish Museum of Art & Design, 2005), esp. 12–14; and Houkjaer, *Tin-Glazed Earthenware from the Netherlands, France and Germany 1600–1800* (Copenhagen: Designmuseum Danmark, 2016), esp. 13–27.

**25** Cyril Cook, *The Life and Work of Robert Hancock: An Account of the Life of the 18th-Century Engraver and of His Designs on Battersea and Staffordshire Enamels and Bow and Worcester Porcelain* (London: Chapman and Hall, 1948); and Copeland, *Manufacturing Processes*, 141–52.

**26** Good sources on the early history of cobalt painting and underglaze painting in Chinese ceramics are Nigel Wood and Mike Tite, "Blue and White—The Early Years: Tang China and Abbasid Iraq Compared," in Stacey Pierson, ed., *Transfer: The Influence of China on World Ceramics* (London: University of London, 2007), 21–45; and Anne Gerritsen, *City of Blue and White:*

*Chinese Porcelain and the Early Modern World* (Cambridge: Cambridge University Press, 2020), 61–113. On the structure of the Chinese porcelain business, with underglaze decoration taking place in Jingdezhen and overglaze painting often taking place in Canton, see Finlay, *The Pilgrim Art*; Rose Kerr, "Asia in Europe: Porcelain and Enamel for the West," in Anna Jackson and Amin Jaffer, eds., *Encounters: The Meeting of Asia and Europe 1500–1800* (London: V&A Publications, 2004), 222–31; and Teresa Canepa, *Silk, Porcelain and Lacquer: China and Japan and Their Trade with Western Europe and the New World, 1500–1644* (London: Paul Holberton, 2016), 122–321.

**27** João Castel-Branco Pereira, *Portuguese Tiles from the National Museum of Azulejo, Lisbon* (Lisbon: Instituto Português de Museus, 1995); and Maria Antónia Pinto de Matos et al., *The Exotic Is Never at Home? The Presence of China in the Portuguese Faience and Azulejo (17th–18th Centuries)* (Lisbon: Museu Nacional do Azulejo, 2013).

**28** Nicholas Thomas and Julie Adams, eds., *Tapa: Barkcloth Paintings from the Pacific* (Birmingham, UK: Ikon Gallery, 2013); and Willow Mullins, *Felt* (Oxford: Berg, 2009).

**29** On the different types of knotting and knitting, see Irene Emery, *The Primary Structures of Fabrics: An Illustrated Classification* (Washington, DC: Textile Museum, 1966). On knotting, see Tim Ingold, "Of String Bags and Birds' Nests," in Ingold, *The Perception of the Environment: Essays on Livelihood, Dwelling and Skill* (New York: Routledge, 2000), 349–61; and Lissant Bolton, *Baskets & Belonging: Indigenous Australian Histories* (London: British Museum Press, 2011). A good introduction to lace is Pat Earnshaw, *A Dictionary of Lace* (Aylesbury, UK: Shire Publications, 1982).

**30** Some helpful studies of looms include Christopher Buckley and Eric Boudot, "The Evolution of Ancient Technology," *Royal Society Open Science* 4, no. 5 (May 2017): 1–22; Anni Albers, *On Weaving* (Middletown, CT: Wesleyan University Press, 1963), esp. 19–37; Ann Hecht, *The Art of the Loom: Weaving, Spinning and Dyeing across the World* (London: British Museum Publications, 1989), esp. 9–16; Irene Emery and Patricia Fiske, eds., *Looms and Their Products* (Washington, DC: Textile Museum, 1977); and Rahul Jain, "The Indian Drawloom and Its Products," *Textile Museum Journal* (1993–94): 50–81.

**31** Albers, *On Weaving*, esp. 66–70; and Thomas Campbell, *Tapestry in the Renaissance: Art and Magnificence* (New Haven, CT: Yale University Press, 2002).

**32** Hecht, *The Art of the Loom*, 32–36. For a helpful discussion of weave structures, see Dorothy Burnham, *Warp and Weft: A Textile Terminology* (Toronto: Royal Ontario Museum, 1980).

**33** Mattiebelle Gittinger, *Master Dyers to the World: Technique and Trade in Early Indian Dyed Cotton Textiles* (Washington, DC: Textile Museum, 1982), esp. 18–29; and Elena Phipps, "Global Colors: Dyes and the Dye Trade," in Amelia Peck, ed., *Interwoven Globe: The Worldwide Textile Trade, 1500–1800* (New York: Metropolitan Museum of Art, 2013), 120–35.

**34** See, for example, Rosemary Crill, ed., *The Fabric of India* (London: V&A Publishing, 2015), esp. 50–61; and Hecht, *The Art of the Loom*, 36–39.

**35** Sarah Fee, ed., *Cloth That Changed the World: The Art and Fashion of Indian Chintz* (Toronto: Royal Ontario Museum, 2019), esp. 3–15; Gittinger, *Master Dyers to the World*, esp. 58–135; and Krill, *The Fabric of India*, 38–50.

**36** Eiluned Edwards, *Textiles and Dress of Gujarat* (London: V&A Publishing, 2011), 112–53; and Alfred Bühler and Eberhard Fischer, eds., *The Patola of Gujarat: Double Ikat in India* (Basel: Krebs, 1979).

**37** The classic source is Florence Montgomery, *Printed Textiles: English and American Cottons and Linens 1700–1850* (New York: Viking, 1970).

**38** Good guides to embroidered textiles include Ignazio Vok, *Suzani: A Textile Art from Central Asia* (Munich: Edition Vok, 1994); Andrew Morrall and Melinda Watt, eds., *'Twixt Art and Nature: English Embroidery from the Metropolitan Museum of Art* (New Haven, CT: Yale University Press, 2008); and Darielle Mason, ed., *Phulkari: The Embroidered Textiles of Punjab* (Philadelphia, PA: Philadelphia Museum of Art, 2017). On quilting, see Darielle Mason, ed., *Kantha: The Embroidered Quilts of Bengal* (Philadelphia, PA: Philadelphia Museum of Art, 2009); and Linda Eaton, *Quilts in a Material World: Selections from the Winterthur Collection* (New York: Abrams, 2007), esp. 60–109.

**39** Maikel Kuijpers, *An Archaeology of Skill: Metalworking Skill and Material Specialization in Early Bronze Age Central Europe* (New York: Routledge, 2018); and M.H.G. Kuijpers, "Material Is the Mother of Invention," in Anna Mignosa and Priyatej Kotipalli, eds., *A Cultural Economic Analysis of Craft* (London: Palgrave Macmillan, 2019), 257–70.

**40** Cyril Stanley Smith, *A Search for Structure: Selected Essays on Science, Art, and History* (Cambridge, MA: MIT Press, 1981), 127–73, 254–72; and Robert Bagley, "Shang Ritual Bronzes: Casting Technology and Vessel Design," *Archives of Asian Art* 43 (1990): 6–20.

**41** On molds for casting pewter, see Pierre Auguste Salmon, *L'Art du Potier d-Etain* (Paris: L. F. Delatour, 1788); Ledlie Laughlin, *Pewter in America: Its Makers and Their Marks* (Boston: Houghton Mifflin, 1940), 1:10–18; and Charles Montgomery, *A History of American Pewter* (New York: Praeger, 1973), 20–41. See also Donald Fennimore, *Metal Work in Early America: Copper and Its Alloys from the Winterthur Museum* (Woodbridge, UK: Antique Collectors' Club, 1996), 16–29.

**42** On the seasonality of mining and smelting, see Eugenia Vanina, *Urban Crafts and Craftsmen in Medieval India* (New Delhi: Munshiram Manoharlal Publishers, 2004), 43–45. On pattern molding copper alloys and the role of women moldmakers, see Meera Mukherjee, *Metalcraftsmen of India* (Calcutta: Anthropological Survey of India, 1978), 212, 222, 300–308, 322–26.

**43** Ruth Reeves, *Cire Perdue Casting in India* (New Delhi: Crafts Museum, 1962); Oppi Untracht, *Metal Techniques for Craftsmen: A Basic Manual on the Methods of Forming and Decorating Metals* (London: Robert Hale, 1969), 319–51; Robert E. Stone, "Antico and the Development of Bronze Casting in Italy at the End of the Quattrocento," *Metropolitan Museum of Art Journal* 16 (1981): 87–116; Laurence Garenne-Marot, "Occurrence of the Process of Mould-cum-Crucible in the Cire-Perdue Casting Technique in West Africa: Independent Innovation or Importation," in Laurence Garenne-Marot et al., eds., *Transmission of Knowledge: Terracotta and Metals in West Africa* (Ibadan, Nigeria: Institut Français de Recherché en Afrique, 2004), 1–13; Lee Horne, "Making Metal in West Bengal," in Pika Ghosh et al,, *Cooking for the Gods: The Art of Home Ritual in Bengal* (Newark, NJ: Newark Museum, 1995), 33–38; Marcos Martinon-Torres, "Depletion Gilding, Innovation, and Life Histories: The Changing Colours of Nahuange Metalwork," *Antiquity* 91, no. 359 (October 2017): 1253–67; and Mukherjee, *Metalcraftsmen of India*, 212–25.

**44** John Fuller, *Art of Coppersmithing* (New York: David Williams, 1894); and Untracht, *Metal Techniques for Craftsmen*, 240–57.

**45** Untracht, *Metal Techniques for Craftsmen*, 301–10; and George Gibb, *The Whitesmiths of Taunton* (Cambridge, MA: Harvard University Press, 1943).

**46** Untracht, *Metal Techniques for Craftsmen*, 111–19.

**47** Untracht, *Metal Techniques for Craftsmen*, 93–110.

**48** Shena Mason, ed., *Matthew Boulton: Selling What All the World Desired* (Birmingham, UK: Birmingham City Council, 2009); Gibb, *The*

*Whitesmiths of Taunton*; and Fennimore, *Metal Work in Early America*, 440–46.

**49**   Untracht, *Metal Techniques for Craftsmen*, 138–53

**50**   Nancy Netzer, *Catalogue of Medieval Objects: Enamels and Glass* (Boston: Museum of Fine Arts, Boston, 1986), xix; Giles Cosgrove Maynard, *The Enamels of China and Japan* (New York: Dodd, Mead, 1974); and Jorge Welsh and Luísa Vinhais, eds., *China of All Colours: Painted Enamels on Copper* (London: Jorge Welsh Research & Publishing, 2015).

**51**   Good guides to green woodworking include Drew Langsner, *Country Woodcraft* (Emmaus, PA: Rodale, 1978); John D. Alexander, Jr., *Make a Chair from a Tree: An Introduction to Working Green Wood* (Newtown, CT: Taunton Press, 1978); and Mike Abbott, *Green Woodwork: Working with Wood the Natural Way* (Lewes, UK: Guild of Master Craftsman Publications, 1989).

**52**   The term "workable moisture content" was introduced by Peter Follansbee in "What Is Green Woodworking?," Joiner's Notes, November 23, 2009, https://pfollansbee.wordpress.com/2009 /11/23/what-is-green-woodworking, accessed July 27, 2018.

**53**   For examples of pit and trestle sawing, see Daniel Finamore, "Furnishing the Craftsman: Slaves and Sailors in the Mahogany Trade," in Luke Beckerdite, ed., *American Furniture 2008* ((Milwaukee, WI: Chipstone Foundation, 2008): 61–68; and Duncan James, "Saw Marks in Vernacular Buildings and Their Wider Significance," *Vernacular Architecture* 43, no. 1 (2012), 7–18. The advantages of water-powered saw mills are discussed in Benno Forman, "Mill Sawing in Seventeenth Century Massachusetts," *Old-Time New England* 60, no. 220 (Spring 1970): 110–30; and Abbott Lowell Cummings, *The Framed Houses of Massachusetts Bay, 1625–1725* (Cambridge, MA: Belknap Press of Harvard University Press, 1979), esp. 46–47.

**54**   On planing and dimensioning stock, see Jennie Alexander and Peter Follansbee, *Make a Joint Stool from a Tree: An Introduction to 17th-Century Joinery* (Fort Mitchell, KY: Lost Art Press, 2012); William Coaldrake, *The Way of the Carpenter: Tools and Japanese Architecture* (New York: Weatherhill, 1990), esp. 29–88; and Eberhard Fischer, "Wood Working," in Eberhard Fischer and Haku Shah, *Rural Craftsmen and Their Work: Equipment and Techniques in the Mer Village of Ratadi in Saurashtra, India* (Ahmedabad: National Institute of Design, 1970), 65–107.

**55**   Bruce Hoadley, *Understanding Wood: A Craftsman's Guide to Wood Technology* (Newtown, CT: Taunton Press, 1980); Steven Powers, *North American Burl Treen: Colonial and Native American* (Brooklyn, NY: S. Scott Powers Antiques, 2005); and Peter Follansbee, *Joiner's Work* (Fort Mitchell, KY: Lost Art Press, 2019), 86–117. Useful reminders that woodworkers often used a combination of joinery techniques include Phil Zea, "Construction Methods and Materials," in Brock Jobe and Myrna Kaye, eds., *New England Furniture: The Colonial Era* (Boston: Houghton Mifflin, 1986), 73–100.

**56**   Alexander and Follansbee, *Make a Joint Stool from a Tree*; and Follansbee, *Joiner's Work*.

**57**   On dovetails and finger joints, see Charles Hayward, *Woodwork Joints: Kinds of Joints, How They Are Cut, and Where Used* (London: Evans Brothers, 1950).

**58**   On bending greenwood and steamed wood, see Abbott, *Green Woodwork*; and Drew Langsner, *The Chairmaker's Workshop: Handcrafting Windsor and Post-and-Rung Chairs* (New York: Lark Books, 1997).

**59**   Jarrod Dahl catalogs the various axis orientations and drive systems of the lathe across cultures in "Japanese Woodturning—Part One," Woodspirit Handcraft, December 26, 2020, https://www.woodspirithandcraft.com/blog /japanese-woodturning-part-one?ss_source =sscampaigns&ss_campaign_id=5fe7646137 d49f5188629510&ss_email_id=5fe7670374 b19313024207f0&ss_campaign_name=Japanese +Woodturning+-+Part+One&ss_campaign_sent _date=2020-12-26T16%3A39%3A01Z, accessed January 9, 2021. On the lathe's various uses, see Edward Cooke, Jr., "Turning Wood in America: New Perspectives on the Lathe" in Tran Turner, ed., *Expressions in Wood: Masterworks from the Wornick Collection* (Oakland: Oakland Museum of California, 1997), 39–46.

**60**   A good discussion of eighteenth-century finishes is Robert Mussey, "Transparent Finishes in New England, 1700–1825," *Old-Time New England* 72 (1987): 287–311.

**61**   A helpful discussion of Atlantic-world stains and paints is Nancy Evans, *Windsor-Chair Making in America: From Craft Shop to Consumer* (Hanover, NH: University Press of New England, 2006), 143–87. On Italian painted furniture, see Andrea Bayer, ed., *Art and Love in Renaissance Italy* (New York: Metropolitan Museum of Art, 2008). On the grisaille decoration on Dutch and Dutch-American cupboards, see Peter Kenny, *American Kasten* (New York: Metropolitan Museum of Art, 1991), 28–32.

**62**   Many scholars treat lacquer as its own medium, but I have grouped it with paint and varnish to describe a specific finish on wood substrates. Sometimes the wood structure is elaborately constructed, but other times the wood is merely a simple core and the layers of lacquer do

constitute the substance of the object. But for the purpose of a broad comparative discussion, it is helpful to think of lacquer as a finish.

**63**   Marianne Webb, *Lacquer: Technology and Conservation* (Oxford: Butterworth-Heinemann, 2000); Monika Kopplin, ed., *Lacquerware in Asia, Today and Yesterday* (Paris: UNESCO, 2002); Denise Patry Leidy, *Mother-of-Pearl: A Tradition in Asian Lacquer* (New York: Metropolitan Museum of Art, 2006), 9–50; and Leidy, "Cinnabar."

**64**   Monika Kopplin, *European Lacquer: Selected Works from the Museum für Lackkunst, Münster* (Munich: Hirmer Verlag, 2010); and Tara Cederhom and Christine Thomson, "'Tortoiseshell and Gold': Robert Davis and the Art of Japanning in Eighteenth-Century Boston," in Brock Jobe and Gerald Ward, eds., *Boston Furniture, 1700–1900* (Boston: Colonial Society of Massachusetts, 2017), 48–77.

**65**   Mitchell Codding, "The Lacquer Arts of Latin America" in Dennis Carr, ed., *Made in the Americas: The New World Discovers Asia* (Boston: Museum of Fine Arts, Boston, 2015), 74–89.

**66**   Charles Hummel, *With Hammer in Hand* (Charlottesville: University Press of Virginia, 1968), 100–123; and James Gaynor and Nancy Hagedorn, *Tools: Working Wood in Eighteenth-Century America* (Williamsburg, VA: Colonial Williamsburg Foundation, 1993), 95–110.

**67**   Bernard D. Cotton, *The English Regional Chair* (Woodbridge, UK: Antique Collectors' Club, 1990), esp. 13–31.

**68**   Joseph Forgione, *Wood Inlay: Art and Craft* (New York: Van Nostrand, 1973); Amin Jaffer, *Furniture from British India and Ceylon* (London: V&A Publications, 2001), 160–65, 172–91, 285–93; and María Carlés de Peña, *A Surviving Legacy in Spanish America: Seventeenth- and Eighteenth-Century Furniture from the Viceroyalty of Peru* (Madrid: Ediciones el Viso, 2013), 150–67.

**69**   E. W. Hobbs, *Veneering and Its Possibilities* (London: Cassell, 1934); Jaffer, *Furniture from British India and Ceylon*, 191–211, 313–28; Leidy, *Mother-of-Pearl*; Carlés de Peña, *A Surviving Legacy in Spanish America*, 86–111, 238–87; and Yayoi Kawamura, ed., *Lacas Namban: Huellas de Japón en España; IV centenario de la embajada Keichô* (Madrid: Museo Nacional de Artes Decorativas in association with the Japan Foundation, 2013).

**70**   Margaret Graves, *Arts of Allusion: Object, Ornament, and Architecture in Medieval Islam* (New York: Oxford University Press, 2018), esp. 26–58.

**71**   For a recent study of the arts et métiers, see Paola Bertucci, *Artisanal Enlightenment: Science and the Mechanical Arts in Old Regime France*

(New Haven, CT: Yale University Press, 2017). The visual categorization of artisanal knowledge was in essence an imperial or racist project that accorded European practice the highest level: Edward Cooke, Jr., "Utensils," in Martina Droth, Nathan Flis, and Michael Hatt, eds., *Britain in the World: Highlights from the Yale Center for British Art* (New Haven, CT: Yale University Press, 2019), 96–99; and Edward Cooke, Jr., "Utensils and Metallurgical Knowledge in South Asia," *West 86th* (forthcoming).

**72**   Joseph Moxon, *Mechanick Exercises, or The Doctrine of Handy-Works* (1678; reprint ed., New York: Praeger, 1970); and Denis Diderot, *Encyclopédie, ou dictionnaire raisonné des sciences, des arts et des métiers* (Paris, 1751–72). The difficulty of understanding artisanal time is discussed in Edward Cooke, Jr., "Making Time: The Cumulative, Partially Invisible, Nonlinear, and Episodic Nature of Artisanal Work," in Edward Town and Glenn Adamson, eds., *Marking Time: Objects and Temporality in Britain, 1600–1800* (New Haven, CT: Yale University Press, 2020), 83–89. On the seductive power of YouTube videos in regard to craft skills, see Michael Kardas and Ed O'Brien, "Easier Seen Than Done: Merely Watching Others Perform Can Foster an Illusion of Skill Acquisition," *Psychological Science* 29, no. 4 (April 2018): 521–36.

# Chapter 3. Circulation and Interchange

**1**   For a classic account of Chinese export ware, see Carl Crossman, *The Decorative Arts of the China Trade* (Woodbridge, UK: Antique Collectors' Club, 1991). A more recent corrective that speaks to the complexity and hybridity of interchange between China and the West is Petra Ten-Doesschate Chu and Ning Ding, eds., *Qing Encounters: Artistic Exchanges between China and the West* (Los Angeles: Getty Research Institute, 2015).

**2**   I borrow the term "the social life of an object" from Arjun Appadurai, ed., *The Social Life of Things: Commodities in Cultural Perspective* (New York: Cambridge University Press, 1986), but want to expand the concept beyond the notion of commodity to a consideration of material culture. On the importance of distinguishing between an object made for export and one that simply happens to be exported, see Stacey Pierson, "The Movement of Chinese Ceramics: Appropriation in Global History," *Journal of World History* 23, no. 1 (2012): 9–39.

**3**   Sarah Fee, ed., *Cloth That Changed the World: The Art and Fashion of Indian Chintz* (Toronto: Royal Ontario Museum, 2019), xvii.

**4**  Sofia Sanabrais, "The *Biombo* or Folding Screen in Mexico," in Donna Pierce and Ronald Otsuka, eds., *Asia and Spanish America: Trans-Pacific Artistic and Cultural Exchange, 1500–1850* (Denver, CO: Denver Art Museum, 2009), 69–106; and Mitchell Codding, "The Lacquer Arts of Latin America," in Dennis Carr, ed., *Made in the Americas: The New World Discovers Asia* (Boston: Museum of Fine Arts, Boston, 2015), 82.

**5**  A useful architectural example is Sugata Ray, "Introduction: Translation as Art History," *Ars Orientalis* 48 (2018): 1–19.

**6**  On the production, functions, and distribution of Greek painted pottery, see Philip Spairstein, "Painters, Potters, and the Scale of the Attic Vase-Painting Industry," *American Journal of Archaeology* 117, no. 4 (October 2013): 493–510; Soffia Gunnarsdottir, "(Re)creating the Divine: The Material Theology of Athenian Pottery" (PhD diss., Yale University, forthcoming); Milette Gaifman, *The Art of Libation in Classical Athens* (New Haven, CT: Yale University Press, 2018); and Sheramy D. Bundrick, *Athens, Etruria, and the Many Lives of Greek Figured Pottery* (Madison: University of Wisconsin Press, 2019).

**7**  On the Roman ceramic industry and the *taberna* economy, see Emanuel Mayer, *The Ancient Middle Classes: Urban Life and Aesthetics in the Roman Empire, 100 BCE–250 CE* (Cambridge, MA: Harvard University Press, 2012), esp. 61–99; and Roberta Tomber, *Indo-Roman Trade: From Pots to Pepper* (London: Duckworth, 2008).

**8**  For a suggestive study of the power of domestic goods as pervasive but subtle extensions of empire, see John Plotz, *Portable Property: Victorian Culture on the Move* (Princeton, NJ: Princeton University Press, 2008).

**9**  On early silk, see Shelagh Vainker, *Chinese Silk: A Cultural History* (London: British Museum Press, 2004), esp. 46–73; Angela Sheng, "Textiles from the Silk Road," *Expedition* 52, no. 3 (2010): 33–43; Sheng, "Reading Textiles: Transmission and Technology of Silk Road Textiles in the First Millennium," in Jennifer Harris, ed., *A Companion to Textile Culture* (Hoboken, NJ: John Wiley & Sons, 2020), 109–26; Sheng, "Innovations in Textile Techniques on China's Northwest Frontier, 500–700 A.D.," *Asia Major* 11 (1998): 117–60; Regina Schorta, ed., *Central Asian Textiles and Their Contexts in the Early Middle Ages* (Riggisberg, Switzerland: Abegg-Stiftung, 2006); Zhao Feng, "The Ever-Changing Technology and Significance of Silk on the Silk Road," in Ivan Gaskell and Sarah Anne Carter, eds., *The Oxford Handbook of History and Material Culture* (New York: Oxford University Press, 2020), 222–35; and Yong Cho, "The Mongol Impact: Rebuilding the Arts System in Yuan China (1271–1368)" (PhD

diss., Yale University, 2020), esp. chap 5. On the Chinese silk trade from the eighth through the fifteenth centuries, see James Watt and Anne Wardwell, *When Silk Was Gold: Central Asian and Chinese Textiles* (New York: Metropolitan Museum of Art, 1997).

**10**  Stefano Carboni, ed., *Venice and the Islamic World 828–1797* (New York: Metropolitan Museum of Art, 2007); and Ela Jordana, *Gnalic-Treasure of a 16th Century Sunken Ship* (Zagreb: Croatian History Museum, 2013).

**11**  Regina Krahl et al., eds., *Shipwrecked: Tang Treasures and Monsoon Winds* (Washington, DC: Arthur M. Sackler Gallery, Smithsonian Institution, 2010); Alan Chong and Stephen Murphy, eds., *The Tang Shipwreck: Art and Exchange in the 9th Century* (Singapore: Asian Civilizations Museum, 2017); and John Guy, *Oriental Trade Ceramics in South-East Asia, Ninth to Sixteenth Century* (New York: Oxford University Press, 1986).

**12**  See Sarah Guérin, "Gold, Ivory, and Copper: Materials and Arts of Trans-Saharan Trade," and Raymond Silverman, "Red Gold: Things Made of Copper, Bronze, and Brass," in Kathleen Bickford Berzock, ed., *Caravans of Gold, Fragments of Time: Art, Culture, and Exchange across Medieval Saharan Africa* (Princeton, NJ: Princeton University Press, 2019), 175–201, 257–67; and Laurence Garenne-Marot, "Occurrence of the Process of Mould-cum-Crucible in the *Cire-Perdue* Casting Technique in West Africa: Independent Innovation or Importation?," in J. Polet et al., eds., *Transmission of Knowledge: Terra Cotta and Metals in West Africa* (Ibadan, Nigeria: Institut Français de Recherché en Afrique, 2004). Gold had negative associations in terms of its exploitative mining and worry about evil spirits escaping the metal while working it. In contrast, copper responded well to a variety of techniques, and its shaping in a mold-cum-crucible kept the spirits of the metal intact.

**13**  Giorgio Riello and Tirthankar Roy, eds., *How India Clothed the World: The World of South Asian Textiles, 1500–1850* (Leiden, Netherlands: Brill, 2009); Giorgio Riello and Prasannan Parthasarathi, eds., *The Spinning World: A Global History of Cotton Textiles, 1200–1850* (Oxford: Oxford University Press, 2009); Ruth Barnes, "Indian Cotton for Cairo: The Royal Ontario Museum's Gujarati Textiles and the Early Western Indian Ocean Trade," *Textile History* 48, no. 1 (Spring 2017): 15–30; Prita Meier and Allyson Purpura, eds., *World on the Horizon: Swahili Arts across the Indian Ocean* (Champaign, IL: Krannert Art Museum and Kinkead Pavilion, 2018); and Pedro Machado, Sarah Fee, and Gwyn Campbell, eds., *Textile Trades, Consumer Cultures, and the*

*Material Worlds of the Indian Ocean* (Cham, Switzerland: Palgrave Macmillan, 2018).

**14**  John Guy, *Woven Cargoes: Indian Textiles in the East* (New York: Thames and Hudson, 1998); and Ruth Barnes, *Indian Block-Printed Textiles in Egypt: The Newberry Collection in the Ashmolean Museum, Oxford* (Oxford: Clarendon Press, 1997).

**15**  Anne Wardwell, "Luxury-Silk Weaving under the Mongols," in Watt and Wardwell, *When Silk Was Gold*, 127–41; Juliane von Fircks, "Panni Tartarici: Splendid Cloths from the Mongol Empire in European Contexts," *Orientations* 45, no. 7 (October 2014): 28–37; and Juliane von Fircks and Regula Schorta, eds., *Oriental Silks in Medieval Europe* (Riggisberg, Switzerland: Abegg-Stiftung, 2016).

**16**  Good summaries of the Portuguese expansion are two catalogs of the same exhibition: Jay Levenson, ed., *Encompassing the Globe: Portugal and the World in the 16th and 17th Centuries* (Washington, DC: Arthur M. Sackler Gallery, Smithsonian Institution, 2007); and *Encompassing the Globe: Portugal and the World in the 16th and 17th Centuries* (Lisbon: Museu Nacional de Arte Antiga, 2009). See also Victoria Weston, ed., *Portugal, Jesuits and Japan: Spiritual Beliefs and Earthly Goods* (Chestnut Hill, MA: McMullen Museum of Art, 2013); Luisa Vinhais and Jorge Welsh, eds., *After the Barbarians II: Namban Works of Art for the Japanese, Portuguese and Dutch Markets* (Lisbon: Jorge Welsh Books, 2008); and Luisa Vinhais and Jorge Welsh, eds., *Art of the Expansion and Beyond* (Lisbon: Jorge Welsh Books, 2009).

**17**  On the Portuguese political economy, see Manuel Nunes Dias, "Portuguese Monarchical Capitalism, 1415–1549: Contribution to the Origins of Modern Capitalism" (PhD diss., University of Coimbra, 1963). Samuel Luterbacher kindly brought this dissertation to my attention.

**18**  Karina Corrigan, Jan van Campen, and Femke Diercks, eds., *Asia in Amsterdam: The Culture of Luxury in the Golden Age* (New Haven, CT: Yale University Press, 2015); and Deborah Krohn and Peter Miller, eds., *Dutch New York between East and West: The World of Margrieta van Varick* (New York: Bard Graduate Center, 2009).

**19**  Etsuko Rodriguez, "Early Manila Galleon Trade: Merchants' Network and Market in 16th- and 17th-Century Mexico," in Pierce and Otsuka, *Asia and Spanish America*, 37–57; Karina Corrigan, "Asian Luxury Exports to Colonial America," and Donna Pierce, "By the Boatload: Receiving and Recreating the Arts of Asia," in Carr, *Made in the Americas*, 38–73; and José Gasch-Tomás, *The Atlantic World and the Manila Galleons: Circulation, Market, and Consumption*

*of Asian Goods in the Spanish Empire, 1565–1650* (Leiden, Netherlands: Brill, 2019).

**20**  See Cary Carson, *Face Value: The Consumer Revolution and the Colonizing of America* (Charlottesville: University of Virginia Press, 2017).

**21**  See C. A. Bayly, *Imperial Meridian: The British Empire and the World, 1780–1830* (London: Longman Group, 1989); Philip J. Stern, *The Company-State: Corporate Sovereignty and the Early Modern Foundations of the British Empire in India* (London: Oxford University Press, 2012); Rupali Mishra, *A Business of State: Commerce, Politics, and the Birth of the East India Company* (Cambridge, MA: Harvard University Press, 2018); and William Dalrymple, *The Anarchy: The Relentless Rise of the East Indian Company* (London: Bloomsbury, 2019). On goods from South Asia, see Margot Finn and Kate Smith, eds., *East India Company at Home* (London: UCL Press, 2018).

**22**  Berzock, *Caravans of Gold, Fragments of Time*, 167–68, 260–62.

**23**  Leland Ferguson, *Uncommon Ground: Archaeology and Early African America, 1650–1800* (Washington, DC: Smithsonian Institution Press, 1992); and Charles Cobb and Chester DePratter, "Multisited Research on Colonowares and the Paradox of Globalization," *American Anthropologist* 114, no. 3 (September 2012): 446–61.

**24**  Simon Digby, "The Mother-of-Pearl Overlay Furniture of Gujarat: An Indian Handicraft of the 16th and 17th Centuries," in Robert Skelton et al., *Facets of Indian Art* (London: Victoria & Albert Museum, 1986), 213–22; Vinhais and Welsh, *Art of the Expansion and Beyond*, 54–65; and Yayoi Kawamura, ed., *Lacas Namban: Huellas de Japón en España; IV centenario de la embajada Keichô* (Madrid: Museo Nacional de Artes Decorativas in association with the Japan Foundation, 2013), 160–62.

**25**  See Ana Claro and Maria João Ferreira, "Chinese Textiles for the Portuguese Market: Rethinking Their History through Dye Analysis," *Textile Museum Journal* 47 (2020): 109–35; Elena Phipps, "The Iberian Globe: Textile Traditions and Trade in Latin America," in Amelia Peck, ed., *Interwoven Globe: The Worldwide Textile Trade, 1500–1800* (New York: Metropolitan Museum of Art, 2013), 28–45; and Carr, *Made in the Americas*, 27–29.

**26**  Gilbert Vincent, "The Bombé Furniture of Boston," in Walter Muir Whitehill et al., *Boston Furniture of the Eighteenth Century* (Boston: Colonial Society of Massachusetts, 1974), 137–96.

**27**  Zara Anishanslin, *Portrait of a Woman in Silk: Hidden Histories of the British Atlantic World*

(New Haven, CT: Yale University Press, 2016).

**28**  Rachel Ward, "Brass, Gold and Silver from Mamluk Egypt: Metal Vessels Made for Sultan al-Nasir Muhammad," *Journal of the Royal Asiatic Society* 14, no. 1 (April 2004): 59–73; Maryam Ekhtiar, Sheila Canby, Navina Haidar, and Priscilla Soucek, *Masterpieces from the Department of Islamic Art in The Metropolitan Museum of Art* (New York: Metropolitan Museum of Art, 2011), 156–57; and Yuka Kadoi, *Islamic Chinoiserie: The Art of Mongol Iran* (Edinburgh: Edinburgh University Press, 2009), 79–86.

**29**  Watt and Wardwell, *When Silk Was Gold*, 23–24; Sheng, "Innovations in Textile Technique on China's Northwest Frontier, 500–700 A.D."; and Cho, "The Mongol Impact."

**30**  Nuno Vassalo e Silva, ed., *A herança de Rauluchantim* (Lisbon: Comissão Nacional para as Comemorações dos Descobrimentos Portugueses, 1996).

**31**  Jan Veenendaal, *Furniture from Indonesia, Sri Lanka, and India* (Delft, Netherlands: Volkenkundig Museum Nusantara, 1985); and Shweta Raghu, "Coastal Vision and the Negotiated Arts of Coromandel, 1610–1798" (PhD diss., Yale University, forthcoming), chap. 2.

**32**  Robert Hunter, "John Bartlam: America's First Porcelain Manufacturer," Stanley South, "John Bartlam's Porcelain at Cain Hoy," and Lisa Hudgins, "John Bartlam's Porcelain at Cain Hoy: A Closer Look," in Robert Hunter, ed., *Ceramics in America 2007* (Milwaukee: Chipstone Foundation, 2007), 193–208.

**33**  Jack Holden et al., *Furnishing Louisiana: Creole and Acadian Furniture, 1735–1835* (New Orleans, LA: Historic New Orleans Collection, 2010), 426–28.

**34**  George Kubler, *The Shape of Time: Remarks on the History of Things* (New Haven, CT: Yale University Press, 1962), 79–84.

**35**  See George Birdwood, *The Industrial Arts of India* (London: Chapman and Hall, 1880); and Robert Trent, *Hearts and Crowns: Folk Chairs of the Connecticut Coast, 1720–1840* (New Haven, CT: New Haven Colony Historical Society, 1977), esp. 23–24.

**36**  On the translation of images in different locales, see Alessandro Russo, *The Untranslatable Image: A Mestizo History of the Arts in New Spain, 1500–1600* (Austin: University of Texas Press, 2014); Emily Floyd, "Privileging the Local: Prints and the New World in Early Modern Lima," in Emily Engel, ed., *A Companion to Early Modern Lima* (Leiden, Netherlands: Brill Academic Publishers, 2018), 360–84; Avinoam Shalem, "The Poetics of Portabilty," and Anna Contadini, "Threads of Ornament in the Style World of the Fifteenth and Sixteenth Centuries," in Gülru

Necipoğlu and Alina Payne, eds., *Histories of Ornament: From Global to Local* (Princeton, NJ: Princeton University Press, 2016), 250–61, 290–305; and Suzanne Karr Schmidt and Edward Wouk, eds., *Prints in Translation, 1450–1750: Image, Materiality, Space* (London: Routledge, 2017).

**37**  Teresa Canepa, *Silk, Porcelain and Lacquer: China and Japan and Their Trade with Western Europe and the New World, 1500–1644* (London: Paul Holberton, 2016), 263–65; and Rose Kerr, "Asia in Europe: Porcelain and Enamel for the West," in Anna Jackson and Amin Jaffer, eds., *Encounters: The Meeting of Asia and Europe 1500–1800* (London: V&A Publications, 2004), 222–31.

**38**  Yeewan Koon, "Narrating the City: Pu Qua and the Depiction of Street Life in Canton," in Chu and Ding, *Qing Encounters*, 228. In an April 24, 2020, webinar talk titled "Originality among *las arts du feu*: Illusionistic Painting on Glass, Copper, and Porcelain in Early Modern Canton," Kee Il Choi addressed the complicated imagery of the punch bowl and suggested it combined both British and Chinese visual traditions. On the connections between enamel painting on porcelain and on copper, see Luisa Vinhais and Jorge Welsh, eds., *China of All Colours: Painted Enamels on Copper* (London: Jorge Welsh, 2015), esp. 30–36.

**39**  Kee Il Choi kindly supplied information on the Danish bowl, now in the collection of the KODE Museum in Bergen, Norway. That bowl features the initials of Christian Morch and his wife, Johanne Marie Morch, who lived in Kristiansand, Denmark, a town now part of southern Norway. Around the rim in gold in Danish is a drinking verse translated as "Welcome honest friend, to this stately home, but take heed so you don't get drunk." For additional insights on the Hogarth image, see Lars Tharp, *Hogarth's China: Hogarth's Paintings and Eighteenth-Century Ceramics* (London: Merrell Holbertson, 1997); and Karen Harvey, "Barbarity in a Teacup? Punch, Domesticity and Gender in the Eighteenth Century," *Journal of Design History* 21, no. 3 (2008): 205–21.

**40**  For a discussion of the bunch of grape dishes, see Nurhan Atasoy and Julian Raby, *Iznik: The Pottery of Ottoman Turkey* (London: Thames and Hudson, 1989), 121–24.

**41**  Margaret Graves, *Arts of Allusion: Object, Ornament, and Architecture in Medieval Islam* (New York: Oxford University Press, 2018), 66.

**42**  Barbara Karl, *Embroidered Histories: Indian Textiles for the Portuguese Market during the Seventeenth and Eighteenth Centuries* (Vienna: Böhlau Verlag, 2016); and Peck, *Interwoven Globe*, 145–49.

**43**   Guy, *Woven Cargoes*; Barnes, *Indian Block-Printed Textiles in Egypt*; and Barnes, "Indian Cotton for Cairo."

**44**   Peck, *Interwoven Globe*, 26–27, 74–75.

**45**   For examples of this wide-ranging visual vocabulary, see Mary McWilliams, "Qajar Lacquer as a Medium of Exchange," in David Roxburgh and Mary McWilliams, eds., *Technologies of the Image: Art in 19th-Century Iran* (Cambridge, MA: Harvard University Art Museums, 2017), 25–52; and Pika Ghosh, *Making Kantha, Making Home: Women at Work in Colonial Bengal* (Seattle: University of Washington Press, 2020), 93–124.

**46**   A helpful essay that stresses looking *into* cross-cultural objects rather than simply *at* them is Marta Ajmar, "The Renaissance in Material Culture: Material Mimesis as Force and Evidence of Globalization," in T. Hodos, ed., *The Routledge Handbook of Archaeology and Globalization* (London: Routledge, 2016), 669–86.

**47**   On the importance of copying to skill acquisition, see Alexander Langlands, *Cræft: An Inquiry into the Origins and True Meaning of Traditional Crafts* (New York: Norton, 2017); and Tim Ingold, *The Perception of the Environment: Essays on Livelihood, Dwelling and Skill* (London: Routledge, 2000), esp. 357–58, 372, 396–96. On the cabinetmakers' petition to Parliament about the threat of Indian woodworkers to the trade, see "The case of the Joyners Company against the importation of manufactured cabinet-work from the East-Indies" (London, ca. 1710), consulted at the Lewis Walpole Library, Farmington, Connecticut, file 63 710 J89+.

**48**   Gustavo Curiel, "Perception of the Other and the Language of 'Chinese Mimicry' in the Decorative Arts of New Spain," in Pierce and Otsuka, *Asia and Spanish America*, 19–36. On copying as the language of the market, see Robert Emlen, "Wedding Silver for the Browns: A Rhode Island Family Patronizes a Boston Goldsmith," *American Art Journal* 16, no. 2 (Spring 1984): 39–50.

**49**   Classic examples of emulation studies are T. H. Breen, "An Empire of Goods: The Anglicization of Colonial America, 1690–1776," *Journal of British Studies* 25, no. 4 (October 1986): 465–99; and Richard Bushman, *The Refinement of America* (New York: Knopf, 1992).

**50**   Ajmar, "The Renaissance in Material Culture."

**51**   Samuel Luterbacher, "Layovers: Japanese Export Lacquer's Transit and Re-use across Early Modern Iberian Empires" (PhD diss., Yale University, 2020), esp. chap. 1.

**52**   For the histories of lacquer and lacquer approximations, see Monika Kopplin, ed., *Lacquerware in Asia, Today and Yesterday* (Paris:

UNESCO, 2002); Teresa Canepa, *Silk, Porcelain and Lacquer*, 324–405; Monika Kopplin, *European Lacquer: Selected Works from the Museum für Lackkunst, Münster* (Munich: Hirmer Verlag, 2010); Annemarie Klootwijk, "Curious Japanese Black: Shaping the Identity of Dutch Imitation Lacquer," *Netherlands Yearbook for History of Art 66: Netherlands Art in Its Global Context* (2016): 253–71; Adam Bowett, *English Furniture, 1660–1714: From Charles II to Queen Anne* (Woodbridge, UK: Antique Collectors' Club, 2002), 144–69; Tara Cederholm and Christine Thomson, " 'Tortoiseshell and Gold': Robert Davis and the Art of Japanning in Eighteenth-Century Boston," in Brock Jobe and Gerald Ward, eds., *Boston Furniture, 1700–1900* (Boston: Colonial Society of Massachusetts, 2017), 48–77; and Mitchell Codding, "The Lacquer Arts of Latin America" in Carr, *Made in the Americas*, 74–89.

**53**   Ben Skarratt, "From India to Europe: The Production of the Kashmir Shawl and the Spread of the Paisley Motif," *Case Study #4 of the Oxford Global History of Capitalism* (August 2018; https://globalcapitalism.history.ox.ac.uk/sites/default/files/globalcapitalism/documents/media/case_04_-_the_paisley_0.pdf), accessed May 31, 2020; and Chitralekha Zutshi, " 'Designed for Eternity': Kashmiri Shawls, Empire, and Cultures of Production and Consumption in Mid-Victorian Britain," *Journal of British Studies* 48, no. 2 (April 2009): 420–40.

**54**   On chinoiserie, see David Porter, "Monstrous Beauty: Eighteenth-Century Fashion and the Aesthetics of the Chinese Taste," *Eighteenth-Century Studies* 35, no. 3 (2002): 395–411; Ethan Lasser, "Reading Japanned Furniture," in Luke Beckerdite, ed., *American Furniture 2007* (Milwaukee, WI: Chipstone Foundation, 2007), 167–90; Sarah Fayen Scarlett, "The Chinese Scholar Pattern: Style, Merchant Identity, and the English Imagination," in Robert Hunter, ed., *Ceramics in America 2011* (Milwaukee, WI: Chipstone Foundation, 2011), 2–45; Stacey Sloboda, *Chinoiserie: Commerce and Critical Ornamentation in Eighteenth-Century Britain* (Manchester: Manchester University Press, 2014); Kristel Smentek et al., *Imagining Qianlong: Louis XV's Chinese Emperor Tapestries and Battle Scenes Prints at the Imperial Court in Beijing* (Hong Kong: Hong Kong University Press, 2017); and Zhang Hongxing, *The Qianlong Emperor: Treasures from the Forbidden City* (Edinburgh: National Museum of Scotland, 2002).

**55**   On Hay and "Euroiserie," see Anna Grasskamp and Monica Juneja, eds., *Eurasian Matters: China, Europe, and the Transcultural Object, 1600–1800* (Cham, Switzerland: Springer, 2018), 11–12.

**56** The agency of the maker is critical to Alessandra Russo's study of Indigenous makers in New Spain: *The Untranslatable Image*. The sophisticated production system for chintz, as well as the agency of the different specialist crafts-people and even the cloth itself, is articulated by Sylvia Houghteling, "Politics, Poetry and the Figural Language of South Asian Cloth, 1600–1730" (PhD diss., Yale University, 2015), chap. 2.

**57** Yayoi Kawamura, ed., *Lacas Namban: Huellas de Japón en España; IV centenario de la embajada Keichô* (Madrid: Museo Nacional de Artes Decorativas in association with the Japan Foundation, 2013), 132–35, 144–47; Pierce, "By the Boatload," 70; Danielle Kisluk-Grosheide, "The (Ab)Use of Export Lacquer in Europe," *ICOMOS–Hefte des Deutschen Nationalkomitees* 35 (2000): 27–42; and Michael Yonan, "Veneers of Authority: Chinese Lacquers in Maria Theresa's Vienna," *Eighteenth-Century Studies* 37, no. 4 (Summer 2004): esp. 657.

**58** For entanglement, see Ralph Bauer and Marcy Norton, "Introduction: Entangled Trajectories; Indigenous and European Histories," *Colonial Latin American Review* 26, no. 1 (2017): 1–17. Certain scholars use the term "hybrid-ity" productively in this manner, but others still find that term skewed toward a colonial perspective: Matthew Liebmann, "Parsing Hybridity: Archaeologies of Amalgamation in Seventeenth-Century New Mexico," in Jeb Card, ed., *The Archaeology of Hybrid Material Culture* (Carbondale: Southern Illinois University Press, 2013), 25–49; and Carolyn Dean and Dana Leibsohn, "Hybridity and Its Discontents: Considering Visual Culture in Colonial Spanish America," *Colonial Latin American Review* 12, no. 1 (2003): 5–35.

**59** For a discussion of the connection between China and the Abbasid Empire, see Jessica Hallett, "Pearl Cups like the Moon: The Abbasid Reception of Chinese Ceramics," in Regina Krahl, John Guy, J. Keith Wilson, and Julian Raby, eds., *Shipwrecked: Tang Treasures and Monsoon Winds* (Washington, DC: Arthur Sackler Gallery, 2010), 74–81; Regina Krahl, "Green, White, and Blue-and-White Stonewares: The Precious Part of the Ceramic Cargo," in Chong and Murphy, *The Tang Shipwreck*, 80–104; N. Wood et al., "A Technological Examination of Ninth-Century AD Abbasid Blue-and-White Ware from Iraq, and Its Comparison with Eighth-Century AD Chinese Blue-and-White *Sancai* Ware," *Archaeometry* 49, no. 4 (2007): esp. 681–82; and Oliver Watson "Ceramics and Circulation," in Finbarr Barry Flood and Gülru Necipoğlu, eds., *A Companion to Islamic Art and Architecture* (London: John Wiley & Sons, 2017), 488–91.

**60** On Iranian and Ottoman blue and white, see Oliver Watson, *Ceramics of Iran* (New Haven, CT: Yale University Press, 2020), 16–19, 347–97; Julian Raby, "The Making of an Iznik Pot," in Nurhan Atasoy and Julian Raby, eds., *Iznik: The Pottery of Ottoman Turkey* (London: Thames and Hudson, 1989), 50–64; Yolande Crowe, *Persia and China: Safavid Blue and White Ceramics in the Victoria & Albert Museum 1501–1738* (London: la Borie, 2002); M. Matin and A. M. Pollard, "From Ore to Pigment: A Description of the Minerals and an Experimental Study of Cobalt Ore Processing from the Kashan Mine, Iran," *Archaeometry* 59, no. 4 (August 2017): 731–46; and M. S. Tite, S. Wolf, and R. B. Mason, "The Technological Development of Stonepaste Ceramics from the Islamic Middle East," *Journal of Archaeological Science* 38, no. 3 (March 2011): 570–80.

**61** On Chinese blue and white, see Denise Leidy and Maria Antonia Pinto de Matos, *Global by Design: Chinese Ceramics from the R. Albuquerque Collection* (London: Jorge Welsh Research and Publishing, 2016); and Anne Gerritsen, *City of Blue and White: Chinese Porcelain and the Early Modern World* (Cambridge: Cambridge University Press, 2020). For the influence of underglaze cobalt painting on Jingdezhen, see Watson, *Ceramics of Iran*, 347; and on "Muslim blue," see Gerritsen, *City of Blue and White*, 163–66.

**62** John Guy, *Oriental Trade Ceramics in South-East Asia: Ninth to Sixteenth Centuries* (New York: Oxford University Press, 1986); and John Stevenson and John Guy, *Vietnamese Ceramics: A Separate Tradition* (Chicago: Art Media Resources, 1997).

**63** On tin-glazed production in Portugal, see Mário Varela Gomes and Tânia Casimiro, eds., *On the World's Routes: Portuguese Faience (16th–18th Centuries)* (Lisbon: Instituto de Arqueologia e Paleociências, 2013), 19–56.

**64** On the popularity of kraak porcelain in the seventeenth century, see Teresa Canepa, *Kraak Porcelain: The Rise of Global Trade in the Late 16th and Early 17th Centuries* (London: Jorge Welsh Books, 2008).

**65** Florence Lister and Robert Lister, "Maiolica in Colonial Spanish America," *Historical Archaeology* 8 (1974): 17–52; Sean Kingsley, Ellen Gerth, and Michael Hughes, "Ceramics from the Tortugas Shipwreck: A Spanish-Operated *Navio* of the 1622 Tierra Firma Fleet," in Robert Hunter, ed., *Ceramics in America 2012* (Milwaukee: Chipstone Foundation, 2012), 77–97; Meha Priyadarshini, *Chinese Porcelain in Colonial Mexico: The Material Worlds of an Early Modern Trade* (Cham, Switzerland: Palgrave, 2018); and Farzaneh Pirouz-Moussavi, *Clay between Two*

*Seas: From Baghdad to the Talavera of Pueblo* (Madrid: Grupo Planeta, 2017).

**66** George Miller and Robert Hunter, "How Creamware Got the Blues: The Origins of China Glaze and Pearlware," in Robert Hunter, ed., *Ceramics in America 2001* (Milwaukee, WI: Chipstone Foundation, 2001), 135–61; and John Carswell, *Blue and White: Chinese Porcelain around the World* (London: British Museum Press, 2000).

**67** Pamela Smith, "Nodes of Convergence, Material Complexes, and Entangled Itineraries," in Pamela Smith, ed., *Entangled Itineraries: Materials, Practices, and Knowledge across Eurasia* (Pittsburgh, PA: University of Pittsburgh Press, 2019), 5–24.

**68** Glenn Adamson, *Fewer, Better Things: The Hidden Wisdom of Objects* (New York: Bloomsbury Publishing, 2018).

# Chapter 4. Function

**1** Mary Douglas and Baron Isherwood, *The World of Goods: Towards an Anthropology of Consumption* (New York: Basic Books, 1979), 5, 10.

**2** The foundational text on affordance is James J. Gibson, *The Ecological Approach to Visual Perception* (Boston: Houghton Mifflin, 1979). See also Georg Simmel, "The Handle," reprint of 1911 essay in *Hudson Review* 11, no. 3 (Autumn 1958): 371–85.

**3** Rodris Roth, *Tea Drinking in Eighteenth-Century America: Its Etiquette and Equipage* (Washington, DC: Smithsonian Institution, 1961); Ann Smart Martin, "The Role of Pewter as Missing Artifact: Attitudes towards Tablewares in Late 18th Century Virginia," *Historical Archaeology* 23, no. 2 (1989): 1–27; and Elizabeth Perkins, "The Consumer Frontier: Household Consumption in Early Kentucky," *Journal of American History* 78, no. 2 (September 1991): 486–510.

**4** Helpful critiques of modern functionalism include David Pye, *The Nature of Design* (New York: Reinhold, 1964); and Adrian Forty, *Objects of Desire: Design and Society from Wedgwood to IBM* (New York: Pantheon Books, 1986).

**5** On the importance of such bronze objects in large British medieval and early modern households, see Edward Town and Glenn Adamson, eds., *Marking Time: Objects and Temporality in Britain, 1600–1800* (New Haven, CT: Yale University Press, 2020), 191, 199–206, 434–35.

**6** On the pitcher, see T. A. Joyce, "English Ewer and Punch-Bowl from Ashanti," *British Museum Quarterly* 8, no. 1 (1933): 52; Malcolm McLeod, "Richard II, Part 3, at Kumase," in David Henige

and T. C. McCaskie, eds., *West African Economic and Social History: Studies in Memory of Marion Johnson* (Madison: University of Wisconsin's African Studies Program, 1990), 171–75; and Jonathan Alexander and Paul Binski, eds., *Age of Chivalry: Art in Plantagenet England 1200–1400* (London: Weidenfeld and Nicholson, 1987). I am indebted to Suzanne Blier, who brought this pitcher to my attention in a talk titled "Worlds of Art in a Vessel: Ewers, Punch Bowls, Gold, and Soul Bearers, Ghana and England, 1397–1897," delivered at Yale University, November 12, 2014. The cast inscription, in Lombardic script, reads "HE THAT WYL NOT SPARE WHEN HE MAY HE SHALL NOT / SPEND WHEN HE WOULD DEME THE BEST IN EVRERY / DOWT TIL THE TROWTHE BE TRYID OWTE."

**7** On the difference between technomic, socio-technic, and ideo-technic artifacts, see Lewis Binford, "Archaeology as Anthropology," *American Antiquity* 28, no. 2 (October 1962): 215–25.

**8** A helpful introduction to the different levels of utility is John Crowley, *The Invention of Comfort: Sensibilities and Design in Early Modern Britain and Early America* (Baltimore, MD: Johns Hopkins University Press, 2001).

**9** Suggestive studies of such types of objects include John Worrell, "Ceramic Production in the Exchange Network of an Agricultural Neighborhood" (paper presented to the Society for Historical Archaeology, Philadelphia, 1982); and Robin Wood, *The Wooden Bowl* (Ammanford, Wales: Stobart Davies, 2005).

**10** William Sturtevant, *Boxes and Bowls: Decorated Containers by Nineteenth-Century Haida, Tlingit, Bella Bella, and Tsimshian Indian Artists* (Washington, DC: Renwick Gallery, 1974).

**11** Erving Goffman, *The Presentation of Self in Everyday Life* (Garden City, NY: Doubleday Anchor, 1959); and Bruno Latour, *Reassembling the Social: An Introduction to Actor-Network-Theory* (New York: Oxford University Press, 2007). For applications of Goffman, see Philip Zea, *Useful Improvements, Innumerable Temptations" Pursuing Refinement in Rural New England, 1750–1850* (Deerfield, MA: Historic Deerfield, 1998); and Kenneth Ames, "Meaning in Artifacts: Hall Furnishings in Victorian America," *Journal of Interdisciplinary History* 9, no. 1 (Summer 1978): 19–46.

**12** Key to this is the study of proxemics, a classic example of which is Edward Hall, *The Hidden Dimension* (Garden City, NY: Doubleday, 1966). For a suggestive discussion of privacy, see David Flaherty, *Privacy in Colonial New England* (Charlottesville: University Press of Virginia, 1972),

**13**  A helpful explication of the threshold of permanence is Cary Carson et al., "Impermanent Architecture in the Southern American Colonies," *Winterthur Portfolio* 16, nos. 2–3 (1981): 135–78.

**14**  For a discussion of this drawing, see William Sturtevant, "Two 1761 Wigwams at Niantic, Connecticut," *American Antiquity* 40, no. 4 (October 1975): 437–48.

**15**  On the developing awareness of comfort in the early modern period, see Witold Rybczynski, *Home: A Short History of an Idea* (New York: Viking, 1986).

**16**  Useful studies of the cultural aspects of lighting include Ann Smart Martin, "Before the Light Bulb: A Material Culture of Luminosity and Reflection," in Anne Gerritsen and Giorgio Riello, eds., *Writing the History of Material Culture* (London: Bloomsbury Publishers, 2015), 157–64; and Wolfgang Schivelbusch, *Disenchanted Night: The Industrialization of Light* (Berkeley: University of California Press, 1988).

**17**  On seating and chairs, see Galen Cranz, *The Chair: Rethinking Culture, Body, and Design* (New York: Norton, 2000). A good introduction to the early origins of chairs is Nancy Berliner, "Considering Influences from Afar: The Impact of Foreign Cultures on Chinese Furniture," in Nancy Berliner and Edward Cooke, eds., *Inspired by China: Contemporary Furnituremakers Explore Chinese Traditions* (Salem, MA: Peabody Essex Museum, 2006), 16–39.

**18**  Peter Brown, *Come Drink the Bowl Dry: Alcoholic Liquors and Their Place in 18th Century Society* (York, UK: Fairfax House, 1996).

**19**  Gerald Ward, " 'Avarice and Conviviality': Card Playing in Federal America," in Benjamin Hewitt et al., *The Work of Many Hands: Card Tables in Federal America 1790–1820* (New Haven, CT: Yale University Art Gallery, 1982), pp. 14–38.

**20**  Roth, *Tea-Drinking in Eighteenth-Century America*; Peter Brown, *In Praise of Hot Liquors: The Study of Chocolate, Coffee, and Tea Drinking 1600–1850* (York, UK: Fairfax House, 1995); Ann Smart Martin, "Tea Tables Overturned: Rituals of Power and Place in Colonial America," in Dena Goodman and Kathryn Norberg, eds., *Furnishing the Eighteenth Century: What Furniture Can Tell Us about the European and American Past* (New York: Routledge, 2007), 169–81; and Sarah Fayen, "Tilt-Top Tables and Eighteenth-Century Consumerism," in Luke Beckerdite, ed., *American Furniture 2003* (Milwaukee, WI: Chipstone Foundation, 2003), 95–137. On the Japanese tea ceremony, see Morgan Pitelka, *Handmade Culture: Raku Potters, Patrons, and Tea Practitioners in Japan* (Honolulu: University of Hawai'i Press, 2005); and Andrew Watsky, *Chikubushima: Deploying the Sacred Arts in Momoyama Japan*

(Seattle: University of Washington Press, 2004), esp. 252–57.

**21**  See also Dora Ching et al., *Around Chigusa: Tea and the Arts of Sixteenth-Century Japan* (Princeton, NJ: Department of Art and Archaeology, 2017).

**22**  Patricia Darish, "Dressing for the Next Life: Raffia Textile Production and Use among the Kuba of Zaire," in Annette Weiner and Jane Schneider, eds., *Cloth and the Human Experience* (Washington, DC: Smithsonian Institution Press, 1989), 117–40; and Pika Ghosh, *Making Kantha, Making Home: Women at Work in Colonial Bengal* (Seattle: University of Washington Press, 2020).

**23**  Ann Withington "Manufacturing and Selling the American Revolution," in Catherine Hutchins, ed., *Everyday Life in the Early Republic* (Winterthur, DE: Winterthur Museum, 1994), 285–315.

**24**  See Joseph Richel, ed. *The Arts in Latin America, 1492–1820* (New Haven, CT: Yale University Press, 2006); and Andrew Hamilton, "The Emperor's New Clothes: The Biography of a Royal Inca Tunic" (book manuscript in progress).

**25**  For a discussion of such side tables, see Sarah Handler, *Austere Luminosity of Chinese Classical Furniture* (Berkeley: University of California Press, 2001), 224–38.

**26**  Glenn Adamson, "The Politics of the Caned Chair in America," in Luke Beckerdite, ed., *American Furniture 2002* (Milwaukee, WI: Chipstone Foundation, 2002), 174–206.

**27**  For a discussion of the role of quantity and design economics, see Cary Carson, *Face Value: The Consumer Revolution and the Colonizing of America* (Charlottesville: University of Virginia Press, 2017); and Michael Ettema, "Technological Innovation and Design Economics in Furniture Manufacture," *Winterthur Portfolio* 16, nos. 2–3 (Summer/Autumn 1981): 197–223.

**28**  Thorstein Veblen, *The Theory of the Leisure Class: An Economic Study in the Evolution of Institutions* (1899; New York: Modern Library, 1934).

**29**  This notion of other-directed and inner-directed is adapted from David Riesman's classic sociological study *The Lonely Crowd: A Study of the Changing American Character* (New Haven, CT: Yale University Press, 1950).

**30**  Exhibition brochure for "Blue on Gold: The Porcelain Room in Santos Palace," Museu Nacional de Arte Antiga, 2015, http://www.museudearteantiga.pt/exhibitions/blue-on-gold, accessed June 21, 2020; "Exhibition of Chinese Porcelain Plates Opens in Lisbon," *China Daily*, May 10, 2015, https://www.chinadaily.com.cn/culture/art/2015-05/10/content_20673514_2.htm, accessed June 21, 2020; and Prita Meier, "Toward

an Itinerant Art History: The Swahili Coast of Eastern Africa," in Stacey Sloboda and Michael Yonan, eds., *Eighteenth-Century Art Worlds: Global and Local Geographies of Art* (New York: Bloomsbury Visual Arts, 2020), 227–44.

**31**   On the relationship between geography, exoticism, and objects, see Benjamin Schmidt, *Inventing Exoticism: Geography, Globalism, and Europe's Early Modern World* (Philadelphia: University of Pennsylvania Press, 2015), esp. chap. 4.

**32**   Alexandre Nobre Pais and João Pedro Monteiro, "The Exotic in the Faience and *Azulejo* of the 17th Century," in *"The Exotic Is Never at Home?": The Presence of China in the Portuguese Faience and Azulejo (17th–18th Centuries)* (Lisbon: Museu Nacional do Azulejo, 2013), 58–79; Jan C. Leuchtenberger, *Conquering Demons: The Kirishitan, Japan, and the World in Early Modern Japanese Literature* (Ann Arbor: Center for Japanese Studies, University of Michigan, 2013), 22–51; and Kee Il Choi, Jr., "Scènes and Sensibility: William Chambers and François Boucher's Designs for the Opèra-Comique, *Aline, Reine de Golconde* (1766)," webinar presentation, June 19, 2020.

**33**   Yumiko Kamada, "The Use of Imported Persian and Indian Textiles in Early Modern Japan," *Textile Society of America Symposium Proceedings* (2012): 1–11; Pitelka, *Handmade Culture*, 89–159; and Amelia Peck, ed., *Interwoven Globe: The Worldwide Textile Trade, 1500–1800* (New York: Metropolitan Museum of Art, 2013), 60–62, 154.

**34**   Frances Gruber Stafford, *American Furniture in the Metropolitan Museum of Art: Early Colonial Period* (New York: Metropolitan Museum of Art, 2007), 65–70.

**35**   Dennis Carr, "In Search of Japanning in the Colonial Americas," *Antiques & Fine Art* 15, no. 1 (Spring 2011): 204–11; and Karen Rose Mathews, "Other Peoples' Dishes: Islamic *Bacini* on Eleventh-Century Churches in Pisa," *Gesta* 53, no. 1 (Spring 2014): 5–23.

**36**   Susan Stewart, *On Longing: Narratives of the Miniature, the Gigantic, the Souvenir, the Collection* (1984; Durham, NC: Duke University Press, 1993), 151. A helpful study that addresses the many motives for collecting in the broadest sense is Russell Belk, "Possessions and the Extended Self," *Journal of Consumer Research* 15 no. 2 (September 1988): 139–68; but also see John Elsner and Roger Cardinal, eds., *The Cultures of Collecting* (Cambridge, MA: Harvard University Press, 1994). On the idea of the fetish within collecting practice, see William Pietz, "The Problem of the Fetish, I," *RES: Anthropology and Aesthetics* 9 (Spring 1985): 5–17; and Pietz, "The Problem

of the Fetish, II: The Origin of the Fetish," *RES: Anthropology and Aesthetics* 13 (Spring 1987): 23–45.

**37**   For example, see Ethan Lasser, *The Philosophy Chamber: Art and Science in Harvard's Teaching Cabinet, 1766–1820* (Cambridge, MA: Harvard Art Museums, 2017); and Mungo Campbell and Nathan Flis, eds., *William Hunter and the Anatomy of the Modern Museum* (New Haven, CT: Yale Center for British Art, 2018).

**38**   Christopher E. G. Benfey, *The Great Wave: Gilded Age Misfits, Japanese Eccentrics, and the Opening of Old Japan* (New York: Random House, 2003). On the connections between morphology and design, see Laurel Waycott, "The Pattern-Seekers: The Science of Discernment, 1850–1920" (PhD diss., Yale University, 2019).

**39**   See Barbara Gutfleisch and Joachim Menzhausen, "How a Kunstkammer Should Be Formed: Gabriel Kaltemarckt's Advice to Christian I of Saxony on the Formation of an Art Collection, 1587," *Journal of the History of Collections* 1 (1989): 3–32; and Thomas DaCosta Kaufmann, "Remarks on the Collections of Rudolf II: The Kunstkammer as a Form of Representation," *Art Journal* 38, no. 1 (Autumn 1978): 22–28.

**40**   Gutfleisch and Menzhausen, "How a Kunstkammer Should Be Formed," 11.

**41**   Mark Meadow and Bruce Robertson, eds., *The First Treatise on Museums: Samuel Quiccheberg's "Inscriptiones" 1565* (Los Angeles: Getty Research Institute, 2013), 64.

**42**   Sunglim Kim, "*Chaekgeori*: Multi-Dimensional Messages in Late Joseon Korea," *Archives of Asian Art* 64, no. 1 (2014): esp. 3–6.

**43**   On Ardabil, see John Pope, *Chinese Porcelains from the Ardabil Shrine* (Washington, DC: Freer Gallery of Art, 1956); and Kishwar Rizvi, *The Safavid Dynastic Shrine: Architecture, Religion and Power in Early Modern Iran* (London: I. B. Taurus, 2010). On Charlottenburg Palace and European rulers' use of Chinese porcelain to demonstrate authority and physically establish connections with Asian empires on asymmetrical terms, see Filip Suchomel, *300 Treasures: Chinese Porcelain in the Wallenstein, Schwarzenberg and Lichnowsky Family Collections* (Prague: Academy of Arts, Architecture and Design in Prague, 2015); Tara Zanardi, "Kingly Performance and Artful Innovation: Porcelain, Politics, and Identity at Charles III's Aranjuez," *West 86th: A Journal of Decorative Arts, Design History, and Material Culture* 25, no. 1 (Spring–Summer 2018): 31–51; and Aaron Hyman, "The Hapsburg Re-Making of the East at Schloss Schönbrunn, 'or Things Equally Absurd,'" *Art Bulletin* 101, no. 4 (December 2019): 39–69.

**44** The collection of the Maharajas is discussed in Sylvia Houghteling, "Politics, Poetry and the Figural Language of South Asian Cloth, 1600–1730" (PhD diss., Yale University, 2015), chap. 3. On the importance of classification, see Jean Baudrillard, *The System of Objects* (1968; New York: Verso, 1996).

**45** Lasser, *The Philosophy Chamber*; Carol Paul, ed., *The First Modern Museums of Art: The Birth of an Institution in 18th- and 19th-Century Europe* (Los Angeles: Getty Publications, 2012); Benedicte Savoy et al., *The Museum Is Open: Towards a Transnational History of Museums 1750–1940* (Berlin: DeGruyter, 2014); and Carla Yanni, *Nature's Museums: Victorian Science and the Architecture of Display* (New York: Princeton Architectural Press, 2005).

**46** Malcolm Baker and Brenda Richardson, eds., *A Grand Design: The Art of the Victoria and Albert Museum* (New York: Abrams, 1997); Jeffrey Auerbach, *The Great Exhibition of 1851: A Nation on Display* (New Haven, CT: Yale University Press, 1999); and Lara Kriegel, *Grand Designs: Labor, Empire, and the Museum in Victorian Culture* (Durham, NC: Duke University Press, 2007).

**47** Tim Barringer and Tom Flynn, eds., *Colonialism and the Object: Empire, Material Culture and the Museum* (New York: Routledge, 1998); Arindam Dutta, *The Bureaucracy of Beauty* (New York: Routledge, 2007); and Edward Cooke, Jr., "Village Crafts, Rural Industry: The Politics of Modern Globalized Craft," in Janice Helland, Beverly Lemire, and Alena Buis, eds., *Craft, Community and the Material Culture of Place and Politics, 19th–20th Century* (London: Ashgate, 2014), 11–36.

**48** Elizabeth Edwards, Chris Gosden, and Ruth Phillips, eds., *Sensible Objects: Colonialism, Museums, and Material Culture* (Oxford: Berg, 2006). It is telling that the collection that the silver designer Edward C. Moore gave to the Metropolitan Museum of Art in 1891 was initially shown together but then parceled out to several different curatorial departments including Islamic, Japanese, Classical, and American. Medill Higgins Harvey, ed., *Collecting Inspiration: Edward C. Moore at Tiffany & Co.* (New York: Metropolitan Museum of Art, 2021).

# Chapter 5. Memory and Gift

**1** Jan Vansina, "Raffia Cloth in West Central Africa, 1500–1800," in Maureen Fennell Mazzaoui, ed., *Textiles: Production, Trade and Demand* (Brookfield, VT: Ashgate Publishing, 1998), 263–81. The quotation is from D. Pacheco Pereira, writing ca. 1505–7.

**2** On the Sri Lankan caskets, see Zoltán Biedermann, "Diplomatic Ivories: Sri Lankan Caskets and the Portuguese-Asian Exchange in the Sixteenth Century," in Zoltán Biedermann, Anne Gerritsen, and Giorgio Riello, eds., *Global Gifts: The Material Culture of Diplomacy in Early Modern Eurasia* (Cambridge: Cambridge University Press, 2018), 88–118.

**3** Alisa LaGamma, "Kongo: Power and Majesty," John Thorton, "The Kingdom of Kongo," and LaGamma, "Out of Kongo and into the Kunstkammer," in Alisa LaGamma, ed., *Kongo: Power and Majesty* (New York: Metropolitan Museum of Art, 2015), 24–30, 91–98, 131–59; and Christine Giuntini and Susan Brown, "Patterns without End: The Techniques and Designs of Kongo Textiles," The Met, https://www.metmuseum.org/exhibitions/listings/2015/kongo/blog/posts/patterns-without-end, accessed June 23, 2020.

**4** On the intersection of production and consumption, see Adrian Forty, *Objects of Desire: Design and Society from Wedgwood to IBM* (New York: Pantheon Books, 1986); and Ann Smart Martin, "Makers, Buyers, and Users: Consumerism as a Material Culture Framework," *Winterthur Portfolio* 28, nos. 2–3 (Summer–Autumn 1993): 141–57.

**5** Arjun Appadurai, "Introduction: Commodities and the Politics of Value," and Igor Kopytoff, "The Cultural Biography of Things: Commidization," in Arjun Appadurai, ed., *The Social Life of Things: Commodities in Cultural Perspective* (New York: Cambridge University Press, 1986), 3–91.

**6** For additional discussion of the ewer, see Reino Liefkes and Hilary Young, eds., *Masterpieces of World Ceramics in the Victoria and Albert Museum* (London: V&A Publishing, 2008), 68–69.

**7** On such objects as living entities, see Katherine Nova McCleary, Leah Tamar Shrestinian, and Joseph Zordan, *Place, Nations, Generations, Beings: 200 Years of Indigenous North American Art* (New Haven, CT: Yale University Art Gallery, 2019). A critical source on decolonization is Amy Lonetree, *Decolonizing Museums Representing Native America in National and Tribal Museums* (Chapel Hill: University of North Carolina Press, 2012).

**8** Typical classic works on "thing theory," which dematerialize objects and reject processes' contributions to meaning, include Martin Heidegger, "The Thing," in *Poetry, Language, Thought* (New York: Harper & Row, 1971), 163–86; and Bill Brown, ed., *Things* (Chicago: University of Chicago Press, 2004).

**9**   Here I draw on Michael de Certeau, *The Practice of Everyday Life* (Berkley: University of California Press, 2011); and Nicholas Thomas, *Entangled Objects: Exchange, Material Culture, and Colonialism in the Pacific* (Cambridge, MA: Harvard University Press, 1991).

**10**   Edmund de Waal, *The White Road: Journey into an Obsession* (New York: Farrar, Straus and Giroux, 2015), 19. The notion of a porcelain pilgrimage is also explicit in Robert Finlay's book *The Pilgrim Art: Cultures of Porcelain in World History* (Berkeley: University of California Press, 2010). I am grateful to Emily Cox for pointing out the material meanings of the term "pilgrimage."

**11**   Samuel Griswold Goodrich, *A Glance at Philosophy, Mental, Moral, and Social* (Boston: Pierce & Rand, 1848), 46. In her recent dissertation, Ruthie Dibble points out the importance of Goodrich. "Home Wars: Resistance, Trauma, and Memory in Domestic Arts of the Civil War Era" (PhD diss., Yale University, 2020).

**12**   See Alexander Bain, *The Senses and the Intellect* (London: J. W. Parker, 1855), 393–98, 544–50. For a more extended discussion of the philosophy of object education in the long nineteenth century, see Sarah Ann Carter, *Object Lessons: How Nineteenth-Century Americans Learned to Make Sense of the Material World* (New York: Oxford University Press, 2018).

**13**   Susan Stewart, *On Longing: Narratives on the Miniature, the Gigantic, the Souvenir, and the Collection* (Durham, NC: Duke University Press, 1993), esp. 132–69.

**14**   Dave Tabler, "The Memory Jug," Appalachian History.net (blog), May 3, 2018, https://www.appalachianhistory.net/2018/05/memory-jug.html, accessed May 11, 2020; and Claudia Mooney, April Hynes, and Mark Newell, "African-American Face Vessels: History and Ritual in 19th-Century Edgefield," in Robert Hunter, ed., *Ceramics in America 2013* (Milwaukee, WI: Chipstone Foundation, 2013), 2–37.

**15**   See, for example, Margot Finn and Kate Smith, eds., *The East India Company at Home, 1757–1857* (London: UCL Press, 2018). On the agency of Coromandel Coast artisans, see Sylvia Houghteling, "Politics, Poetry and the Figural Languages of South Asia Cloth, 1600–1730" (PhD diss., Yale University, 2015); and Edward Cooke, Jr., "The Material Culture of Furniture Production in the British Colonies," in Sarah Carter and Ivan Gaskell, eds., *Oxford Handbook of History and Material Culture* (New York: Oxford University Press, 2020), 451–73.

**16**   Karina Corrigan, Jan van Campen, and Femke Diercks, eds., *Asia in Amsterdam: The Culture of Luxury in the Golden Age* (Amsterdam: Rijksmuseum; Salem, MA: Peabody Essex Museum, 2015); Teresa Canepa, *Silk, Porcelain and Lacquer: China and Japan and Their Trade with Western Europe and the New World, 1500–1644* (London: Paul Holberton, 2016), 324–405; and Samuel Luterbacher, "Layovers: Japanese Export Lacquer's Transit and Reuse across Early Modern Iberian Empires" (PhD diss., Yale University, 2020).

**17**   Ruth Phillips, *Trading Identities: The Souvenir in Native American Art from the Northeast, 1700–1900* (Seattle: University of Washington Press, 1998); Marta Weigle and Barbara Babcock, eds., *The Great Southwest of the Fred Harvey Company and the Santa Fe Railway* (Phoenix, AZ: Heard Museum, 1996); Jonathan Batkin, *The Native American Curio Trade in New Mexico* (Santa Fe, NM: Wheelwright Museum of the American Indian, 2008); and Kathy M'Closkey, *Swept under the Rug: A Hidden History of Navajo Weaving* (Albuquerque: University of New Mexico Press, 2002).

**18**   William Hosley and Gerald Ward, eds., *The Great River: Art and Society of the Connecticut Valley, 1635–1820* (Hartford, CT: Wadsworth Atheneum, 1985); Thomas Denenberg, *Wallace Nutting and the Invention of Old America* (New Haven, CT: Yale University Press, 2003); and R. Ruthie Dibble, "The Hands That Rocked the Cradle: Interpretations in the Life of an Object," in Luke Beckerdite, ed., *American Furniture 2012* (Milwaukee, WI: Chipstone Foundation, 2012), 1–23.

**19**   Mildred Archer, Christopher Rowell, and Robert Skelton, eds., *Treasures from India: The Clive Collection of Powis Castle* (London: National Trust, 1987). Fascination with Tipu continues to the present, as the London auction house Bonham's sold arms and armor associated with the Mysore ruler for £6 million on April 21, 2015. *Islamic and Indian Art* (London: Bonham's, 2015), 85–91. The Clive Collection at Powis Castle in Wales is currently being studied as part of a project titled Legacies of Colonialism, overseen by a collaborative Open-Oxford-Cambridge Consortium.

**20**   On the Benin bronzes, see Barbara Plankensteiner, ed., *Benin: Kings and Rituals: Court Arts from Nigeria* (Vienna: Museum für Völkerkunde, 2007). Debora Silverman explores the complex issues of the Belgian Royal Museum for Central Africa in "Art Nouveau, Art of Darkness: African Lineages of Belgian Modernism, Part I," *West 86th: A Journal of Decorative Arts, Design History, and Material Culture* 18, no. 2 (Fall–Winter 2011): 139–81. An excellent report on the need for African repatriation is Felwine Sarr and Benedicte Savoy, *The Restitution of African Cultural Heritage: Toward*

*a New Relational Ethics* (Paris: Université Paris Nanterre, 2018).

**21**   Laurel Thatcher Ulrich, *The Age of Homespun: Objects and Stories in the Creation of an American Myth* (New York: Knopf, 2001); and Pika Ghosh, *Making Kantha, Making Home: Women at Work in Colonial Bengal* (Seattle: University of Washington Press, 2020).

**22**   Nicholas Saunders, *Trench Art: Materialities and Memories of War* (New York: Oxford, 2003); and Heather Smith, *Keepsakes of Conflict: Trench Art and Other Canadian War-Related Craft* (Moose Jaw, Canada: Moose Jaw Museum & Art Gallery, 2017). On the difference between stock work and custom work in the production of artillery shell vases, see the recollections of the wood turner Harry Nohr. John Lus, "Harry Nohr, the Man," in *Wisconsin Academy Review* 24, no. 1 (December 1977): 13. The Anglo-American work is different from that of Ottoman trench art, which tended to be the work of existing metal shops. Marcus Milwright and Evanthia Baboula, "Damascene 'Trench Art': A Note on the Manufacture of Mamluk Revival Metalwork in Early 20th-Century Syria," *Levant* 46, no. 3 (2014): 382–98.

**23**   On mazers, see Robin Wood, *The Wooden Bowl* (Ammanford, Wales: Stobart Davies, 2005), 99–110.

**24**   On ceramic repair, see Angelika Kuettner, "Simply Riveting: Broken and Mended Ceramics," in Robert Hunter, ed., *Ceramics in America 2016* (Milwaukee, WI: Chipstone Foundation, 2016), 122–40.

**25**   Chiara Lorenzetti, *Kintsugi: The Art of Repairing with Gold* (privately printed, 2018); and Kelly Richman Abdou, "Kintsugi: The Centuries-Old Art of Repairing Broken Pottery with Gold," My Modern Met, September 5, 2019, https://mymodernmet.com/kintsugi-kintsukuroi, accessed May 13, 2020.

**26**   Pamela Parmal, *Women's Work: Embroidery in Colonial Boston* (Boston: Museum of Fine Arts, Boston, 2012), 44–61. On refashioning textiles, see Linda Baumgarten, *What Clothes Reveal: The Language of Clothing in Colonial and Federal America* (Williamsburg, VA: Colonial Williamsburg Foundation, 2002), 182–207.

**27**   Marcel Mauss, *The Gift: The Form and Reason for Exchange in Archaic Societies* (1950; reprint ed., New York: W. W. Norton, 1990), but see also Anthony Cutler, "Significant Gifts: Patterns of Exchange in Late Antique, Byzantine, and Early Islamic Diplomacy," *Journal of Medieval and Early Modern Studies* 38, no. 1 (Winter 2008): 79–101.

**28**   A helpful introduction to diplomatic gifts is Biedermann, Gerritsen, and Riello, *Global Gifts*. See also a special issue of the *Journal of Early Modern History* 20, no. 1 (January 2016), as well as Cynthia Viallé, "'To Capture Their Favor': On Gift-Giving by the VOC," in Thomas DaCosta Kaufmann and Michael North, eds., *Mediating Netherlandish Art and Material Culture in Asia* (Amsterdam, Netherlands: Amsterdam University Press, 2014), 291–319.

**29**   Elena Phipps, "Garments and Identity in the Colonial Andes," in Elena Phipps et al., *The Colonial Andes: Tapestries and Silverwork, 1530–1830* (New York: Metropolitan Museum of Art, 2004), 16–39.

**30**   Gerlinde Klatte, "New Documentation for the 'Tenture des Indes' Tapestries in Malta," *Burlington Magazine* 153, no. 1300 (July 2011): 464–69; and Carrie Anderson, "Material Mediators: Johan Maurits, Textiles, and the Art of Diplomatic Exchange," *Journal of Early Modern History* 20, no. 1 (January 2016): 63–85.

**31**   See Barbara Karl, "Objects of Prestige and Spoils of War: Ottoman Objects in the Hapsburg Networks of Gift-Giving in the Sixteenth Century," in Biedermann, Gerritsen, and Riello, *Global Gifts*, 119–49; and Stewart Gordon, ed., *Robes of Honour: Khil'at in Pre-Colonial and Colonial India* (New Delhi: Oxford University Press, 2003).

**32**   Yumiko Kamada, "The Use of Imported Persian and Indian Textiles in Early Modern Japan," *Textile Society of America Symposium Proceedings* (2012): 1–11; and Thomas Allsen, *The Royal Hunt in Eurasian History* (Philadelphia: University of Pennsylvania Press, 2006).

**33**   Phipps, "Garments and Identity in the Colonial Andes," 27.

**34**   On Indian attitudes, see Saloni Mathur, *India by Design: Colonial History and Cultural Display* (Berkeley: University of California Press, 2007). On the presentation of Lankan caskets, see Zoltán Biedermann, "Diplomatic Ivories: Sri Lankan Caskets and the Portuguese-Asian Exchange in the Sixteenth Century," in Biedermann, Gerritsen, and Riello, *Global Gifts*, 88–118.

**35**   Luterbacher, "Layovers: Japanese Export Lacquer's Transit and Reuse across Early Modern Iberian Empires"; and Yayoi Kawamura, ed., *Lacas Namban: Huellas de Japón en España; IV centenario de la embajada Keichô* (Madrid: Museo Nacional de Artes Decorativas in association with the Japan Foundation, 2013) esp. 75–78, 154–55. On the gifting of silver and other objects to colonial American churches, see Barbara Ward, "'In a Feasting Posture': Communion Vessels and Community Values in Seventeenth- and Eighteenth-Century New England," *Winterthur Portfolio* 23, no. 1 (Spring 1988): 1–24; and Dell Upton, *Holy Things and Profane: Anglican Parish Churches in Colonial Virginia* (New Haven, CT: Yale University Press, 1986), 101–62.

**36** See Helen A. Cooper et al., *Life, Liberty, and the Pursuit of Happiness: American Art from the Yale University Art Gallery* (New Haven, CT: Yale University Art Gallery, 2008), 108–9; and Ronald Fuchs II, "A History of Chinese Export Porcelain in Ten Objects," in Robert Hunter, ed., *Ceramics in America 2014* (Milwaukee, WI: Chipstone Foundation, 2014), 53–55.

**37** The classic study of potlatch is Aldona Jonaitis, ed., *Chiefly Feasts: The Enduring Kwakiutl Potlatch* (Seattle: University of Washington Press, 1991). See also Aaron Glass, *Objects of Exchange: Social and Material Transformation on the Late Nineteenth-Century Northwest Coast* (New York: Bard Graduate Center for Decorative Art, Design History, Material Culture, 2011). The verb-oriented language of many Indigenous people was noted by Robbie Richardson in his "Sucker-Fish Writings: Indigenous Inscription and the History of the Written Language in the 18th Century," presented at "Viewing Topography across the Globe Workshop II: Indigenization," organized by the Lewis Walpole Library, May 13, 2021.

**38** Thomas, *Entangled Objects*. On the values of moveable things, see Ulrich, *The Age of Homespun*; John Plotz, *Portable Property: Victorian Culture on the Move* (Princeton, NJ: Princeton University Press, 2008); and Lily Higgins, "Reading into Things: Articulate Objects in Colonial North America, 1650–1815" (PhD diss., Yale University, forthcoming).

**39** Lorna Wetherill, *Consumer Behaviour and Material Culture in Britain 1660–1760* (New York: Routledge, 1996); and Barbara Ward, "Women's Property and Family Continuity in Eighteenth-Century Connecticut," in Peter Benes, ed., *Early American Probate Inventories, Annual Proceedings of the Dublin Seminar for New England Folklife* 12 (1989): 74–85.

**40** Elizabeth Perrill, *Zulu Pottery* (Western Cape, South Africa: Print Matters, 2012).

**41** Dave Davis, "Hereditary Emblems: Material Culture in the Context of Social Change," *Journal of Anthropological Archaeology* 4, no. 3 (September 1985): 149–76. On the copper alloy basin and candlestick, see Luitgard Mols, "Arabic Titles, Well-Wishes and a Female Saint: A Mamluk Basin in the Rijksmuseum, Amsterdam," in Venetia Portier and Mariam Rosser-Owen, eds., *Metalwork and Material Culture in the Islamic World: Art, Craft and Text* (London: I. B. Taurus, 2012), 201–13; and Ladan Akbarnia et al., *The Islamic World: A History in Objects* (London: British Museum, 2018), 128–29.

**42** The classic study of armorial porcelain is David Howard, *Chinese Armorial Porcelain* (London: Faber, 1974–2003).

**43** On the English practice of dating objects to commemorate transitional moments, see Edward Town, ed., *Marking Time: Objects, People, and Their Lives, 1500–1800* (New Haven, CT: Yale University Press, 2020). On the Hannah Barnard cupboard, see Ulrich, *The Age of Homespun*, 108–41; and on the Menéndez coverlet, see Amelia Peck, ed., *Interwoven Globe: The Worldwide Textile Trade, 1500–1800* (New York: Metropolitan Museum of Art, 2013), 168.

**44** Town, *Marking Time*; Romita Ray, "Elihu Yale at Yale," in *Yale University Art Gallery Bulletin 2012*: 52–65; Angela McShane, "Belonging and Belongings: Identity, Emotion and Memory Stored in a Tobacco Box," in Dagmar Freist, Sabine Kyora, and Melanie Unseld, eds., *Transkulturelle Mehrfachzugehörigkeit als kulturhistorisches Phänomen: Räume, Materialitäten, Erinnerungen* (Bielefeld, Germany: Transcript, 2019), 59–82; and Madeline Siefke Estill, "Colonial New England Silver Snuff, Tobacco, and Patch Boxes: Indices of Gentility," in Jeannine Falino and Gerald Ward, eds., *New England Silver and Silversmithing 1620–1815* (Boston: Colonial Society of Massachusetts, 2001), esp. 44–60.

**45** Appadurai, *The Social Life of Things*; and Fred Myers, ed., *The Empire of Things: Regimes of Value and Material Culture* (Santa Fe, NM: School of American Research Press, 2001).

**46** Alfred Gell, *Art and Agency: A New Anthropology* (Oxford: Oxford University Press, 1998).

**47** On relationality, see Aileen Moreton-Robinson, "Relationality: A Key Presupposition of an Indigenous Social Research Paradigm," in Chris Anderson and Jean O'Brien, eds., *Sources and Methods in Indigenous Studies* (New York: Routledge, 2017), 69–77; and Christine DeLucia, "Terrapolitics in the Dawnland: Relationality, Resistance, and Indigenous Futures in the Native and Colonial Northeast," *New England Quarterly* 92, no. 4 (December 2019): 548–83. On ancestor cloth, see C.H.M. Nooy-Palm, "The Sacred Cloths of the Toraja: Unanswered Questions," in Mattiebelle Gittinger, ed., *To Speak with Cloth: Studies in Indonesian Textiles* (Los Angeles: UCLA Museum of Cultural History, 1989), 162–80.

# Chapter 6. Appearance

**1** Tim Ingold, *Making: Anthropology, Archaeology, Art and Architecture* (New York: Routledge, 2013).

**2** Alfred Gell, "The Enchantment of Technology and the Technology of Enchantment," in Jeremy Coote and Anthony Shelton, eds., *Anthropology, Art, and Aesthetics* (Oxford: Oxford University Press, 1992), 40–63.

**3**   On surfaces, see Victoria Kelley, "A Superficial Guide to the Deeper Meaning of Surface," in Glenn Adamson and Victoria Kelley, eds., *Surface Tensions: Surface, Finish and the Meaning of Objects* (Manchester, UK: Manchester University Press, 2013), 13–25; and Rebecca Coleman and Liz Oakley-Brown, "Visualizing Surfaces, Surfacing Vision: Introduction," *Theory, Culture & Society* 34, nos. 7–8 (2017): esp. 15, 22. On modern design's fixation on cladding, see Anne Anlin Cheng, "Skin, Tattoos, and Susceptibility," *Representations* 108, no. 1 (Fall 2009): esp. 101–2.

**4**   The classic article on the formal analysis of an object remains Jules Prown, "Mind in Matter: An Introduction to Material Culture Theory and Method," *Winterthur Portfolio* 17, no. 1 (Spring 1982): 1–19.

**5**   A useful discussion of function, style, and mode can be found in Dell Upton, *Holy Things and Profane: Anglican Parish Churches in Colonial Virginia* (Cambridge, MA: MIT Press, 1986), esp. 101–3.

**6**   The seminal work on the importance of size is Susan Stewart, *On Longing: Narratives on the Miniature, the Gigantic, the Souvenir, and the Collection* (Durham, NC: Duke University Press, 1993).

**7**   On the design economics of size, see Michael Ettema, "Technological Innovation and Design Economics in Furniture Manufacture," *Winterthur Portfolio* 16, nos. 2–3 (Summer–Autumn 1981): 197–223.

**8**   Thomas Campbell, *Tapestry in the Renaissance: Art and Magnificence* (New Haven, CT: Yale University Press, 2002), esp. 3–11, 24–27; and Amelia Peck, ed., *Interwoven Globe: The Worldwide Textile Trade, 1500–1800* (New York: Metropolitan Museum of Art, 2013), 192.

**9**   A good survey about the long history of ornament and its meanings is Gülru Necipoğlu and Alina Payne, eds., *Histories of Ornament: From Global to Local* (Princeton, NJ: Princeton University Press, 2016).

**10**   On painted cottons, see Rosemary Crill, *Chintz: Indian Textiles for the West* (London: V&A Publishing, 2008); and Sarah Fee, ed., *Cloth That Changed the World: The Art and Fashion of Indian Chintz* (Toronto: Royal Ontario Museum, 2019). On painted furniture, see Andrea Bayer, ed., *Art and Love in Renaissance Italy* (New York: Metropolitan Museum of Art, 2008); Nancy Goyne Evans, "Documentary Evidence of Painted Seating Furniture: Late Colonial and Federal Periods," in Luke Beckerdite, ed., *American Furniture 2011* (Milwaukee, WI: Chipstone Foundation, 2011), 204–85; and Alexandra Kirtley and Peggy Olley, *Classical Splendor: Painted Furniture for a Grand Philadelphia House* (Philadelphia, PA: Philadelphia Museum of Art, 2017), esp. 67–87.

**11**   Jorge Welsh and Luísa Vinhais, eds., *China of All Colours: Painted Enamels on Copper* (London: Jorge Welsh Research & Publishing, 2015); and Vanessa Alayrac-Fielding, "'Luscious Colors and Glossy Paint': The Taste for China and the Consumption of Color in Eighteenth-Century England," in Andrea Feeser, Maureen Daly Goggin, and Beth Fowkes Tobin, eds., *The Materiality of Color: The Production, Circulation, and Application of Dyes and Pigments, 1400–1800* (Farnham, UK: Ashgate, 2012), 81–97.

**12**   On dyeing cloth, see Mattiebelle Gittinger, *Master Dyers to the World: Technique and Trade in Early Indian Dyed Cotton Textiles* (Washington, DC: Textile Museum, 1982). On bidriware, see Oppi Untracht, *Metal Techniques for Craftsmen: A Basic Manual on the Methods of Forming and Decorating Metals* (London: Robert Hale, 1969), 138–49. Zimmermann's patination is discussed in Deborah Waters, *The Jewelry and Metalwork of Marie Zimmermann* (New Haven, CT: Yale University Press, 2011).

**13**   Beatrix von Rague, "The Makie Tradition," in William Watson, ed., *Lacquerwork in Asia and Beyond* (London: Percival David Foundation, 1981), 85–104; Denise Patry Leidy, *Mother-of-Pearl: A Tradition in Asian Lacquer* (New York: Metropolitan Museum of Art, 2006); and Mitchell Codding, "The Lacquer Arts of Latin America," in Dennis Carr, ed., *Made in the Americas: The New World Discovers Asia* (Boston: Museum of Fine Arts, Boston, 2015), 74–89.

**14**   Jack Lindsey, "The Cadwalader Town House and Its Furnishings," *Philadelphia Museum of Art Bulletin* 91, nos. 384–85 (Fall 1996): 10–23.

**15**   Curtis Evarts, "The Artistry of Chinese Furniture Joinery: A Manifold Expression," *Orientations* 24, no. 1 (January 1993): 53–57.

**16**   Jennifer Chuong, "The Nature of American Veneer Furniture, circa 1790–1810," *Journal18* 9 (Spring 2020): https://www.journal18.org/4733, accessed February 7, 2021.

**17**   On silver plate, see Charles Venable, *Silver in America: A Century of Splendor* (New York: Abrams, 1994), esp. 20–21; and Stephen Helliwell, *Understanding Antique Silver Plate* (Woodbridge, UK: Antique Collectors' Club, 1996).

**18**   Edwin Churchill, *Simple Forms and Vivid Colors* (Augusta, ME: Maine State Museum, 1983).

**19**   Alice Cooney Frelinghuysen and Nicholas Vincent, "Artistic Furniture of the Gilded Age," *Metropolitan Museum of Art Bulletin* 73, no. 3 (Winter 2016): 5–48.

**20**   Florence Montgomery, *Textiles in America, 1650–1870* (New York: Norton, 1984); and Natalie Rothstein, "The 18th-Century English Silk

Industry," in Regula Schorta, ed., *18th-Century Silks: The Industries of England and Northern Europe* (Riggisberg, Switzerland: Abegg-Stiftung, 2000), 9–23.

**21** See Ulla Houkjaer, *Tin-Glazed Earthenware 1300–1750: Spain—Italy—France* (Copenhagen: Danish Museum of Art and Design, 2005); and Houkjaer, *Tin-Glazed Earthenware from the Netherlands, France and Germany 1600–1800* (Copenhagen: Designmuseum Danmark, 2016).

**22** Alice Rawsthorn, Gaye Blake Roberts, and Mariusz Skronski, *Wedgwood: A Story of Creation and Innovation* (New York: Rizzoli, 2017); Neil McKendrick, "Josiah Wedgwood and the Commercialization of the Potteries," in Neil McKendrick, John Brewer, and J. H. Plumb, eds., *The Birth of a Consumer Society: The Commercialization of Eighteenth-Century England* (Bloomington: Indiana University Press, 1982), 99–145; and David Barker, " 'The Usual Classes of Useful Articles': Staffordshire Ceramics Reconsidered," in Robert Hunter, ed., *Ceramics in America 2001* (Milwaukee, WI: Chipstone Foundation, 2001), 72–93.

**23** John Stalker and George Parker, *A Treatise of Japaning and Varnishing* (Oxford: Printed for and sold by the authors, 1688); Tara Cederholm and Christine Thomson, " 'Tortoiseshell and Gold': Robert Davis and the Art of Japanning in Eighteenth-Century Boston," in Brock Jobe and Gerald Ward, eds., *Boston Furniture, 1700–1900* (Boston: Colonial Society of Massachusetts, 2017), 48–77; Annemarie Klootwijk, "Curious Japanese Black: Shaping the Identity of Dutch Imitation Lacquer," *Netherlands Yearbook for History of Art 66: Netherlands Art in Its Global Context* (2016): 253–71; Monika Kopplin, "*Gelact ende verguld*: New Discoveries from Willem Kick's Workshop in Amsterdam," *Studies in Conservation* 64 (2019): S1, S4–13; Adam Bowett, *English Furniture, 1660–1714: From Charles II to Queen Anne* (Woodbridge, UK: Antique Collectors' Club, 2002), 144–69; and Monika Kopplin, *European Lacquer: Selected Works from the Museum für Lackkunst, Münster* (Munich: Hirmer Verlag, 2010), 39–153, 187–247.

**24** Jonathan Hay, *Sensuous Surfaces: The Decorative Object in Early Modern China* (Honolulu: University of Hawai'i Press, 2010). See also Christine Guth, "Layering, Materiality, Time and Touch in Japanese Lacquer," in Adamson and Kelley, *Surface Tensions*, 34–44.

**25** Bruce Hoadley, *Understanding Wood: A Craftsman's Guide to Wood Technology* (Newtown, CT: Taunton Press, 1980), 181–97.

**26** Hin-cheung Lovell, "Song and Yüan Monochrome Lacquers in the Freer Gallery of Art," *Ars Orientalis* 9 (1973): 121–30.

**27** On glazes, see W. David Kingery and Pamela Vandiver, *Ceramic Masterpieces: Art, Structure, Technology* (New York: Free Press, 1986), 7–45.

**28** Fee, *Cloth That Changed the World*; and Florence Montgomery, *Printed Textiles* (New York: Viking Press, 1970).

**29** Adrienne Hood, *The Weaver's Craft: Cloth, Commerce, and Industry in Early Pennsylvania* (Philadelphia: University of Pennsylvania Press, 2003), 17, 107–10.

**30** On planishing, see Untracht, *Metal Techniques for Craftsmen*, 249.

**31** Grant McCracken, *Culture and Consumption: New Approaches to the Symbolic Character of Consumer Goods and Activities* (Bloomington: Indiana University Press, 1988), 31–43. Jun'ichirō is quoted in Guth, "Layering, Materiality, Time and Touch in Japanese Lacquer," 38.

**32** The work of Edward Said has framed exoticism as a product of colonialism, predominantly from a European perspective: *Orientalism* (New York: Pantheon, 1978). For a more recent sense of the multidirectional aspects of exoticism, see Anna Grasskamp and Monica Juneja, eds., *Eurasia Matters: China, Europe, and the Transcultural Object, 1600–1800* (Cham, Switzerland: Springer, 2018); and "*The Exotic Is Never at Home?" The Presence of China in the Portuguese Faience and Azulejo (17th–18th Centuries)* (Lisbon: Museu Nacional do Azulejo, 2013).

**33** Thomas Cummins, *Toasts with the Inca: Andean Abstraction and Colonial Images on Quero Vessels* (Ann Arbor: University of Michigan Press, 2002), 1–58; and Diane Fane, ed., *Converging Cultures: Art and Identity in Spanish America* (New York: Brooklyn Museum, 1996), 199–205.

**34** On the multiple meanings of Nanban lacquer, see Samuel Luterbacher, "Surfaces for Reflection: Nanban Lacquer in the Iberian World," *Journal of Early Modern History* 23, nos. 2–3 (May 2019): 152–90; and Luterbacher, "Layovers: Japanese Export Lacquer's Transit and Reuse across Early Modern Iberian Empires" (PhD diss., Yale University, 2020).

**35** Jennifer Chuong, " 'A Gloss Equal to Glass': The Material Brilliance of Early American Furniture," in Christopher Maxwell, ed., *In Sparkling Company: Reflections on Glass in the 18th Century British World* (Corning, NY: Corning Museum of Glass, 2020), 255–75; Maxine Berg, "From Imitation to Invention: Creating Commodities in Eighteenth-Century Britain," *Economic History Review* 55, no. 1 (February 2002): 1–30; Glenn Adamson, "The American Arcanum," in Robert Hunter, ed., *Ceramics in America 2007* (Milwaukee, WI: Chipstone Foundation, 2007), 94–119; and Michael Yonan,

"Veneers of Authority: Chinese Lacquers in Maria Theresa's Vienna," *Eighteenth-Century Studies* 37, no. 4 (Summer 2004): 653–72.

**36**  Antje Papist-Matsuo, "Enduring Beauty: On the Art of Negoro Lacquer," *Orientations* 40, no. 7 (2009): 1–6; Papist-Matsuo, "Iconography of Absence: Negoro Lacquers and the Sacred Geography of Their Origin," *Ritsumeiken Studies in Language and Culture* 28, no. 4 (2017): 33–49; Samuel Luterbacher, "Layovers: Japanese Export Lacquer's Transit and Re-use across Early Modern Iberian Empires," chap. 2; Christopher Maxwell, "People in Glass Houses: The Polished and the Polite in Georgian Britain," and Jennifer Chuong, "'A Gloss Equal to Glass,'" in Maxwell, *In Sparkling Company*, 39–66, 255–75; and Edmund Burke, *A Philosophical Enquiry into the Origin of Our Ideas of the Sublime and Beautiful* (London: R. and J. Dodsley, 1757), 98–99, 151–52.

**37**  On the pursuit of porcelain in Europe, see Edmund de Waal, *The White Road: A Pilgrimage of Sorts* (London: Chatto & Windus, 2015), esp. 166–202.

**38**  Charles Plumier, *The Art of Turning* (1701; Paris: C. A. Jombert, 1749); Klaus Maurice, *Der drechselnde Souverän: Materialien zu einer fürstlichen Maschinenkunst* (Zurich: Ineichen, 1985); Noam Andrews, "The Ivory Turn: Of Solids, Curves, and Nests," in Wolfram Koeppe, ed., *Making Marvels: Science and Splendor at the Courts of Europe* (New York: Metropolitan Museum of Art, 2019), 121–28; Ching-fei Shih, "Unknown Transcultural Objects: Turned Ivory Works by the European Rose-Engine Lathe in the Eighteenth-Century Qing Court," in Grasskamp and Juneja, *Eurasian Matters*, 57–76; Ching-fei Shih, "A Hundred-Layered Goblet from the Western Ocean," *Orientations* 46, no. 4 (May 2015): 60–65; and Joyce Yusi Zhou, "European Turned Ivories at the Chinese Imperial Court (1600–1800): A Study in Early Modern Cross-Cultural Knowledge Exchange" (MA thesis, Bard Graduate Center, 2019), esp. 7–16.

**39**  George Kubler, "Time's Perfection and Colonial Art," in E. McClung Fleming, ed., *Spanish, French, and English Traditions in the Colonial Silver of North America* (Winterthur, DE: Henry Francis du Pont Winterthur Museum, 1968), 7–12.

**40**  On British veneering, see Adam Bowett, *English Furniture, 1660–1714: From Charles II to Queen Anne* (Woodbridge, UK: Antique Collectors' Club, 2002), 36–62, 196–226.

**41**  Robert Hooke, *Micrographia, or Some Physiological Descriptions of Minute Bodies Made by Magnifying Glasses, with Observations and Inquiries Thereupon* (London: J. Martyn and J. Allestry, 1665). On the connections between art

and ways of knowing, see Ethan Lasser, "Figures in the Grain: The Enlightenment of Anglo-American Furniture, 1660–1800" (PhD diss., Yale University, 2007), 76–78; Meghan Doherty, "Discovering 'True Form': Hooke's 'Micrographia' and the Visual Vocabulary of Engraved Portraits," *Notes and Records of the Royal Society of London* 66, no. 3 (September 20, 2012): 211–34; and Matthew Hunter, *Wicked Intelligence: Visual Art and the Science of Experiment in Restoration London* (Chicago: University of Chicago Press, 2013).

**42**  Cynthia Kok, "The Plastic Shell: Mother-of-Pearl in an Early Modern Dutch World" (PhD diss., Yale University, forthcoming).

**43**  The historiography of decorative arts is covered in Isabelle Frank, *The Theory of Decorative Art: An Anthology of European and American Writings, 1750–1940* (New Haven, CT: Yale University Press, 2000). On the denial of surface in good design, see Edgar Kaufmann, Jr., *What Is Modern Design?* (New York: Museum of Modern Art, 1950).

**44**  Thomas Friedman, *The World is Flat: A Brief History of the Twenty-First Century* (New York: Farrar, Straus and Giroux, 2005).

**45**  Jeffrey Meikle, *American Plastic: A Cultural History* (New Brunswick, NJ: Rutgers University Press, 1995); Roland Barthes, "Plastics," in *Mythologies* (New York: Macmillan, 1972), 97–99; Alison Clarke, *Tupperware: The Promise of Plastic in 1950s America* (Washington, DC: Smithsonian Books, 2001); Mariana Gosnell, "Everybody Take a Seat," *Smithsonian Magazine* 34 (July 2004): 74–78; John Stuart Gordon, *A Modern World: American Design from the Yale University Art Gallery, 1920–1950* (New Haven, CT: Yale University Art Gallery, 2011); Christopher Wilk, *Plywood* (London: Thames & Hudson, 2017); Tony Fry and Anne-Marie Willis, *Steel: A Design, Cultural, and Ecological History* (London: Bloomsbury, 2015); and Mimi Sheller, *Aluminum Dreams: The Making of Light Modernity* (Cambridge, MA: MIT Press, 2014).

**46**  Gilpin quoted in Edward Cooke, Jr., "The Study of American Furniture from the Perspective of the Maker," in Gerald Ward, ed., *Perspectives on the Study of American Furniture* (New York: W. W. Norton, 1988), 125–26.

# Chapter 7. Touch

**1**  Edmund de Waal, *The Hare with Amber Eyes: A Hidden Inheritance* (New York: Picador, 2010), 10–13.

**2**  On the ewer in Mughal culture, see Mark Zebrowski, *Gold, Silver and Bronze from Mughal India* (London: Alexandria Press, 1997), 135–67.

**3** Georg Simmel, "The Handle," reprint of 1911 essay, *Hudson Review* 11, no. 3 (Autumn 1958): 371–78.

**4** Frank Wilson, *The Hand: How Its Use Shapes the Brain, Language, and Human Culture* (New York: Pantheon Books, 1998); and Tim Ingold, *Making: Anthropology, Archaeology, Art and Architecture* (New York: Routledge, 2013), 109–24.

**5** Margaret Graves, *Arts of Illusion: Object, Ornament, and Architecture in Medieval Islam* (New York: Oxford University Press, 2018), 26–28. On the role of touch in making, consumption, and circulation, see Constance Classen and David Howes, "The Museum as Sensescape: Western Sensibilities and Indigenous Artifacts," in Elizabeth Edwards, Chris Gosden, and Ruth Phillips, eds., *Sensible Objects: Colonialism, Museums, and Material Culture* (Oxford: Berg, 2006), 200.

**6** On facture, see Joseph Koerner, "Facture," *Res: Anthropology and Aesthetics* 36 (Autumn 1999): 5–19; and Rebecca Zurier, "Facture," *American Art* 23, no. 1 (Spring 2009): 29–31. On the visual emphasis of classification, see Milette Gaifman, *Classification and the History of Greek Art and Architecture* (Chicago: University of Chicago Press, forthcoming).

**7** On the inadequacies of language in regard to workmanship, see Richard Sennett, *The Craftsman* (New Haven, CT: Yale University Press, 2008), esp. 95–96.

**8** For example, see Saloni Mathur, *India by Design: Colonial History and Cultural Display* (Berkeley: University of California Press, 2007); Giles Tillotson, "The Jaipur Exhibition of 1883," *Journal of the Royal Asiatic Society* series 3, vol. 14, no. 2 (2004): 111–26; and Edward Cooke, Jr., "Village Crafts, Rural Industry: The Politics of Modern Globalized Craft," in Janice Helland, Beverly Lemire, and Alena Buis, eds., *Craft, Community and the Material Culture of Place and Politics, 19th–20th Century* (London: Ashgate, 2014), 11–36.

**9** Hui-chun Ya, "The Intersection of Past and Present: The Qianlong Emperor and His Ancient Bronzes" (PhD diss., Princeton University, 2007), 31–48. I am grateful to Kee Il Choi for bringing this to my attention. Craig Clunas analyzes Wen Zhenheng's 1620s work *Zhang Wu Zhi* [Treatise on superfluous things] in *Superfluous Things: Material Culture and Social Status in Early Modern China* (1991; Honolulu: University of Hawai'i Press, 2004), esp. 40–74.

**10** Jonathan Richardson, *The Works of Jonathan Richardson* (London: T. and J. Egerton, 1792). For the application of Richardson's ideas to material culture, see Charles F. Montgomery, "Some Remarks on the Science and Principles of Connoisseurship," *Walpole Society Notebook 1961* (Cambridge, MA: 1962), 3–20, later reprinted in Montgomery, *A History of American Pewter* (New York: Praeger, 1973), 42–57.

**11** On the specific valuations of Mughal leaders, see Sylvia Houghteling, "The Emperor's Humbler Clothes: Textures of Courtly Dress in Seventeenth-Century South Asia," *Ars Orientalis* 47 (2017): 91–116. The South Asian courts' interest in assembling distinctive types of textiles from various parts of South Asia is also discussed by C. A. Bayly, "The Origins of Swadeshi (Home Industry): Cloth and Indian Society, 1700–1930," in Arjun Appadurai, ed., *The Social Life of Things: Commodities in Cultural Perspective* (New York: Cambridge University Press, 1986), 285–321.

**12** Christopher Roy, ed., *Clay and Fire: Pottery in Africa* (Iowa City: University of Iowa, 2000); Elizabeth Perrill, *Zulu Pottery* (Western Cape, South Africa: Print Matters, 2012); and Perrill, "Burnishing History: The Legacies of Maria Martinez and Nesta Nala in Dialogue; Parts 1 and 2," *Journal of Modern Craft* 8, no. 3 (November 2015): 263–300; Stephen Trimble, *Talking with the Clay: The Art of Pueblo Pottery* (Santa Fe, NM: School of American Research Press, 1987); and Moira Vincentelli, *Women and Ceramics: Gendered Vessels* (Manchester, UK: Manchester University Press, 2000), esp. 33–57.

**13** David Gaimster, *German Stoneware 1200–1900: Archaeology and Cultural History* (London: British Museum Press, 1997); and Janine Skerry and Suzanne Findlen Hood, *Salt-Glazed Stoneware in Early America* (Williamsburg, VA: Colonial Williamsburg Foundation, 2009).

**14** On the Japanese tea ceremony, see Paul Varley and Kumakura Isao, eds., *Tea in Japan: Essays in the History of Chanoyu* (Honolulu: University of Hawai'i Press, 1989); Morgan Pitelka, *Handmade Culture: Raku Potters, Patrons, and Tea Practitioners in Japan* (Honolulu: University of Hawai'i Press, 2005); and Dora Ching, Louise Allison Cort, and Andrew Watsky, eds., *Around Chigusa: Tea and the Arts of Sixteenth-Century Japan* (Princeton, NJ: Department of Art and Archaeology, 2017), esp. 23–50.

**15** Rodris Roth, *Tea-Drinking in Eighteenth-Century America: Its Etiquette and Equipage* (Washington, DC: Smithsonian Institution, 1961); and Peter Brown, *In Praise of Hot Liquors: The Study of Chocolate, Coffee and Tea-Drinking 1600–1850* (York, UK: York Civic Trust, 1995).

**16** On dining in Japan, see Naomichi Ishige, *The History and Culture of Japanese Food* (London: Kegan Paul, 2001); Eric Rath, *Food and Fantasy in Early Modern Japan* (Berkeley: University of California Press, 2010), esp. chap. 3; and Rath, "Sex and Sea Bream: Food and Prostitution

in Hishikama Moronobu's (d. 1694) *Visit to Yoshiwara*," in Laura Allen, ed., *Seduction: Japan's Floating World* (San Francisco: Asia Art Museum, 2017), 29–43.

**17**   Rath, "Sex and Sea Bream," 31; Sarah Coffin, "Historical Overview," in *Feeding Desire: Design and the Tools of the Table* (New York: Assouline Publishing, 2006), 16–75; and Barbara Carson, *Ambitious Appetites* (Washington, DC: AIA Press, 1990).

**18**   On the power of the armchair, see Galen Cranz, *The Chair: Rethinking Culture, Body, and Design* (New York: Norton, 2000), esp. 31–64.

**19**   Sylvia Houghteling, "Politics, Poetry and the Figural Language of South Asian Cloth, 1600–1730" (PhD diss., Yale University, 2015), 14–17; and Liza Oliver, *Art, Trade, and Imperialism in Early Modern French India* (Amsterdam: Amsterdam University Press, 2019). On the emergence of cotton as the global textile, see Giorgio Riello, "The Globalization of Cotton Textiles: Indian Cottons, Europe, and the Atlantic World, 1600–1850," in Giorgio Riello and Prasannan Parthasarathi, eds., *The Spinning World: A Global History of Cotton Textiles, 1300–1850* (Oxford: Oxford University Press, 2009), 261–88; and Jonathan Eacott, "Making an Imperial Compromise: The Calico Acts, the Atlantic Colonies, and the Structure of the British Empire," *William and Mary Quarterly* 69, no. 4 (October 2012): 731–62. Prized most for its physical properties—weight and flexibility, fluidity in hanging, softness to the touch, ability to maintain color, washability, and relative cost—rather than for its exotic origin, cotton replaced or imitated lightweight silks and fine linens.

**20**   Elena Phipps, "Cumbi to Tapestry: Collection, Innovation, and Transformation of the Colonial Andean Tapestry Tradition," in Elena Phipps, Johanna Hecht, and Cristina Esteras Martin, eds., *The Colonial Americas: Tapestries and Silverwork, 1530–1830* (New York: Metropolitan Museum of Art, 2004), 72–99, 213–16; Phipps, "The Iberian Globe: Textile Traditions and Trade in Latin America," in Amelia Peck, ed., *Interwoven Globe: The Worldwide Textile Trade, 1500–1800* (New York: Metropolitan Museum of Art, 2013), 28–45.

**21**   Eiluned Edwards, *Textiles and Dress of Gujarat* (London: V&A Publishing, 2011).

**22**   Edmund Burke, *A Philosophical Enquiry into the Origin of Our Ideas of the Sublime and Beautiful* (London: R. and J. Dodsley, 1757), 98–99, 151–52. The historian Richard Bushman uses Burke to contrast the qualities of rough and smooth strictly along class lines in his *The Refinement of America: Persons, Houses, Cities* (New York: Vintage, 1993), esp. 71–73.

**23**   Pedro Cancela de Abreu, "The Construction Techniques of Namban Objects," and Miho Kitagawa, "Materials, Tools and Techniques Used on Namban Lacquerwork," in Jorge Welsh and Luísa Vinhais, eds., *After the Barbarians II: Namban Works of Art for the Japanese, Portuguese and Dutch Markets* (London: Jorge Welsh, 2008), 52–88.

**24**   A study that emphasizes the aesthetics of exoticism is Teresa Canepa, *Silk, Porcelain and Lacquer: China and Japan and Their Trade with Western Europe and the New World, 1500–1644* (London: Paul Holberton, 2016).

**25**   Pika Ghosh et al., *Cooking for the Gods: The Art of Home Ritual in Bengal* (Newark, NJ: Newark Museum, 1995).

**26**   Jan Veenendaal, *Furniture from Indonesia, Sri Lanka and India during the Dutch Period* (Delft, Netherlands: Volkenkundig Museum Nusantara, 1985); Amin Jaffer, *Furniture from British India and Ceylon: A Catalogue of the Collections in the Victoria and Albert Museum and the Peabody Essex Museum* (Salem, MA: Peabody Essex Museum in association with V&A Publications, 2001); and Shweta Raghu, "Coastal Vision and the Negotiated Arts of the Coromandel, 1610–1798" (PhD diss., Yale University, forthcoming), chap. 2.

**27**   Tian Jiaqing, *Destiny with Zitan: Yue Hua Xuan's Collection of Fine Qing Furniture and Items* (Beijing: Cultural Relics Press, 2007).

**28**   Denise Patry Leidy, "Cinnabar: The Chinese Art of Carved Lacquer," *Arts of Asia* (November–December 2015): 76–87; and Michelle Erickson and Robert Hunter, "Dots, Dashes, and Squiggles: Early English Slipware Technology," in Robert Hunter, ed., *Ceramics in America 2001* (Milwaukee, WI: Chipstone Foundation, 2001), 95–114.

**29**   Sumpter Priddy argues that fancy, the stimulation of one's imagination, was primarily a two-dimensional graphic form, but we need to expand beyond flat surfaces to engage with three-dimensional form. Priddy, *American Fancy: Exuberance in the Arts, 1790–1840* (Milwaukee, WI: Chipstone Foundation, 2004).

**30**   Rosalind Krauss, "Sculpture in the Expanded Field," *October* 8 (Spring 1979): 30–44.

**31**   A suggestive volume is Martina Droth and Penelope Curtis, eds., *Taking Shape: Finding Sculpture in the Decorative Arts* (Leeds, UK: Henry Moore Institute; Los Angeles: Getty Publications, 2009). See also Graves, *Arts of Illusion*, esp. 215–16.

**32**   See Edward Town and Glenn Adamson, eds., *Marking Time: Objects and Temporality in Britain, 1600–1800* (New Haven, CT: Yale University Press, 2020).

**33**   Laurel Thatcher Ulrich, *The Age of*

*Homespun: Objects and Stories in the Creation of an American Myth* (New York: Knopf, 2001); and Pika Ghosh, *Making Kantha, Making Home: Women at Work in Colonial Bengal* (Seattle: University of Washington Press, 2020).

**34**  Ruskin wrote about the importance of "savageness," while Yanagi defined *mingei* as the modern successor to the *wabi-sabi* philosophy of the tea ceremony. *Mingei* specified that functional objects be made by anonymous craftspeople using traditional hand techniques for a local market. John Ruskin, "The Nature of Gothic," in *The Stones of Venice* (1851–53; reprint ed., London: Smith Elder and Co., 1874), 2:151–231; and Yanagi Muneyosh, *Folk-Crafts in Japan* (Tokyo: Kokusai Bunka Shinkokai, 1936).

**35**  On the class implications of patina, see Pierre Bourdieu, *Distinction: A Social Critique of the Judgement of Taste* (Cambridge, MA: Harvard University Press, 1984), 76–77; and Grant McCracken, *Culture and Consumption: New Approaches to the Symbolic Character of Consumer Goods and Activities* (Bloomington: University of Indiana Press, 1988), 32. The value of human work rather than precise work is expressed by William Morris in "The Lesser Arts of Life," in *Lectures on Art, Delivered in Support of the Society for the Protection of Ancient Buildings* (London: Macmillan & Co., 1882). On free workmanship, see David Pye, *The Nature and Art of Workmanship* (New York: Cambridge University Press, 1968).

**36**  Doreen Bolger Burke et al., *In Pursuit of Beauty: Americans and the Aesthetic Movement* (New York: Rizzoli, 1986); and William Hosley, Jr., *The Japan Idea: Art and Life in Victorian America* (Hartford, CT: Wadsworth Atheneum, 1990).

**37**  A classic example of historical archaeology working with fragments is James Deetz, *In Small Things Forgotten* (Garden City, NY: Anchor Press, 1977).

**38**  Adam Gopnik, "Feel Me: What the New Science of Touch Says about Ourselves," *New Yorker* 92, no. 14 (May 16, 2016): 56.

**39**  Susan Stewart, "Prologue: From the Museum of Touch," in Marius Kwint, Christopher Breward, and Jeremy Ainsley, eds., *Material Memories: Design and Evocation* (Oxford: Berg, 1999), 28; and Classen and Howes, "The Museum as Sensescape," 199–222.

**40**  For a helpful discussion on the visual biases of the field, see Fiona Candlin, *Art, Museums and Touch* (Manchester, UK: Manchester University Press, 2010), 9–27.

**41**  An excellent introduction to the work of the picture frame and the meaning of framing is Verity Platt and Michael Squire, "Framing the Visual in Greek and Roman Antiquity: An Introduction," in Verity Platt and Michael Squire, eds., *The Frame in Classical Art: A Cultural History* (Cambridge: Cambridge University Press, 2017), 3–99. Samuel Luterbacher kindly drew my attention to this essay. On the hierarchy of senses, see Michael Foucault, *The Order of Things: An Archaeology of the Human Senses* (London: Tavistock, 1970); Paul Stoller, *The Taste of Ethnographic Things: The Senses in Anthropology* (Philadelphia: University of Pennsylvania Pres, 1989); Constance Classen, *Worlds of Sense: Exploring the Senses in History and across Cultures* (London: Routledge, 1998); and Classen, *The Deepest Sense: A Cultural History of Touch* (Urbana: University of Illinois Press, 2012).

**42**  Elizabeth Edwards, Chris Gosden, and Ruth Phillips, "Introduction," in Edwards, Gosden, and Phillips, *Sensible Objects*, 14–23.

**43**  B. W. Higman, *Flatness* (London: Reaktion Books, 2017), esp. 7–17, 156–74, and Pye, *The Nature and Art of Workmanship*.

**44**  Zeynep Çelik Alexander, *Kinaesthetic Knowing: Aesthetics, Epistemology, Modern Design* (Chicago: University of Chicago Press, 2017); and Sarah Carter, *Object Lessons: How Nineteenth-Century Americans Learned to Make Sense of the Material World* (New York: Oxford University Press, 2018).

**45**  On our current lack of material intelligence, see Glenn Adamson, *Fewer, Better Things: The Hidden Wisdom of Objects* (New York: Bloomsbury Publishing, 2018).

# Conclusion

**1**  For more on the historiography of American decorative arts scholarship, see Edward S. Cooke, Jr., "American Decorative Arts and the Academy," *Walpole Society Notebook 2013*, 81–99.

**2**  Henri Lefebvre, *The Production of Space* (1974; English translation, Oxford: Basil Blackwell, 1991).

**3**  In his *Zur Farbenlehre* (1810), Johann Wolfgang von Goethe uses the term *sanfte Empirie*, which can be translated as "gentle empiricism," in which one undertakes "an open-minded and unprejudiced description and explanation of phenomena." For Goethe's humanities approach, see Carl Graumann, "The Phenomenological Approach to People-Environment Studies," in Robert Bechtel, ed., *Handbook of Environmental Psychology* (New York: J. Wiley, 2002), 96. I am indebted to Henrike Lange for bringing the idea of soft empiricism to my attention.

**4**  For another example of a painted cotton depicting European military engagements on the Coromandel Coast, likely commissioned by the East India Company, see Amelia Peck, ed.,

Interwoven Globe: The Worldwide Textile Trade, 1500–1800 (New York: Metropolitan Museum of Art, 2013), 277–79. David Porter explores the keen interest in the exotic materials and images of Asia as part of a polite fashion system in "Monstrous Beauty: Eighteenth-Century Fashion and the Aesthetics of the Chinese Taste," *Eighteenth-Century Studies* 35, no. 3 (2002): 395–411.

**5** On the British preference for clothes presses with sliding trays, see Susan Stuart, *Gillows of Lancaster and London, 1730–1840* (Woodbridge: UK: Antique Collectors' Club, 2008), 2:46–65; and Ronald Hurst and Jonathan Prown, *Southern Furniture 1680–1830* (Williamsburg, VA: Colonial Williamsburg, 1997), 389–409. The lacquering imagery resembles examples in Carol Crossman, *The Decorative Arts of the China Trade* (Woodbridge, UK: Antique Collectors' Club, 1991), 246, 264–75.

**6** On the differences between Chinese and Kolkata glass, see Jaya Appasamy, *Indian Paintings on Glass* (New Delhi: Indian Council for Cultural Relations, 1980); Phyllis Granoff, "Reverse Glass Paintings from Gujarat in a Private Canadian Collection: Documents of British India," *Artibus Asiae* 40, nos. 2–3 (1978): 204–14; and Thierry Audric, *Chinese Reverse Glass Painting 1720–1820* (Bern, Switzerland: Peter Lang, 2020), 153–55.

**7** The quotation reproduces the words of Thomas Davies, the owner of Palmetto Fire Brick Works in Edgefield, as published in Edwin Atlee Barber, *The Pottery and Porcelain of the United States and Marks of American Potters* (New York: Feingold & Lewis, 1909), 466.

**8** The most thorough source on the Edgefield face jug tradition is Claudia Mooney, April Hynes, and Mark Newell, "African-American Face Vessels: History and Ritual in 19th-Century Edgefield," in Robert Hunter, ed., *Ceramics in America 2013* (Milwaukee, WI: Chipstone Foundation, 2013), 2–37.

**9** For example, see Elena Phipps et al., *The Colonial Andes: Tapestries and Silverwork, 1530–1830* (New York: Metropolitan Museum of Art, 2004).

**10** Heather Lechtman, "The Materials Science of Material Culture: Examples from the Andean Past," in David Scott and Pieter Meyers, eds., *Archaeology of Pre-Columbian Sites and Artifacts* (Los Angeles: Getty Conservation Institute, 1994), 3–12; Izumi Shimada and John Merkel, "Copper-Alloy Metallurgy in Ancient Peru," *Scientific American* 265, no. 1 (July 1991): 80–86; Marcos Martinon-Torres, "Depletion Gilding, Innovation, and Life Histories: The Changing Colours of Nahuange Metalwork," *Antiquity* 91, no. 359 (October 2017): 1253–67; and José Berenguer, ed.,

*El arte del cobre en el mundo andino* (Santiago, Chile: Museo Chileno de Arte Précolombino, 2004). Andrew Hamilton kindly brought the tumbaga literature to my attention.

**11** Bruno Strasser emphasizes the importance of a similar link between natural history and scientific experimental practices in the history of life sciences. "Laboratories, Museums, and the Comparative Perspective: Alan A. Boyden's Seriological Taxonomy, 1925–1962," *Historical Studies in the Natural Sciences* 40, no. 2 (2010): 149–82.

# Index

Barthes, Roland, 56

Bartlam, John, 123–24, 125; sherds of teapots in the "pineapple" pattern, 123–24, *123* (fig. 3.26); tea bowl, *123* (fig. 3.27), 124

base metals and metalwork, 40–45; bell metal, 43; bidriware, 44; brass, 42; bronze, 42–43; competition from aluminum and stainless steel, 234–35; competition from plastics and synthetics, 234–35; conceptualization of, 77; copper, 40–41; decoration of, 81–83, 216; fabrication in, 79–81; paktong, 43; pewter, 44; precious metals compared to, 10, 40; realization of objects in, 77, 79–83; surface treatment of, 80, 226; tin, 41; trade in, 104–6; tumbaga, 43–44; zinc, 41. *See also specific metals*

basin, Mamluk Empire, Syria or Egypt, 202–3, *202* (fig. 5.21)

Bassett, John, tankard, 44, *44* (fig. 1.23), 79

batch production, 52, 57, 58, 67

batea (tray), Peribán, Michoacán, Mexico, *92* (fig. 2.41), 93

batik, 72, 133

bedcover, Mary Drew Fifield and Mary Fifield Adams, Boston, Massachusetts, *6* (fig. 0.5), 7–8, 77, 194

bed curtain, Coromandel Coast, India, 7, *7* (fig. 0.6)

Belgium, 35

bell metal, 43, 80

bell tower, Nossa Senhora da Conceição do Monte, Cachoeira, Brazil, 169–70, *169* (fig. 4.17)

Bengal: colcha, 108, *109* (fig. 3.8), 132, 214; embroidery, 8, 123, 130, 132, 163, 190; jamdani cottons, 72, 107, 244; puja (worship ceremonies), 250; silk production, 39. *See also* Bangladesh

Benin bronzes, 189

bentwood chest, Haida culture, British Columbia, 87, *87* (fig. 2.34), 155

Berenson, Bernard, 254

beverages, 156–57, 159–60

bidriware: fabrication and decoration, 83, 216; properties, 44; South Asian locale, 44, 50; uses, 44

bidriware, objects: ewer, Deccan region, India, 130, *131* (fig. 3.40); hookah base, Deccan region, India, *44* (fig. 1.24), 45, 83, 216

Biedermann, Zoltán, 280n17

Binford, Lewis, 150–51

block printing, 72, 74

bodily experience. *See* sensory experience

Boldü family, 203

Bonnart, Nicolas, plate featuring scene from engraving by, *126* (fig. 3.30)

border, lace, Italy, 69, *70* (fig. 2.19)

Böttger, Johann Friedrich, 230

bottles: Frechen, Germany, 29, *29* (fig. 1.7), 61, 62, 245; Gangjin, Korea, 64, *65* (fig. 2.11); Jingdezhen, China, 126, *126* (fig. 3.29)

bowback Windsor armchair, Ebenezer Tracy, Lisbon, Connecticut, 47, *49* (fig. 1.27)

bowls: Anishinaabe artisan, Michigan, Wisconsin,

or Ontario, 182, *182* (fig. 5.3); Asante, Offin River region, Ghana, 113, *114* (fig. 3.14); Awatovi Pueblo, northeastern Arizona, 4–5, *5* (fig. 0.4), 7, 58, 63; Changsha, Jiangxi Province, China, 105, *106* (fig. 3.3); drinking bowl, China, 54, *55* (fig. 2.2), 214, 251; drinking bowl, England, 53–54, *54* (fig. 2.1); footed bowl, South Carolina, 113–14, *115* (fig. 3.16); Iran, *58* (fig. 2.4), 59; Iraq, *65* (fig. 2.12), 66; probably Egypt, 113, *114* (fig. 3.13). *See also* punch bowls

Brandenburg, Friedrich Wilhelm van, 195

brass, 42, 80

brass, objects: bowl, Asante, Orrin River region, 113, *114* (fig. 3.14); bowl, probably Egypt, 113, *114* (fig. 3.13); escutcheon plate, Birmingham, England, 111, *112* (fig. 3.12), 138; ewer, India, *41* (fig. 1.20), 42, 80; tobacco or snuff box, England, 207, *209* (fig. 5.31), 214; tray stand, Cairo, Egypt, 121, *121* (fig. 3.24); vase made from 75-mm artillery shell casing by Sgt. First Class Jack J. Clarke of an armored division for his girlfriend Myrtle, 191, *191* (fig. 5.12)

Brazil, bell tower, Nossa Senhora da Conceição do Monte, Cachoeira, 169–70, *169* (fig. 4.17)

Bridenbaugh, Carl, 52

Bridport, George, sideboard, 215, *216* (fig. 6.2)

Bright, George, 118

Britain: ceramic decoration, 66; chintzes, 7–8; interchange involving, 7–8, 113–14, 118–19, 121, 127, 129, 137–38, 144–46; metal alloys, 50; pewter, 50; tea culture, 160–61, 245; trade, 111–12, 184; wool production, 38

Britain, objects: armchair, Cheshire, England, 203, *205* (fig.5.24); armchair, London, 164, *164* (fig. 4.12); *Asante Jug*, London, 149–50, *151* (fig. 4.1), 189, 252; back cover for a sofa, designed by Richard Ovey, printed at Bannister Hall, Lancashire, 225, *226* (fig. 6.13); dress fabric, Spitalfields, London, 121, *121* (fig. 3.23); drinking bowl, 53–54, *54* (fig. 2.1); escutcheon plate, Birmingham, 111, *112* (fig. 3.12), 138; jug, London, 23–25, *24* (fig. 1.2), 61; linen press, 118, *120* (fig. 3.22); mazer, England, 192, *192* (fig. 5.13); *The Palanquin*, designed by John Vanderbank, woven by Great Wardrobe, London, 165, *165* (fig. 4.13); pitcher, Herculaneum Pottery, 163, *163* (fig. 4.11); plate, Bristol, England, 205, *206* (fig. 5.27); plate, Devon, 63, *64* (fig. 2.10), 251; plate, London, 66, *67* (fig. 2.14), 138; plate, Spode Ceramics Works, Stoke-on-Trent, 144, *145* (fig. 3.53), 146, 222; punch bowl, *A Midnight Modern Conversation*, Liverpool, 127, *127* (fig. 3.32); punch bowl, Leeds, 113–14, *115* (fig. 3.15); samples of harrateen (worsted wool), Norwich, 111, *112* (fig. 3.11), 135; shawl, Paisley, Scotland, 137, *138* (fig. 3.47); tea bowl and saucer, attributed to Josiah Wedgwood and Sons with decoration after engraving by Robert Hancock, Staffordshire, England, 187, *188* (fig. 5.8); teapot, Josiah Wedgwood and Sons, Stoke-on-Trent, Staffordshire,

62, *62* (fig. 2.8), 187; teapot, Sheffield, England, 219, *220* (fig. 6.6); teapot, Staffordshire, *59* (fig. 2.5), 60; teapot, Wedgwood and Company, Ferrybridge, Yorkshire, 28, *28* (fig. 1.6), 61, 66, 111, 148–49; tobacco or snuff box, England, 207, *209* (fig. 5.31), 214

British East India Company, 111–12, 159, 184, 188, 247, 261

bronze, 42–43; casting of, 80; properties of, 42; uses, 42–43

bronze, objects: *Asante Jug*, London, 149–50, *151* (fig. 4.1), 189, 252; lidded ritual wine container, China, 42, *42* (fig. 1.21), 79; roped pot, Igbo Ukwu, Nigeria, 106, *107* (fig. 3.5)

Brunias, Agostino, *Linen Market, Dominica*, 239, *239* (fig. 7.2)

Buddhism, 229

Burke, Edmund, 229–30, 248, 253

Burton, Scott, 251

cabinets: attributed to Jan van Mekeren, Amsterdam, 94, *96* (fig. 2.45); cabinet-on-stand, Martin Schell, Dresden, Germany, 136, 222, *223* (fig. 6.11), 224; collector's cabinet, Netherlands, 94, *94* (fig. 2.43); dressing cabinet, probably Jerusalem, 233, *233* (fig. 6.19); lacquered panels from Kyoto, Japan, cabinet carcass from the Netherlands, 139, *140* (fig. 3.48); probably Pulicat, Coromandel Coast, India, *122* (fig. 3.25), 123; secretaire cabinet, Guangzhou, China, 259–61, *260* (fig. 8.2); writing cabinet, Nagasaki, Japan, 90, *90* (fig. 2.38), 95, 136, 217

cabinets of curiosities, 171

Cadwalader, John, 217–18

camlets, 221

candlesticks: Damascus, Syria, 203, *203* (fig. 5.22); Guangzhou, China, 43, *43* (fig. 1.22), 79, 135

Candlin, Fiona, 254

card playing, 159

card receiver, Rogers, Smith and Company, West Meriden, Connecticut, 219, *220* (fig. 6.7)

card table, Thomas Affleck (cabinetmaker) and James Reynolds (carver), Philadelphia, Pennsylvania, 217–18, *218* (fig. 6.4)

carpet, Pazyryk culture, Siberia, 69, *70* (fig. 2.17)

carving, 93, 218, 250

case furniture, 118, 138, 139, 248–49

caskets: Hoshiarpur District, Punjab, India, 198–99, *199* (fig. 5.19); Pasto, Colombia, 136–37, *136* (fig. 3.45)

cassone, attributed to workshops of Apollonio di Giovanni di Tomaso and Marco del Buono Giamberti, Florence, Italy, 88, *89* (fig. 2.36), 215

casting, of metals, 79–80

Catalin, 234

Catholicism, 229

cedar, 34, 46, 47

center/periphery paradigm, 8, 10, 11, 16, 100, 120, 125

Central Asia: cloth of gold with winged lions and griffins, 108, *108* (fig. 3.6); inlaying techniques, 83; trade, 15, 39, 103–4

ceramics: competition from plastics and synthetics, 234–35; decoration of, 60–68; fabrication of, 58–60; interchange involving, 146; realization of, 57–68; surface treatment of, 224–25; trade in, 103. *See also* clay; creamware; earthenware; fritware; kilns and firing techniques; porcelain; stoneware

chairs: armchair, Cheshire, England, 203, *205* (fig. 5.24); armchair, London, 164, *164* (fig. 4.12); folding chair, Nagasaki area, Japan, 1, *2* (fig. 0.1), 3, 212; folding church chair, Netherlands, 1, 3, *3* (fig. 0.2); pair of side chairs, Vizagapatam, India, 94, 184, *185* (fig. 5.5); side chair, Walter Corey, Portland, Maine, 220, *221* (fig. 6.8)

champlevé, 83

Chancay culture, textile fragment, 216

charger with VOC emblem, Arita, Japan, *185* (fig. 5.6), 186

chasing, of metals, 81–82

chests: attributed to Thomas Dennis, Ipswich, Massachusetts, 85, *86* (fig. 2.32); Azores, 85, *86* (fig. 2.33); bentwood chest, Haida culture, British Columbia, 87, *87* (fig. 2.34); chest with drawers, Chester County, Pennsylvania, *93* (fig. 2.42), 94; high chest of drawers, Boston, Massachusetts, 231, *232* (fig. 6.18); high chest of drawers, japanned by Robert Davis, Boston, Massachusetts, 90, *91* (fig. 2.39), 136, 138, 222; reliquary chest, Nagasaki, Japan, 114–16, *116* (fig. 3.18), 200; two-drawer, Shaftsbury, Vermont, 88, *88* (fig. 2.35), 135

child's coat with "ducks in pearl" medallions, probably Sogdiana, 104, *105* (fig. 3.2), 139

Chilkat robe, Chilkat Tlingit, Alaska, 34, *34* (fig. 1.13), 69

China: base metals and metalworking, 43, 79; cabinets of curiosities in, 171; cloisonné, 83; dining, 246; glazes, 61; interchange involving, 1, 3, 116, 121, 122, 125–27, 129–30, 137–46, 259–61; lacquer, 90, 224, 251, 259; porcelain, 25, 31, 67, 125–26, 142, 282n7; silk production, 39; trade, 1, 103–5; woodworking, 47

China, objects: bottle, Jingdezhen, 126, *126* (fig. 3.29); bowl, Changsha, Jiangxi Province, 105, *106* (fig. 3.3); candlestick, Guangzhou, 43, *43* (fig. 1.22), 79, 135; covered tureen, serving platter, and plate, Society of Cincinnati service, Jingdezhen and Guangzhou, 68, *68* (fig. 2.15), 200, 214; cup, Xing kilns, northern China, 29, *29* (fig. 1.8), 105; cups, 224, *225* (fig. 6.12); dish, Zhangzhou kilns, 129, *129* (fig. 3.35); dish with lozenge and foliate motifs, Gongxian kilns, 141, *141* (fig. 3.50); drinking bowl, 54, *55* (fig. 2.2), 214, 251; ewer, Gongxian kilns, Henan Province, 105, *106* (fig. 3.4); ewer, Guangzhou, 130, *131* (fig. 3.39); ewer, Jingdezhen, 130, *131* (fig. 3.38), 152; ewer with Portuguese coat of arms, Jingdezhen, 180–81, *181* (fig. 5.2); hot water plate, Jingdezhen, *145* (fig.

cushion cover, Kongo people, 35, 179, *180* (fig. 5.1)

Damascene work, 83
Dasi, Srimati Manadasundari, kantha, *76* (fig. 2.26), 77, 163, 190, 251
Davis, Robert, high chest of drawers, 90, *91* (fig. 2.39), 136, 138, 222
decoration: base metals, 81–83; ceramics, 60–68; as component of appearance, 215–24; fiber and textiles, 71–77; flexibility in addressing varied audiences through, 215; wood, 87–95. *See also* ornament
decorative art. *See* applied/decorative art
Denmark: platter, Nicolai Hindrich Ludvik Hagelsten, Haderslev, *128* (fig. 3.34), 129; temple, Wilhelm of Hesse, Copenhagen, 230, *231* (fig. 6.17)
Dennis, Thomas, chest, 85, *86* (fig. 2.32)
depletion gilding, 44
desks: desk and bookcase, Benjamin Frothingham, Charlestown, Massachusetts, 47, *48* (fig. 1.26), 118; portable writing desk, Pasto, Colombia, *92* (fig. 2.40), 93, 111, 217; writing desk, Gujarat, India, 108, *108* (fig. 3.7)
de Waal, Edmund, 183, 209, 236
Diderot, Denis, *Encyclopédie*, 97, 146
diffusionism, 15, 16, 113, 134, 146
dining, 245–46
dishes: Basra, Iraq, 61, 64, 141, *141* (fig. 3.49); Bucks County, Pennsylvania, 207, *208* (fig. 5.30); Bursa or Edirne, Turkey, 31, *32* (fig. 1.11); with lozenge and foliate motifs, Gongxian kilns, China, 141, *141* (fig. 3.50); Netherlands, 143, *144* (fig. 3.52), 222; Turkey, probably Iznik, 130, *130* (fig. 3.37); Vietnam, 142, *143* (fig. 3.51); Zhangzhou kilns, China, 129, *129* (fig. 3.35)
distilled spirits, 159
domestic space, 156, 157–58
Douglas, Mary, 148
dovetailing, 85
drape molding, 59
dress fabric, Spitalfields, London, 121, *121* (fig. 3.23)
dressing cabinet, probably Jerusalem, 233, *233* (fig. 6.19)
drop-front secretary, Vizagapatam, India, 94, *95* (fig. 2.44)
drop stamping, 82
Dutch East India Company. *See* Vereenigde Oostindische Compagnie
dyeing, 72–75, 216

earthenware, 27–29; colors of, 27; geographies of, 27; preparation of materials for, 27–28; properties of, 27–28; uses, 27–28
earthenware, objects: bowl, Awatovi Pueblo, northeastern Arizona, 4–5, *5* (fig. 0.4), 7, 58, 63; bowl, Iraq, *65* (fig. 2.12), 66; cooking pot, Iroquois people, St. Lawrence River region, *26* (fig. 1.3), 27, 58, 153; dish, Basra, Iraq, 61, 64, 141, *141* (fig. 3.49); dish, Bucks County, Pennsylvania, 207, *208* (fig. 5.30); dish, Netherlands, 143, *144* (fig.

3.52), 222; ewer, Nishapur, Iran, 152, *152* (fig. 4.2); footed bowl, South Carolina, 113–14, *115* (fig. 3.16); jar, Santa Clara Pueblo, New Mexico, 61, *61* (fig. 2.6), 153; jug, London, 23–25, *24* (fig. 1.1), 61; *lebrillo* (basin), Puebla, Mexico, 111, *111* (fig. 3.10), 144; memory vase, United States, possibly southern, 183, *184* (fig. 5.4); pitcher, Herculaneum Pottery, 163, *163* (fig. 4.11); plate, Bristol, England, 205, *206* (fig. 5.27); plate, Deruta, Italy, 66, *66* (fig. 2.13), 222; plate, London, 66, *67* (fig. 2.14), 138; plate, Portugal, *27* (fig. 1.5), 28, 61, 143, 222; plate, Puebla or Tlaxcala, Mexico, *58* (fig. 2.3), 59; plate, Spode Ceramics Works, Stoke-on-Trent, England, 144, *145* (fig. 3.53), 146, 222; stamnos, Attica, Greece, 63, *63* (fig. 2.9), 103; tea bowl and saucer, attributed to Josiah Wedgwood and Sons with decoration after engraving by Robert Hancock, Staffordshire, England, 187, *188* (fig. 5.8); teapot, John Griffith, Elizabethtown, New Jersey, 211–12, *213* (fig. 6.1); teapot, Josiah Wedgwood and Sons, Stoke-on-Trent, Staffordshire, 62, *62* (fig. 2.8), 187; teapot, Wedgwood and Company, Ferrybridge, Yorkshire, 28, *28* (fig. 1.6), 61, 66, 111, 148–49; tiles on National Palace, Sintra, Portugal, 68, *69* (fig. 2.16); *urpu*, Cuzco area, Peru, 153–54, *154* (fig. 4.4); vessel, La Graufesenque, France, *27* (fig. 1.4), 28, 103
East Africa, 33; porcelain display in merchant mansion, Lamu, Kenya, 166, *167* (fig. 4.15)
East Asia: glazes, 61; interchange involving, 136; lacquer, 136; silk, 105; trade, 110; value of objects from, 53
East India Company. *See* British East India Company; Vereenigde Oostindische Compagnie
ebonizing, 220
Eckhoudt, Albert, designs for *Tenture des Indes* cycle, 195, *196* (fig. 5.16), 214
Edenshaw, Albert Edward, copper engraved by, *200* (fig. 5.20), 201
edge tools, 84
Egypt: cotton production, 36; fritware production, 31; interchange involving, 113, 121; linen production, 35
Egypt, objects: basin, Mamluk Empire, 202–3, *202* (fig. 5.21); bowl, 113, *114* (fig. 3.13); tray stand, Cairo, 121, *121* (fig. 3.24)
*einfühlung* (empathy), 255
electroplating, 44
Elizabeth of Carinthia, 202–3
embroidery/needlework, 7–8, 77, 116, 123, 130, 132, 161, 163, 190, 252
empirical knowledge, 25, 30, 45, 96. *See also* knowledge; local knowledge; tacit knowledge
*Empress of China* (ship), 200
emulation, 135
enamel decoration, 31, 67, 83, 127, 142, 200–201, 203, 215–16, 222
enchantment: appearance as source of, 212; makers' role in, 210, 235; of novelty and the future, 234;

(fig. 5.10); textile, Java, 72, *73* (fig. 2.21); textile fragment, Chancay culture, Andes, 216; textile fragment, Gujarat, India (first–fifth centuries CE), 72, *73* (fig. 2.22); textile fragment, Gujarat, India (950–1050), 36, *36* (fig. 1.15), 107; textile fragment, Gujarat, India (second half of the tenth century–fifteenth century AD), 74, *74* (fig. 2.23); textile fragment, Gujarat, India (probably 1500s), 132–33, *132* (fig. 3.41); textile fragment, "Les travaux de la manufacture" pattern, designed by Jean-Baptiste Huet, made at Oberkampf Manufactory, France, 75, *75* (fig. 2.25), 77; textile fragment, Sogdiana, 39, *39* (fig. 1.18); wrap, Kashmiri region, Asia, 137, *137* (fig. 3.46)

Fifield, Mary Drew, and Mary Fifield Adams, bedcover, *6* (fig. 0.5), 7–8, 77, 194

Fifield, Richard, 7

finger joints, 85

finishing treatments, 80, 224–26

firing techniques. *See* kilns and firing techniques

Flanders: napkin, 203, *204* (fig. 5.23); napkin with the coat of arms of Anne Boleyn and a portrait of her daughter, Queen Elizabeth, *35* (fig. 1.14), 36

folding chair, Nagasaki area, Japan, 1, *2* (fig. 0.1), 3, 212

folding church chair, Netherlands, 1, 3, *3* (fig. 0.2)

footed bowl, South Carolina, 113–14, *115* (fig. 3.16)

Forcella, Nicola, *In the Copper Souk*, 242, *242* (fig. 7.5)

form: function in relation to, 149, 152, 211–12; meanings suggested by, 212

formalism, 149

France, 121, 124

France, objects: tapestry, *Le chevay rayé* from the *Tenture des Indes* cycle, designs by Frans Post and Albert Eckhoudt, woven by Gobelins Manufactory, Paris, 195–96, *196* (fig. 5.16), 214; textile fragment, "Les travaux de la manufacture" pattern, designed by Jean-Baptiste Huet, made at Oberkampf Manufactory, 75, *75* (fig. 2.25), 77; vessel, La Graufesenque, *27* (fig. 1.4), 28, 103

Franklin, Benjamin, 163

Frederick I, 171–72

free workmanship, 56, 62, 155, 253

fritware: decoration of, 66, 141–42; geographies of, 31; in Iran, 23, 31, 66, 67, 141–42; press molding of, 59

fritware, objects: bowl, Iran, *58* (fig. 2.4), 59; dish, Bursa or Edirne, Turkey, 31, *32* (fig. 1.11); dish, Turkey, probably Iznik, 130, *130* (fig. 3.37); ewer, Kashan, Iran, 152, *153* (fig. 4.3); jug, Kashan, Iran, 23–24, *24* (fig. 1.1); tile panel, Iznik, Turkey, 31, *32* (fig. 1.10), 59

Frothingham, Benjamin, desk and bookcase, 47, *48* (fig. 1.26), 118–19

Funcke, George, teapot and cover decoration, 230, *230* (fig. 6.16)

function/use, 17–18, 148–75; affordances and, 148–50; assemblage of objects and, 155; brass, 42; bronze, 42–43; cultural adaptations of, 3–5, 7; earthenware, 27–28; form in relation to, 149, 152, 211–12; improvements, 152, 157–64; leisure and, 156–57; luxuries, 152, 164–74; necessities, 152–57; raffia, 34; realization in relation to, 53–55, 148; specialization of, 18, 152, 157, 159; touch and, 244–50; traditional approaches to, 149; types of value, 150–51; usage of domestic spaces, 156; varieties of, 148–50, 174; wood, 45. *See also* gifting; memory; users/audience

gauge post, 60

Gell, Alfred, 208–9, 210

genius, critique of art histories based on notion of, 9, 55

Germany, 35; bottle, Frechen, 29, *29* (fig. 1.7), 61, 62, 245; cabinet-on-stand, Martin Schell, Dresden, 136, 222, *223* (fig. 6.11), 224; Porcelain Room, Old Charlottenburg Palace, Berlin, 171–72, *173* (fig. 4.19); teapot and cover, Meissen Porcelain, Meissen, 230, *230* (fig. 6.16)

Ghana, 113; bowl, Asante, Orrin River region, 113, *114* (fig. 3.14)

Gibson, James, 148

gifting, 18; diplomatic, 178–79, 194–99; fraternal affirmation through, 200; interpersonal, 201–8; life transitions as occasion for, 204, 207; meanings of, 194, 201; and memory, 201–2; misunderstandings in, 195, 196, 199; potlatch as example of, 200–201; religious, 199–200; of textiles, 195–98. *See also* exchange

Gilpin, Hank, 235

glazes and glazing, 24, 28–30, 61–62, 211, 224–26, 244. *See also* lead glazes; tin glazes

"global," methodological and terminological considerations, 13–14

Gobelins Manufactory, tapestry, *Le cheval rayé* from the *Tenture des Indes* cycle, 196, *196* (fig. 5.16), 214

Godwin, E. W., 220

Göethe, Eosander von, 171–72

Goethe, Johann Wolfgang von, 257

Goffman, Erving, 155–56

gold: in African culture, 40; alloys using, 43–44; in Andean culture, 40, 262–63; cultural value of, 102, 105, 166, 262; decorative use of, 3, 11, 64, 77, 83, 90, 101–2, 107–8, 116, 152, 169, 217, 222, 234, 244, 259; in hierarchy of metals, 10, 40; meanings of, 262–63, 290n12; repair of tea bowls with, 192, 194; trade in, 105, 107, 150

Goodrich, Samuel Griswold, 183

Gopnik, Adam, 254, 255

Graves, Margaret, 97, 238

Great Exhibition, Crystal Palace (London, 1851), 173

Great Wardrobe, *The Palanquin*, 165, *165* (fig. 4.13)

Greece, 103; stamnos, Attica, 63, *63* (fig. 2.9), 103

green woodworking, 84–85

Griffith, John, teapot, 211–12, *213* (fig. 6.1)

grisaille, 88

Guangzhou, China, 67, 83, 101, 104, 129, 138–39, 204, 215–16, 240, 259–61
Gucht, Maximiliaan van der, 195
Gujarat, India, 7, 8, 36, 72, 74, 77, 106–8, 114–15, 130, 132–33, 136, 168, 197, 214, 228–29, 247, 250

Hagelsten, Nicolai Hindrich Ludvik, platter, *128* (fig. 3.34), 129
Haida culture, objects: bentwood chest, 87, *87* (fig. 2.34), 155; copper, engraved by Albert Edward Edenshaw, *200* (fig. 5.20), 201
Hall, Boardman & Co., teapot, 81, *81* (fig. 2.29)
Hall, Edward, 156
Hancock, Robert, tea bowl and saucer decoration after engraving by, 187, *188* (fig. 5.8)
handles, 238
hangings. *See* palampores
Hans von Aachen, *Portrait of Emperor Matthias*, 196, *197* (fig. 5.17)
haptic sense. *See* touch
Harper, Douglas, 57
harrateens, 221; Norwich, England, 111, *112* (fig. 3.11), 135, 221, 226
Hay, Jonathan, 139, 224
headrest, Zimbabwe, Shona culture, 85, *85* (fig. 2.31)
Herat metalworkers, 10–11, 83, 121; ewer, *82* (fig. 2.30), 83, 152, 251, 252
Herculaneum Pottery, pitcher, 163, *163* (fig. 4.11)
Herter Brothers, 220; secretary, 220–21, *221* (fig. 6.9)
Hideyoshi, Toyotomi, 197–98
high chests of drawers: Boston, Massachusetts, 231, *232* (fig. 6.18); japanned by Robert Davis, Boston, Massachusetts, 90, *91* (fig. 2.39), 136, 138, 222
Hogarth, William, 157; *A Midnight Modern Conversation*, 127, *127* (fig. 3.31), 129
Holker, John, 112
hookah base, Deccan region, India, *44* (fig. 1.24), 45, 83, 216
Hooke, Robert, 231
hot beverages, 160
hot water plate, Jingdezhen, China, *145* (fig. 3.54), 146, 222
Howes, David, 254
Huet, Jean-Baptiste, textile fragment, "Les travaux de la manufacture" pattern, 75, *75* (fig. 2.25), 77
Huguenot weavers, 120–21, 125

iconography, 125
ikat, 74–75, 133
Ikhwan al-Safaʾ, 146
imagery, interchange involving, 11, 125–33
imitation. *See* copying and imitation
imperial/racist perspectives, 9, 18, 101–2, 137–39, 150, 173, 174, 187–90, 195, 255, 261, 289n71, 299n19
improvements, 152, 157–64; beverage consumption, 159–61; card playing, 159; domestic interiors, 157–59; personal/social affiliation, 163–64; social display, 162–63

Inca, All Tʾoqapu tunic, 38, *38* (fig. 1.17), 111, 163–64, 195
India: cotton production, 36; interchange involving, 7–8, 114–15, 258–59; metal alloys, 50; silk production, 39
India, objects: bed curtain, Coromandel Coast, 7, *7* (fig. 0.6); cabinet, probably Pulicat, Coromandel Coast, *122* (fig. 3.25), 123; casket, Hoshiarpur District, Punjab, 198–99, *199* (fig. 5.19); coffer, Gujarat, 114–16, *116* (fig. 3.17); drop-front secretary, Vizagapatam, 94, *95* (fig. 2.44); ewer, *41* (fig. 1.20), 42, 80; ewer, Deccan region, 130, *131* (fig. 3.40); ewer, northern India, 130, 236–37, *237* (fig. 7.1); hookah base, Deccan region, *44* (fig. 1.24), 45, 83, 216; kantha, made by Srimati Manadasundari Dasi, Bengal, *76* (fig. 2.26), 77, 163, 190, 251; pair of side chairs, Vizagapatam, 94, 184, *185* (fig. 5.5); palampore (hanging), Coromandel Coast, 36, *37* (1.16), 72, 215; palampore (hanging), Machilipatnam, 258–59, *258* (fig. 8.1); patolu, Gujarat, 74–75, *74* (fig. 2.24), 133, 214; skirt cloth, Coromandel Coast, *132* (fig. 3.42), 133; tent, Coromandel Coast, 189, *189* (fig. 5.10); textile fragment, Gujarat (first–fifth centuries CE), 72, *73* (fig. 2.22); textile fragment, Gujarat (950–1050), 36, *36* (fig. 1.15), 107; textile fragment, Gujarat, India (second half of the tenth century–fifteenth century AD), 74, *74* (fig. 2.23); textile fragment, Gujarat, India (probably 1500s), 132–33, *132* (fig. 3.41); writing desk, Gujarat, 108, *108* (fig. 3.7)
*indianilla* (South Asian painted cottons), 139
Indigenous peoples: changing meanings of work by, 181–82; museum classification/display of objects of, 174, 182; pottery techniques of, 58; value of materials for, 40. *See also* Native Americans
Indonesia: batik, 72; cotton, 36; foreign production for market of, 133, 142; tin, 41; trade, 105, 106
Industrial Revolution, 166
Industrious Revolution, 111, 157, 166
influence. *See* interchange
Ingold, Tim, 56
inlay, 83, 94
inscriptions, 190–91, 252
intellect of the hand, 97, 238
interchange, 100–146; agency operating in, 101, 139, 146; art history based on, 8–16, 258–63; ceramics' role in, 146; copper's role in, 146–47; forms of, 135–40; Herat metalworkers and, 10–11; historical concerns similar to notion of, 14–15; knowledge developed out of, 133, 134, 146, 147; methodological and terminological considerations for, 19, 101–2, 134–35; in preindustrial era, 11, 102; surfaces' role in, 235; textiles' role in, 130, 132–33; trade systems and, 103–13; transmission of imagery and style, 125–33; transmission through makers, 10–11, 120–25; transmission through objects, 1–8, 102, 113–20; wood's role in, 147. *See also* circulation of objects; exchange; reception of objects

Iran: fritware, 23, 31, 66, 67; interchange involving, 141–42; lusterware, 66

Iran, objects: bowl, *58* (fig. 2.4), 59; *chini-khaneh* (house of porcelain), shrine of Shaykh Safi al-din, Ardabil, 171, *172* (fig. 4.18); detail of cloth, Isfahan, 133, *134* (fig. 3.44); ewer, Kashan, 152, *153* (fig. 4.3); ewer, Nishapur, 152, *152* (fig. 4.2); jug, 23–24, *24* (fig. 1.1)

Iraq, 140–41; bowl, *65* (fig. 2.12), 66; dish, Basra, 61, 64, 141, *141* (fig. 3.49); pyxis, Mosul, 11, *12* (fig. 0.7), *13* (detail) (fig. 0.8), 81

Ireland, 35

Iroquois people, cooking pot, *26* (fig. 1.3), 27, 58, 153

Islamic world: fritware, 31, 59; imagery sought by, 11, 129–30; inlaid decoration, 11, 83; interchange involving, 11, 83, 129–30; metalwork, 106, 130; objects valued in, 11, 142; tile techniques, 68; trade, 105

Italian Renaissance, 88

Italy: ceramic decoration, 66; silk production, 39; wool production, 38

Italy, objects: border, lace, 69, *70* (fig. 2.19); cassone, attributed to workshops of Apollonio di Giavanni di Tomaso and Marco del Buono Giamberti, Florence, 88, *89* (fig. 2.36), 215; plate, Deruta, 66, *66* (fig. 2.13), 222

ivory, 94; temple, Wilhelm of Hesse, Copenhagen, Denmark, 230, *231* (fig. 6.17)

Jahangir, Emperor, 197, 244

jamdani stole, Dhaka, Bangladesh, 72, *72* (fig. 2.20), 251

James, Henry, 187

Japan: dining, 245–46; interchange involving, 1, 3, 114–16, 136, 139, 197, 229; lacquer, 1, 3, 90, 94, 101, 115–16, 136, 199, 224, 227, 229; marquetry, 94–95; porcelain production, 282n7; tea culture, 161, 168, 192, 194, 245, 253

Japan, objects: charger with VOC emblem, Arita, *185* (fig. 5.6), 186; coffer, Nagasaki, 110, *110* (fig. 3.9), 139; folding chair, Nagasaki area, 1, *2* (fig. 0.1), 3, 212; *jinbaori* (surcoat), textile woven in Kashan, Safavid Empire, 197–98, *198* (fig. 5.18); *kakeban* (nobleman's meal table), 227, *227* (fig. 6.14); Nanban trade screen (ca. 1600), 1, *4* (detail) (fig. 0.3); Nanban trade screen (ca. 1700), 240, *240–41* (fig. 7.3); reliquary chest, Nagasaki, 114–16, *116* (fig. 3.18), 200; writing cabinet, Nagasaki, 90, *90* (fig. 2.38), 95, 136, 217

japanning, 90, 136, 222, 224

jar, Santa Clara Pueblo, New Mexico, 61, *61* (fig. 2.6), 153

Java: sarong, Lasem, 133, *133* (detail) (fig. 3.43); textile, 72, *73* (fig. 2.21)

Jay Gould house, New York City, 221

Jerusalem, dressing cabinet, 233, *233* (fig. 6.19)

Jesuits, 229, 230

jigger, 60

*jinbaori* (surcoat), textile woven in Kashan, Safavid Empire, 197–98, *198* (fig. 5.18)

João I Nzinga Nkuwu, 178

joined work, 85

jolly, 60

Josiah Wedgwood and Sons: tea bowl and saucer, 187, *188* (fig. 5.8); teapot, 62, *62* (fig. 2.8), 187. *See also* Wedgwood and Company

Judd, Donald, 251

jugs: face jug, Edgefield, South Carolina, 60–62, 261–62, *262* (fig. 8.3); Kashan, Iran, 23–24, *24* (fig. 1.1); London, 23–25, *24* (fig. 1.2), 61. *See also* ewers; pitchers

Jun'ichirō, Tanizaki, 227

*kakeban* (nobleman's meal table), Japan, 227, *227* (fig. 6.14)

Kant, Immanuel, 9

kantha, Srimati Manadasundari Dasi, Bengal, India, *76* (fig. 2.26), 77, 163, 190, 251

Kashmir, wrap, 137, *137* (fig. 3.46)

kast, New York, 88, *89* (fig. 2.37)

Kenya, porcelain display in merchant mansion, 166, *167* (fig. 4.15)

kerf bent boxes, 87, 154–55, 249

kero: Lambayeque culture, 44, 262–63, *263* (fig. 8.4); pair of kero cups, Peru, 228, *228* (fig. 6.15)

Kick, Willem, plate, 222, *223* (fig. 6.10)

kilns and firing techniques, 28–31, 61, 63

Kimbel & Cabus, 220

knowledge: associated with use of materials, 15, 17, 23, 25, 47, 49; collecting as expression of/means to, 170–72; commercial, 239–40, 242; and conceptualization of objects, 55–56; decorating techniques, 216–17; for earthenware production, 29–31; and fabrication of objects, 56; interchange as spur to development of, 133, *134*, 146, 147; of materials, 15, 17, 23, 25, 47, 49, 235; metalware production, 41–42, 45; privileging of visuality in regard to, 255; in realization of objects, 95–97; sensory experience's role in, 255; of surfaces, 230–32; touch's role in, 236, 255; utilized in mimicry, 219; woodworking, 46. *See also* tacit knowledge

Koerner, Joseph, 239, 245

Kongo people, 178–79, 261–62; cushion cover, 35, 179, *180* (fig. 5.1)

Koon, Yeewan, 129

Kopytoff, Igor, 179

Korea: ceramic decoration, 63–64, 66; lacquer, 90; porcelain production, 282n7

Korea, objects: bottle, Gangjin, 64, *65* (fig. 2.11); tea bowl, Gyeongsangnam-go Province, 192, *193* (fig. 5.15)

kraak-style decorative borders, 143, 222

Krauss, Rosalind, 251

Kubler, George, 125, 231

*Kunstkammers/Kunstkabinetts*, 171

lacemaking, 69

sions, 162–74; ritualistic, 35, 155, 170; theatrical analogies for, 156

Peru: cotton production, 36; interchange involving, 116, 118, 136, 247; mother-of-pearl, 233; wood decoration, 93

Peru, objects: cover, 116, 118, *119* (fig. 3.21); pair of kero cups, 228, *228* (fig. 6.15); *urpu*, Cuzco area, 153–54, *154* (fig. 4.4)

pewter: competition from fused and plated base metals, 219; fabrication in, 80, 81; popularity of, 44, 50; properties of, 44; uses, 44

pewter, objects: platter, Nicolai Hindrich Ludvik Hagelsten, Haderslev, Denmark, *128* (fig. 3.34), 129; tankard, John Bassett, New York, 44, *44* (fig. 1.23), 79; teapot, Hall, Boardman & Co., Philadelphia, Pennsylvania, 81, *81* (fig. 2.29)

Philippines, 34, 142

Philips, Charles, *Tea Party at Lord Harrington's House, St. James*, 159, *160* (fig. 4.7)

pier table, northeastern United States, *218* (fig. 6.5), 219

pilgrimage, as analogy for human-object relations, 183, 209

pinching (ceramics), 58

pine, 46, 47

pitchers: *Asante Jug*, London, 149–50, *151* (fig. 4.1), 189, 252; Herculaneum Pottery, 163, *163* (fig. 4.11). *See also* ewers; jugs

planishing, 81, 226

plastics, 234–35

plates: Bristol, England, 205, *206* (fig. 5.27); Deruta, Italy, 66, *66* (fig. 2.13), 222; with grapes and floral sprays, Jingdezhen, China, 130, *130* (fig. 3.36); hot water plate, Jingdezhen, China, *145* (fig. 3.54), 146, 222; Jingdezhen, China (1590–95), *30* (fig. 1.9), 31, 61, 163, 203; Jingdezhen, China (early eighteenth century), 126, *126* (fig. 3.30); Jingdezhen, China (1810–20), *145* (fig. 3.55), 146, 222; London, 66, *67* (fig. 2.14), 138; North Devon, England, 63, *64* (fig. 2.10), 251; Portugal, *27* (fig. 1.5), 28, 61, 143, 222; Puebla or Tlaxcala, Mexico, *58* (fig. 2.3), 59; Spode Ceramics Works, Stoke-on-Trent, England, 144, *145* (fig. 3.53), 146, 222; Willem Kick, Amsterdam, Netherlands, 222, *223* (fig. 6.10)

platter, Nicolai Hindrich Ludvik Hagelsten, Haderslev, Denmark, *128* (fig. 3.34), 129

plunder, 187–89

plywood, 234

poplar, 47

porcelain: armorial, 203; in China, 25, 31, 67, 125–26, 142, 282n7; cultural display of, 166, 171–72; interchange involving, 125–26; mimicry of, 222; non-Chinese production of, 282n7; popularity of, 25, 50, 222; simulation of, 62

porcelain, objects: bell tower, Nossa Senhora da Conceição do Monte, Cachoeira, Brazil, 169–70, *169* (fig. 4.17); bottle, Jingdezhen, China, 126, *126* (fig. 3.29); charger with VOC emblem, Arita, Japan, *185* (fig. 5.6), 186; *chini-khaneh* (house of porcelain), shrine of Shaykh Safi al-din, Ardabil, Iran, 171, *172* (fig. 4.18); covered tureen, serving platter, and plate, Society of Cincinnati service, Jingdezhen and Guangzhou, China, 68, *68* (fig. 2.15), 200, 214; dish, Zhangzhou kilns, China, 129, *129* (fig. 3.35); ewer, Jingdezhen, China, 130, *131* (fig. 3.38), 152; ewer with Portuguese coat of arms, Jingdezhen, China, 180–81, *181* (fig. 5.2); hot water plate, Jingdezhen, China, *145* (fig. 3.54), 146, 222; merchant mansion, Lamu, Kenya, 166, *167* (fig. 4.15); plate, Jingdezhen, China (1590–95), *30* (fig. 1.9), 31, 61, 163, 203; plate, Jingdezhen, China (early eighteenth century), 126, *126* (fig. 3.30); plate, Jingdezhen, China (1810–20), *145* (fig. 3.55), 146, 222; plate with grapes and floral sprays, Jingdezhen, China, 130, *130* (fig. 3.36); Porcelain Room, Old Charlottenburg Palace, Berlin, 171–72, *173* (fig. 4.19); Porcelain Room, Santos Palace, Lisbon, Portugal, 166, *167* (fig. 4.14); punch bowl, Jingdezhen and Guangzhou, China, 127, *128* (fig. 3.33), 129; punch bowl, Jingdezhen, China, 192, *193* (fig. 5.14); scarab vase (*The Apotheosis of the Toiler*), Adelaide Alsop Robineau, Syracuse, New York, 62, *62* (fig. 2.7), 251; tea bowl, Gyeong-sangnam-go Province, Korea, 192, *193* (fig. 5.15); tea bowl, Jingdezhen and Guangzhou, China, 203–4, *205* (fig. 5.26); tea bowl, John Bartlam, Cain Hoy, South Carolina, *123* (fig. 3.27), 124; tea bowl and saucer, Jingdezhen and Guangzhou, China, 203, *205* (fig. 5.25); tea bowl and saucer, made in Jingdezhen and decorated in Canton, China, 240, *241* (fig. 7.4); teapot and cover, Meissen Porcelain, Meissen, Germany, 230, *230* (fig. 6.16)

Porcelain Room, Old Charlottenburg Palace, Berlin, 171–72, *173* (fig. 4.19)

Porcelain Room, Santos Palace, Lisbon, Portugal, 166, *167* (fig. 4.14)

portable writing desk, Pasto, Colombia, *92* (fig. 2.40), 93, 111, 217

Portugal: interchange involving, 116, 123, 126, 136, 142–43, 229; and Kongo people, 178–79; trade, 108–9, 115

Portugal, objects: panel, 116, *118* (fig. 3.20); plate, *27* (fig. 1.5), 28, 61, 143, 222; Porcelain Room, Santos Palace, Lisbon, 166, *167* (fig. 4.14); tiles on National Palace, Sintra, 68, *69* (fig. 2.16)

Post, Frans, designs for *Tenture des Indes* cycle, 195, *196* (fig. 5.16), 214

potlatch, 200–201

potter's wheel, 5, 24–25, 27, 58, 60

pottery. *See* ceramics

precious metals: cultural value of, 10, 40, 102; decoration using, 83; scholarly attention paid to, 10. *See also* gold; silver

*preekstoeltje* (sermon chair), 1, *3* (fig. 0.2)

preindustrial era: characteristics of labor in, 30, 35, 52–53, 55, 96; cultural interchange in, 11, 102

press molding, 59, 62

Priddy, Sumpter, 306n29
print-inspired imagery, 126–29, 132
processes. *See* realization
production. *See* realization
progress, critique of art histories based on principle
    of, 10, 17, 52–53, 55, 58, 254
provenance, 15, 119, 149, 187
proxemics, 156
puddle casting, 79
Puebla or Tlaxcala, Mexico, plate, *58* (fig. 2.3), 59
Pueblo potters. *See* Awatovi Pueblo
punch bowls: Jingdezhen, China, 192, *193* (fig.
    5.14); Jingdezhen and Guangzhou, China, 127,
    *128* (fig. 3.33), 129; Leeds, England, 113–14, *115*
    (fig. 3.15); *A Midnight Modern Conversation*,
    Liverpool, England, 127, *127* (fig. 3.32)
Pye, David, 54, 56, 253
pyxis, Syria or Mosul, Iraq, 11, *12* (fig. 0.7), *13*
    (detail) (fig. 0.8), 81

quilts, 77; American, 77, *78* (fig. 2.28); possibly
    made by Elizabeth Connelly Middleton, Virginia,
    77, *78* (fig. 2.27), 251

racism. *See* imperial/racist perspectives
raden, 3, 94, 115–16, 186, 217, 229
raffia: geographies of, 34; preparation of materials
    for, 34–35; uses, 35, 178
rayon, 234
realization, 17, 52–97; base metals, 77, 79–83;
    ceramics, 57–68; conceptualization phase, 55–56;
    cotton, 36–38; defined, 52, 54–55; earthenware,
    27–28; fabrication phase, 56–57; function/use
    in relation to, 53–55, 148; individualized vs.
    mass-produced, 8; knowledge involved in, 95–97;
    linen, 35; performance phase, 57; raffia, 34–35;
    silk, 39; social context for, 52–53, 55–57; stone-
    ware, 29–30; tapa (barkcloth), 33–34; textiles,
    68–77; wood, 45, 83–95; wool, 36–38. *See also*
    low technology; makers
reception of objects: in circulation, 97, 174–75; equal
    in significance to production, 224; factors in, 57;
    touch as component in, 255. *See also* interchange;
    users/audience
redware, plate, North Devon England, 63, *64*
    (fig. 2.10), 251
relationality, between objects and humans, 183,
    209
reliquary chest, Nagasaki, Japan, 114–16, *116*
    (fig. 3.18), 200
repair of objects, 179, 191–94
repoussé chasing, 81–82
Reynolds, James, card table, 217–18, *218* (fig. 6.4)
Richardson, John, *Two Discourses*, 256
Riegl, Alois, 254
Riello, Giorgio, 36
riving, 84
robe, Chilkat Tlingit, Alaska, 34, *34* (fig. 1.13),
    69
Robineau, Adelaide Alsop, scarab vase (*The
    Apotheosis of the Toiler*), 62, *62* (fig. 2.7), 251

Rogers, Smith and Company, card receiver, 219, *220*
    (fig. 6.7)
Rome, 56, 103, 113, 170, 196
roped pot, Igbo Ukwu, Nigeria, 106, *107* (fig. 3.5)
Roux, Pierre, armoire, 124, *124* (fig. 3.28)
rug, Navajo Nation, 186–87, *186* (fig. 5.7)
Ruskin, John, 10, 253
Ryôko. *See* Utagawa Kunisada I and Ryôko

Safavid Empire, 171, 195–98; *jinbaori* (surcoat),
    textile woven in Kashan, 197–98, *198*
    (fig. 5.18)
Safi al-din, Shaykh, 171
Said, Edward, 303n32
sampler, Nabby Martin, Providence, Rhode Island,
    190, *190* (fig. 5.11)
sand casting, 79
*sanggam* (ceramics), 63–64
Santa Clara Pueblo, jar, 61, *61* (fig. 2.6), 153
sarong, Lasem, Java, 133, *133* (detail) (fig. 3.43)
sawing, 84
scarab vase (*The Apotheosis of the Toiler*), Adelaide
    Alsop Robineau, Syracuse, New York, 62, *62*
    (fig. 2.7), 251
Schell, Martin, cabinet-on-stand, 136, 222, *223*
    (fig. 6.11), 224
science, 146, 170–71, 219, 230–32, 235
Scotland, shawl, Paisley, 137, *138* (fig. 3.47)
sculpture, 251–52
seating, 159
secretaire cabinet, Guangzhou, China, 259–61, *260*
    (fig. 8.2)
secretary, Herter Brothers, New York, 220–21, *221*
    (fig. 6.9)
Semper, Gottfried, 10
Sen no Rikyu, 253
sensory experience: enchantment resulting from, 210;
    hierarchy of, 254; knowledge and, 255; knowledge
    of metalworking dependent on, 77; meaning
    resulting from, 18; memory and, 183, 236; role of,
    in making, 97. *See also* touch
sgraffito, 63, 207, 251
Shaw, Samuel, 200, 214
shawl, Paisley, Scotland, 137, *138* (fig. 3.47)
shellac, 88
Shona culture, headrest, 85, *85* (fig. 2.31)
Siberia, carpet, Pazyryk culture, 69, *70* (fig. 2.17)
sideboard, designed by Benjamin Latrobe, made by
    John Aitken, painted and marbleized by George
    Bridport, Philadelphia, Pennsylvania, 215, *216*
    (fig. 6.2)
side chair, Walter Corey, Portland, Maine, 220, *221*
    (fig. 6.8)
silk: mimicry of, 221–22; preparation of materials for,
    39; properties of, 39; trade in, 103–4
silver: in Andean culture, 262; cultural value of, 101,
    102, 195, 200; decorative use of, 3, 10–11, 64, 77,
    83, 94, 101, 113, 116, 136, 152, 169, 216–17, 222,
    234, 252; fusing and electroplating of, 219; gifting
    of, 202; in hierarchy of metals, 10, 40; imitation of,
    43, 135; plating or fusing with, 80, 219; repair of

tea caddy with European figures, Guangzhou, China, 83, 216, *217* (fig. 6.3)

tea culture, 160–61, 168, 192, 194, 245, 253

teapots and teakettles: Hall, Boardman & Co., Philadelphia, Pennsylvania, 81, *81* (fig. 2.29); John Griffith, Elizabethtown, New Jersey, 211–12, *213* (fig. 6.1); John Morrison, Philadelphia, Pennsylvania, 40, *40* (fig. 1.19), 80; Josiah Wedgwood and Sons, Stoke-on-Trent, Staffordshire, 62, *62* (fig. 2.8), 187; Sheffield, England, 219, *220* (fig. 6.6); sherds of teapots in the "pineapple" pattern, John Bartlam, Cain Hoy, South Carolina, 123–24, *123* (fig. 3.26); Staffordshire, *59* (fig. 2.5), 60; teapot and cover, Meissen Porcelain, Meissen, Germany, 230, *230* (fig. 6.16); Wedgwood and Company, Ferrybridge, Yorkshire, 28, *28* (fig. 1.6), 61, 66, 111, 148–49

techniques of production. *See* realization

temple, Wilhelm of Hesse, Copenhagen, Denmark, 230, *231* (fig. 6.17)

tent, Coromandel Coast, India, 189, *189* (fig. 5.10)

terra sigillata, 56, 103

textiles. *See* fiber and textiles

texture, 248–49, 252

Thailand, 72, 105, 133, 142

thing theory, 13

Thomas, Nicholas, 201

tiles, 59, 68; National Palace, Sintra, Portugal, 68, *69* (fig. 2.16); tile panel, Iznik, Turkey, 31, *32* (fig. 1.10)

tin, 40

tin glazes, 50, 61–62, 64, 66, 88, 110–11, 127, 138, 141–44, 160, 170, 192, 204, 222, 225, 248, 249

Tipu Sultan (Tiger of Mysore), 187–88, 299n19

Tlaxcala, Mexico. *See* Puebla or Tlaxcala

Tlingit people: Chilkat robe, 34, *34* (fig. 1.13), 69; oil box, 154, *155* (fig. 4.5)

tobacco or snuff box, England, 207, *209* (fig. 5.31), 214

Toraja, 209

touch, 18–19, 236–55; circulation and, 250–51; consumption and, 238–44; and dichotomy of intellect and craft, 239; enchantment resulting from, 236; and facture, 238–39; function and, 244–50; knowledge gained through, 236; memory and, 236, 238, 255; and narrative, 252; sculptural treatments and, 251–52; significance of, for understanding objects, 238; variability of responses to, 253; vision privileged over, 254–55

Tracy, Ebenezer, bowback Windsor armchair, 47, *49* (fig. 1.27)

trade: complex nature of, 113; geographies of, 103–13; interchange perspective on, 102; knowledge applicable to, 239–40, 242; metalwork, 104–6; silk, 103–4; stoneware, 104–5; textiles, 106–7. *See also* circulation of objects; exchange

trade history, 15

transfer decoration, 66

transmission. *See* circulation of objects; interchange

tray stand, Cairo, Egypt, 121, *121* (fig. 3.24)

Tschirnhaus, Ehrenfried von, 230

tumbaga, 43–44, 262–63

tumbaga, objects: kero, Lambayeque culture, 44, 262–63, *263* (fig. 8.4)

Tupperware, 234

Turkey, 39, 129–30

Turkey, objects: dish, Bursa or Edirne, 31, *32* (fig. 1.11); dish, probably Iznik, 130, *130* (fig. 3.37); tile panel, Iznik, 31, *32* (fig. 1.10), 59

turning. *See* lathes

Uighur weavers, 122

*unheimlich* (uncanny), 255

United States. *See* North America

*urpu*, Cuzco area, Peru, 153–54, *154* (fig. 4.4)

use. *See* function/use

users/audience: agency of, 210; and appearance, 210–35; collected objects in relation to, 170; enchantment of, 18, 210, 235; makers' flexibility in addressing, 215; object in relation to, 148–50, 210, 238; role of, in art historical approaches, 13, 14; and touch, 236–55. *See also* reception of objects

use value, 150–51, 170

Utagawa Kunisada I and Ryôko, *Fond of Tea Gatherings* (*Chanoyu kō*), 161, *161* (fig. 4.8)

value: social, 150–51, 155, 170; symbolic, 150–51, 169–70, 195; use, 150–51, 170

Vanderbank, John, *The Palanquin*, 165, *165* (fig. 4.13)

Vasari, Giorgio, 9

vases: made from 75-mm artillery shell casing by Sgt. First Class Jack J. Clarke of an armored division for his girlfriend Myrtle, 191, *191* (fig. 5.12); memory vase, United States, possibly southern, 183, *184* (fig. 5.4); scarab vase (*The Apotheosis of the Toiler*), Adelaide Alsop Robineau, Syracuse, New York, 62, *62* (fig. 2.7), 251

Veblen, Thorstein, 166

veneers, 94–95, 211, 219, 231–33

Venice, 104, 203

Vereenigde Oostindische Compagnie (VOC, Dutch East India Company), 110, 123, 125, 185, 186

vessel, La Graufesenque, France, *27* (fig. 1.4), 28, 103

Victoria, Queen, 198–99

Vietnam, 105, 142; dish, 142, *143* (fig. 3.51)

visuality, privileging of, 254–55. *See also* appearance

VOC. *See* Vereenigde Oostindische Compagnie

Wadsworth Atheneum, Hartford, Connecticut, 187

Warner, Polly, 207

Washington, George, 163, 187, 200

weaving, types of, 71–72

Wedgwood, Josiah, 144, 235. *See also* Josiah Wedgwood and Sons

Wedgwood and Company, 61; teapot, 28, *28* (fig. 1.6), 61, 66, 111, 148–49. *See also* Josiah Wedgwood and Sons

weight, 249

Wellesley, Richard, 188–89

West Africa: metalwork, 105–6; raffia, 34, 178

# Photo Credits

Rijksmuseum, Amsterdam (figs. 0.2, 2.43, 2.45, 3.25, 3.48, 5.21, 5.23)

Museu Nacional de Arte Antiga, Lisbon; photograph by Luísa Oliveira / José Paulo Ruas, 2015 (fig. 0.3); photograph by Luísa Oliveira, 2018 (fig. 2.33)

Peabody Museum of Archaeology and Ethnology, Harvard University, Cambridge, MA (fig. 0.4)

Photograph © 2022 Museum of Fine Arts, Boston (figs. 0.5, 0.6. 2.27, 2.28, 2.32, 3.21, 3.22, 4.8, 4.10, 6.19)

The Metropolitan Museum of Art, New York (figs. 0.7, 0.8, 1.10, 2.4, 2.13, 2.19, 2.24, 2.25, 2.36, 2.37, 2.38, 3.8, 3.19, 3.24, 3.37, 4.2, 4.4, 5.3, 5.29, 6.9, 6.12, 6.18)

The Sarikhani Collection; photograph by Clarissa Bruce (fig. 1.1)

© The Trustees of the British Museum, London. All rights reserved (figs. 1.2, 1.4, 2.18, 2.21, 2.30, 3.1, 3.14, 4.1, 5.22, 8.1)

Canadian Museum of History, Quebec (figs. 1.3, 5.20)

Photograph by Gavin Ashworth (figs. 1.5, 2.10, 8.3)

Victoria and Albert Museum, London (figs. 1.6, 1.14, 1.16, 1.24, 1.25, 2.2, 2.5, 2.20, 2.22, 3.15, 3.23, 3.40, 3.47, 3.53, 4.3, 5.2, 5.25, 6.6)

The Chipstone Foundation, Milwaukee, WI; photograph by Gavin Ashworth (figs. 1.7, 3.16, 5.4); photograph by Jim Wildeman (fig. 3.27)

Asian Civilizations Museum, Singapore (figs. 1.8, 1.11, 3.3, 3.4, 3.30, 3.35, 3.38, 3.42, 3.49, 3.50, 3.51)

Thomas Lurie Collection, Columbus, OH; photograph by Larry Hamill Photography (fig. 1.9)

Courtesy of the Penn Museum, Philadelphia (fig. 1.12)

Hood Museum of Art, Dartmouth College (fig. 1.13)

Ashmolean Museum, Oxford (figs. 1.15, 1.20, 2.9, 2.23)

© Dumbarton Oaks, Pre-Columbian Collection, Washington, DC (fig. 1.17)

Los Angeles County Museum of Art, www.lacma .org (fig. 1.18)

Winterthur Museum, Winterthur, DE (figs. 1.19, 1.22, 2.29, 2.42, 3.32, 3.54, 3.55, 4.9, 5.26); photograph by Gavin Ashworth (fig. 2.15)

Arthur M. Sackler Gallery, Smithsonian Institution, Washington, DC (fig. 1.21)

Wayne & Phyllis Hilt American and British Pewter, hiltpewter.com; photograph © Wayne A. Hilt (fig. 1.23)

Diplomatic Reception Rooms, US Department of State, Washington, DC (fig. 1.26)

Yale University Art Gallery, New Haven, CT (figs. 1.27, 2.3, 2.31, 3.52, 4.11, 4.13, 6.1, 6.5, 6.7, 6.8, 6.14)

© Mary Rose Trust (fig. 2.1)

National Museum of the American Indian, Smithsonian Institution, Washington, DC; photograph by the NMAI Photo Services (fig. 2.6)

Everson Museum of Art, Syracuse, New York (fig. 2.7)

Photograph by Allen Phillips / Wadsworth Atheneum, Hartford, CT (figs. 2.8, 5.8, 5.9)

Freer Gallery of Art, Smithsonian Institution, Washington, DC (figs. 2.11, 5.15)

Cleveland Museum of Art, Cleveland, OH (figs. 2.12, 3.2, 3.6, 3.36, 3.46)

Bryan Collection, USA (figs. 2.14, 5.24, 5.27, 5.31)

Photograph by the author (figs. 2.16, 5.12)

The State Hermitage Museum, St. Petersburg, Russia (fig. 2.17)

Gurusaday Museum, Kolkata; photograph by Subhodeep Chanda, chief photographer, PALETTE (fig. 2.26)

UBC Museum of Anthropology, Vancouver, Canada; photograph by Kyla Bailey (fig. 2.34)

Shelburne Museum, Shelburne, VT; photograph by J. David Bohl (fig. 2.35)

Photograph by David Stansbury (fig. 2.39)

Hispanic Society of America, New York (figs. 2.40, 2.41)

Photograph by Katherine Wetzel; © Virginia Museum of Fine Arts, Richmond, VA (fig. 2.44)

Photograph © Dirk Bakker / Bridgeman Images (fig. 3.5)

Photograph by Travis Fullerton; © Virginia Museum of Fine Arts, Richmond, VA (fig. 3.7)

Archivo Real y General de Navarra (AGN) (fig. 3.9)

Franz Mayer Museum, Mexico City (fig. 3.10)

© MAD, Paris (fig. 3.11)

Photograph by Joan Parcher (fig. 3.12)

Image originally published in Detlef Gronen-

born, ed., *Gold, Slaves, and Ivory: Medieval Empires in Northern Nigeria* (Mainz, Germany: Römisch-Germanisches Zentralmuseum, 2011). Volume accompanying the exhibition at the Römisch-Germanisches Zentralmuseum, September 22, 2011–January 1, 2012 (fig. 3.13)

© Islamic Arts Museum Malaysia; photograph courtesy of Sotheby's (fig. 3.17)

Photograph by Samuel Luterbacher (fig. 3.18)

Museum of Portuguese Decorative Arts, Ricardo do Espírito Santo Silva Foundation, Lisbon; © PH3 / José Dominguez Vieira (fig. 3.20)

From the collections of the Charleston Museum, SC; photograph by Gavin Ashworth (fig. 3.26)

Missouri Historical Society, St. Louis (fig. 3.28)

The Walters Art Museum, Baltimore, MD (fig. 3.29)

Yale Center for British Art, New Haven, CT (figs. 3.31, 4.7, 7.2)

The Chen Art Gallery, Torrance CA; photograph courtesy of Christie's, Inc. (fig. 3.33)

Pewtersellers.com (fig. 3.34)

Photograph courtesy of Amir Mohtashemi (fig. 3.39)

Photograph courtesy of the Royal Ontario Museum; © ROM (fig. 3.41)

Photograph by Queen Sirikit Museum of Textiles, Bangkok, Thailand (fig. 3.43)

The Textile Museum, Washington, DC (figs. 3.44, 7.7)

Thomas Coulborn & Sons (fig. 3.45)

Peabody Museum of Natural History, Yale University (fig. 4.5)

Ezra Stiles Papers, General Collection, Beinecke Rare Book and Manuscript Library, Yale University (fig. 4.6)

The Connecticut Historical Society, Hartford, CT (fig. 4.12)

Album / Alamy Stock Photo (fig. 4.14)

National Library of Scotland, Edinburgh (fig. 4.15)

Harvard Law School Library, Historical & Special Collections, Cambridge, MA (fig. 4.16)

Wikimedia Commons; photograph by Paul R. Burley, https://commons.wikimedia.org/wiki/File:Igreja_de_Nossa_Senhora_da_Concei%C3%A7%C3%A3o_do_Monte_Cachoeira_9935.jpg (fig. 4.17)

Ivan Vdovin / Alamy Stock Photo (fig. 4.18)

Hemis / Alamy Stock Photo (fig. 4.19)

© The Royal Court, Sweden; photograph by Alexis Daflos (fig. 5.1)

H. Blairman & Sons, London; photograph by Prudence Cuming Associates (fig. 5.5)

Peabody Essex Museum, Salem, MA; photograph by Walter Silver (fig. 5.6)

The Lucke Collection (fig. 5.7)

© National Trust Images / Erik Pelham (fig. 5.10)

RISD Museum of Art, Providence, RI (fig. 5.11)

© Canterbury Museums and Galleries (fig. 5.13)

© Bristol Culture: Bristol Museum & Art Gallery (fig. 5.14)

Photograph by Martine Beck-Coppola; © RMN-Grand Palais / Art Resource, New York (fig. 5.16)

Photograph by KHM-Museumsverband (fig. 5.17)

Kodai-ji Temple, Kyoto (fig. 5.18)

© Victoria and Albert Museum, London. Courtesy Royal Collection Trust / Her Majesty Queen Elizabeth II 2022 (fig. 5.19)

The Henry Ford Museum, Dearborn, MI (fig. 5.28)

Philadelphia Museum of Art (figs. 5.30, 6.2)

Hong Kong Museum of Art Collection (fig. 6.3)

Dietrich American Foundation; photograph by Gavin Ashworth (figs. 6.4, 7.4)

Gustavanium, Uppsala University Museum; photograph by Mikael Wallerstedt (fig. 6.10)

© Museum für Lackkunst, Munster, Germany; photograph by Tomasz Samek (fig. 6.11)

Historic New England (fig. 6.13)

Brooklyn Museum (fig. 6.15)

Photo courtesy of Bonham's (fig. 6.16)

Rosenborg Castle, Copenhagen (fig. 6.17)

Courtesy of Michael Backman Ltd, London (fig. 7.1)

Photo © Christie's Images / Bridgeman Images (fig. 7.3)

© Private collection; photograph courtesy of Sotheby's (fig. 7.5)

Allen Memorial Art Museum, Oberlin College (fig. 7.6)

Photo courtesy of Sotheby's (fig. 8.2)

Museo Larco, Lima, Peru (fig. 8.4)